★ SOVIET ★
DISSIDENT
ARTISTS

SOVIET DISSIDENT ARTISTS

INTERVIEWS AFTER PERESTROIKA

EDITED BY

RENEE BAIGELL

AND

MATTHEW BAIGELL

RUTGERS UNIVERSITY PRESS
NEW BRUNSWICK, NEW JERSEY

LIBRARY OF CONGRESS CATALOGING-IN-PUBLICATION DATA
Soviet dissident artists : interviews after Perestroika / co-edited by
 Renee Baigell and Matthew Baigell.
 p. cm.
 Includes bibliographical references and index.
 ISBN 0-8135-2223-4 (alk. paper)
 1. Dissenters. Artistic—Soviet Union—Interviews. 2. Art and
state—Soviet Union. I. Baigell, Matthew. II. Baigell, Renee.
N6988.s6753 1995 95-12435
709'.2'247—dc20 CIP

BRITISH CATALOGING-IN-PUBLICATION INFORMATION AVAILABLE

This publication has been supported in part by a grant from the Avenir
Foundation.

Published by Rutgers University Press, New Brunswick, New Jersey

Manufactured in the United States of America

Composition and Interior Design by Martin-Waterman Associates

For artists everywhere who have had to fight for
their artistic freedom

★ CONTENTS ★

LIST OF ILLUSTRATIONS ix

PREFACE xi

INTRODUCTION 1

 Norton Dodge 25

 Elii Beliutin 36

 Dmitrii Lion 44

 Vladimir Nemukhin 53

 Dmitrii Krasnopevtsev 60

 Džemma Skulme 65

 Ernst Neizvestny 75

 Lydia Masterkova 84

 Boris Sveshnikov 90

 Oskar Rabin 94

 Leonid Lamm 106

 Leonid Sokov 114

 Valery Yurlov 120

 Gleb Bogomolov 132

 Ilya Kabakov 142

 Erik Bulatov and Oleg Vassiliev 152

 Oleg Tselkov 162

 Ivan Chuikov 171

 Yurii Dyshlenko 179

 Dmitri Plavinsky 185

 Igor Shelkovsky 190

 Eduard Shteinberg 204

 Vladimir Yankilevsky 211

 Dmitrii Prigov 218

 Arkadii Petrov 227

 Gennadii Zubkov 235

Viacheslav Koleichuk 243

Vladimir Ovchinnikov 251

Alexander Kosolapov 257

Vitaly Komar and Alexander Melamid 264

Leonid Borisov 277

Igor Makarevich 285

Mikhail Chemiakin 293

Natalia Nesterova 305

Grisha Bruskin 313

Alexander Petrov 323

Olga Bulgakova and Aleksandr Sitnikov 332

Svetlana Kopystianskaia and Igor Kopystiansky 344

Sergei Sherstiuk 355

Irina Nakhova 366

Elena Figurina 373

Georgii Senchenko and Arsen Savadov 379

Sergei Bugaev "Afrika" 389

GLOSSARY 395

INDEX 399

★ ILLUSTRATIONS ★

All of these paintings and sculptures are in the Norton and Nancy Dodge Collection of Nonconformist Art from the Soviet Union in the Zimmerli Art Museum, Rutgers University.

Elii Beliutin, *Landscape* AFTER PAGE 176

Elii Beliutin, *Woman and Child* 41

Dmitrii Lion, *Biblical Stories (Legends)* 49

Vladimir Nemukhin, *Still Life with Guitar and Cards* AFTER PAGE 176

Dmitrii Krasnopevtsev, *Still Life with Three Pots* 63

Džemma Skulme, *Untitled* AFTER PAGE 176

Ernst Neizvestny, *Bertran de Born* 79

Lydia Masterkova, *Composition* AFTER PAGE 176

Boris Sveshnikov, *Meeting the Guests* AFTER PAGE 176

Oskar Rabin, *Untitled* AFTER PAGE 176

Leonid Lamm, *The Tree of Life: Great Light* AFTER PAGE 176

Leonid Sokov, *Problem* AFTER PAGE 176

Valery Yurlov, *Counterform* AFTER PAGE 176

Gleb Bogomolov, *Untitled* AFTER PAGE 176

Ilya Kabakov, *From the Series: Shower—A Comedy* 147

Erik Bulatov, *Two Landscapes on a Red Background* AFTER PAGE 176

Oleg Vassiliev, *Spatial Composition* 158

Oleg Vassiliev, *Stroll* AFTER PAGE 176

Oleg Tselkov, *Falling Mask* AFTER PAGE 176

Ivan Chuikov, *All Power... (To the Soviets)* 175

Yurii Dyshlenko, *Concise Guidebook* AFTER PAGE 176

Dmitri Plavinsky, *Untitled* AFTER PAGE 176

Igor Shelkovsky, *Lagni Vari* 196

Eduard Shteinberg, *Composition* AFTER PAGE 176

Vladimir Yankilevsky, *Triptych #7* AFTER PAGE 176

Dmitrii Prigov, *Glasnost* 221

Arkadii Petrov, *Aunt Niusia* 230

Arkadii Petrov, *Times of the Day* AFTER PAGE 176

Gennadii Zubkov, *Country Road* AFTER PAGE 176

Viacheslav Koleichuk, *Möbius* 247

Vladimir Ovchinnikov, *Handing over Command of Dmitrii Donskoi's Tank Column Which Was Established with Contributions from Believers, March 7, 1944* 254

Alexander Kosolapov, *Untitled* AFTER PAGE 176

Vitaly Komar and Alexander Melamid *Our Goal Is Communism* 269

Leonid Borisov, *Untitled* 281

Igor Makarevich, *Box Containing Plastercast Impressions of Fingerprints* AFTER PAGE 176

Mikhail Chemiakin, *Carcass* AFTER PAGE 176

Natalia Nesterova, *Spaghetti* 309

Grisha Bruskin, fragment from part III of *The Fundamental Lexicon* AFTER PAGE 176

Alexander Petrov, *Untitled* AFTER PAGE 176

Olga Bulgakova, *Untitled* AFTER PAGE 176

Aleksandr Sitnikov, *Abduction* AFTER PAGE 176

Svetlana Kopystianskaia, *Landscape* 349

Igor Kopystiansky, *Construction* 352

Sergei Sherstiuk, *Islands* 360

Irina Nakhova, *Untitled* 370

Elena Figurina, *Victors* AFTER PAGE 176

Georgii Senchenko and Arsen Savadov, *Untitled* 385

Sergei Bugaev "Afrika," *Stalin* 390

★ PREFACE ★

The genesis of this book lies in conversations held with Norton and Nancy Dodge soon after they donated their collection of Soviet nonconformist art to Rutgers University in 1991. We (Renee Baigell and Matthew Baigell) believed that it was important to hear the artists' own words concerning their everyday experiences under Communism: When did they realize they were dissident artists? How were they harassed by the artists' unions, by the Ministry of Culture, and by the secret police (KGB)? How did they find and develop a supportive audience? When did they first see modern western art and what were their responses to it?

The Dodges agreed, and we then began to interview as many artists as possible in Russia, France, and the United States. Since the Dodge Collection—its full title is the Norton and Nancy Dodge Collection of Nonconformist Art from the Soviet Union—is the largest and the most important of its kind in the world, numbering close to ten thousand works by about eight hundred artists (and still growing), the problem was not in finding artists to interview, but in how to limit their number. This proved to be a somewhat random procedure. The nonconformist movement began in the late 1950s and ended with perestroika in 1987 when artists who had not adhered to the acceptable styles and ideology of socialist realism came out, as it were, from underground. During the thirty-year period of the movement, several generations of artists had flourished, if not openly, then known to each other, to their relatively small supportive audience of other artists and members of the intelligentsia, a few foreign collectors, and, alas, to the authorities.

Certain key figures emerged in each generation by virtue of

the quality of their art as well as by their bravery in the face of oppressive tactics by officialdom. We tried to interview as many major figures as possible, but, since perestroika, several formerly underground artists have begun to move about and live almost as gypsies in France, Germany, and the United States, as well as in Russia and other countries of the former Soviet Union. Without unlimited funds, it was impossible for us to track down as many as we would have liked. We also felt the great constraint of time in that we wanted to talk to the artists before their memories of the recent past had faded or had altered, and events as well as attitudes, had been re-created in their minds. Alas, we sometimes did hear different and conflicting interpretations of the same events, which without corroborative evidence we let stand as given. For example, in the instances of the famous Bulldozer Exhibition of 1974 in Moscow or the Gaz Palace exhibition in Leningrad in the same year, artists told us about their particular experiences, their speculations, and what they had heard about these events, which varied with each individual telling.

We knew that other factors might also hinder accurate readings of the past. After all, we were strangers who asked personal questions about sometimes harrowing, sometimes humiliating confrontations with the authorities, and the artists understandably were more or less candid, depending upon how much they could or would reveal about their sometimes literally painful experiences. Often, some would begin to respond to a question and then speak no further about a particular topic, leaving us tantalized but unfulfilled by the information given. (This is reflected in the occasional abrupt breaks in the flow of conversation during some interviews.) And sometimes telephone calls and other interruptions jogged the already illogical processes of memory down paths different from those on which they had started. A few interviews were found to be unusable either because the artists were not forthcoming enough or because of space limitations.

All of the interviews were taped and conducted by Renee, who is fluent in Russian. Sometimes during a pause Matthew was apprised of the general drift of the conversation and was able to ask a few questions. Dr. Natalia Barbash, to whom we owe a special debt of gratitude, transcribed the tapes. Renee then translated the interviews, now in manuscript form, into English, and both she and Matthew edited the final versions.

We have spelled the names of the artists who have emigrated to the West as they do themselves. For artists who are, or were, active chiefly in the former Soviet Union, and for places, we have used the following spelling systems: the Library of Congress system of transliteration of Cyrillic for Russian names; and the system developed for the Ukrainian Encyclopedia and used by the Slavic Department of the New York Public Library for Ukrainian names.

Although each interview was different, a basic set of questions was asked. All of the interviews were shortened to eliminate irrelevant information and were edited for the sake of clarity and continuity. We were very careful, however, not to change the context of the artists' intentions or meanings. The interviews are presented chronologically according to the ages of the artists, that, we decided, being the most reasonable and practical kind of organization.

We want to thank Dennis Cate, director of the Zimmerli Art Museum; Alla Rosenfeld, curator of the Russian and Soviet collections; and Barbara Trelstad, the registrar, for their support and especially for expediting the selection of the illustrations. All of the tapes are deposited in the museum.

We also want to thank Leslie Mitchner, editor in chief of Rutgers University Press, for enthusiastically encouraging the publication of these interviews and Judith Martin Waterman for her careful and unobtrusive copyediting.

Naturally our greatest thanks and heartfelt appreciation are reserved for Norton and Nancy Dodge who supported our work

in every way possible. Without their constant encouragement (and knowledge of the whereabouts of many artists), this book would never have been published.

Renee Baigell
Matthew Baigell
Highland Park, N.J.

★ SOVIET ★
DISSIDENT
ARTISTS

★ INTRODUCTION ★

From the late 1950s until the advent of perestroika in 1987, many artists in the Soviet Union rebelled against the styles and ideology of socialist realism. They have been called underground artists, nonconformists, unofficial artists, and dissidents. All of these terms apply, but each needs qualification. Some artists object to "dissident" because to them it implies active political engagement against the government. These artists feel that the creation of art that was unacceptable to the authorities before perestroika was a matter of individual conscience rather than a political act of disobedience, a fine splitting, it would seem, of ideological hairs. Most were not truly underground artists, because that implies constant hiding. In fact, many worked as book illustrators, decorators, theatrical designers, and even as official artists, saving their "underground" art for their spare time. Terms such as "nonconformist" and "unofficial" are generally acceptable, but state what the artists were not, rather than what they were. Furthermore, in the 1980s when the authorities tried to co-opt these artists by offering them officially sponsored exhibitions, their exact degree of nonconformity or unofficialness becomes more difficult to define. But the one characteristic all of the artists shared, whatever their degree of opposition to the authorities, was their desire to pursue their own vision of art at the expense of state supervision. In effect, because the particular generic term—nonconformist, dissident—is less important than the attitudes the artists held in common, all these terms will be used interchangeably throughout this book, except in those interviews of artists who took issue with the term "dissident."

In the interviews contained here and in private conversations,

A smaller version of this introduction is included in Alla Rosenfeld and Norton Dodge, eds., *Gulag to Glasnost: NonConformist Art from the Soviet Union, the Norton and Nancy Dodge Collection* (New York: Thames and Hudson, 1995).

virtually all of the artists spoke about "the authorities." Who were the authorities? Basically they were three bodies controlled by the Cultural Section of the Central Committee of the Communist Party: the Ministry of Culture, which controlled all art museums, exhibitions in museums, acquisitions of works, and some publications; the Academy of Arts of the USSR, which controlled all important art schools; and the USSR Union of Artists, which controlled artists' unions of the republics and major cities such as Moscow and Leningrad, supervised commissions and exhibitions in public spaces, and handled some publications.[1] Quite often in conversation artists would refer to "the union" without indicating which one—the Soviet, the republic (Russian, Ukrainian), or the local (Moscow, Leningrad), but the inference was that it hardly mattered even though there were differences between the three levels. Furthermore, artists also mentioned that they often were confronted simultaneously by representatives of the union and the Ministry as well as the by KGB and the local police so that it was difficult, if not always impossible, to defy, let alone resist, "the authorities."

Nevertheless, opposition to official artistic ideology surfaced after Stalin's death in 1953, became quite visible during the Khrushchev Thaw of the late 1950s and early 1960s, and was suppressed or tolerated to greater or lesser degree in the following decades until perestroika in 1987. But even today it is still difficult for artists to get their works out of the former Soviet Union. When an artist has an exhibition abroad, he or she has to create the works in another country and leave them there if they are to be sold at some future date in the West.

[1] For more thorough accounts of the Soviet art apparatus, see Igor Golomshtok, "Unofficial Art in the Soviet Union," in *Unofficial Art in the Soviet Union*, ed. Igor Golomshtok and Alexander Glezer (London: Secker and Warburg, 1977), 91–92; Norton Dodge and Alison Hilton, eds., *New Art from the Soviet Union: The Known and the Unknown* (Washington, D.C.: Acropolis Books, 1977), 10; Norton Dodge, "Two Worlds of Soviet Art," in *Nonconformists: Contemporary Commentary from the Soviet Union* (College Park: University of Maryland Art Gallery, 1980); and Marilyn Rueschemeyer, Igor Golomshtok, and Janet Kennedy, *Soviet Emigre Artists: Life and Work in the USSR and the United States* (Armonk, N.Y.: M. E. Sharpe, 1985), 25.

Certain key events, exhibitions, and associations of artists have come to define the development of the nonconformist art movement. It might be said to have begun with the founding of Elii Beliutin's Studio of Experimental and Graphic Arts in 1954, considered the "first coherent manifestation of non-conformism" in the Soviet Union.[2] By 1956 government-approved exhibitions of works by Picasso and Matisse were held in Leningrad, and a Picasso show took place in Moscow. Exhibitions of impressionist works were also held, and in official art circles carefully controlled experimentation was encouraged. One of the most important exhibitions accompanied the Seventh International Youth Festival in Moscow in 1957 where artists saw abstract expressionist works for the first time. An American graphics show in 1963 introduced Robert Rauschenberg and Jasper Johns as well. During these years exhibitions of Russian avant gardists of the 1920s, whose works had been locked away, were also held. An exhibition of contemporary American art in 1975 introduced photorealism to Russia.

Given the changing political climate and the number and

[2] Matthew Cullerne Browne, *Contemporary Russian Art* (New York: Philosophic Library, 1989), 20. The following discussion is based on Elena Kornetchuk, "Soviet Art and the State," in *The Quest for Self-Expression: Painting in Moscow and Leningrad, 1965–1990*, ed. Norma Roberts (Columbus, Ohio: Columbus Museum of Art, 1990), 19–42; John E. Bowlt, "Moscow: The Contemporary Art Scene," and Konstantine Kuzminsky, "Two Decades of Unofficial Art in Leningrad," in Dodge and Hilton, eds., *New Art*, 20–21, 28; Golomshtok, "Unofficial Art," and Alexander Glezer, "The Struggle to Exhibit, in *Unofficial Art*, ed. Golomshtok and Glezer, 85–90, 104, 107–120; Charlotte Douglas and Margarita Tupitsyn, co-curators, *Gennady Zubkov and the Leningrad 'Sterligov' Group: Evidence of Things Not Seen* (New York: Contemporary Russian Art Center of America, 1983); M. Tupitsyn, "The Decade 'B.C.' (Before Chernenko) in Contemporary Russian Art," in *Apt Art: Moscow Vanguard in the '80s*, ed. Norton Dodge (New York: Contemporary Russian Art Center of America, 1985), 5–11; Szymon Bojko, "Three Waves of Emigration," in *Russian Samizdat Art*, ed. Charles Doria, (New York: Willis Locker and Owens, 1986), 72; M. Tupitsyn, *Margins of Soviet Art* (Milan: Grancarlo Politi Editore, 1989), 33–37, 61; Andrew Solomon, *The Irony Tower* (New York: Knopf, 1991), 76–96; Selma Holo, ed., *Keepers of the Flame: Unofficial Artists of Leningrad* (Los Angeles: University of Southern California, 1991); and, *No!— and the Conformists: Faces of Soviet Art of '50s to '80s* (Warsaw: Fundacja Polskiez Sztuki Nowoczesnej, 1994), 411–424.

variety of exhibitions of modern art, Soviet artists were emboldened to stage their own exhibitions of contemporary art or were included in officially sponsored shows. The most notorious early exhibition, entitled "Thirty Years of Moscow Art," took place in 1962 at the Manezh, an exhibition hall in downtown Moscow. The show included some two thousand paintings, prints, and sculptures, and a representation of experimental art by Elii Beliutin and his students, among others, whose works were solicited by Dmitrii Polikarpov, the head of the Culture Section of the Central Committee of the Communist Party. Khrushchev, when visiting the exhibition, was enraged by what he saw (and probably by his argument with Ernst Neizvestny) and denounced modernism in no uncertain terms. It has been suggested that Mikhail Suslov, then party chief of ideology, set up the exhibition to discredit the modernists, and that Vladimir Serov, then president of the Academy of Arts, who escorted Khrushchev through the exhibition, was part of the plot. Be that as it may, repression followed and the nonconformist movement went underground. A similar fate befell nonconformist artists who worked at various menial jobs in the Hermitage in Leningrad. In 1964 their exhibition, "Working Artists from the Hermitage Staff," was closed by the authorities almost as soon as it opened.

Through the 1960s unofficial artists began to exhibit their works—sometimes for as long as a single day—in apartments. According to several artists, an exhibition was termed a success if it opened and closed without a visit from the authorities who had their moles, evidently, everywhere. Various scientific institutes, which were able to maintain some autonomy from the authorities, also held exhibitions of nonconformist art. In fact, scientists along with the intelligentsia, musicians, and the literati became the chief supporters of the artists and were clearly important components of their psychological landscape.

Lose groupings of artists also appeared by the late 1950s, including the group that formed around Oskar Rabin and Lev Kropivnitsky at Lianozovo, near Moscow, and the Sretensky Boulevard Group to which Erik Bulatov and Ilya Kabakov, among

others, belonged. Another group, led by Lev Nusberg, was called *Dvizhenie* (Movement) Group.

The so-called Bulldozer exhibition of September 15, 1974, and the follow-up exhibition at Izmailovsky Park on September 29, were the most publicized exhibitions of the 1970s. Organized by Oskar Rabin, Vitaly Komar, Alexander Glezer, and others, the Bulldozer exhibition was held on a deserted street in Moscow for as long as it took the police to hose down, bulldoze, and destroy as many works as possible that were presented by the fourteen participating artists. The international outcry was so strong that the authorities allowed a four-hour exhibition two weeks later at Izmailovsky Park in which seventy artists participated. In Leningrad major unofficial exhibitions were held at the Gaz Palace of Culture in December 1974 and at the Nevsky Palace of Culture in September 1975.

Despite the postexhibition repressions in both cities, small groups of artists began to proliferate in Moscow and Leningrad through the middle and late 1970s. These included, in Moscow, the Collective Action Group (1976) and the Mukhomor (Toadstool) Group (1978) and, in Leningrad, the Association for Experimental Exhibitions (1975) and the Association of Experimental Visual Art (1981). A number of smaller groups were also formed by the middle 1980s, including the 5/4 Group, MITKI, Aleph, and The New Ones.

This is by no means an exhaustive list of exhibitions or groups that energized the nonconformist movement from the late 1950s through the late 1980s. But the point is made that there was neither a single nonconformist style nor voice. In fact, the variety of styles and interests of the artists is staggering, given the kinds of harassment and repression they had to confront each day. "All that unites us," Nikolai Vechtomov said, "is lack of freedom."[3] One historian of the movement has defined its three major stages. Initially, artists explored alternatives to socialist realism, with its emphasis on the material splendors of Soviet life, by using realistic modes to explore personal and spiritual feelings. The second

[3] Glezer, "The Struggle to Exhibit," 109.

stage was begun by artists who came of age around 1960. They began to experiment with the great variety of styles seen in exhibitions of Western modern art and of the Russian avant garde of the 1920s. In fact several avant gardists were still alive and often accessible to the nonconformists during their school years in the 1950s. These included Vladimir Tatlin, Aleksandr Rodchenko, Yakov Chernikhov, Varvara Stepanova, Robert Falk.[4] In addition, nonconformists, including Vitaly Komar and Alexander Melamid, Leonid Sokov, and Erik Bulatov, looking carefully at socialist realist sources, as well as images from the popular media, developed sots art, a Soviet equivalent of pop art. (Komar and Melamid invented the term in 1972.) The third major period began in the 1970s when Soviet artists began to develop their own versions of performance art, installations art, conceptual art, and other contemporary movements.

Whatever the styles, attitudes, and levels of commitment of the artists, it has not been emphasized nearly enough that the history of nonconformist art is one of the great heroic stories of the last half of this century. It is the story of several generations of artists who had learned their skills in the rigorous state-supported system of training, but who insisted on the kind of interior freedom that was anathema to the authorities. Some artists were jailed, a few, perhaps, were killed, many were harassed. They certainly suffered economic and psychological deprivation in ways Westerners can barely understand, but their desire to create from a sense of inner necessity and honesty prompted their refusal to accept the authority of the state in matters of art. As Ilya Kabakov has suggested, "[t]he principle meaning of unofficial art is the negation of all preconceived artistic traditions and official life

[4] Innesa Lekova-Lamm, "After Isolation," in *Transit: Russian Artists between East and West*, ed. Eleanor Flomenbaft and Innesa Lekova-Lamm (New York: Eduard Nakhamkin Fine Arts, 1889), 40.

shaped on Soviet ideology and to propose, instead, an alternative way of thinking, of expression, and an individual lifestyle."[5]

The artists' stories are not monolithic, and the degree of terror each artist experienced ranges from the frightening to the truly horrible—with nothing in the experience of Western artists being in any way comparable. Generally, however, the earlier nonconformists suffered more than the later ones, but this is only a generalization. For example, Boris Sveshnikov was eighteen years old when he was sent to a concentration camp for eight years. Although obviously traumatized by his experiences to this very day, he still did not make works completely acceptable to the authorities after his return to Moscow. Elii Beliutin, a painter and a teacher comparable in significance to such American artist/teachers as Robert Henri and Hans Hofmann for bringing out unique qualities in each student, lost his teaching position and was sent into internal exile for a few years after participating in the Manezh exhibition in 1962. Leonid Lamm was jailed from 1973 to 1976 after applying to emigrate from the Soviet Union and, on at least one occasion, was the victim of a temporary drug-induced psychosis. Yet, on his return to Moscow he painted works that were not always acceptable. Mikhail Chemiakin was incarcerated in a psychiatric clinic in 1961, was drugged, and remembers seeing other artists who were also being "cured" of the "virus of modernism."[6] Ivan Chuikov, like many others, was questioned, intimidated, and threatened by the KGB on more than one occasion. Yurii Dyshlenko, when he arrived by car to hang his paintings at an officially sanctioned nonconformist exhibition in Leningrad in 1974, told his friend to drive off with the paintings still in the trunk if he (Dyshlenko) had not returned from the exhibition hall within five minutes. He did not know if this was a ruse to get all of the artists inside in order to arrest them. The message here is that both the very act of creation and its public exhibition were probable

[5] Christine Tache, "Questions of the Present—A Dialogue with the Past," in *Igor and Svetlana Kopystiansky* (Berlin: Museum fur Moderne Kunst, 1991), 93.

[6] *Mikhail Chemiakin* (Oakville, Ontario: Mosaic Press, 1986), 19–25.

causes for arrest and detention. And Konstantin Zvezdochetov was drafted into the army in the 1970s as punishment for his activities and sent to a post in eastern Siberia that was, for all intents and purposes, the end of the world, certainly of his world.[7]

Yet, some artists, when asked if they thought of themselves as heroic, denied any interest in the concept, associating it rather with Stakhanovite tractor drivers from the Stalinist era. Nor did they think of themselves as the kind of heroic artists Westerners have long since mythologized into attics and garrets, starving for their art and dying of tuberculosis. Mikhail Chemiakin, a leader of the Leningrad nonconformists, has said, "We simply lived and worked as we knew how. And had the audacity in those days to try to look at the world with our own eyes." And Erik Bulatov said "We [were] afraid to show our work, but we show[ed] it. There [was] no other way."[8]

But there has been too little heroization of the nonconformists. It can be argued that they fulfill to a much greater extent the role assigned to School-of-Paris modernists than the modernists themselves played. As Donald Kuspit has observed, the avant-garde artist has been perceived as an heroic resister to bourgeois civilization, a risk taker, "a kind of Promethean adventurer." This has led to a fetishization of the modern artist because "he [was] able to be himself in a way that is impossible for other people." The avant-garde artist has been imagined as a person who confronts officialdom and who is subversive through "his perceptual and personal authenticity [and who] transmutes the lives of others, giving them a liberation they were too sunk in suffering to know they needed."[9]

While Soviet society was not bourgeois and while there is no compelling reason to fetishize the nonconformists, we should recognize the role they played in maintaining whatever authenticity, whatever sanity, and whatever mental health existed within

[7] Solomon, *Irony Tower*, 117–122.

[8] Holo, ed., *Keepers of the Flame*, 50; and Roberts, ed., *Quest for Self-Expression*, 44.

[9] Donald Kuspit, *The Cult of the Avant-Garde Artist* (New York: Cambridge University Press, 1993), 1–2.

the decadence and moral rot of the Soviet system. One might argue that the increasing weakness of the system allowed the artists to flourish because during the 1930s and 1940s they would have been summarily imprisoned or killed. Nevertheless, they did flourish within a system of what Robert Jay Lifton has called ideological totalism, a system that, whatever their individual heroism, Western modernists never had to confront daily.

Lifton defines one aspect of this system as "the principle of doctrine over person" which occurs when a conflict exists between what one feels oneself experiencing and what the doctrine or dogma says one should experience.[10] Ilya Kabakov described this situation pungently when recounting life in a communal apartment. Imagine a small, crowded room, terrible bathroom facilities, noises coming through the walls. The radio might be playing a song with the following lyrics: "Moscow mine, O nation mine, you'll be in no one's thrall,/Moscow mine, O nation mine, I love you best of all. . . ." Then Kabakov says, "Out there is paradise, out there healthy young creatures are off to display their athletic prowess in the May Day parade through Red Square. While in here, you, sucker, live like a dog. You should be ashamed! It's a form of disgrace."[11]

Another aspect of the system Lifton describes, called "dispensing of experience," occurs when one, who is placed in the category "of not having the right to exist, can experience psychologically a tremendous fear of inner extinction or collapse." Several artists gave personal testimony to these words—that what Lifton had considered in a theoretical construction was the lived reality for most nonconformists. Igor Makarevich described the situation succinctly in his interview. He said that the double life he and others had to live in order to survive "bred in us a duplicitous way of thinking. We lived a double life intellectually. There is

[10] Kuspit cites Lipton in the epigraph to *The Cult of the Avant-Garde Artist*. For the entire essay from which it is drawn, see Robert Jay Lifton, "Cults: Religious Totalism and Civil Liberties," in his *The Future of Immortality and Other Essays for a Nuclear Age* (New York: Basic Books, 1987), 209–219.

[11] Victor Tupitsyn, "From the Communal Kitchen: A Conversation with Ilya Kabakov," *Artsmagazine*, 66 (October 1991): 51.

something wrong with that, something negative in our upbring-
ing and development, a whole generation of people formed in a
double manner." One had to "mask who one really was." To resist
the authorities was to become isolated. "If one did not comply
officially, one stopped existing. One was blotted out, erased."
Excluded from the artists' union, and therefore unable to purchase
supplies, an artist "ceased to exist as a material person." The
achievements, then, of the non-conformist artists are all the more
astonishing when we realize that they did not live lives as societal
outlaws devoted totally to their art, but often held jobs during
normal working hours and were unofficial artists in their spare
time. They lived both within and without the Soviet system,
leading, in effect, parallel but distinct lives in which there was no
easy commerce between the two. Furthermore, and this is prob-
ably of greater consequence than we realize, the nonconformists
must have realized that they, the most interesting, the most vital,
and unquestionably the best artists in the country, were being
driven by their government into the artistic underground or, in
several instances, into physical, let alone spiritual, exile. The psy-
chological toll must have been enormous.

When did nonconformists realize their nonconformity? Vitaly
Komar said, only half jokingly, that in the Soviet Union everybody
was born a nonconformist. You were labeled as one only when
you came out of the closet. Most artists found like-minded friends
in art school. Some of the more rambunctious ones were dismissed
from school for not painting proper subjects, but most, as Sholom
Shvarts has indicated, led "acceptable" lives on the surface, "but
behind the scenes, between friends, we were looking for new ways
to express new ideas, and new solutions."[12] Hard decisions had to
be made upon graduation from art school. To paint acceptable
subject matter in acceptable styles meant capitulation to the sys-
tem. Refusing to do so meant that an artistic career was a near
impossibility. Thus, many entered less ideologically explosive
fields and became commercial artists. The making of unofficial art
became, in effect, an escape into sanity, into self-awareness, and

[12] Holo, ed., *Keepers of the Flame*, 76.

self-understanding, an act of defiance against the government, an act of honesty in face of the falsely optimistic subject matter required of official artists. As Igor Makarevich has said, "any attempt at serious analysis [of society] was suspect."

Artists, then, went underground. Those who came of age in the 1950s and 1960s tried to distinguish themselves as much as possible from the ideology of socialist realism, from official art. Even today they insist they were not dissident artists, which implies political dissent. Rather, they insist that they wanted to use art for purposes more private than conforming to the dictates of the authorities. But the very desire to distance themselves from socialist realism and all that it represented was clearly a political act, although not directly an adversarial one. What else is one to make of Erik Bulatov's definition of art in the face of the steady barrage of Soviet propaganda concerning collective cooperation? Art is, he said, "a rebellion of man against the everyday reality of life. . . . A picture interests me as some kind of system, not hermetically sealed, but opening into the space of my everyday existence."[13] In other words, art was a vehicle to deconstruct the Soviet construction of reality. And Oleg Vassiliev, has said very precisely in personal conversations that he channeled his resistance into his art, refusing even to take part in certain exhibitions because that would have assumed too much of a political and, therefore, a dissident position.

Artists of Bulatov's and Vassiliev's generation were particularly aware of the subversive quality of their art and of the inevitable discrepancies between public utterances by the authorities and their inner needs. Gleb Bogomolov stated that he "hated socialist realism, its lying and superficiality. [Art] was my personal rebellion. I had to understand the world, and making paintings was a way of consolidating that understanding."[14] Vassiliev extended this sense of contempt to the entire society of mass man and mass art and the dangers he found there. He likened the situation to an invasion of grasshoppers. One grasshopper might

[13] Roberts, ed., *Quest for Self-Expression*, 76.
[14] Holo, ed., *Keepers of the Flame*, 46.

be appealing, but a swarm is not. "We see exactly the same thing in life, in art: the greatest dangers are posed by totality and mass." [15]

The tragedy implicit in these statements reveals the degree of spiritual exile the artists must have felt in a country they loved and revered. It is not too strong to say that for them the Soviets destroyed Russian culture (as well as that of the other republics). Of some of his moody landscapes, Vassiliev said that they were not illustrations of a text by Chekhov, meaning pre-Soviet Russia, but rather "a lamentation about an old world destroyed from its foundations onwards. The Soviet reality is intertwined with the romanticism of an abandoned house."[16] Chemiakin has spoken of artists withdrawing "into the depths of their selves," and into Russian history and culture, "away from the noise of the world and from the numbing effects of Soviet reality to find a creative idea or impulse . . . which allowed them to survive and create something very much their own."[17] Lydia Masterkova has also commented on the isolation she felt both as a Russian and a nonconformist. "There is no feeling of the real world. There is only one's own world," she once said.[18]

But isolation was not just a state of mind. In an extreme instance, Valery Yurlov left Moscow for the town of Guliropschi in the Caucasus in the late 1950s after learning that Moscow was a dangerous place in which to make abstract paintings.[19] Bulatov pointed out a few years ago that since there was neither an art market nor a museum of modern art in the Soviet Union, it was quite difficult to find out what was happening elsewhere. "This means that we really lack[ed] a cultural environment, that is to say, an atmosphere in which art can live. Art [had] no room to breath in this country [Russia]. Indeed, this [was] the paradox of

[15] "Oleg Vassiliev, Interview with Mikhail Chemiakin," in *Art of Russia and the West*, 1 (March 1989): 100.

[16] From an undated and unlabeled magazine on file at the Phyllis Kind Gallery, New York City.

[17] Holo, ed., *Keepers of the Flame*, 50.

[18] Golomshtok and Glezer, eds., *Unofficial Art*, 151.

[19] "Artist's Statement," *Valery Yurlov: Works 1955–1965*, (New York: Berman–E. N. Gallery, 1994), 6.

our cultural life; we [had] no cultural environment, but we [did] have art." Bulatov also mentioned on another occasion that after traveling in western Europe in 1988, he realized that he was not "some rare exotic creature, but just an artist; I felt that I was among people engaged in a shared endeavor."[20] Vladimir Yankilevsky summed up the entire situation succinctly when he said, "Nurtured only by simple straightforward acts, man loses his imagination—that is, he loses his inner freedom. He is less and less an individual as he becomes integrated into a gigantic theater of marionettes that are manipulated by the legislators of fashion, sowing their seeds of banality, vulgarity, and depersonalization."[21] Apropos these statements, it is not a mere afterthought to say that a by-product of the artists' experiences with the state apparatus is their near total distrust of any sort of government in any country in which they now happen to be living.

Of their own country, distrust gave way to detestation. Boris Sveshnikov thought that anything labeled as culture had already come to an end. Kabakov's nihilistic response to Soviet society reflected a pervasive mood among many of his generation when he said that "the artist is a totally sick being with an absolutely iron constitution." How otherwise could he go on? Since Kabakov held all interpretations of a work to be equal, he implied that all motivation was also equal. He rejected all and any "faith in grand words 'predestined' to build a radiant future" and refused in general to grant speech ontological status.[22] Although this might sound like a typical Western postmodernist statement about the equality of all values, it takes on a particular resonance and social relevance in its Soviet context in that it describes a state-of-mind brought on by living in a society where doublespeak and Orwellian inversions of language were commonplace.

[20] "Erik Bulatov and Oleg Vassiliev: A Conversation with Margarita and Victor Tupitsyn," in *Eric Bulatov and Oleg Vassiliev* (New York: Phyllis Kind Gallery, 1991), 8; and, Barry Schwabsky and Jane Bobko, "Perestroika in New York: A Conversation with Erik Bulatov," *Artsmagazine*, 64 (November 1989): 86.
[21] Roberts, ed., *Quest for Self-Expression*, 168.
[22] V. Tupitsyn, "From the Communal Kitchen": 54, 55.

Not all artists reacted with such profound repugnance to Soviet society, however. Yet, being able to create art while navigating past the assaults on one's individuality and grasp of reality was no easy job. Irina Nakhova felt that "basically every thing was a threat to the government, everything that was out of their control. Any free thought was a potential threat. . . . We always came up against the authorities. Clearly we drank it in with mother's milk. Everyone knew what was allowed to be expressed and what was not. It was kept on a subterranean level." If, as Aleksandr Yulikov said, "on a general level the task of art is to express freedom, one of man's main endeavors," how was one to begin this endeavor, let alone succeed at it?[23] Kabakov answered by saying "everybody built an art system for himself from his inner personal world."[24]

Nakhova and artists of her generation who came of age in the 1970s, while certainly understanding what older artists had experienced, responded somewhat differently in their "inner personal worlds" to changing official policies in the 1970s and 1980s. The need for self-assertion having become less necessary, they could either indulge their aesthetic interests to a greater extent, or, building on the brave example of their elders, allow their art and their actions to become more confrontational. Olga Bulgakova appeared less concerned with using art to reflect the position of an artist in society when she said "the most important theme for me is the interrelationship of creative work to life." Igor Kopystiansky asserted, "I create new contexts and play with art, which form a game of the spirit and intellect on the highest level." Or the Gerlovins have suggested that "the thinking game which occurs consciously or intuitively is the basis of our work. We express this thinking in different sign systems. In the process of this game one assimilates external and internal views of the world, surmounts inner and outer conflicts, and analyzes the self."[25] The kinds of

[23] *Alexander Yulikov: Recent Paintings* (Helsinki: Galleria Bronda, 1989).
[24] Tache, *Kopystiansky*, 93.
[25] For Bulgakova and Kopystiansky, see Roberts, ed., *Quest for Self-Expression*, 74, 108. For the Gerlovins, see Norton Dodge, ed., *Russian Wave: Russian New Wave* (New York: Contemporary Russian Art Center of America, 1981).

involvement of the self with the art-making process indicated here would probably be viewed as a luxury for the older artists who were more concerned with the self and society. On the other hand, these newer concerns also reflected the interest in conceptual art and performance art that flourished during the 1970s, art forms that had not existed in the Soviet Union during the 1960s.

By comparison, the work of the sots artists, based on socialist realist sources and images of the mass media such as the ever-present street posters and banners, was more confrontational. Komar and Melamid, at one point compared American overproduction of consumer goods with Soviet Russia's overproduction of ideology and concluded that sots art "puts our mass poster art into a frame for examination" which they and other sots artists such as Alexander Kosolapov and Erik Bulatov in his sots-art works, have done in the intervening years.[26] But, in comparison to efforts by American pop artists, there is often a sardonic Russian twist. This quality is also noticeable in Soviet conceptual art. As Sven Gundlakh has pointed out, "We lived in a country in which factories produced not goods, but the rhetoric of a productive proletariat and its triumphs. In retrospect, one can understand that conceptualism and the Soviet cultural system were the same, producing not things, but the ideas of things."[27]

Artists who were born in the 1960s and came to maturity at a time when Western images and ideas were more available than they had been earlier, often sound postmodern in their manipulation of those ideas and images. The attitudes of two young artists will suffice to make this point. First, Andrei Yakhnin, who objectifies himself by photographing, drawing, and videotaping himself in order to provide a distance from himself (he views himself as an other), says that "in this manner the artist removes himself from all responsibility not only for the pictures, but also for the actions and the further life of his hero, who is himself."[28] Second, Sergei

[26] Hedrick Smith, "Young Soviet Painters Score Socialist Art," *New York Times*, March 19, 1974, 30.
[27] Solomon, *The Irony Tower*, 86.
[28] Roberts, ed., *Quest for Self-Expression*, 166.

Bugaev "Afrika" indicated in his interview that although he once rejected a request from the KGB to spy on other artists, he might not refuse the offer today. "Perhaps now such work might appeal to me because of my interest in theoretical aspects of how the ideological system functions and how it controls. I could learn better being on the inside." Certainly that kind of attitude, morally, politically, and aesthetically neutral at best, marks both the end of nonconformist art and the merging of contemporary art in the former Soviet Union with Western neo–avant gardism. Yakhnin's point of view, if it is a generally held one, suggests that his generation has institutionalized the old Western avant garde and the premises on which it was based. His point of view suggests recyclings of ideas within the art world rather than explorations of ideas, thoughts, and feelings beyond that world. Bugaev seems concerned only with manipulation, unlike earlier nonconformists who could not countenance the idea of collaborating with the KGB.

One might want to argue that many, perhaps all, nonconformist artists based their art on Western avant-garde styles and, therefore, should be considered as little more than belated followers, working in styles already a generation or two old, of artists in the cosmopolitan centers of Paris, New York City, and Moscow (in the 1920s). But it is probably more appropriate to consider the situation differently, not as a horse race or as some kind of evolutionary Darwinian spectacle of who did what first, if for no other reason then that we would have to assign a low position to all but a small handful of form givers such as Picasso, Matisse, or Kandinsky. Much more important, we need to assess the damage inflicted upon modern Russian art by the Stalinist disavowal of earlier Western as well as of Russian avant-garde art. And we also need to realize that nonconformists tried to restore an organic continuity, to reestablish and to maintain a dialogue with those earlier styles, despite minimal availability of visual and written information. It is necessary, as well, to understand some of the objections artists have voiced concerning their relationship to Western sources,

which might not be as subservient as Western observers have insinuated. And finally, we need to take into account the variations on modern styles with specific Russian references easily overlooked by Western observers. In all of this there is material for several lengthy studies.

The range of sources is enormous. Some artists have looked into their Russian past, both visually and religiously. Grisha Bruskin very seriously explored his Jewish heritage. Other artists, in interview after interview, have said that the first modern Western works they saw were those exhibited beginning in the late 1950s during the Khrushchev Thaw. Others said that when they worked in various museums they discovered and surreptitiously studied paintings locked in vaults. Western art magazines, although rare, were available, and articles were translated by those who could read French or English. Valerii Lukka was not really far off the mark when he said, "our present [art] is not determined by the past. . . . We have neither memory nor history." But the saddest comment concerning the nonconformist desire to connect with anything other than socialist realism was offered by Vladimir Nemukhin. After first seeing modern Western art, he and his fellow nonconformists began, he said, "to recognize in foreign artists their own selves and their own strivings."[29] In effect, the artists had to apprentice themselves to avant-garde artists, perhaps just like Americans who, on visiting Paris around 1910, had to digest Picasso and Matisse, among others, before finding their own voices. Or, perhaps, some nonconformists followed the pattern of Arshile Gorky who painted in the manner of several masters—Picasso, Miro—before developing a style of his own. Regardless, the nonconformists needed and wanted to learn the older modern as well as traditional vocabularies before expressing "their own strivings."

As Picasso and Matisse hold a special place for Western artists, Kazimir Malevich occupies a similar place for Russians. As Erik Bulatov, who saw reproductions of Malevich's work only in

[29] Roberts, ed., *Quest for Self-Expression*, 110; and, Golomshtok and Glezer, eds., *Unofficial Art*, 89.

the 1980s, said, "At bottom, he is in our blood."[30] Malevich as well as other early Russian avant gardists had to be confronted in one way or another before many nonconformists could move on. From this point of view it is totally beside the point to call the work of Eduard Shteinberg, as one Western critic has done, "beautiful but essentially lifeless academic variations on constructivist themes" for the following two reasons.[31] First, Shteinberg's handling of the tonal relationships of creams and tan-browns are among the most subtle ever created since late Braque. Second, had he grown up in the West, where examples of suprematism and constructivism could be found in museums, a case against him might possibly be made (in any event, he certainly surpasses in tonal subtlety any American artist who worked in similar styles during the 1930s), but Shteinberg grew up in the Soviet Union and did not discover Malevich until the early 1960s when he saw a few paintings in the George Costakis collection.[32] Western models of criticism simply do not apply here.

Staying with Malevich for a moment, there are other factors beyond the stylistic that also need to be considered in any assessment of nonconformist art. For Shteinberg, an artist like Malevich served purposes other than as a model to develop an abstract look or manner. Shteinberg, an artist of mystical tendencies, found in Malevich's "Black Square" (1915) both a portent of doom for Russia—"a child doomed to solitude"—and a path to truth and the transcendent. Of this and other similar works, Shteinberg has said, "by allowing the spectator to retain his freedom, the language of geometry forces the artist to renounce his Ego. Attempts to make him an ideologue or utilitarian constitute a violence against his person." Neither appropriating Malevich's style nor making mere clever variations upon it, Shteinberg used Malevich to meliorate his situation in the Soviet Union. "It seems to me," he said,

[30] *Back to Square One*, (New York: Berman–E. N. Gallery, 1991), 32, 33.

[31] David Ross, "Provisional Reading: Notes for an Exhibition," in *Between Spring and Summer: Soviet Conceptual Art in the Era of Late Communism*, ed. David Ross (Boston: Institute of Contemporary Art, 1990), 23.

[32] Eduard Steinberg [sic], *An Attempt at a Monograph* (La Chaux-de-Fonds, Switzerland: Éditions d'en Haut and Moscow: Art MIF, 1992), 12.

"that the human mind will always return to such a language in moments of mystical suffering at the tragedy of God's abandonment." So Malevich provided Shteinberg with a way to turn inward, to find and to explore his own spiritual and religious feelings through his art.[33] Whatever else might be said about Shteinberg and Malevich, it is also clear that the Soviet system forced Shteinberg to rediscover the past in order to find himself as an artist and his own sense of personhood in the present. The situation provided him with an adversary against which self-discovery became possible. As cited earlier, Bulatov said "Art is a rebellion of man against the everyday reality of life. A picture [is] some kind of system . . . opening into the space of my everyday existence."

Leonid Lamm also reveals religious feelings in his abstract paintings and has also confronted Malevich in his art, but his responses are entirely different from Shteinberg's. Lamm has rejected Malevich's insistence on a "two-dimensional world which he [Malevich] wanted to impose as a creator of Space, as a 'Chairman of Space,' the title he used in referring to himself. But the world of [the] real Creator is infinity. The world of Malevich is two-dimensional, but the world of Nature is three-dimensional...

We witness here the idea of unfreedom as a foundation of Malevich's world." For Lamm, Malevich might also be a symbol of the Soviet system, since Lamm sees him trying to prove he was "a divinity or celestial being. . . . The attempt to construct his utopian world and to herd man into it . . . , to appropriate the third dimension from man by decree, to deprive man of his living space—these were acts of unabashed violence."[34]

Where Shteinberg found Malevich's desire for flattened pictorial space a door through which to pass to his own inner world, Lamm found Malevich's flatness an act of violence. It is interesting to note that Lamm, who had been imprisoned for three years during the 1970s, finds himself in agreement with Donald Kuspit

[33] Steinberg [sic], *An Attempt*, 67–68.
[34] Leonid Lamm, "Supersignal," typed manuscript, 1992; and *Back to Square One*, 34.

who argues that Malevich's sense of abstraction is "an authoritarian revelation of a doctrinaire self that crushes every other self." Malevich's paintings of squares and crosses are, for Kuspit, "forms to swear on, not a geometry to play with. . . . You either stand on their side—the side of abstraction—or on the side of nature—the enemy's side."[35]

Yet, another view of Malevich has been suggested by Oleg Tselkov. Malevich is a more neutral spirit for him. "One has the feeling that it is as if he [Malevich] subsumes all his emotions into an apparently very simple formula. . . . Malevich taught me simplicity," Tselkov has said.[36]

This short discussion of Malevich and the nonconformists does not even scratch the tip of the iceberg. There must be dozens upon dozens more collaborations and confrontations among and between nonconformists and earlier Russian and Western avant gardists just waiting to be discovered and analyzed—not with the intent of determining whose work is superior, but of understanding the nature of nonconformist art and building its proper history. One more example. We know that Barnett Newman's stripe paintings and some of Lamm's abstract works are based on precise Kabbalistic sources concerning the idea of creation.[37] Yet, Newman's work is totally flat and Lamm's paintings evoke the third dimension. What prompted such opposite stylistic interpretations? As the art of the non-conformists becomes better known and understood, many more such questions will have to be framed and answered.

Given the extraordinary difficulties all of these artists had to tolerate, it is remarkable that there is a relative lack of what the American painter, Robert Motherwell, termed, when considering Max Ernst's work, "a sense of a vicious past . . . , a black mass, a bloody nun, an invader from the east." According to Motherwell,

[35] Kuspit, *Cult of the Avant-Garde*, 50, 51.
[36] John E. Bowlt, "Moscow: The Contemporary Art Scene," in *New Art from the Soviet Union*, ed. Dodge and Hilton, 23.
[37] Thomas Hess, *Barnett Newman* (New York: Museum of Modern Art, 1971), 52–61; and, Lamm, "Supersignal."

who wrote this in 1948, such images did not and still do not arouse deep feelings in most Americans, and it would also seem that such images or ideas did not arouse the nonconformists, either.[38] True, Boris Sveshnikov, in labor camps for eight years, has said that everything he paints is for the grave, and Vladimir Yankilevsky, projecting his frustrations and grievances through his art, has said that "for me the ideal in art is the ability to scream silently, and not merely to imitate a scream" (his extraordinary ink sketches, particularly, invoke a world of grotesque, deformed, and mutant creatures). Yet, only a few artists allude to the dark underside of Soviet life, the kind that projects a bleak vision of the present and future, akin to certain central and east European writers.[39] Perhaps the threats were too immediate. One did not have to imagine a Kafkaesque universe; one had to cope with it daily. Lev Nusberg's visceral cry from Leningrad during a particularly repressive period in the 1970s, "our teeth are being knocked out," bypasses fiction entirely.[40]

The immediacy of lived experience is also conveyed in the works and writings of Leonid Lamm and Ilya Kabakov. Lamm's "Sots-Geo Manifesto–Manifestation of the Procrustean Bed," written in 1987–1988, was published in 1990, the same year as Kabakov's essay, "On Emptiness." Lamm's manifesto, filled with mordant irony, perhaps the only way he was able to deal with his experiences in and out of Soviet prison camps, concerns the brutal physical standardization of individuals (or victims) on a Procrustean bed as a way to ensure their equality and "freedom."[41] Kabakov, in his article, tried to describe the idea of emptiness, not as a space or a place, but as a state of mind and of being. He thought that people (Soviet people) live in a state of emptiness and

[38] Prefatory note to *Max Ernst: Beyond Painting and Other Writings by the Artist and His Friends* (1948), in *The Collected Writings of Robert Motherwell*, ed. Stephanie Terenzio (New York: Oxford University Press, 1992), 48.

[39] Roberts, ed., *Quest for Self-Expression*, 168.

[40] Konstantine Kuzminsky, "Two Decades of Unofficial Art in Leningrad," Dodge and Hilton, eds., *New Art from the Soviet Union*, 30.

[41] Lamm, *Sots-Geo Manifesto—Manifestation of the Procrustean Bed* (New York: Eduard Nakhamkin Fine Arts, 1990).

interact only with acquaintances and others they can trust, and with nobody else. Emptiness, as Kabakov describes it, is not a space waiting to be filled, but an active volume "opposed to genuine existence, genuine life, serving as the absolute antipode to any living existence." He suggests four ways to deal with such emptiness: ignore it or accept it as natural and go on from there; try to change it; search for a higher truth in a mystical, religious way; or describe it directly.[42]

In his installations of apartment interiors, Kabakov chose to describe Soviet existence, and these were among the most confrontational and political works created by a nonconformist before perestroika. Profoundly moving statements about Soviet life, and also stylistically exacting for their extraordinary balance between description and accretion of detail and suggestion, they are filled with the kinds of "degenerate" ideas, forms, and materials Soviet authorities had termed unacceptable as art, in order to show just how degenerate Soviet life was. Since Kabakov insists on calling himself a Soviet rather than a Russian man, meaning that he is a product of the Soviet system, these works are, in effect, a view from within that state of emptiness about which he wrote so touchingly.

As the many works by nonconformists become better known, it will become clear that these artists are among—or simply are— the best trained and most technically secure artists anywhere in the world. Singling out one or another does a disservice to the rest, whether the artist works in an abstract or a representational manner, whether the style is hard edged or soft focused, photorealist or expressionist, magic realist or free-form, whether the medium is painting, sculpture, or some type of installation art. However, one might mention Vladimir Yankilevsky and Mikhail Chemiakin whose technical facilities and imaginative resources in a variety of media—ink drawings, paintings, collage, relief, and free standing sculpture—are among the most astonishing of all.

Stating this adds its small measure to the loss of unity and

[42] Ilya Kabakov, "On Emptiness," in *Between Spring and Summer*, ed. Ross, 53–54, 59.

common purpose most nonconformists shared before perestroika in general, as well as before the auction of nonconformist and official art held by Sotheby's, which took place in Moscow in 1988, in particular. At that event, the Western market economy imposed itself in a way that could no longer be ignored, despite occasional sales to Western buyers over the previous twenty-odd years. Varying prices were assigned to the works of different artists, thus exploding forever the sense of equality and solidarity that had existed in the past. In fact, the Western market economy and, specifically, the gallery system soon became particularly irksome to several artists who now feel they have substituted one boss (the gallery owners) for another (the state). Furthermore, after perestroika, artists began to travel abroad, some becoming virtual gypsies, commuting between major art centers in the West and their home cities in the former Soviet Union. It is no wonder that Ivan Chuikov, a wonderful conceptualist, is to this day nostalgic for the comraderie of the preperestroika period, despite the hardships and authoritarian impositions.

But what of the nonconformists' lives abroad after perestroika? The problems are enormous and fascinating to consider and can only be touched on here. Some artists have joined emigre communities upon leaving the Soviet Union or the postunion republics, their work personal in manner but easily absorbed within the trans-Atlantic mainstream, even if it might contain Soviet references. In the United States these artists have become the latest group to join the several generations of hyphenated American artists—Jewish-American, Italian-American, Latino-American, Chinese-American, Japanese-American, African-American—whose works can easily move back and forth between the mainstream and the recognizably ethnic or national, whatever the particular style or subject matter. Given the internationalization of the art world in the last several decades, the former nonconformists, compared to artists of earlier generations, seem to have less conflict in that inner dialogue between where they came from and where they are. Some, of course, might be homesick, and, especially with sots artists, they might use obvious Russian subject

matter, yet their artistic strength comes as much, if not more, from themselves and the history of modern art, than it does from a mystic sense of and the traditions of a homeland, although, among the Russians, the homeland is ever present in their minds. Of course, they all come from a place that is different from other places, and in that regard their experiences and memories obviously affect their art, but there seems to be little or nothing that can be called essentially or intrinsically Russian, however that might be defined, about their work. Whether they will ever become domesticated in a Western country or remain internationalists is yet to be determined and is not, perhaps, even a relevant concern. Most nonconformists insist on being called artists with no qualifying adjectives concerning location or background. Suffice it to say that as a group they rejoined the history of modern art at tremendous personal cost, which indicates that the gravitational pull of modernism and individualism was stronger than the nationalism and authoritarianism of the Soviet system. Deep down, however, they will probably remain displaced persons wherever they may be because, in the end, they rejected their government and were, in turn, rejected by it.

Norton Dodge

RB: *How did you become interested in collecting dissident Soviet art?*
ND: My interest developed through a number of stages. As a youngster I thought I might become an artist, but I soon realized that I was not as focused as I should have been for a career in art, so collecting prints and paintings was one of the ways I sublimated that interest. The Russian involvement came though my belief that the Soviet Union would be this country's biggest foreign problem during my lifetime. As a result I began to study Russian at Cornell. My Russian studies continued at Harvard where I had a fellowship at the Russian Research Center while working on my PH.D. in Soviet economics. Even though the Soviets viewed the Center as a training ground for CIA agents, my father, a retired physicist and college president, helped me get a visa to visit the Soviet Union as his assistant in 1955. This was after the Iron Curtain had opened a crack following Stalin's death. My main goal was to do research on various aspects of the Soviet economy, especially the importance of the Soviet Union's economic growth of technology transfer and the development of human capital. I was also eager to see exhibitions from the French impressionist and postimpressionist collections at the Hermitage Museum in Leningrad. These had long been hidden in storage.

RB: *Did you see any dissident art then?*
ND: No, it was too early, but since dissident writing was being published by *samizdat* [self-publishing, underground] and brought to the West for publication in translation, I suspected that dissident art was being created as well. Dissident literary works were widely read and studied in the West, and figures such as Boris Pasternak and Evgenii Yevtushenko had become well known, but nothing comparable was happening in the visual arts. I felt that

someone should try to develop a similar record for the visual arts. But 1955 was too early since Intourist was then in complete charge of the daily routines of all visitors. An unauthorized meeting between an American and a dissident artist might have created trouble for the artist.

RB: *When did you begin to make contacts?*
ND: During a visit in 1962. A graduate student friend at the Russian Research Center had spent a year at Moscow University as an exchange student. His Russian roommate had expected to become an artist but switched to philology when he found he was unable to reconcile the requirements of painting at school with his own way of painting at home. Toward the end of my visit, we went to a poet's apartment to see an exhibition of abstract paintings by Lev Kropivnitsky, an early and talented dissident artist. The apartment exhibit was path breaking because it was the first since the 1920s showing abstract paintings. I acquired a small painting that would fit into my suitcase as well as an abstract work on paper by Vladimir Yakolev. These works, plus several given to me by my student guide, constituted the beginning of my collection.

RB: *Did others help you find dissident artists?*
ND: Yes. George Costakis, the great Moscow collector of avant-garde art of the teens and twenties as well as of contemporary nonconformists, was very helpful. When I first visited his apartment his collection included works by Dmitri Plavinsky, Dmitrii Krasnopevtsev, Anatolii Zverev, Vladimir Nemukhin, Evgenii Rukhin and others. Costakis was very encouraging to these artists in their struggles against pressures to conform. Fortunately, he gave me several small, fine works by Zverev, but more important, he helped me meet the artists. I also met a number of artists willing to risk meeting a foreigner through friends at the American Embassy. One artist would then lead me to another. By good fortune I met Tania Kolodzei, a major Moscow collector, in the mid-1970s. She played a crucial role, over a period of years, by introducing me to two dozen major artists who were shy about contacts with

foreigners. In addition, by the mid-1970s, group exhibitions were simultaneously held, in the spring, in a half dozen apartments or studios. If one were there at the right time and knew where to go, one could see a great variety of works easily and quickly. And catching the major nonconformist exhibitions, such as the Bee-keeping Pavilion exhibition in Moscow in 1975 or those held periodically at the Union of Moscow Graphic Artists gallery depended on being in the right place at the right time. I was able to see a number of major exhibitions and felt somewhat guilty when I would be ushered, as a distinguished foreigner, past the huge crowds waiting to get in.

RB: *What about other cities?*
ND: When I was on my own in other cities, I often had difficulty locating artists. There were no telephone books then, but, if I had an address, I would take a taxi close, but not too close, to my destination. I would then search around courtyards and stairwells trying to find the right apartment. Often entryway or hall lights operated briefly on timers before leaving a person in total darkness. I quickly learned always to carry a small flashlight.

RB: *The size and breadth of your collection suggests that you were concerned, even then, with more than collecting just a few works at random.*
ND: That's true. At that time, since nonconformist art was neglected by Western art historians, I felt I had a real mission to try to record the struggle for artistic freedom in the Soviet Union. At first I didn't think it would be possible to bring out the art works themselves, so I began photographing art in apartments and studios, at apartment exhibitions, and in collections of Western diplomats and journalists in the Soviet Union as well as in the West. I thought that creating a photographic record was extremely important until I found ways to get the art works themselves past customs and safely out of the country. My aim then shifted to creating a representative collection of nonconformist art until such time as better qualified persons or institutions could assume the task.

RB: *Were your early trips just for collecting?*

ND: No. In the late 1960s I was doing research on the role of women in the Soviet economy and traveled to many major cities— Tashkent, Samarkand, Bokhara, Alma-Ata—but finding free time to look for art was sometimes difficult. Later, in the 1970s, I would join group tours sponsored by various educational institutions. I'd skip some of the organized activities to search out interesting artists, and more than one tour guide threatened to report me to the KGB for leaving the group. In a city like Kiev, where I had no names or addresses, my only hope was to find works at the outer limits of acceptability in an official art gallery and then, with any luck, locate the artist. But I often drew a blank. On one occasion, for instance, I did have a very busy and productive time seeing artists in Tallinn with Professor Stephen Feinstein [University of Wisconsin–River Falls], a tour leader who had Estonian contacts.

RB: *Two questions here. How many times were you in the Soviet Union, and why did you think it necessary to travel so much?*

ND: I went ten times. My economic research dictated much of my itinerary. I had also decided, in the 1960s, that the collection should include a good sampling of works by artists outside of Moscow and Leningrad. Since collecting often required developing connections over a period of several visits, I really needed more and longer visits to be fully effective.

RB: *Were there problems in getting a work out of a studio and into your hotel room or to a collection point?*

ND: Not if the work could be rolled, and the roll wasn't too long or too bulky. Large works were major problems, especially sculpture and works on pressboard.

RB: *Why didn't the authorities squelch the nonconformist movement?*

ND: They could have, but they were worried about negative reactions abroad. They also began to realize that excessive control stifled creativity. And several nonconformist artists developed friendships with diplomats and journalists, which provided them with some protection. Oskar Rabin, a leading nonconformist,

knew many journalists and diplomats, all quite loyal to his cause. Another leader, Evgenii Rukhin, who flouted his foreign connections, might have overstepped the bounds because he died in a fire of suspicious origin in his studio. People who refused to conform were never really safe. Foreign friends were not enough.

RB: *Were you ever afraid?*

ND: During the 1960s and 1970s fear permeated life there. Nonconformist artists were especially vulnerable. Their jobs were at risk. They could lose studio space or the privilege of living in Moscow or another major city. Their art could be seized. Several artists were sent to labor camps and mental institutions or even lost their lives. As a foreigner I was less threatened by these kinds of danger, but I grew increasingly anxious whenever I prepared to leave the country. I usually exchanged a lot of dollars for rubles legally, but I would worry that I might have to account for my expenses at the currency check at the airport. On one of my last trips my address book was photostated—which might have caused trouble for some artists. My film was confiscated a number of times, but, fortunately, they seized mostly unexposed film. Then once they did a near strip search. My anxieties grew with each departure.

RB: *When was your last trip?*

ND: In the spring of 1977. I had squeezed six trips into a four-year period, and I knew I must have become quite visible to the authorities. A KGB frame-up began to seem like a real possibility. I was becoming a bit paranoid. I knew of other visiting scholars who had been set up and arrested. A manuscript might be thrust into a person's hand, as happened to Professor Barghorn of Yale who was then arrested for trying illegally to smuggle dissident literature out of the country. Such arrests occurred whenever the KGB wanted to make a trade for agents held in the West. After I curated a major exhibition, "New Art from the Soviet Union," in Washington, D.C., in 1977, I assumed the Soviet authorities knew what I had been up to, if they hadn't known it already.

RB: *How large was your collection at that time?*

ND: About fifteen hundred works by over two hundred artists. Now it's about ten thousand works by some eight hundred artists.

RB: *You must have had both frightening as well as exhilarating experiences during your many visits.*

ND: Well, you wonder if certain unexpected encounters happened by chance or if they were planned, or why a particular person was so interested in what you were doing. I remember late one evening, in Samarkand, when I had gone to see Timur's [Tamerlaine's] tomb. On the way back to my hotel I paused to take a picture of a teahouse with its string of lights reflected in outline across a shallow pool. As I leaned against a cypress tree to steady my camera, I heard a voice say in Russian: "You're taking a picture? How can you do that in the dark?" I froze as I thought of all of the times I had my film seized for taking what I thought were innocent pictures. I was not encouraged when I realized the voice belonged to a man in uniform. He wasn't the militia, but he seemed friendly enough. He said he was interested in photography, wanted to know the film I used, and he wanted to see my camera. He then said that he was meeting some officers and friends and would like me to join them. He said they would all like to learn more about the West. Contradictory thoughts flickered through my mind. Here perhaps was a unique chance to make some human contact in this remote and exotic place. Would this be an evening never to be forgotten? But what might his real motives be? Were his friends military or KGB? How far away were they? Could I get back, could I ever get back, to my hotel despite the late hour? I took the coward's way out and, complaining of stomach troubles, I told him I had to get back to the hotel at once. He walked with me, and on the way through an amusement park he stopped to make a phone call. My silent questions: to whom? for what reason? to his friends? to the KGB? Then we walked near an open air movie where some disheveled kids had climbed up a wall to see the movie free. My acquaintance suggested I take a picture. I thought that this might be a provocation since such a photograph would not show the Soviet Union in a good light. I said it was too dark and hurried back to the hotel. Then all night I thought I might

hear a knock at the door, have my camera seized, be grilled about my photographic wanderings, and accused of Lord knows what. On the other hand, and equally paranoid, I felt that I might just as well have unseen protectors following me. The atmosphere in the Soviet Union encouraged such musings.

RB: *What about visits to artists' studios?*

ND: One stands out, a visit to the apartment and studio of Elii Beliutin. He became a nonconformist in the 1940s and is also a collector of antique furniture, icons, and old master paintings. His collection surprised me, especially his presumed Leonardo da Vinci, but I was astonished by a painting in his basement studio which covered most of a wall. It showed Lenin being carried in an ice casket by Politburo pallbearers with Stalin cast as Judas. It was a powerful work, dangerous to be seen by any but his closest friends. I was amazed that he dared keep it where it could be seen by his students—he had hundreds of them. Then he showed me dozens of paintings, spreading them out on the floor, walking over them in an extraordinary demonstration of casualness to get batches of others to show me. Another surprise was a visit to the studio of Ilya Kabakov, which was under the roof of an apartment. I had to go up eight flights, and then walk over planks laid on beams in an attic, and then through a massive door that opened into an amazingly large, light, and airy studio tucked under the roof. By contrast the studio of Vladimir Yankilevsky was in a cellar. The basement was filled with a press, for making his grotesque and surreal etchings, and with the disassembled sections of many large three-part works. There was no space to put them all together at the same time. I wondered how he could ever get them out of the cellar and then out of the country, or what kind of dedication prompted him to make them. But now these works are seen around the world and several are in the collection of the Zimmerli Art Museum at Rutgers. It was the risk taking, the deep involvement, and the persistence of these three artists that I found so impressive. And they are just three of the many I could mention.

RB: *Many artists have said that they were able to see journals and catalogues of modern art. Did you bring any with you on your visits?*
ND: Yes. I brought in all that I could sneak through customs. The copies would then be past around from artist to artist. This didn't signify, as Western critics have sometimes asserted, that nonconformist art was derivative. The major figures have their own distinctive styles.

RB: *How did you get the works out of the country?*
ND: After I stopped going, I had to find other ways both to acquire art and get it out. I had to depend more and more on the help of others—emigrating artists, collectors bringing work with them, western diplomats leaving the country at the ends of their tours of duty. For example I acquired some works from an artist who immigrated to Israel and had shipped out a number of huge and provocative canvasses rolled in oriental rugs. Eduard Nakhamkin and his son-in-law, Nathan Berman, who ran art galleries in New York City after 1975, have been important sources for many years. Elena Kornetchuk, who heads International Images Gallery in Sewickley, near Pittsburgh, became an important supplier—with Soviet approval. The Soviet need for dollars allowed her to get out questionable and unapproved works, which the authorities were only too happy to get rid of. Garig Basmadjian, who had a gallery in Paris, was also a major source, first of Armenian art and then of nonconformist art from all over the Soviet Union. He almost succeeded in getting out a truckload of works by Kabakov and others in the early 1980s. But Kabakov's huge works, which had to be lowered by ropes from the eighth floor, had then to be returned. In 1989 Basmadjian left his hotel room in Moscow one morning and was never seen again. The Russian Mafia or the KGB or some combination of the two is suspected. It was a major tragedy and cast a pall over my collecting. Since the late 1970s several dealers have become interested in nonconformist art, including Ronald Feldman, Phyllis Kind, Gregory Vinitsky, Diane Beal, Richard Fraumeni, Alexander Levin, and others. I have also received much help and advice from Rita and Victor Tupitsyn, Konstantin Kuzminsky, and Alexander

Glezer. Galina Main in Germany was crucial in obtaining major works by Erik Bulatov, Eduard Gorokhovsky, Semyon Faibisovich, and Vadim Zakharov, among others.

RB: *What are the limits to your collection?*
ND: I have acquired only art made in the Soviet Union. Emigré art is excluded because my wife Nancy and I want the collection to show specifically what could be done under adverse Soviet conditions. Also, we decided on a logical time limit, initially at Brezhnev's demise, but we extended it to the period of glasnost and perestroika under Gorbachev. The differences between unofficial and official art lost much of their significance at that time. So the collection covers a three-decade period, from the time of Khrushchev's speech denouncing Stalin's excesses to 1986.

RB: *What have you done to publicize your collection?*
ND: Exhibiting and publicizing nonconformist art has been just as much our goal as collecting it. After an initial exhibition of works on paper, in 1976, at the meeting of the American Association for the Advancement of Slavic Studies, a larger exhibition was held at the annual meeting the following year. It included the catalogue *New Art from the Soviet Union: The Known and the Unknown*. Similar exhibitions followed over the next fifteen years at a dozen colleges and universities.[1] Unusual venues for exhibits included a month-long exhibition of forty works with a religious or spiritual orientation, at the Washington National Cathedral in 1984; a one-day exhibit of conceptual art at the Kennedy Center in Washington, D.C., in 1986, an exhibit at the WPA [Washington Project for the Arts] in 1985;[2] and an exhibit of Baltic art, in a

[1] Exhibitions were at St Mary's College of Maryland (1977–1991); Antioch College (1978); Columbia University with the Pratt Institute (1978); Montgomery Junior College (1979); Dickinson College (1979); University of Minnesota (1982); University of Wisconsin–River Falls (1982); Phillips Academy (1986); University of North Carolina (1986); and Kenneshaw College (1987). Individual works have been lent to other college exhibitions as well.

[2] The exhibition included a mockup of an apt-art exhibit with a catalogue, *Apt Art: Moscow Vanguard in the '90s* prepared by Margarita and Victor Tupitsyn and designed by Leonid Lamm.

Canadian government gallery in Toronto in 1993. Works from the collection made up a large portion of the paintings in the exhibition "The Quest for Self-Expression" at the Columbus [Ohio] Museum of Art in 1990, which traveled to the University of North Carolina in Greensboro and the Arkansas Art Center in Little Rock. Works have also been exhibited by Alexander Glezer in the rotundas of the Senate and House office buildings in Washington, D.C. Paintings have also been loaned to exhibitions in several museums. After the exhibit entitled "Nonconformists: Contemporary Commentary from the Soviet Union," at the University of Maryland in 1980, Rita Tupitsyn, who had helped organize the show and contributed to its catalogue, moved to New York City with her husband Victor and helped organize and supervise the Contemporary Russian Art Center of America in a large space in Soho provided by Eduard Nakhamkin. The first exhibition, "Russian New Wave," curated by Rita, opened in December 1981. In the following two years nine exhibitions were organized there.[3]

After the Soho space closed in 1982, exhibitions were then held at the Firebird Gallery in Alexandria, Virginia,[4] and at the CASE [Committee for the Absorption of Soviet Emigrés] Museum of Contemporary Russian Art in Jersey City.[5] Dennis Roach helped

[3] "New Russian Wave" (1981–1982); "Vagrich Bakhchanyan: Visual Diary—1/1/80–12/3/80" (1982); "New Art from the Soviet Union: Selections" (1982); "Henry Khudiakov: Visionary Nonwearables: (1982); "Baltic Images I—Raul Meet: Line, Shape, and Form" (1982); "Baltic Images II—Latvia, Lithuania, and Estonia: Selected Contemporary Works" (1983); "Lydia Masterkova: Striving upward to the Real and Russian Women Artists" (1983); Gennadii Zubkov and the Sterligov Group" (1983), and "Come Yesterday and You'll Be First" (1983, originated at City without walls in Newark, New Jersey, with Margarita Tupitsyn as curator).

[4] "Soviet Artists in Exile at Home and Abroad: Leningrad" (1984); "Soviet Artists in Exile at Home and Abroad: Moscow" (1984); "Leonid Lamm: Recollections from the Twilight Zone: 1973–1985" (1985); "Back to Back: Rakhman–Shnurov" (1986); and "Post Socialist Realism: The New Soviet Reality" (1987–1988).

[5] The museum was initially known as the Museum of Russian Artists in Exile. The exhibitions and catalogues included: *Evgenii Mikhnov-Voitenko: Abstract Visions* (1988); *Eduard Gorokhovsky* (1989–1990); *Dmitrii Krasnopevtsev:*

prepare catalogues for both exhibition venues. The CASE Museum was established by Arthur Goldberg and directed by Alexander Glezer, who also headed a similar museum in Montgeron, outside of Paris. Glezer, who had been expelled from the Soviet Union in 1975, was able to bring his very considerable collection to the West, which he then exhibited widely, culminating in the ICA [Institute of Contemporary Art] show in London in 1977. When Glezer's commitments grew too large, I became acting director of the CASE Museum. It was the opening of the Sergei Sherstiuk exhibition to which George Riabov brought Dennis Cate, the director of the Zimmerli Art Museum, to explore the possibility of bringing my collection to Rutgers, where it could join George's more historically oriented collection.

RB: *Did you have any stylistic preferences in your collecting?*
ND: Initially I tried to find art markedly different from socialist realism. This means that I looked for surreal, abstract, conceptual, minimal, and erotic art. I also tried to find art overtly political and critical of the regime. But I didn't find much of this until the 1980s. The pioneer nonconformists of the 1950s, 1960s, and early 1970s will probably remain central to the collection, but many works by both younger and older artists have been added, giving it more depth and bringing it up to date. Nancy, who fully supports the project since she became acquainted with it in the mid-1970s, and I have similar tastes in art and the same goal of building and ultimately achieving a comprehensive collection.

A Retrospective Exhibition (1990); *Sergei Sherstiuk: Soviet Post Socialist Realism* (1990–1991); *Aleksandr Shnurov: Twelve Year Perspective: 1978–1989* (1990); and *Aleksandr Kharitonov* (1991).

Elii Beliutin
Элий Белютин

Born in Moscow, 1924; graduated from the Depart-
ment of Art of the Moscow Pedagogical Institute, 1949;
studied at the Repin Institute of Painting, Sculpture
and Architecture in Leningrad, 1952; taught at the
Moscow Institute of Graphic Arts until 1959; founded
the Studio of Experimental Painting and Graphic Arts
in Moscow; major exhibitor with his students at the
Manezh exhibition, 1962; lives in Moscow.

Style is close to abstract expressionism.

RB: *Would you call yourself a dissident?*
ЭБ: I have been a dissident all of my life. I was born one, and
since I can remember I have opposed everything that has been
done in this country.

RB: *When did you begin to paint?*
ЭБ: At the age of sixteen, before World War II. We studied
German and French, but not English, which was not considered
an international language at the time. Now, of course, everything
is reversed. I first exhibited my work in 1947.

RB: *What about the famous exhibition at the Manezh in 1962?*
ЭБ: I made the exhibition happen. Ernst Neizvestny
dragged along in my footsteps and carried my galoshes.
Nevertheless, he was able to appropriate all of the glory for

himself.[1] In fact, that event grew from myself and my students. We were the organizers of the exhibition, and it was I who invited Neizvestny, a sculptor, to participate. Afterward, I was discharged from my position as a professor. Actually, I had been banned from teaching at the Institute of Graphic Arts since 1959 because I painted abstractions. The Manezh show came about because I had created a school under the auspices of the GORKOM. There were three hundred people at the school, and we organized the show from that school. The exhibition was allowed to take place because one of my students was the son of Ilyichev, who replaced Mikhail Suslov as the Party's major ideologue. I am also a Doctor of Science, yet I was denied that title even though I have written sixteen books.

RB: *Tell me more about the Manezh exhibition.*
ЭБ: I was the only famous artist in the exhibition and had a certain position of authority. I was able to negotiate and to fight for the young artists who needed to be seen and recognized. That is why I had access to Khrushchev. After the Manezh show, the KGB established and promoted its own avant garde. My paintings were confiscated, but I was not imprisoned. I was, however, banned everywhere. I was not allowed to paint, and all of the artists who worked in my studios were also prohibited from painting. Over two thousand painters were at my studios. I had my own union. About six hundred people participated at the Manezh, and sixty showed there for the first time. Actually, I continued to paint despite the ban. The Soviets were not very civilized or cultured and did not follow up on their threat. They simply issued a warning, but I continued to work.

RB: *Clearly, you were the leader of the exhibiting artists.*
ЭБ: I was called that because for thirty years I was the leader of the new art in the Soviet Union. They tried to shove us under the rug after the exhibition. My name was even prohibited from appearing in print. Even Igor Golomshtok [a Soviet art historian

[1] Neither this nor other information stated below could be corroborated by the editors.

and early supporter of unofficial art who emigrated to England in 1972] would not acknowledge me. He was not allowed. Americans do not understand what went on here.

RB: *When did you receive permission to resume your work?*
ЭБ: I exhibited in England in 1989.

RB: *Why do you remain in Russia?*
ЭБ: I could not leave because I was not granted an exit visa.

RB: *What did you do between 1962 and 1989?*
ЭБ: I kept myself busy. I was forbidden to teach in any department of higher education or to write books. The authorities claimed that I corrupted students by teaching Western art, which, of course, was not allowed. Basically, I was banished from the USSR Union of Artists. Getting art supplies was very difficult since everything was centralized at the time. So my wife and I bought an estate and built a workshop and studio. We helped artists who were not afraid to join us. They settled on our property, and several are still there. My studios were and are the backbone of what remained of my art after 1962. There are still about five hundred people working at Abramtsevo [the town in which the studio is located] on the way to Zagorsk. I am also interested in academic art, art in the grand style. After the Manezh exhibition, scientists, who were a privileged group in the Soviet Union, were allowed to invite me, but, as I said, I was prohibited from teaching. The money I earned allowed us only to subsist.

RB: *Did you always paint in abstract styles?*
ЭБ: Yes. I was raised on the ideas of Malevich, whom I knew as a youth, and on Kandinsky. I once worked in the studio Kandinsky occupied on Zubovskii Boulevard.

RB: *Do you travel in the West?*
ЭБ: I travel now to the rest of Europe and America. I have no problems.

RB: *Has your work changed since the 1960s?*
ЭБ: I consider art to be a very serious matter. Often I have been

asked, in America, about the fact that American artists look to art for its shock value and as a means for financial gain. My answer is a negative one. Art is very serious, much deeper than science. That is why art has an impact on the spiritual life of each individual. I always search for an activity or a motif that will affect the spiritual life of humanity and of the world. This is my goal. I have developed a theory of contact in which I have articulated the means by which art can affect an individual's emotional, intellectual, and spiritual life so that stressful conditions in life, in the family structure, or among friends, can be modified. Art has the power to be that effective. I don't mean art of the past like socialist realism, but contemporary art. My teaching has been based on this overall concept for the past thirty-odd years. As in the past, Braque and Picasso sought new forms to represent the world of objects, so I, we, try to represent the inner world of human beings. That is why our movement is called the new reality. The reality that we represent is not a visible one, but the noumenal one. The noumenal is, in short, our reality. We consider ourselves to be the continuers of the tradition of Malevich and Kandinsky, not in form, but in essence. It is rather silly to continue to paint abstract art for its own sake. After all, many decades have passed since Jackson Pollock and other Abstract Expressionists became famous. Our artists now paint sheer fluff. An artist must be original. A follower is already a corpse. An artist who is a first, an original, is a genius; the follower is a clown. Recently [1992], we had an arts festival here with about twenty artists from different countries. They rebelled against me, saying that I overshadowed them, that I was too good. They wanted me to lower my standards. They were astounded and terrified by my work. It just killed them.

RB: *Who bought your work?*
ЭБ: They were honest people, scientists, doctors. I was not allowed to socialize with foreigners, so I could not make those kinds of contacts. You needed special permission to have contact with foreigners. My first encounter with Americans occurred in 1990. It must be hard for you to imagine this, but we were

watched and followed. Every encounter was observed. Artists like Neizvestny or Oskar Rabin were permitted to socialize with foreigners. Rabin lived beyond the Moscow city limits at Lianozovo. Foreigners were not supposed to go there even after the ban on such travel was lifted. Rabin's home was off-limits, but people still visited him. My wife and I bought our place fifty-five kilometers outside of Moscow. Why fifty five? Foreigners could only travel fifty kilometers outside of Moscow. So we were quite isolated, like in a prison. We were in effect told to go ahead and paint, but don't make contact with anybody. All of the people who worked in my studio were barred from contact with foreigners. They had to sign a statement agreeing not to meet or socialize with any of them or to exhibit their work anywhere. You must understand that for over thirty years we lived like the slaves in Egypt. The old mechanism has now collapsed. Nobody makes any remarks now.

RB: *Were you involved in the Sotheby's auction in 1988?*
ЭБ: One of my best pupils, Yankilevsky, participated in it. The next day about seventy people involved with it came out to Abramtsevo to see our operation. I put up some of my paintings in my area there, and when the buyers and museum and gallery people saw them they became upset. They wanted to know why they hadn't seen my work, why Sotheby's hadn't shown them anything of ours. They said the work that was sold was decadent. They said that they would have bought paintings from my studio if they had known about it. They immediately offered about a million dollars for my works and works by some students, but we could not accept any money. If we had done any private business, we would have ended up in prison.

RB: *Do you consider yourself the first and most important leader of the dissident artists?*
ЭБ: I was their leader. I taught them freedom, even when such teaching was forbidden. It was very scary to be threatened with the loss of a job, or of commissions, or of being expelled from the union. Artists gathered around me because it was important to

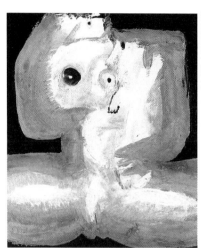

JACK ABRAHAM

Elii Beliutin, *Woman and Child #3*, 1973, oil on canvas

them. At Abramtsevo we led our own existence and were allowed to exist as a group. We were not imprisoned. Nobody, or very few people, came to visit us, but we were known. We had visitors from all the republics and students from many places. There are even Eskimos who studied with me.

RB: *You must have known several generations of artists. What about artists like Kosolapov and Melamid?*

ЭБ: They never studied with me. One artist in New York, Oswald Ronberg, told me that he took them in after they came to New York because they said that they had studied with me. I also consider conceptual art rather old fashioned now, decadent. I knew Vladimir Tatlin, Robert Falk, and Natan Altman. I had to leave Moscow in 1947 or be thrown in prison. People were being shot then, but I was spared since my family was held in high esteem. So I went to Leningrad where I met Altman. When I went to his house, he said that he could not offer me anything but some tea and crackers. He said that he was dying of hunger. It was true. Many painters were dying of hunger. But that is when I began my struggles. I understood that I had to build a studio and start taking on students. Anyway, when Russian artists had the opportunity to express themselves in a new language and to reveal their emotions in their work, then they could achieve

unbelievable success as in the past with Malevich, Tatlin, and Kandinsky. An architect like Konstantin Melnikov had new ideas because he was free from the yoke of slavery. These people were my teachers. But I learned an important lesson. The individual cannot act alone. He can't accomplish much alone. You need a group of like-minded people to do anything. Art is created in an environment, a milieu, with other artists. It's easy to work in Paris because there is a community of artists there. It is much harder in New York because the art market is there, not an artistic community. Perhaps it is better in San Francisco because there is no market there. I came to understand this when I once lived and worked outside of New York for three weeks. Gallery owners kept visiting me. They were not interested in art, but in the financial value of a work. Their interests were purely commercial. An artist is, after all, not an artisan. Generally speaking, an artist is crazy. He looks for things that nobody needs. Then he is a true artist. If he contemplates selling his work, then he ceases to be an artist. So back in the past I decided to organize a group of artists who shared common views. I felt this very strongly in the 1970s. People from that time still work in my studio. They are as one, but they are all different. I am considered to be a very talented teacher, but nobody in the United States has paid attention to this aspect of my work. I have never been offered a teaching position. I could have created a whole new school of thought in American painting. I know how to touch and awaken a person's talent, how to get out of him his special gift. It is impossible to teach art, instead, you have to draw out a person's awareness of his own talent. Once that occurs, then you can teach certain fundamentals. As a teacher I have been grateful to God that I have been able to help artists realize themselves, because the more artists there are the more enriched the world will be. After all, we all come to an end sometime. What hangs on the wall is what remains permanent. *That* was the basis for building my studio. I once visited the museum at Brandeis University, and artists there were amazed by my work. They said they were enchanted with my work, by the way I look at things. They said they were tired of dripping paint as if they were

making textile patterns. They considered this to be a matter of technique, nothing serious. But they thought of me as an artist, that I painted like an artist, that the work came from within my being. But since I don't speak English, it is difficult to teach in America. But this really is not important. An artist does not need to talk. He is like a dog who understands everything. People tried to persuade me to stay in America and open a school, anyway. But in America I would have to work individually, not as part of a group. Even Neizvestny told me it is better to work alone. But I feel that art is a communal activity. The impressionists were a group. Art is a serious enterprise in which each person complements the other.

If you work alone, you are immediately crushed.

Dmitrii Lion
Дмитрий Лион

Born in 1925 and died in 1994; Moscow Institute of Graphic Arts, 1953.

Graphics artist, semi-abstract style.

RB: *When did you first know that you were a dissident?*

ДЛ: I do not subscribe to such arbitrary labelings and divisions. During the course of my life I have painted works that were officially unacceptable. I have had many difficulties in my life, but I must say that I have been able to endure them with a degree of lightness. As an artist and as a spiritual person, one pays little attention to material surroundings, but to tell the truth our problems were overwhelmingly difficult. In 1952 I returned from the military after ten years of service.

RB: *When did you first begin to paint?*

ДЛ: I always drew and painted—for as long as I can remember, perhaps since I was two years old. Despite the horrors of the war [World War II], I continued with my art. I gave away ten years of my life and the traces are still left on my soul.

RB: *How did you come to paint Biblical themes?*

ДЛ: A few years ago I was surprised to see my name mentioned in a small Catholic journal called *Istina i zhizn* [*Truth and Life*] for which I had been interviewed. The interviewer asked me. "Dmitrii Borisovich, I don't want to discuss with you just the meaning of light and dark, but rather I want to know what you think about the first antithesis—the separation of truth from lies, truth from nontruth, of black from white. What are your ideas concerning all of this?" I had this same discussion with a Lithuanian art critic, Eliazar Levitas. We discussed how artists make use of black and white as a trace of their consciousness. Since I am first of all a graphics artist, I said that there was an analogy to Day One, as we read in the Bible.

RB: *How does this apply to your work?*

ДЛ: During the 1950s and 1960s Biblical themes were neither fashionable nor advantageous. But I literally was shattered by conversations I had with Jews who had suffered from Hitler's genocide. When I returned from the army, I hung above my bed the numbers of how many Jews had perished at Auschwitz and in other camps—six million three hundred and fifty-one thousand. This gave me shivers up and down my spine, and chills. Everyday I would get up and paint nonstop—no break, no holiday, for many years. I could not show anybody what I was doing because it was forbidden. But people began, through word-of-mouth, to know about my work. I became a legendary figure. Gradually, I moved away from these drawings. I subsequently came to realize that such tragedies have been a constant in history, and that humanity strays from the right path, but returns to it. During this time I turned to the Bible and gained a sense of compassion for the great tragedies and suffering that had occurred. Now, remember, Stalin was still alive when I returned home from the army and began to paint. You can imagine what those times were like! Among the drawings I made was one which could not be seen or shown. Even now I hardly show it to anybody, and it has never been exhibited. It is an allegorical and symbolical representation of the suffering of the Jewish people. The sad mood also reflects the famous

doctors' plot organized by Stalin [in which it was suggested that several Jewish doctors had intended to kill Stalin]. I made the drawing at the time the doctors were imprisoned. Rumors began to be spread about me at that time, as I said, and, in truth, ever since. But I have continued to be who I am. I did not join, nor did I belong to, any group or circle. However, I knew quite well people like Kabakov, Yankilevsky, Chuikov, and Shteinberg. Many were younger, but a few are my contemporaries. I believe that nobody is older than me. But what I want to say is that dissident art did not begin in the 1960s. This is a myth invented by the artists of the 1960s. Rather, I believe that in the 1950s, right after Stalin's death, even before his denouncement by Khrushchev and the unmasking of the cult of personality, artists began to sense a change, a breath of freedom, and began to paint in a way previously unacceptable. They went far beyond the prescribed limits just as I did. At that time, while I was still studying at the Institute of Graphic Arts, different movements began to arise. One could see greater individualism—some constructionism, some surrealism. I have to tell you, and I want to emphasize, that there were a number of wonderfully enlightened teachers there, true humanists. These brave and fearless teachers encouraged a small group of us by telling us stories about artists who had been banned, artists under strict prohibition, whose works could only be seen underground and in great secrecy. These forbidden artists included the great Russians like Vassilii Kandinsky, Kazimir Malevich, and Pavel Filonov. The actions of our teachers gave us courage and also stimulated our minds.

RB: *Did you see works by Kandinsky and the others?*
ДЛ: They spoke about them. I studied with a wonderful artist named Ivan Ivanovich Chikmazov, a student of Kandinsky, who died about thirty years ago. He was the first teacher who talked to us about color, composition, color equilibrium, the symbolic meaning of color and of particular colors, and about the meaning of shapes and form, about triangles, squares, and rectangles. Nobody had ever heard of these ideas before, not even among the intelligentsia. Nobody could even imagine all of this.

RB: *When did you learn about this?*

ДЛ: In 1953 when I began to study art after the army. I did not consider myself a dissident, but, in fact, I was one of the first.

RB: *Did you show your works officially?*

ДЛ: Officially I was starving from hunger. I completed my studies with distinction—better than anyone—at the Institute, and they asked me to remain and become a teacher there. I did not stay because I wanted to paint and draw for myself. Teaching would distract me from what I wanted to do. So I painted independently and didn't worry about getting commissions. But times change, and now my works hang in the Tretiakov Gallery, the Pushkin Museum, and in museums and galleries in other countries— France, England, Japan. When I was in France, in 1991, I learned that some of my drawings are in Lisbon and Zurich. I didn't even know about it. But back in the 1950s and 1960s I kept from starving by working as a book and graphics designer and an illustrator of books—enough to subsist. I made drawings the rest of the time.

RB: *Do you belong to the artists' union?*

ДЛ: I was admitted in 1958, but I did not join at that time. I did not bring the necessary documents to sign up. I was lazy, I guess. I joined the next time I applied. That was in 1978. The union did not provide graphics artists with any work, but it did grant some small favors, like free admission to shows.

RB: *When did you have your first show?*

ДЛ: In 1990. But between 1989 and 1992 I exhibited over thirty times in group shows. For instance, there was a show in 1992 called "Romantic Moscow." I even had a Jewish show. Another show was called "New Beginnings." I have also been shown at galleries in Paris.

RB: *Did you exhibit at the Manezh exhibition in 1962?*

ДЛ: I was not invited by the officials. All of my friends were, but not me. I was also too smart to get involved. One friend told me that there was a fresh breeze coming our way, but I was skeptical. I told him: "The cook must have forgotten to shut the door of the

wood-burning stove. A draft came and blew some ashes, and you believe it to be fresh air." No, I did not believe in the possibility that things would get better even though I have a good imagination. The exhibition at the Manezh drew a lot of attention, but I never ran after attention. I just wanted to paint and didn't try to take part in exhibitions.

RB: *Did the government harass you?*

ДЛ: No, the KGB did not persecute me. However, I was given a hard time at the publishing house where I worked. For two years I could not get any work. Naturally life grew difficult. I could still buy art supplies because they were cheap, but I went without dinner on many occasions. At the publishing house I never re-worked any illustrations. I would never make corrections. Not once did I do anything that would meet with official approval. But now I remember that the government did threaten to take back my diploma, to banish me from Moscow, and to deny me status as an artist. There were rumors that I was asking for trouble, but I was not afraid. You must understand that I spent ten years in the miliary, and during that time I had an irrepressible desire to paint. I wanted to do what I wanted to do, not take orders. If I became afraid then I would never paint again. I had to do it my way.

RB: *Did you socialize with many artists?*

ДЛ: With the artists I mentioned before—Kabakov and the rest. We were good friends. I also knew some artists on the right, such as Kolia Popov. But I am not inclined to join groups. I need to be alone, to work in solitude, almost like a hermit. I have a need to be immersed in silence in order to get at something worthwhile. I was not, therefore, in a great hurry to exhibit, even in apartment exhibitions, for there would be a great deal of pressure. I considered shows an intrusion on the business of making art, of making real art. At times I did not even put my signature on a piece so that it would seem to stay alive. A work is finished when it has been framed and hung.

RB: *Were you able to sell your art?*

ДЛ: Not until 1973 when collectors suddenly appeared, mainly

Dmitrii Lion, *Biblical Stories (Legends)*, 1977, etching, 24 x 34.5 cm.

from the West. The first collectors were Germans who bought unofficially. A friend from the Institute of Graphic Arts lectured in Germany and showed slides of my work. He was told that my graphic work was the best, that I was the best graphic artist. I sold things for very little money.

RB: *When did you first see Western art?*

ДЛ: In reproductions starting in 1953, but my teacher Chikmazov showed us things underground. I saw reproductions of works by Van Gogh, Malevich, Picasso. Picasso was a scary figure here because he was considered the enemy of the workers and the peasants. My teacher used to say that you should not listen to anybody, be true to yourself, and that all of this [authoritarian rule] would eventually pass.

RB: *Did you work in media other than graphics?*

ДЛ: I made frescos, but they were destroyed. They were in wooden houses in Moscow that were demolished. But I had no money for paints. Perhaps that's why I turned to graphics. But also when I first studied art, I painted still lifes. However, I had no time to

worry about buying paints. So I began to work in graphics. I found I could express myself in that medium. A critic once said that my work looked as if one could express almost everything within the perimeters of black and white.

RB: *What do you think about leaving or staying in Russia?*
ДЛ: I remain because I have so many works here, perhaps fifteen thousand pieces. I cannot part from them anymore than I can part from my three daughters. Had I been alone, I might have been able to leave. Perhaps I am not very practical, but that is how it is. Figuratively speaking, I believe that for each talented artist who leaves the country, a thousand street criminals are born. Out goes youthful idealism. A moral vacuum is left that becomes filled with something else. For the last twenty-odd years I have been saying to those who leave that they are leaving a vacuum behind them, but I don't judge them. One of my students—at least he considers himself to be my student—left Moscow for Paris twenty years ago. He became very successful and wealthy there. His name is Yuri Kooper, and he owns an estate, an apartment, and a studio where Delacroix once lived. But I keep on living here in Moscow because I have always considered that the more successful an artist is, the worse he is as an artist. If an artist receives praise and recognition, it means that he is not very good. And besides, I would say that, for most people, their homeland is their house, their street, and even the trees on that street. On the other hand, I do believe that the whole world can be a homeland, a global village, and that we should begin to think in those terms. Anyway, I did not participate in many shows in the 1950s and 1960s. I would submit works to exhibitions only if I could choose my works. If you had a friend on the selection committee, it was possible to manage things, but in a circuitous way.

RB: *Were these apartment exhibitions?*
ДЛ: No, official exhibitions.

RB: *What about your development as an artist?*
ДЛ: Well, perestroika played no part in it, although I was extremely happy about the course of events. I did not need perestroika for

my inner development. In the 1950s I drew scenes of German and
Soviet camps, realistically, with real live people. My work then
was reminiscent of Goya's graphic portrayals of war. Then I began
to see the sheet of paper as a sheet of paper rather than as a surface
on which some characters move around like on a stage, characters
engaged in conflict or discussion. I began to see the paper as a
universal space, a separate cosmos. My work assumed a higher,
more painterly quality at this time. There was a qualitative im-
provement. I don't know if everyone would agree, but, false
modesty aside, I would say that there was no other graphics artist
in Moscow who could be compared to me, not in terms of quality.

RB: *When did you begin to travel abroad?*
ДЛ: In 1989. When I was in Paris, I visited the Louvre forty times.
I know it better than the Parisians do. I have also been in Austria
and Turkey as well as Germany and Switzerland. On my first trip
the experience of freedom overwhelmed me. I did not have to
think about freedom, but here in Russia we are constantly preoc-
cupied with it. For instance, if you are in a line and somebody
shoves you or insults you, how do you react? It is shameful not to
respond, but what do you do?

RB: *How do you respond to the rising anti-Semitism?*
ДЛ: Well, I feel no hatred now toward Germans whom we fought,
but I cannot comprehend why there is so much hatred of the Jews.
It pains me enormously. When friends of mine, simple folk, talk
about somebody and ask me if it is true that Jews are such and
such, I ask them if he is a bad person? They might reply by saying
"No, he is a saint." And then I ask, "What about me? I am a Jew?"
So, we talk. But I always felt an obligation and a personal duty to
create art about the Holocaust and about Jewish themes. Lately,
however, I have felt less intense about my obligations. But I have
participated in a Holocaust exhibition and, some time ago, two
benefit exhibitions for Jewish orphans of World War II. The show
was called "Diaspora." My friends were amazed that I actually
did it. In 1962–1963 I painted a triptych, which only a few people
saw at the time, dedicated to the memory of the Polish writer and

doctor Janusz Korczak, who sheltered Jewish children in Poland and died with them in the camps. He joined them in the ovens. It is not a literal rendition of the event, but it includes people from Warsaw, rabbis, and simple Jews going to the ovens. I included the birth of a child who was also sent to the ovens. There is also a part about widows and pregnant women.

The triptych was shown in Moscow in 1990.

Vladimir Nemukhin
Владимир Немухин

Born in Moscow, 1925; studied with Petr Efimovich Sokolov, a student of Malevich, in 1942; studied at, and expelled from, the Surikov Art Institute, 1957; member of Lianozovo group, late 1950s-early 1960s; lives in Germany and Russia.

Paints abstract works that often include images of playing cards.

RB: *When did you decide to become an artist?*
BH: At the age of sixteen.

RB: *Did you consider yourself to be a dissident artist?*
BH: A dissident is, first of all, an intellectual, a cultured person, somebody with moral principles who stands firm in his convictions.

RB: *Did you consider yourself a nonconformist?*
BH: The distinction between conformist and nonconformist is socially constructed. It has little bearing on art. My own position in Soviet society was nonconformist, but it is absolutely impossible to paint a so-called unofficial picture, and it is equally impossible to paint an official one. There has to be a different way to use these terms. By unofficial art do we mean acknowledged or unacknowledged art? These are arbitrary labels and have little to do with the direction in which art moves. They are imposed by political

structures or state-mandated structures. From my point of view to paint unofficially is a misnomer. A painting cannot be unofficial on its own merit.

RB: *Did your mentor, Sokolov, introduce you to the avant-garde art of the 1920s?*

BH: Yes, during the war in 1943. Sokolov had been an assistant to Malevich, but left him and worked with Pavel Kuznetsov and Ilya Mashkov because of disagreements over political and artistic matters. Concerning the latter, Malevich's ideas about volume were quite different from Sokolov's. Had it been up to me, I would have gone along with Malevich. Anyway, I saw reproductions of avant-garde art in Sokolov's books. It was enough just to see these illustrations to make my head spin. They were profoundly influential on my work.

RB: *When did you first see Western work?*

BH: Until 1952 the Tretiakov Gallery was a place to display gifts Stalin received on his birthdays. There were some lamps, coal carts, flags, carpets, and all kinds of rubbish. The Pushkin Museum was also closed down. We didn't see any impressionist works until after Stalin died, and I believe these were war booty from Dresden, brought to Russia in 1954. Afterwards, works gradually appeared. In 1956 or 1957 the Pushkin Museum organized a show of impressionist paintings. The Tretiakov Gallery had an exhibit of old Russian art. Of course Kandinsky and Malevich were not yet shown. You can imagine all of the things that were still unavailable. But in time we saw their things, too. During the thaw we were able to get down into the basements of the Tretiakov and see what was in storage. Exhibitions were held twice a year at the Pushkin and the Tretiakov.

RB: *All of this coincided with the International Youth Festival in 1957 in which modern art was exhibited.*

BH: Yes. It included an enormous international exhibition. There was another show in 1959. Then there was a French show in 1960 where I saw for the first time the works of many artists. But it is

important to note that for a long time we saw nothing during the years of my youth.

RB: *As a young artist what were your thoughts about the Soviet authorities?*
BH: I related to them not at all. I didn't care about the government, and it didn't care about me. I never expected anything from it. I had no need for Soviet welfare. I made no demands and got nothing in return. I am very proud of that, and I am proud that I was never a member of the artists' union, although, I did apply for admission in 1958, but was rejected. I am proud that I do not get a pension from the state even to this day. I don't want to have anything to do with the past or present government, and I hope to God that I will have no need of it in the future. But when I was younger I could only devote time to my art work on Sundays. So I liked Soviet holidays because I could spend the time sketching. I wanted many more first-of-May holidays and seventh-of-October [on the old calendar] holidays.

RB: *How did you earn a living?*
BH: I made money by pure chance. Initially, I worked as an illustrator for a publishing house called The Young Guard and did illustration and design for the journal *Around the World*. This was during the 1960s. Later I worked as art editor for the magazine *The Searcher*. By 1967 or 1968 I was able to live on the sales of my paintings, mainly to foreigners.

RB: *How did you get supplies?*
BH: In my youth it was very difficult to get supplies. During World War II nothing was available. I would exchange a piece of bread for paints and canvases. After the war commercial stores were opened, but they charged exorbitant prices. I would spend virtually my entire pay check on supplies. Later, art supplies were sold in special stores for members of the artists' union. Since I wasn't a member, friends got supplies for me.

RB: *Did you have a supportive circle of friends?*
BH: I was not isolated or alone. I had close associations with

artists who shared my ideas about art. I was very close to Sokolov, my first teacher. I have to say that nature itself was another important relationship. The village of Priluki, where I continue to work to this day, is like a large studio for me, an experimental laboratory where I can exercise my creative energies. There I met Lydia Masterkova with whom I lived for twelve years. This was, of course, a very meaningful relationship both personally and professionally. At Lianozovo I found a group of people with similar interests—Oskar Rabin, his wife, Valentina Kropivnitskaia, her father, Evgenii Kropivnitsky, and her brother, Lev Kropivnitsky. There were also Evgenii Anechkin, Nikolai Vechtomov, and Boris Sveshnikov. The poets, Seva Nekrasov, Igor Kholin, and Genrikh Sapgir lived nearby. So this was the supportive circle. We helped one another and we helped young artists. Rabin held viewings in his apartment on weekends, mostly works by artists other than ourselves.

RB: *Did you exhibit your own work?*

BH: All of our first exhibitions took place in apartments—in Lianozovo and in Rabin's apartment. Masterkova and I would have small exhibitions on Gorky Street, literally on the street, usually on Mondays and Wednesdays. But I did not participate in the apt-art [apartment art] shows organized in 1975 and 1976. By that time I was already working with the GORKOM [which Nemukhin joined in 1971]. Our apartment shows were organized differently. We made our own decisions and had our own agenda. We were more political and more involved with protests. This was of the greatest importance for our creative life. I also showed at the Bulldozer and Izmailovsky Park exhibitions in 1974.

RB: *Were you involved with the Manezh exhibition in 1962?*

BH: No. That was organized by Elii Beliutin. This show was a provocation, and it was the one where Khrushchev decided, in a most foul manner, to clamp down on artists.

RB: *Tell me about the Bulldozer exhibition.*

BH: I participated with my friends. We were all together.

RB: *Were you bothered in any way by the government?*

BH: Yes. Persecuted is a better word for it. The people who harassed us were party officials and members of the Moscow art union. The artists conducted a campaign behind the party screen. For example, I can recall many television broadcasts by artists rather than by party members, by, say, Vladimir Serov, who was president of the Russian Union of Artists, or other academic artists who mocked and desecrated young artists by referring to them as "so-called artists" or "formalists." After the trials of Siniavsky and Daniel in 1965, they began to use the term "dissident."[1] We were always fearful because there was always the threat that we could be summoned at any moment for interrogation at some mysterious place or be put away in some God-forsaken place. Personally, I was never directly threatened. But they had their ways of exerting pressure, which came in different guises and under various pretexts. My activist friends were especially affected. I could be called in a case dealing with artists who sold their paintings privately. Or they might terrorize my mother by visiting her regularly and asking all sorts of questions about me—what is he doing? who is he seeing? who visits him? Then they might bother our neighbors who would then tell my mother about their visits. My mother would end up begging me to stop painting my pictures.

RB: *Tell me about the Sotheby's auction in 1988.*

BH: There had never been an auction in Moscow. When I was approached to participate in it, I had no idea of what it was or what was involved. I did see an enormous advertisement for it, which created a certain resonance. In any case I submitted two paintings. The effect of the auction was to splinter the artists. It seemed like an attempt to set us off against each other once again, the known artists against the unknown. And those who were paid more were considered to be better artists than those who received

[1] Andrei Siniavsky, who published anti-Soviet material abroad under the pseudonym of Abram Tertz, and Yulii Daniel, who did the same under the pseudonym of Nikolai Arzhak, were sentenced to long jail terms in 1965.

smaller sums. It was difficult to figure out what was going on, particularly since we had no idea about the selection process. It seems that gallery owners rather than Sotheby's did the selecting.

RB: *Can you describe your evolution as an artist?*

BH: I would say that when I first began to work with Sokolov, I was most influenced by cubo-futurism and constructivism. But by the middle 1940s I began to develop my own powers as an artist, which reached fruition in 1957. I would also say that when I came in contact with works by Kandinsky and Malevich I was painting landscapes. Now, I feel closer to constructivism. Because of what I said earlier, I wouldn't say that I was a dissident. The dissident condition relates more to one's position in society than to one's art. In Russia the question was, could you be recognized as an artist on the merit of your work or on your position as a member of the artists' union? All of us who were not members were not considered to be artists. I was a nonartist. We were looked upon as a social evil and, through our paintings, potential evil doers to society.

RB: *Has perestroika changed your art in any way?*

BH: Art did not change after perestroika, but there have been some shifts. Many of us began to work in the West, myself included. Half of each year I work in Germany and the other half in Moscow. The dangers lie, not in changes of painting style, but of life style. There has been a demand for individual exhibitions. A new quality of life has come into being. I produce more paintings now.

RB: *If your early work grew in response to the political situation, what kinds of questions do you ask of your work now?*

BH: I am almost seventy years old and my mind is preoccupied with entirely different things now. I am not so concerned with political questions anymore. Before, the political aspect was always present. I never sought it, but Soviet society always imposed itself on people. Official artists worked together with party officials to make our lives miserable. Problems, today, do not com-

pare with those of the past. I can't say that I am free of worries, but I have tried to liberate myself from the past. Yet I don't think an artist can ever be entirely free.

RB: *It is important for you to keep close to Russian culture?*
BH: This is an important question. If we say there is such a thing as American art, then we must have in mind an American culture. The same with French art, and so on. But we do associate French art with the School of Paris. I consider myself to be from the School of Moscow which developed a long time ago, in the sixteenth century, and continues to the present. Therefore everything that occurs—anything that a painter might do—who was born or who has lived in Moscow has his antecedents in the Moscow school of painting. However he thinks he has changed, wherever he has moved, his Russianness comes through. No matter how long he has been away from Russia, his culture and his images are still Russian, however disguised they might be.

RB: *Then do you consider yourself an internationalist?*
BH: No question about it. I feel that I belong to the greater world of art, but my emphasis on belonging to the Moscow school of painting is about a way of seeing, a way of perceiving, certain structures in art. I take pride in anything created as a beautiful object. I am proud of it in a spiritual way.

RB: *What about Russia today?*
BH: After 1990 the entire Soviet system collapsed. With all my heart I hope Russia remains a free and open society, but it is a very complicated process. If I had the means to help, I certainly would do so because I am very worried now about what is happening.

We cannot really seem to get rid of the Soviet mentality. But I have hopes.

★

Dmitrii Krasnopevtsev
Дмитрий Краснопевцев

Born in Moscow, 1925; Surikov Art Institute, 1955; for about twenty years worked as an advertising graphic artist for Reklamfilm; died in 1995.

Paints imaginary still lifes.

ДК: I speak poorly, so I can tell you everything in a few words. My life has not been bad because I just sit and work. I was never part of the artistic underground. I worked openly, but I did not show my paintings. I didn't even aspire to do so. My friends saw my work, and that was enough.

RB: *Did you ever exhibit?*
ДК: Not really, but I did have two marvelous shows at the home of the famous musician, a great genius, Sviatoslav Richter, for a narrow circle of our friends. I did not feel the need to exhibit because my home was open to everyone who wanted to see my work. They were welcome.

RB: *Has your style changed over the years?*
ДК: My works from the 1950s were more decorative. I don't have many left. Many are in America, perhaps because Americans are rich. But I really do not have different periods or styles. Whatever

the changes, the transitions have been very smooth. Years ago, I used to paint portraits and landscapes, but now I only paint still lifes.

RB: *Did you ever have confrontations with the authorities?*

ДК: No. The only time I had a "meeting" with the authorities was caused by an American event. A journalist named Marshak visited me at the request of the House of Friendship. He liked my work and he even bought one. After a while, *Life* magazine printed an article of his in which he described his visit to the Soviet Union and the artists he visited. This was sometime in 1959. The article carried a slight political tone, and it prompted some attention in necessary or perhaps unnecessary places. I was then summoned to explain myself. I told them everything because I had nothing to hide. But there was no unpleasantness.

RB: *Did they believe you?*

ДК: I think so, because there were no repercussions.

RB: *Were you a member of the artists' union?*

ДК: I joined quite late, sometime in the 1970s—the Moscow Section of the Union of Artists. How can I explain this to you? In our country they wanted you to belong to something, otherwise you were considered a freeloader or something like that. So I joined the union. I don't even know why, but I knew there would not be any talk or gossip if I did. It served as a passport. Many joined, but some didn't. The famous author Ilya Ehrenburg never joined the union of writers. He was ineligible for some reason, but from time to time they would print his work. It was a very silly situation. One could be a wonderful writer and still not be a member of the union.

RB: *Was it difficult to get materials when you weren't in the union?*

ДК: No. Now it is harder because prices have risen so much. Before it was simple and not very expensive. I was known at the store where art supplies were sold. They never asked me to show my permit. They knew who I was and I often went to the store with friends who were union members. So they were familiar with me.

RB: *Did you ever take part in official exhibitions?*

ДК: No, but sometime in the 1970s, I joined the GORKOM. Why this organization came into existence is not clear. The authorities objected to apartment exhibitions, but in these GORKOM exhibitions they could keep everything and everybody under surveillance. And I could show almost all of my works without getting involved in politics. Soon after that I joined the Moscow Section of the Union of Artists. Oskar Rabin, who now lives in France, called me on the phone and asked me to quit the GORKOM. He wanted me to join with his friends and not exhibit in the official exhibitions. But I did show in some group exhibitions even though I was a bit reluctant.

RB: *Did you have any government commissions?*

ДК: No. The government did not bother me with after the *Life* magazine incident.

RB: *Your paintings did not upset them?*

ДК: No. They were bothered more by the fact that I was becoming famous abroad and that foreigners were coming to my house. They did not persecute me for that; they just didn't like it.

RB: *Did you have any exhibitions abroad?*

ДК: I was in group shows, not solo exhibitions. Some of these were put on by Alexander Glezer, a collector who lived in Moscow and who was asked to leave the country in the early 1970s. He took his collection with him. I don't know the details, but somehow he received permission to leave with it. He must have made a deal with the officials that he would leave without a scandal, if he could take his collection with him. He lives in France now.

RB: *Did you have any local or foreign buyers?*

ДК: There were a few Russian ones, but far fewer than Western ones—mostly German, French, and American. I can't remember their names, and I would write down something like "Mr. Smith from New York." Not much of a list, as it turns out. Russians paid me much less money than the Westerners. But, on the whole, sales were sporadic. I made a living in film advertising, for about twenty years, making small film posters for Reklamfilm.

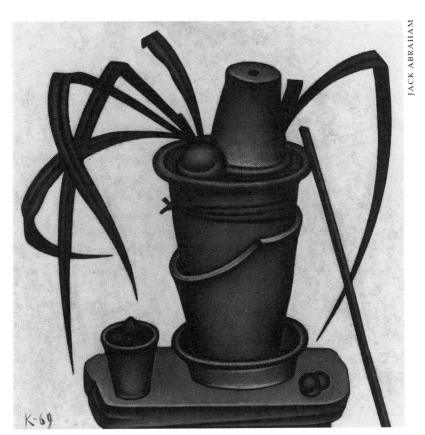

Dmitrii Krasnopevtsev, *Still Life with Three Pots*, 1969, oil on masonite, 60 x 58.5 cm.

RB: *How do you feel about all the changes that have taken place in Russia?*

ДК: Well, there are many positive as well as negative aspects. Life, generally speaking, is more difficult. Yet, something has taken place. I don't know if it will be permanent, but it has occurred. I would say, though, that even though my art has changed over the years, perestroika has had absolutely no effect.

RB: *Did you belong to a circle of friends, of artists, with whom you shared ideas?*

ДК: I never belonged to any group. I do have friends, but from diverse groups, and for the most part these groups developed

from where you lived. I was not close to the different groups of artists. I did not require it or need moral support. Even if everybody would have told me not to paint the way I did, I still would have continued to do so, to paint in my own way.

RB: *Did you take part in the Manezh or Bulldozer exhibitions in 1962 and 1974?*
ДК: No, although I was sort of invited, through hints. I thought the events around the Manezh exhibition were very foul because of that incident with Khrushchev. It was provoked by official artists, particularly Vladimir Serov. He brought Khrushchev to the show, a man totally ignorant of art. After seeing some paintings, Khrushchev, a temperamental man, began to shake his fists. What is there to say about his behavior? [See Ernst Neizvestny.]

RB: *Did you think the artists should have shown their opposition to the system?*
ДК: Certainly. It was necessary. But my nature is different from theirs. I never stood up against anything. I simply worked. I did not sit underground; I sat in my room. Literally so. I never had a studio, so I worked at home. We used to live in the center of Moscow on the Arbat, but they moved us in the early 1960s to these apartment houses on the outskirts, where we now live. The authorities took our house in Moscow, saying they were going to renovate it and then let us move back in. But we never received permission to return.

Gradually, I got used to living where we are now, but it isn't Moscow.

Džemma Skulme
Джемма Скулме

Born in Riga, Latvia, 1925; Academy of Arts in Riga, 1949; Repin Institute of Painting, Sculpture, and Architecture, Leningrad, 1955; Deputy Chair, Latvian Union of Artists, 1972–1977; Secretary, Latvian Union of Artists, 1977–1982; Chair, Latvian Union of Artists, since 1982; Laureate of the USSR State Prize, 1984.

Abstract figurative artist who often uses family themes and folkloric elements in her evocations of human feelings.

ДС: I studied at the Academy of Arts in Latvia, which is usually referred to as the school of Riga. During all of the difficult years, our academy maintained the best traditions of contemporary Latvian art that emerged after World War I, when Latvia was a free and independent country. Styles were based on some western European models and the Russian avant garde. All of our major artists were nurtured in these modes and saw the major modern collections in Moscow both before and after the Communist Revolution.

RB: *Did you have the opportunity to see avant-garde paintings in Riga when you were an art student?*
ДС: I did, because many works were still there, but it was forbidden to study them. My parents were both artists [Oto and Marta

Skulme], so, of course, I saw paintings that were labeled avant garde. The two of them were part of a group called the Riga School, which was also known as the Expressionist Group. There were about ten or twelve members. They were known in Europe and had connections with artists in Paris, Berlin, and Russia. I can remember that, in the 1930s, Soviet artists were still allowed to travel abroad, and they would tell my parents of events in the Soviet Union.

RB: *Did you experience very much repression when you studied art?*
ДС: Yes, when I studied at the Academy from 1944 to 1949. These were really hard times, but the most difficult period occurred in Leningrad, when I was a graduate student at the Repin Art Institute from 1952 to 1955. I went there to be with Ojārs Abols who became my husband. Despite everything, we felt spiritually free, even though we were repressed.

RB: *What was the situation in Riga?*
ДС: Don't forget, we were free until 1940, so we had around twenty more years of freedom than Soviet artists. Therefore, we were able to maintain our own traditions because we had a memory of the past. But there was a lot of pressure to conform to the socialist realist style. Many of our best artists were labeled formalists. After the political thaw instituted by Khrushchev in 1956, we pretty much went our own way. We gained a reasonable amount of independence both in our culture and our art. Things were good for a while. But then, in 1962, another wave of repression came. That particular year was a difficult one. My husband and some other artists were called formalists. These repressive waves would start in the Soviet Union, particularly when there were economic problems, and we would feel the effects in Riga.

RB: *Did you have to paint in the official style?*
ДС. Yes, I made a bunch of silly official paintings. But after 1962, I went my own way and worked independently and with greater freedom. In my official works, I did a series about Latvian riflemen. There is a certain romantic quality about these paintings that coincided with my inner mood at the time. But pathos and drama have always been a part of my art. In the official paintings I

stressed dramatic elements because the riflemen led our revolution. They were like sacrificial lambs, sort of like in the myth of the Greek god Kronos who ate his children. Clearly, I had a subtext in these works.

RB: *Nonconformist artists in Russia told me that they painted socialist realist works, officially, or that they worked as book illustrators, but, unofficially, they did their own work unbeknown to the authorities. Was that the situation in Latvia?*

ДС: For us it was somewhat different. We gradually assumed authority over ourselves, and we were successful at it. Even the worst leaders, who knew us as their enemies, took pride in us as individuals, respected us, and valued us as artists. Perhaps we were lucky that the leaders of the USSR Union of Artists valued work being done in the Baltic states [Estonia, Lithuania, Latvia], and they liked visiting us. We began to organize exhibitions that took place three and four times a year. This could never have happened in the Soviet Union, and we were reprimanded, but we were shrewd and crafty. Our Latvian artists' union was subordinate to the USSR Union of Artists, but as the leader of the Latvian union, I managed to hold our exhibitions anyway. So we really did not have any dissident artists because they could exhibit officially. If, for instance, an artist painted in an abstract, or even in a unacceptable realistic style we would exhibit those works with the design department, as if they were designs rather than paintings. In Russia, there were no such exhibitions. We used this device as a cover to exhibit anything we wanted to in the 1970s. But earlier, in 1956, we began to designate exhibitions as special art days, because we had exhibitions all over Latvia. If we were reprimanded in some way, if somebody showed up from Moscow, or a person from the USSR Union of Artists was in Riga and saw such works, there would be some problems. But we would say that our viewers were ready for this kind of work, that every person from the countryside would understand this art. We would say that exhibitions of, say, birch trees, were not enough, that there was need to show something altogether different so that the people would see with new eyes and be able to think and to contemplate new thoughts. In fact, we really wanted to educate and prepare future

leaders and functionaries of the party who would be the guardians of our culture. This is why we exhibited in villages. The leadership in the countryside was accessible to us, and we wanted them to get used to us. We were educating them. We did not do this because we believed precisely as Lenin had proclaimed: "Art belongs to the people." This type of slogan was used only when we delivered official speeches. Instead, we tried to prepare the people to be able to think and to decide for themselves. I believed that people who saw diversity in art would have a wider scope of life, of politics, and would be able to develop their thinking facilities. You should know that what I just said now was forbidden language in the old days.

RB: *You were not challenged as head of the Latvian union?*
ДС: We were united as a block, like an army, and agreed on our goals. At that time we artists thought alike, and we were a large group. We supported each other, and through such support we helped strengthen our culture. Our group exhibitions were events. Many people came. We in Latvia were the first to have such exhibitions. Now, of course, things are different. We have nobody to oppose. We each go our own way. And this is normal. I am not scolding anybody. But it is true that our former closeness, our friendships, helped us a great deal. We supported each other, and this allowed us to proclaim our own culture and protect it from Russian culture.

RB: *Did you have faith that one day all of this might change?*
ДС: Yes, of course. Perhaps we did not think that the regime would just fall apart—crash—but we did our best to help our situation. We tried to create a better life because it was shameful that we were stuck while the rest of the world operated on a different level and had an entirely different standard of living. Where things were evolving elsewhere, we had to live within the confines of our system, which we tried to change as best we could.

RB: *Could you see Western art and contemporary art?*
ДС: After the thaw in 1956 we were able to see everything and to obtain whatever information we wanted, especially through foreign journals. Polish journals had the best reproductions.

RB: *Did this material have an effect on you?*

ДС: We saw reproductions. But for me there were not too many surprises, since my father worked in the spirit of the 1920s and made cubist paintings. I started out painting this way. We were pressured not to do so, but we managed. Perhaps we were somewhat behind in abstract art, but we saw examples and intuited the rest. It was not anything unexpected. We simply made use of everything available, from the Renaissance on.

RB: *During the oppressive times, could you have solo exhibition? and did these have to take place in apartments as in Russia?*

ДС: Yes, at times. But we did not have to show in apartments. We had more freedom and, in effect, did not have the kind of dissident art that existed in Russia. We could always show through some official channel. There were, however, moments when we were insulted and reprimanded. My son, for instance, Juris Dimiters, experienced some problems. But, again, we managed. I know that people in Moscow used to say, "She can do what she pleases. She is independent."

RB: *Did you know about the Manezh exhibition in 1962 when Khrushchev created such a scene?*

ДС: Yes, Ernst Neizvestny was a friend of ours, and, when he came to Riga soon afterward, he told us how Khrushchev came at him with his belly. Ernst felt his gut! I was in Riga at the time, and it was rather horrifying. We did not expect such an outburst because the thaw in 1956 gave us some hope that there might be some possibilities for free expression. Then we realized that Khrushchev was rather stupid. We knew that a struggle always existed between academic and avant-garde artists, and this was one of the lessons of 1962. One group of conservative artists under the leadership of Vladimir Serov with sculptors Matvei Manizer and Nikolai Tomsky—a whole pack of them—drove Khrushchev to distraction. They pressured and angered him and, since he knew nothing about art, he responded violently. In this instance the Communist Party took advantage of the moment. It didn't have to dirty its hands because these artists did the job instead. But that period was also a time of unrest, and our party functionaries,

our leaders, had to find people to discipline. They just had to do so. My husband and I lost commissions. Our daughter, Marta, was born then, and we had no means to support ourselves. We had no idea of what we were going to do. My father had already retired and was living on his pension. We sold our books. I began to make illustrations, very serious ones, for Latvian classics and for translations of Dickens. I began to earn a good living from illustrating, and fifteen years after graduating from art school that was how I earned a living.

RB: *Did you experience fear in 1962?*

ДС: No. We were young then and fearless. What we felt was anger, fury, but not fear. I did have one moment of fear, however, in 1975 when my husband and I were returning from a trip to Canada where we did not have an exhibition of our own, but our work had been shown. Customs officials found money in our wallets. So they really searched us.

RB: *When did you first exhibit in the West?*

ДС: In 1981 I showed in group exhibitions in Germany and the United States. We had a family show in Berlin that year—works by my parents, my husband, and my son, but none of us were allowed to attend the exhibition. It was impossible to leave Riga at the time.

RB: *What about the Bulldozer exhibition in 1974, did you know about it?*

ДС: Yes, everybody knew about it. We got the news from Radio Freedom, which had nurtured us for several years. We were very supportive of the artists, and we thought that such unrest might come to Riga, but we responded in our own way. I was acquainted with Oskar Rabin [one of the organizers of the Bulldozer exhibition]. He had studied in Riga [from 1946 to 1948] with an artist named Shedelman, a Latvian painter who emigrated around 1974. He is a fine, very interesting graphics artist whom we loved and admired. He was well known and respected, but he left after some of his works were removed from an exhibition. He was Jewish, so he was able to leave the country. We met him in Canada in 1981. Shedelman was from Riga, and when he returned a few years ago we gave him an exhibition.

RB: *Did your work change after perestroika?*

ДC: I always did as I pleased, so I was not affected. In fact, my best works were done in 1975.

RB: *What about your working methods?*

ДC: Building through color is the main thing for me. I model with huge masses of color to suggest volume. Figures are less important for me, since it is the use of color, to suggest volume, that is paramount. When I begin a work, I draw something on a sheet of paper, something abstract. Then some inner lyrical voice calls for something human because I need personal contact, a dialogue with that emerging figure.

RB: *How were you able to paint such images in the 1970s and 1980s? Your style is certainly not socialist realist, and, at the same time, you were a major force in the Latvian artists' union.*

ДC: I was not the only one to work this way. There were many of us, and we supported each other. One time, ten of us exhibited in Moscow, and we were very well received even though the KGB saw the works. Nonconformist artists who came to the show said that we were brave and that we achieved something. They told us that they were not allowed to work so independently.

RB: *This is interesting, since Russian artists have told me of instances of the KGB's trying to discipline and reeducate them or to turn them into spies.*

ДC: Well, the KGB did take some illustrations out of my books on one occasion. And in 1968 my husband and I were summoned before the central committee in Riga. One of the reasons we were called was that several of our conservative painters, who were actually failures as artists, wrote a letter accusing us and some others of being avant gardists, of being progressive artists. These conservative artists addressed their letter to four different places: to the Central Committee of the Soviet Union in Moscow, to Mikhail Suslov [1902–1982, head of the Department of Agitation and Propaganda in the Party Central Committee], to the Ministry of Culture of the Soviet Union, and to our local central committee in Riga. The letter said that a person like myself should not be allowed to walk on Soviet ground, that I did not follow Lenin's

dictum that art should follow the direction of socialist realism, that I painted like a Westerner, and that my works were as decadent as works in the West. My husband had been in the army during the Second World War, but veteran's status did not protect him. The committee turned on him and insulted him by calling him a Western-style ideologue. In effect, they were trying to redirect his thoughts and to reeducate him. They also tried to do the same to me. My husband, humoring the committee members, told them that I would change some things for a forthcoming exhibition of mine. He spent five days reorganizing the hanging of the works, but did not remove anything. The show opened, and nothing bad happened. The same show was scheduled to open in Moscow in 1969. The president of the USSR Union of Artists was, at that time, a woman by the name of Balashova, a very brave and clever person and a fine sculptor. She did not particularly like other women, and even though she was older, about sixty, she liked younger men. Yet, Balashova saved my show. She did not permit any of my works to be removed, even though this had happened to me many times in the past. (One time about forty pieces were removed.) She was very ill at the time and died two months later. Like a queen with great authority, she said "This is wonderful art, a wonderful painter. Everything is great." Then she said to me that I was truly a Latvian rifleman. I guess she had nothing to lose by showing such courage to stand up to the authorities. Others had thought that the show would cause a scandal and did not know what to do. They were terrified. Anyway, the show was held at the Kuznetsky Bridge [an exhibition hall] and caused a sensation. In the book of responses, people called my paintings "smears," "idiot work," and said that I was a "Westernizer." At the same time, others wrote that not since Vsevolod Meyerhold [the experimental theatrical director] had they seen anything like my work in Moscow. They told me to keep up my courage, and that this was how a national painter ought to paint. It is also interesting that nonconformist painters were upset that I was allowed to get away with showing my works when they could not show theirs. They were not angry, since they understood that we had more freedom in Latvia. And as I said before,

we had twenty years less of the Soviet regime than the Russians had, so we had a memory of art before the Soviets took over of our country in 1940.

RB: *Can you say more about the Russian nonconformists?*

ДС: Well, they obviously did not have the same kind of memory that we had. But they were a different bunch of people; they were out of the ordinary and deserve praise. We had a more democratic center in Latvia, and this allowed us opportunities they did not have. For instance, our authorities took pride in showing their tolerance and in the "variety of signatures" in Latvia. At various exhibitions in Russia in which we managed to have our works accepted, the works of the Baltic artists stood out and were often quite distinct from those of other Soviet artists. All our leading artists were much looser and freer in their paintings. The Russians kept a tight lid on their artists and oppressed them. With us, it was the reverse. We tried to protect our painters. Let me give you an example. We, in Riga, accepted our own artists into our union, but then we had to get approval from Moscow. We had a very interesting artist named Mizhulis, who worked in a free and loose style, much freer than mine, who had to be reviewed by Moscow. The reviewer at the time was a woman named Assia Zuikova. I asked her not to show his paintings to the committee, but just to mention his name. I said that he was a very good artist and would continue to be so. This was unusual because the reviewer generally had to present a packet of materials, photographs of the artists' work, to the committee. But it worked. At other times, we would tell an artist to send photos of works of inferior quality because that was what the people in Moscow understood. Once a member of the committee who had a keen sense of quality let us know that he had taste, but he would approve our artists anyway. With his own people he was a scold, but not with us. So we were able to fool the authorities and get around them one way or another. This is just how things were. Here is another, different story that shows how we Latvians managed. When we were students in Leningrad during the early 1950s, the horror years, one of our teachers, Boris Johanssen, maintained a love of good art. He knew us and told us to study Degas because he knew that we were more Western in

our inclinations than the other students. He told us this when my husband was working on a painting of the revolution of 1905 and I was making paintings of holiday and festive occasions. And my supervisor at the Repin Institute, Viktor Oreshnikov, would invite us to his house where we constantly discussed Western art. He was an accomplished artist, but he painted hideous portraits in the spirit of socialist realism.

RB: *Did you go to art school as a child as several artists in Russia did?*
ДС: No, there were no such schools in Riga. I started late, by comparison, but I remember the old-timers. In Moscow, the artists used to say that none of us lived during the old times, but our old times dated from before 1940, not from the Communist Revolution.

RB: *Why do you choose to remain in Latvia?*
ДС: I am Latvian. It is my country, my soil. I can't imagine living in another country. There were moments when my husband and I whispered in the dark about leaving, particularly when circumstances were difficult, but with a son and daughter it was impossible. Latvia is a very interesting country, small like Belgium and Holland. Perhaps we have fewer rich traditions, but we have lots of talented people who produce native art. It is in our genes. Almost everyone is capable. Right now, the economy is slow, and people are having a difficult time. But we have great potential. We have two seaports that do not freeze over in winter. In fact it was suggested in 1988 that I become president of the USSR Union of Artists, but I refused. There is lots to do in Latvia. We even discovered that there was discrimination against women which we had not realized before. We know now that we did not examine questions in the same way that people in the West did.

**Now our eyes are opened on this issue—
and on many more.**

★

Ernst Neizvestny
Эрнст Неизвестный

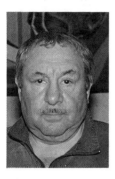

Born in Sverdlovsk, in the Ural Mountains, 1926; in the army from 1942–1945 where he was seriously wounded; taught drawing at Suvorov Institute in Sverdlovsk, 1945–1946; studied at Academy of Arts in Riga, Latvia 1946–1947; studied at Surikov Art Institute and Moscow State University, 1947–1954; immigrated to the West in 1976 and settled in New York City the following year.

Sculptor whose works reveal both expressive distortions and cubo-constructivist concern for form.

RB: *In political terms, what kind of artist did you consider yourself to be?*
ЭН: I did not consider myself a dissident because dissidents have a pure political and an ideological agenda. I had neither.

RB: *What about your background?*
ЭН: I was born into a very special family in Russia. My mother was of Jewish extraction, I think, but she came from a Catholic family from Spain with the title of Baroness de Jour. In Soviet Russia it was dangerous to be from such a family. My father was a capitalist from the Ural Mountains, and he was a White officer during the revolution. Under Stalin families such as mine had a special name. They were called *lishentsy*, which means deprived people or the dregs of society. Still, I was not a dissident, but, by

virtue of being from a family such as mine, you could say I came from a family of dissidents. I did not even belong to the Young Pioneers when I was young. With regard to dissention, I will say that I was an organizer of a group of students in 1949, an unofficial group, but it was not involved in political issues. Rather, its main function was to distribute information. At that time I was a student of philosophy at Moscow State University, and I also studied at the Surikov. Let's say that when studying, I realized that if we were to continue to study philosophy as it was presented at the university, then we would surely graduate as ignoramuses. What we studied about Lenin came from Stalin and material about Karl Marx came from Lenin. I wanted to read authentic material. So we formed a group of four in order to obtain information. The other three were in different disciplines—cinema, journalism. I was the only one with military schooling, since I had been an officer in the army. I had volunteered and had been decorated, and I was wounded four times. I was even awarded the Order of the Red Star posthumously, but I lived. The goal of our underground group was purely a scholarly one. We emulated somewhat St. Ignatius Loyola. Each one of us had the right to get acquainted with one other person and that person would be introduced to the group in order to give information.

RB: *How did you get information?*
ЭH: That was a big task. Certain people knew foreign languages, and so they read and translated things that were forbidden. Some people had access to special archives. This is how information would trickle down.

RB: *Was it dangerous?*
ЭH: Yes, very dangerous. But our search for information was not with political goals in mind. Our aim was to collect everything that we could in order to preserve knowledge. During Stalin's era, the only social group that was able to exist was a social group of drunks, young lively people, playboys. We pretended that we were the same—carefree, young people who didn't think about anything but ways to amuse ourselves and to have a good time. We pretended that we were happy drunks. At that time, we wrote

songs which were forerunners of sots art but were also of high poetic quality. They were student songs. In fact I just spoke with a friend in Moscow who told me that the only other living person from our group, a man named Arkhemenko, recently made a speech in which he described how we wrote the songs. The entire country sang those songs, and it still does.

RB: *Who composed the music?*
ЭH: Young composers. The name of one song was "Ya bil ego v beluiu grud'," which means "I Struck Him on His White Chest." This was a parody of nationalistic songs. Everybody sang them— poor people, beggars on trains. They took these songs seriously. We also wrote a song called "Lev Nikolayevich Tolstoy," another that translates as "The Venetian Moor, Othello," and one called "Hamlet Strolling with a Gun." What type of songs were these? We took the official form and filled it with unofficial content. Just as in the Middle Ages there were anti-liturgies and during Roman times parodies of the emperors, so we accepted the convention and imbued it with a different content and meaning. I would not call this dissident activity, since in our circle there happened to be a number of professional Communists, but they were also pro- gressive and liberal-minded people. During Gorbachev's time, they came into power. And they knew where they came from and where they were nurtured. After perestroika, my biographer, Edik Igelaut, printed my story in *Continent*. It was called "The Journey of the Underground Culture." He met people who told him it was all true. But I don't call myself a dissident. In Russia, everyone was a dissident, even Mikhail Baryshnikov. I was only an artist who wanted to be left alone, to work, an intellectual hungry for knowledge.

RB: *Did you have commissions?*
ЭH: Yes, some during Stalin's era. I made a number of vulgar sculptures when he was still alive.

RB: *Were these official works?*
ЭH: No, I have them here with me now. They could not be official. Some here in my studio are from a series called "The War." When

Stalin died, I began to work on a monument called "Victims of Stalinism or Communism." This was in 1954. Together with Andrei Sakharov, somewhat later, I formed a group, called "Memorial," around this monument. The authorities did not know about any of this.

RB: *What were your relations like with the state?*
ЭH: As a sculptor of monuments I wanted to work for the Soviet state, but the state did not want what I wanted. It demanded compromises, and I was not one to compromise. During my creative life as an artist—from 1954 to 1976—the government bought only four works from me. So I worked as a mason, a bricklayer, a porter, and as an assistant to a sculptor in order to make money. I was a dissident to the extent that I insisted, as an artist, on having rights to my own individuality and private life. So, there arose some controversy between me and the government. Everyone knows about the quarrel I had with Khrushchev at the Manezh exhibition in 1962. I was the main person there. It is in John Berger's book.[1] My own history is linked to my struggle for an artist's right to have freedom and to be whom he wants to be. That struggle can be dated back to 1956, the year of the Soviet intervention in Hungary. An official document was issued that it was stated that I was a major revisionist in Moscow. I was denied the right to work as an artist partly because of that document. My work was not exhibited in Russia and I received no commissions until 1972 when some architect friends of mine intervened on my behalf. [This was probably the work he made for the main pavilion of the "Electro-72" exhibition held in Moscow.] I was also able to make a few large pieces when I was still in Russia. I made all of my works without pay. I was driven by pure energy. Was I harassed and persecuted? Yes, I was. A few times I was in some very dangerous situations. On one occasion the police put out some lies that I was involved in military espionage. I had to undergo an interrogation and so did my friends. I was also investigated about some currency operations at the Lefort Prison. Even after I had left

[1] John Berger, *Art and Revolution* (New York: Pantheon Books, 1969), 79–86.

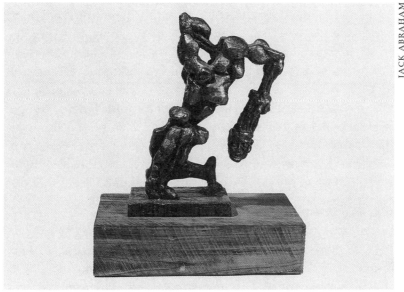

Ernst Neizvestny, *Bertran de Born*, metal on wooden base,
29 x 21.5 x 9.5 cm.

Russia, under Brezhnev, the authorities tried to sully my name.
They dreamed up a story about a murder in my studio. They
called in all my friends on that one, too. But it was all hot air. My
friends did not sell me out. Nobody would agree to lie. Recently,
Russian television began a series of reports on KGB investigations.
One was on the intelligentsia called "The KGB and the Intelligen-
tsia." It told how they hunted people like Rostropovich and my-
self.

RB: *How were you able to leave Russia in 1975?*
ЭН: I never wanted to leave permanently. I applied for a two-year
leave about sixty times because I had so many exhibitions of my
work abroad. I also had commissions for religious pieces—crosses
for churches. I was able to get works out by illegal means. Foreign-
ers took pieces with them. All the artists had to do this. Besides,
after John Berger's book came out I became well known. In an
international competition to illustrate Dante in 1965, I won first
prize over Dali and Rauschenberg. [Probably the illustrations for
Dante's *Short Works* (Moscow, Nauka, 1968).] Still, I could not get

permission to leave. In the end the authorities promised that I could leave for two years with a Soviet passport, but they deceived me. Then, I really began to behave as a dissident. I would give interviews in which I would say why I thought Brezhnev and Podgorny were fools. Then the KGB told me that I could leave on a Jewish passport. Still, they wouldn't let me out. Finally, people like Henry Moore, the sculptor, saved me. He organized a committee to protect me. Ted Kennedy and other Democrats supported me. Kosygin was petitioned directly, and they finally let me out. But all of my family and friends remained in Russia.

RB: *You were already a mature artist when you left Russia. Have there been any significant changes since then?*
ЭH: Yes and no. My basic philosophy has not changed at all. I am working on a "Tree of Life," which is my life's work. Some of its elements have changed. Larger elements have grown smaller and vice versa, but, philosophically I am the same. Technically, things have changed because of the availability of materials. Let me tell you my views. I was an avant gardist when I began to work as an artist. During my first years at the Surikov I befriended Tatlin. I made purely constructivist works as a result. Gradually, I pulled away because I grew disenchanted with its Fabian socialist overtones. I became disappointed with technical progress as an answer or remedy for the human condition. At the same time I understood that technology was permeating our lives and had become a part of them. Since I was wounded several times in the war, the idea of how metal enters a person was important to me. As a result, I began to make ambivalent geological sculptures, part metal and part human. I took advantage of the avant garde, but never moved away from the figurative. So, my true spiritual fathers became Malevich and Kandinsky. They seemed to progress from the human to the abstract to the machinelike or mechanical. Then, I went to a different level in my progression by going from the mechanical back to the human. In this way I combine elements of constructivism with the fundamental problems of man's spiritual life and between one's spiritual life and the body. I would like to say that I am trying to combine constructivist ideas with psycho-

logical and philosophical elements. I also like St. Augustine and respond to his philosophy.

RB: *When did you first see modern Western art?*

ЭH: The notion that we Russians are barbarians is simply not true. I studied Russian avant-garde art when I was a student and also when we started our underground group. I certainly did not have the option of seeing the efforts of the last sixty years of Western modernism, but I did see a lot. Also, what I call the heroic 1960s in the West did have an impact and left its imprint on my consciousness. When students at the Sorbonne rioted in 1968, I was one of their five idols. Their slogans and their pamphlets were my works. But about what we knew in Russia? If you look at the last half-century of Russian activities, it might appear, on a super-ficial level, that we did not know anything past the 1920s. This is not true. Let me make an analogy to German expressionism in the time of Hitler. Artists who worked as German expressionists did have some knowledge of abstract art and of the Bauhaus style, but they could not study or produce purely formal works. So their works seemed old-fashioned when compared to works in other European countries. A similar thing happened to me. Although my inner spiritual needs did not prompt me to work with pure form, I was, nevertheless, concerned with formalist problems. I was steeped in Russian avant-garde art. Within the context of my life, however, and the struggles of my soul, I no longer trusted Fabian socialism. I kept coming back to spiritual needs, to the needs of the human soul. It is not that I ignored notions of artistic progress, but that my aim was to say something about the funda-mental problems of the human race.

RB: *In order to work out your ideas, did you have problems obtaining materials?*

ЭH: Yes, big problems. I used scrap materials. I also had to cast rough in my studio because of the lack of adequate technology. I also made lots of drawings because I often had no paint.

RB: *Even though you were a member of the union?*

ЭH: Yes. When I was still a young student, an honor student, the

Tretiakov Gallery bought my work. I had a lot of prestige. I joined the union when I was still a student. But I was kicked out three times. I just didn't like socialist realism—which is a mistake, not a style.

RB: *Did you take part in the Bulldozer exhibition in 1974?*
ЭH: No. I will tell you why. It is my belief, and not only mine, that when I had the confrontation with Khrushchev at the Manezh exhibition in 1962, it was the result of a provocation. We were used for some other purpose—not just to argue art with Khrushchev. The provocation did not succeed, thanks to the fact that I found the strength to tell Khrushchev the truth. The Bulldozer exhibition was also a political provocation. I saw it this way. There were tensions between the militia and the KGB. The KGB wanted to organize an exhibition to show the militia as well as the Moscow bureaucrats to be barbarians. So they invited artists to show their works, knowing that these would be cut to shreds by bulldozers. It was a set up, the whole thing. I was invited but did not want to participate. But I will say that the artists were heroes and so were the organizers, Oskar Rabin and Alexander Glezer. Others who were very young were less involved.

RB: *Did you take part in apartment exhibitions?*
ЭH: Yes. For the most part these were held in the apartments and institutes of scholar and scientist friends. Many people came to those shows.

RB: *Could you sell anything during those years?*
ЭH: In my time I did not have this option. But after I left many people were able to sell their works. Only George Costakis bought my work when I was a student. He was my first buyer. I met Norton Dodge in Russia, I believe. I think I just gave him works for free, but he also bought something.

RB: *You said that you were a loner. Did you have many friends?*
ЭH: When I began I was very much alone spiritually. People who were around me in the 1960s like Yankilevsky and Kabakov were much, much, younger than I was. Now, the age difference doesn't

matter. And I was not close to the younger people who were involved with *A-Ya*, the magazine published in Paris. But I also had friends who were philosophers, and people like Pasternak and Shostakovich were in my circle.

RB: *Do you maintain ties to Russia, now?*

ЭH: It is important to do so, even if you don't want to. Now that I have commissions for monuments, I certainly have ties there.

I am becoming increasingly important for Russia because I am an artist and because my biography gives authenticity to a certain part of the intellectual elite who consider me as a symbol.

Lydia Masterkova
Лидия Мастеркова

Born in Moscow, 1927; Moscow Secondary Art School, 1943–1946; Moscow Art College, 1946–1950; part of Lianozovo group in the late 1950s; left Russia in 1976 and lives in Saint-Laurent sur Othain in northeastern France.

Works in a nonrepresentational manner.

RB: *When did you first see Western art?*

ЛМ: In 1948. Museums were closed during the war. There had been a museum in the former Sergei Shchukin residence which housed a collection of modern French art, but it, too, was closed during the war. But I saw many reproductions and books published from that collection. So it was possible to see material this way rather than the actual paintings.

RB: *What about the schools you went to?*

ЛМ: My teachers at the Moscow Secondary Art School were fantastic artists and were very close to the students. The teachers, like Mikhail Semenovich Petrutsky and Aleksandr Kuprin, who became a Soviet man [one who sided with the government], also belonged to an organization called Knife. This was in the late 1920s. Generally nobody bothered them or arrested them. A wonderful person named Nina Nikolaevna Hofman opened a special art school which was soon shut down for its leftist inclinations and was merged with the In Memory of 1905 Art School. But I was not

influenced by any of the teachers. I listened but remained my own person.

RB: *What styles did your teachers paint in?*
JM: Petrutsky painted in a postimpressionist manner, but the artists' union cleared out all formalists.

RB: *Do you feel that your work is a continuation of the styles of the 1920s?*
JM: I don't think so. I love that period. It is astonishing that artists of that caliber should have appeared in Russia—like a flock of swans descending on a strange land. Their timing was interesting. Before the revolution the bourgeoisie would not have accepted them, but they arrived in a chaotic time, the 1920s, and their voices were very loud and clear, and they were heard—unlike the French impressionists and postimpressionists in their day.

RB: *Did you exhibit in Russia?*
JM: My first show was in 1961 in a private residence in Moscow. George Costakis, the collector, made a purchase from that show. By that time I was working in an abstract manner. It was one of the first apartment exhibitions. Many foreigners came as well as musicians and literary people. We were able to sell to the foreigners who would contact us when they were in Moscow. There were diplomats, journalists, French people of Russian origin, and Americans who were very nice.

RB: *Did the government bother you?*
JM: I lived with my family in a communal apartment on Gorky Street, and I can tell you that the authorities weren't fond of us. Vladimir Nemukhin [to whom Masterkova was married at the time] also lived there. We were called The Nest of Abstractionists. As an artist I am interested in abstract representation of human situations. Let's say I do a work called "Composition with a Parachute." The meaning is in what lies under the parachute. Who is the person under there and why is he unable to free himself?

RB: *So in your work there is a poetic imagination at work; not just lines, shapes, and colors.*
JM: Definitely so. I am an artist, after all.

RB: *Tell me about the Lianozovo group?*

JIM: We got together in 1956 or 1957. Vladimir Nemukhin and I usually worked in the spring and made enough money to last through the summer. We stayed at Nemukhin's house in Priluki, a town about 100 kilometers from Moscow. Eventually we met Evgenii Kropivnitsky and Oskar Rabin who lived in Lianozovo with his wife Valentina Kropivnitskaia and her brother, the artist Lev Kropivnitsky. We were all good friends, even if our art was different. We lived in Moscow during the winter and would get together at Rabin's place because our place was so small and because Rabin knew many foreigners.

RB: *When did you turn to abstract painting?*

JIM: In 1955 I experienced a crisis. I liked realistic painting since form by itself did not speak to me. I loved painting portraits. Then, suddenly, I felt the need to change and began to develop my abstract style. This was possible during the Khrushchev Thaw. It had been unthinkable under Stalin. By the time of the exhibition of American art in the late 1950s [the International Youth Festival in Moscow in 1957], I had already begun to work in a semi-abstract manner. I worked in the constructivist manner of the Russian avant garde of the 1920s. We were somewhat familiar with those works, and the foreign exhibitions allowed us to think of the Russian avant garde as our springboard and to work along those lines, but not in imitation of them. I had seen some of their paintings in the vaults at the Tretiakov Gallery.

RB: *How did you get into them?*

JIM: A Russian collector, Evgenii Nutovich, worked there, I think. Anyway, we got a pass and I saw a stupendous painting by Kandinsky there. I had already read something about these works. Nemukhin's teacher, Petr Efimovich Sokolov, had been a student of Malevich. But we didn't imitate the 1920s artists. We needed to go our own way. Some time after, I met an artist named Ivan Kudriashev, who was a Malevich student and painted abstractly. He was later forbidden to paint abstract pictures and, eventually, was forbidden to paint at all. But he did make some abstract surrealist works. Once when I was visiting him and his wife, the

KGB knocked. The Kudriashevs shouted out that they knew the KGB men were armed but that they would not open the door. It was brave of them.

RB: *Were you a member of the union?*
JIM: No, and no one in our group belonged. I know that Oskar Rabin tried to join, but was not admitted. I never tried. I had no use for the union. Nemukhin did show and sell works through the GORKOM, but he was never a member of the union.

RB: *How did you get supplies?*
JIM: If you bribed somebody you could walk into an art supply store and you wouldn't be bothered.

RB: *How did you earn a living? and were you ever called a parasite?*
JIM: When I was in my twenties I got a job painting posters for the air force. An acquaintance arranged this for me, but I left soon after and worked in a school painting announcements and things like that. In fact, I was called a parasite twice and was once summoned to the local police station—not to the KGB. Somebody must have informed on me. But the fact was that at that time I had an agreement with an organization to do some work at the end of the year, which would allow me to live for several months without working. We painted the interior of the organization's building, which was in a modernistic style. So we made abstract forms against a white background. Nobody quite knew what we were up to. Nemukhin worked as an editor of a magazine called *Iskatel* [*The Searcher*]. The editor-in-chief, a man named Vladimir Chernetsov, surrounded himself with good artists. And since they all worked hard, the government did not bother them.

RB: *Did you participate in the Manezh exhibition in 1962?*
JIM: No. It was Beliutin's group. We looked upon the whole event as a comedy, a farce. Khrushchev had a big mouth, and when he was in America he acted like a thug.

RB: *Did you exhibit before the Bulldozer exhibition in 1974?*
JIM: Years before that, in 1967, Alexander Glezer helped organize a show of about twelve artists, including Rabin and Valentina, and Evgenii Kropivnitsky, Nemukhin, and Dmitri Plavinsky, that took

place on a highway. The KGB closed the exhibition down in half an hour, loaded us and our works on trucks, and took us to our homes. The authorities did not know how to react to an open exhibition that they didn't know about.

RB: *In retrospect, how do you feel about the Bulldozer and Izmailovsky shows?*
JIM: I showed works in both places. Both were incredible events. I will tell you that had Nemukhin not gone to the first show, it would not have taken place because Rabin would not have dared to go alone. The initial group was Rabin, Nemukhin, me, Evgenii Rukhin, and Nadia Elskaia. The idea for the show was an old one and dates back to when we lived in the country. It was Rabin's idea, originally, to have a show somewhere, anywhere, since we couldn't exhibit our work at all. That is how the idea of an open-air exhibition took root. When we decided to show, I was the first to get up the slight hill where the exhibition took place. I was covered by a tripod. Suddenly I saw a lot of people there who turned out to be artists, and they remained in the area overnight, sleeping in the bushes. We dispersed in two groups, in case the police decided to come after us. In the morning we all went to the field. I felt no fear at all at that point. Then, suddenly, I saw the authorities taking down the paintings. I continued to walk toward them without stumbling. I didn't understand how this could happen. God must have been watching over me because I spoke up and did what I wanted to do and nobody bothered me. About the show at Izmailovsky Park, more than fifteen thousand people came. The police were afraid to touch us at that point. The Russian people have an enormous interest in art and asked us many questions. We had to explain just what we were doing since they hadn't seen anything like that before. People in the West live without art, but Russians are receptive even to new art. They enjoyed the show so much and were so curious.

RB: *Did the KGB get to you after the shows?*
JIM: Yes, they called me and wanted to make certain I worked someplace. They accused me of parasitism. And as soon as was possible afterward, I left Russia. I was able to leave on an Israeli visa even though I am not Jewish, although I think one of my

grandmothers was Jewish. [If the government wanted a person to leave, it could invent a relative who was Jewish.] The authorities did not try to stop me. I wasn't interested in politics, and maybe they didn't like my paintings. When I got to Vienna I applied for a French visa in order to visit some people and got one without any fuss.

RB: *How did you manage after coming to France?*
ЛM: Norton Dodge was a great help as was the Tolstoy Founda-tion. There was also some French funding. But the money was minimal, barely enough to live on. So I moved to the country where I live now. But I was totally unprepared for life in the West. I had no idea about it. I thought you could rent an apartment for a few dollars and just feel free. In addition, nobody took an interest in me in France. In Russia everybody knew me, and I was treated gently. So I really escaped into my work. I no longer had a supportive group.

RB: *How did you feel as a woman artist?*
ЛM: I felt that I was first and not last, that I didn't come after the men, and that nobody could stop me. But I was never interested in such categories as feminist artists, although, I imagine that I had, and still have, some feminist characteristics. But most of all I feel that I am independent, that I don't need to have a label. I just don't care about such things.

RB: *Did you consider yourself a dissident?*
ЛM: There are many gradations. Some people who consider them-selves dissidents really aren't, especially those who came to the West. But we were real dissidents because we dared, despite our fears, to go against the flow of things. We didn't see ourselves as heroic in going against socialist realism; it was just something we had to do. It was a sad and an unstable time in Russia just before I left. Everybody wanted to be a success and live the good life. In the past people left Russia to pursue their art, but no longer.

It was shameful.

★

Boris Sveshnikov
Борис Свешников

Born in Moscow, 1927; began to study at Moscow Institute of Decorative and Applied Art, 1946; in prison camps, 1946–1954.

Style of painting is fantastic realism.

RB: *Did you ever belong to a group of like-minded friends?*
БС: I never belonged to any dissident group. I was raised by the Soviet government in prison cells, in solitary confinement. I remain independent and solitary. I did not affiliate with or join any groups. My art is similarly independent and solitary.

RB: *Why were you sent to prison?*
БС: This is a rather absurd question—why was I sent to prison—because there is no logic in this country. This country functioned on laws of the absurd rather than on logic. I was sent to prison when I was barely nineteen years old. At the beginning I was accused of terrorist activities. Later on, they accused me of "Point 10," something that warranted my deportation to hard-labor camps where I served for eight years until the end of Stalin's era, until his death in 1953. I was freed in 1954. This is my whole story. I've been painting since early childhood. Painting is not only my profession, it is my life. This is how I live, how I breath. I painted while I was in a labor camp, which was rather unusual because it was forbidden.

RB: *Was there something in your early work that disturbed the authorities?*

БС: No, not that. There was a group of people who were arrested, and then the authorities came after me and arrested me. Probably, somebody denounced me or said something. This was enough— that a person could utter a word against you—to be arrested and sent away for a long time.

RB: *How were you able to get art supplies in a labor camp?*

БС: At the beginning, from 1947 to 1949, I worked at hard labor somewhere in the north. I worked at felling trees and digging foundations for gas and oil rigs and oil pipelines. Later on, some people who were concerned for me, people who were free and outside prison, arranged for my transfer to a larger labor camp where there was an art studio. Besides myself there were three other inmates who were busy copying famous masterpieces. These were forgeries. I certainly could not join these persons nor engage in such activities. I could never be a forger. So I obtained a night watchman's position. I was the custodian, the night guard of the art workshop. I would go there and work in the studio all night long. This activity took place from the end of 1949 to the end of 1954. This job saved my life. I owe my survival to it. Had I remained at hard labor, I would never have come out alive. I could not have made it.

RB: *Did anybody see your works then?*

БС: Of course not. Nobody ever saw them. It was nobody's business. I painted for myself.

RB: *Those people who were concerned for you, did they visit you? Did they have the opportunity and the means to travel?*

БС: Only my parents came to see me. They would come once a year, which is all that was allowed. But the person who did something on my behalf, the person who had some power to intervene on my behalf, had me transferred from the hard-labor camp. One had to be clever to arrange such things. He was an old-time prisoner who had been in the same camps as I was. He was a scientist, the husband of an acquaintance of mine, an artist, a

middle-aged woman. He went to prison when he was already an old man. He died shortly after he was released.

RB: *Were you able to give your parents your work when they visited you?*
БС: Yes. This was not unusual. They were able to take my work with them.

RB: *What did they do with your paintings? Did they show or give them to friends?*
БС: No, no, no. They hid everything until I was released, and once I was freed I had everything with me.

RB: *After your release, did you show your paintings or have an exhibition?*
БС: I had no exhibitions. Nobody saw my work. I needed a job to earn a living. I brought some of my drawings to some art publishers, drawings done at the labor camp. I was immediately given work as a book illustrator and remained in this field until I retired and received a pension. What I painted at home I did for myself. At times, somebody would buy a painting. These moments were like dividends for my existence.

RB: *Who were the buyers—Russians or foreigners?*
БС: Foreigners, French people from the French embassy for the most part. Some from Italy as well. Most of my works are in France, but I'm not certain just where. Not long ago an English publisher became interested in my labor-camp drawings and wanted to publish an album of them. My work began to be exhibited in the West during the 1970s, particularly in shows arranged by Alexander Glezer. But I have never traveled in the West.

RB: *How did your viewers find your work?*
БС: You know, I never bothered to find out nor was I interested. I am entirely indifferent.

RB: *Have your style and subject matter changed over the years?*
БС: I believe there have been changes. After all, I am not a machine, but a living organism who changes and evolves. There is always a development. Every artist should go through several phases if he is not just a drone, but a living person.

RB: *Did you make friends after prison?*
БС: I never belonged to a circle of friends. I was always solitary. That is how I have lived.

RB: *Can you tell me about your philosophy of art?*
БС: From childhood I studied European culture especially the middle ages and later centuries. I am fascinated by romanticism and have studied its art and Russian translations of its literature and poetry. I've illustrated many books of German Romantic prose and poetry—Goethe, Heinrich von Kleist, E.T.A. Hoffmann. I really have no interest in the modern periods of art, and I believe that in the twentieth century culture came to an end. We live in a civilization that has no relationship to culture. These two terms are at opposite ends of a spectrum.

RB: *What about the art of the 1920s?*
БС: I do not recognize either modernist art or socialist realism, which are indigenous to Russia. They are all the same to me.

RB: *Did you know about the Manezh exhibition?*
БС: I was not invited to participate.

RB: *Did you think of yourself as an official or an unofficial artist, perhaps an underground artist?*
БС: You know, I was never part of a social group. I was never underground or above ground. All of this is amusing to me. I tell you that once I was liberated my only alternative and goal was just to live and work. In 1956 I got a job as an illustrator. In 1957 I was admitted to the artists' union even though I did nothing to get in. The head of the art department at the publishing house decided on his own initiative to submit me as a candidate, and I was accepted. I have not been harassed since.

Just the same, all of my works are dedicated to the grave.

★

Oskar Rabin
Оскар Рабин

Born in Moscow, 1928; studied at the Academy of Arts, Riga, Latvia; studied at, and was expelled from, the Surikov Art Institute, Moscow; a founder of the dissident group of Lianozovo in the late 1950s; has lived in Paris since 1978.

Paints in a style best described as expressionist realism.

RB: *You were the first organizer of dissident artists during the 1950s.*
OP: This statement is not accurate because there is no "first artist" who did that. Everything happened spontaneously. There was a slight easing after Stalin's death, a slight increase in freedom. As a result, a new group of artists appeared who began to paint and think in new ways. We suddenly had new viewers as well. All of this happened in different parts of the Soviet Union. That is why I cannot take all of the credit for what I did.

RB: *But together with Lydia Masterkova you did organize the Lianozovo Group.*
OP: It became known as a group later on. When we first began to meet, it was to socialize, to share commonly held ideas. Our cultural and artistic interests coincided. At first we never thought of calling ourselves a group. Artists would come to visit us in Lianozovo or we would visit them. It was really a group that wanted to socialize, to talk, and to show each other our work.

RB: *Did you discuss politics?*

OP: We did not speak about the political situation. Our talk was more general. After all, Stalin had just died, and we did not gain that much freedom under Khrushchev. We spoke about our experiences, our suffering. We probably thought about the situation more than we spoke about it. As artists we could engage in action only through our pictures.

RB: *What, then, is your definition of a nonconformist or an unofficial artist?*

OP: For me even unofficial art meant that, as artists, we could never be entirely free, either from our viewers or from our buyers. An artist can never be free in the full sense of the word. In my view, the worst example of nonfreedom is when a government becomes involved in art and becomes the patron of art, the supporter of artists. In a free situation, there is the possibility of choice. The artist can make what he wants; the buyer can buy what he wants. What matters is the freedom of choice. When the government gets involved, there are no alternative possibilities. If you don't comply, you are considered worthless, and you will become the object of abuse. As for the word "dissident," it is a person who chooses to think differently from the norm and from the government, which oppresses him.

RB: *Did you have anything to do with the Manezh exhibition in 1962?*

OP: I had no role in it, but in our small circle we knew everything that was going on. The truth is that only official artists participated in the show. But, because of the thaw, some artists who had never exhibited before were allowed to show. Elii Beliutin and his group were exhibited there, but the public was not allowed to see their works. Only the officials and Khrushchev, who came and scolded and swore at everybody. I can't even say that Beliutin and his group were a part of the exhibition because their work was in a closed off section. Ernst Neizvestny, for some reason, also showed his work there, although, he was an official member of the union. My friends, including Vladimir Nemukhin, Lydia Masterkova, and Dmitri Plavinsky, did not belong to any union, nor could we

be admitted because of the work we did. Even if we had been invited to exhibit at the Manezh, nobody would have spoken to us. So, from my point of view, there is not much to say about the exhibition.

RB: *You were never a member of the union and you always painted unofficial works. Correct?*
OP: Generally speaking, yes.

RB: *How did you earn a living?*
OP: In the mid-1950s, when it all started, I worked at a variety of jobs that had no connection to art. I painted only when I had free time. I was a porter and unloaded cargo at a train station. I worked in construction. Things eased after a while. Buyers, mostly foreigners who lived in Moscow, began to appear.

RB: *Did you socialize with them?*
OP: At first infrequently. Then the diplomats, especially, began to invite us to their affairs.

RB: *Mikhail Chemiakin has said that it was easier to be an unofficial artist in Moscow because of the number of foreign correspondents and diplomats there. If anything would have happened to you, these people could have brought pressure to bear on the government. They were a kind of protection.*
OP: That's true. It was easier in Moscow than in Leningrad. The authorities did not need or want unnecessary scandals. As things went, we were not a major source of evil for the government.

RB: *What about the Bulldozer show in 1974?*
OP: For a long time there was talk about such an exhibition. We understood that the authorities would never give us space, since, generally speaking, they did not want us ever to show our pictures. That is why the idea of an open-air show took hold. We thought that such a show would be like showing pictures at home. You simply would go on the street and show your pictures. A lot of people took part in the exhibition, people who are now forgotten. For instance, Evgenii Rukhin was very active. He was from

Leningrad but considered himself a Muscovite. Without his presence the event would not have turned out as well as it did. He spoke English and actively sought out diplomats and correspondents. Nadezhda Elskaia, who died as a result of the event, should also be remembered. Yuri Zharkikh, who now lives in Paris, was also very active. Of course, Komar and Melamid were also very active.

RB: *What happened after the event?*

OP: The authorities bothered almost everybody after the Bulldozer show. The scandal was enormous; the government was very embarrassed by it. So two weeks later, they allowed us—for the first time officially—to hold a show in the Izmailovsky Park. For four hours we were able freely to show our pictures. Anybody who wanted to could show his pictures. But many artists were frightened and refused to exhibit. The authorities, of course, were as unpleasant as they could be. They tried to frighten us so that we would never do anything like that again. Some were called to appear before the militia.

RB: *Were you summoned?*

OP: No. For the most part, they did not touch me. The KGB kept telling us to ask them for help, that we should run our activities through them. The truth is that we could never get anywhere with them. Certain elements within the KGB might not have objected to the Bulldozer and Izmailovsky exhibitions, but the artists' union was always opposed to us. The only way to get permission to show our paintings was to make constant demands, since we hoped the KGB would no longer want to put artists in jail and, thus, have a potential scandal on their hands. Knowing that we were not well organized, they reactivated the GORKOM, which had been in existence before. The GORKOM admitted book illustrators so that they could be accounted for, and many of us at one time or another illustrated books. The GORKOM guaranteed some commissions to its members, something which the union refused to do. And artists hoped that some day they might obtain membership in the union through the GORKOM.

RB: *All of this occurred after the Bulldozer show?*

OP: Really after the Izmailovsky show, which took place a few weeks later. Artists were promised official standing, that they would be admitted to the union, and that they would have shows. The only condition was that they should not try to organize shows on their own, that it was essential that the authorities alone do the organizing. The KGB promised all sorts of good things if we would comply. Most artists wanted to believe the KGB because nobody wanted to enter into a serious battle with them because, in the end, we were all dependent on them.

RB: *Were you ever arrested?*

OP: I was once arrested for two or three days. In Russia we did not consider such a brief time as an arrest. We called it "being detained." Even if you were sitting in a cell, it was not considered an arrest. Anyway, there was lots of pressure on me, and it was very oppressive. They tried to frighten and intimidate my wife, my son, and me in every possible way. Now, it is very difficult to remember the past, but I can say that it was very frightening. They could do whatever they wanted.

RB: *Can you give me any examples?*

OP: They threatened my son. Skinheads would come up to him on the street and threaten to beat him up, or maim him, or even kill him if I didn't stop my activities. There would also be phone calls—disgusting, endless phone calls—from different people saying that they could arrange to hurt my family. That is how it went. They acted like children playing pranks. They tried to make me feel guilty for forcing them to carry out their threats, that it would have been my fault entirely. All of this took a toll on me. It got on my nerves. These were the standard methods of intimidation used on everybody, not just artists. On everyone, including writers and all dissidents, on everyone they wanted to scare. I was no exception.

RB: *It was a form of terror.*

OP: True, but in actuality they never beat me up. Just the same, it was difficult.

RB: *Were there searches?*
OP: No.

RB: *When did you first see works by the Russian avant garde of the 1920s?*
OP: When I first met my teacher Evgenii Kropivnitsky, my wife's father. He had works at his place. This was in the early 1950s. Later on, I came on books from the West. It was also possible, through friends, to arrange trips to the vaults of the Tretiakov Gallery.

RB: *Could you see any Matisses at the Pushkin Museum?*
OP: Not as long as Stalin was alive. Nothing of that sort. The only paintings there were gifts given to Stalin, birthday gifts, that sort of thing. Only under Khrushchev did impressionist and fauvist paintings appear.

RB: *How did you respond to both Western and Russian avant-garde art?*
OP: I believe, although it might not seem so, that I was not influenced by any of this. Avant-garde art is based on a different set of principles and ideas from my own. I don't concern myself with revolutionary ideas or ideas about the common good that you find in Russian avant-garde art. There is nothing of that sort in my work, no themes that are concerned with the common good of humanity or of revolution. I am interested in my personal experiences, my individual lyricism. At times I can also paint from a feeling of indignation or a reaction to something that happened to me directly. I have no utopian ideas about the future of mankind or any of the programmatic aspects you find in the Russian avant garde about the working class or about bourgeois society. They worked to help form a new society in their art, architecture, and applied arts. I've never been involved with that.

RB: *You often paint images of the city. Are there any particular meanings attached to that?*
OP: True, I always painted the city, but not exclusively. Right now I am painting portraits of artists who participated in the

movement with us. One work is really a requiem for those who have died.

RB: *Have you been to Russia recently?*
OP: In 1993. It was my first trip back. I went as a French citizen. When I returned, I made a painting about it and included my visa in it.

RB: *I notice that you included the word* Evrei *[Jew] in your visa in the painting.*
OP: I made that up.

RB: *Did you experience anti-Semitism in Russia?*
OP: None at all. I can't say that the authorities were particularly repressive because I am Jewish. I never had aspirations of reaching a position in which Jews were not allowed. As a porter unloading freight cars, nobody envied my position. Nobody was after a Jew who worked on the railroad. But I did experience anti-Semitism all of the time, in everyday life from average people. On a train or a trolley, say, somebody would sit next to me and start annoying me. Maybe it could be a drunk who would call me a kike. But among the intelligentsia there was no anti Semitism.

RB: *There were Jewish artists who painted Jewish themes even though they knew these were forbidden.*
OP: Such paintings were not forbidden. You could paint at home and nobody could stop you. Perhaps these artists wanted to exhibit these works. That, of course, was not allowed.

RB: *Since you were never a member of the artists' union, where did you paint? and how did you get supplies?*
OP: I never had a studio. I worked at home instead. Getting supplies was difficult. You couldn't buy everything on the open market, so friends who were members got me things at the proper stores. I would go with them and they would buy things in their names. Somehow I was able to get everything I needed. But the main problems were the inability to exhibit openly, the inability to sell our works officially, and having to earn a living doing some-

thing else. As you know, we had to work or else be accused of parasitism. When I was listed with the GORKOM, I worked as an illustrator. I did this, not out of necessity, because I was already selling my work through private channels, but because I wanted to stay on the list of workers. That way nobody would annoy me. But both before and, especially, after the Bulldozer show, they did bother me. That's because after the Bulldozer and Izmailovsky shows, some artists complied with the authorities. Others did not and demanded greater freedom. I was one of those, part of the group that would not yield. We made demands, wrote letters, complained to foreign correspondents.

RB: *How far up the line could you get?*
OP: We could not get to the minister of culture, but we did reach his representatives who wanted to negotiate with us but give us as little as possible. We held out and began to hold apartment shows. I had some in my apartment. These took place in seven different apartments. In each apartment artists signed a list to exhibit, and artists acted as hosts in most of the apartments. The viewers were sophisticated people for whom art mattered a great deal. Scientists also came to look, and on occasion they would organize shows at their institutes. In Leningrad a scientist named Kazarinov had an exhibition in his apartment. He was promptly banished from his position at an academy for physics and was forced to leave Russia. On one occasion I so outraged the authorities that I was dismissed from the GORKOM. That is when I became a parasite. The police then began to summon me. I had to pass some medical tests. There were many threats. They made it seem as though I would be exiled from Moscow. In fact they exiled me to Paris in 1978. They told us to leave. So we left to visit western Europe. We left Russia as tourists and were not allowed to return. We thought that they might do such a thing, but we had hoped that they would not. It had been years since the government had taken away citizenship from people. We thought that their policy had softened. We were seeing this new phase actually happen. Surely they wouldn't deny citizenship to their own people. But the

year we were away they renewed their old practices. I was not alone in losing my citizenship. This is literally how it happened. After living in Paris for half a year they called us to the consulate. When we entered we handed over our passports. They simply didn't give them back. Instead, they read an edict that deprived us of our citizenship. And that was that. All of our belongings remained in Moscow.

RB: *What went through your mind then?*
OP: Well, it was a very difficult time to be in a strange country, unable to speak the language. On the other hand, our discomfort was eased by the number of friends we had here in Paris. Yet, when you are fifty years old and find yourself in a new place with basically nothing, you feel empty. Also, nothing was familiar in Paris, whereas everything had been familiar in Russia—my experiences, my art, the suffering I had endured. I was familiar with all of this. In Paris I knew only the surfaces, not the subtexts. I had no deep understanding of anything. How could I translate any of this into my paintings? The problems were enormous.

RB: *Is one's native culture important for an artist's sense of creativity?*
OP: Yes, I believe so. That does not mean one should stay in the same place. But Russian culture and the Russian language were a part of my life from childhood. And you know this for your entire life. And then to have it all cut off, suddenly, is really hard. Now, however, I can say that French culture has simply become an extension of my Russian culture.

RB: *Did you get your citizenship back after perestroika?*
OP: Yes, but it was at the very end of Gorbachev's time.

RB: *I know you were no longer in Russia at the time of the Sotheby's auction in 1988, but what are your thoughts on that event?*
OP: It was part of Gorbachev's perestroika. It fit in with his plans. You know, despite the hard times under Stalin, Khrushchev, and Brezhnev, artists did have some leeway, a bit more freedom than other people. We could sell to foreigners, have little exhibitions. After perestroika, artists immediately benefitted. We could do

what we wanted. True, the government then stepped in to sell our pictures like at the auction. Prices were inflated, and such a thing never happened again. The event was self-serving, or, I should say, served the purposes of perestroika. It showed the world that auctions could exist in Russia, that perestroika operated on the cultural level as well as the political.

RB: *Before you were thrown out of the country, in effect, did you meet with artists from Leningrad?*
OP: Thanks to Evgenii Rukhin, who died in a fire in his studio, and to Yuri Zharkikh, we did meet artists from Leningrad. And when they followed our example by holding exhibitions, we had many contacts with them.

RB: *Were there differences between the art of both cities?*
OP: I never understood the division people made between the two cities. But I hear that the Leningrad artists understood the difference. They always speak about it, and they seem to know exactly what they are talking about. The same goes for literature and poetry. I think it is all an invention by Leningraders.

RB: *They say that they are deeper, more introspective.*
OP: Perhaps they think deeper means better.

RB: *When did you have your first solo exhibition?*
OP: In London in 1965. I, of course, was not permitted to attend. But I do have the catalogue. I had the show there because foreigners had begun to buy my pictures, particularly a gallery owner from London who came out to Lianozovo. But he did not buy directly, but rather through middlemen. One such person was Victor Loui, a journalist, who is now dead. He was a Soviet citizen who was jailed during Stalin's time. He was freed during a Khrushchev amnesty and got a job in the agency that provided foreigners with office help. Everybody thought that if you worked for that agency then you might be a KGB person. Who knows with Loui? Later he became a correspondent for American magazines. He began to deal in paintings and was able to travel to the West quite often. It was Loui who got my paintings to London. He

handled other artists as well. We weren't afraid of him because we reasoned that if he was able to get works out of the country then he must have been connected to the KGB or, probably, actually a member. Otherwise he would have been arrested. Many foreigners bought works, too. They did not have too much trouble getting them out of the country, even if it was illegal. The authorities would search a particular diplomat if they didn't like him and confiscate what ever they wanted. At times diplomats would be kicked out of the country, but not because of buying paintings. Sometimes the diplomat or the correspondent would be all right, but a problem existed with that person's home country. So there might be a problem at the border. But usually there were no difficulties.

RB: *Who were your viewers in Moscow?*
OP: All kinds of people. Some were prepared for my work and some weren't. There were lots of quarrels, and those who had no idea what I was up to asked endless questions. Others came who might not understand what they saw but liked the idea that we, the artists, were doing something the authorities did not like. For that alone, they were sympathetic. And then there were those who were sent purposely by the authorities to incite and to cause scandals. This was not unusual. We knew what was going on and tried not to respond.

RB: *Has your art changed since leaving Russia?*
OP: Not in any fundamental way, but something is always happening. On the other hand, I have not really begun to paint large-scale works as others have, except on one occasion when I was commissioned to do so for an exhibition.

RB: *You occupy an important position in the history of modern Russian art as a major early unofficial artist who was also an organizer of artists. How do you feel about all of this?*
OP: It is hard to judge because it depends upon who thinks so. Some recent books and catalogues don't even allude to your question. I would also say that young people and even older

artists now hang around Kabakov. He is now the leader and has forgotten all of his old friends. He has pushed them aside. His kind of art is what people seem to want. In a recent exhibition in Cologne the reaction seemed to be that we had been a provincial development, not at all interesting, something transitory. The current thought is that there was the avant garde of the 1920s and then, suddenly, conceptual art and installations appeared. Our art seems to have gotten lost, gotten old, and died. But it did serve as a springboard.

RB: *I believe that your generation of artists is important historically and that you, in particular, were very heroic to make nonconformist art.*
OP: That is true, but you know everything passes and that, ultimately, it is not so important.

What is important is the result.

Leonid Lamm
Леонид Ламм

Born in Moscow, 1928; Moscow Architecture Institute, 1944–1947; Moscow Institute of Graphic Arts, 1949–1954; Soviet prisons and labor camp, 1973–1976; immigrated to United States, 1982.

Has created figurative and non-objective works, some of the latter are constructivist in style. Has also worked with Kabbalistic imagery.

RB: *Where did you study?*

ЛЛ: I studied at the Architecture Institute in the 1940s with Yakov Chernikhov, a major architect of the Russian avant garde. He opened my eyes to art, but more important, to the avant garde. He showed me reproductions of Malevich's work. I was expelled from school in 1947 because I was friendly with a group of people who called themselves The Poor Sybarites. They came from prominent families in Moscow and were students of mathematics at the Moscow university. They wrote letters that the government intercepted. Soon they were arrested and three of them were given five to eight years in prison. I was lucky not to be arrested, but I was expelled from the Architecture Institute even though I was not a member of the group—just friendly with them. I still have some constructivist drawings I made during this period even though I was told to destroy everything. After that, I worked as an architect

for different organizations. In 1949 I entered the Institute of Graphic Arts without telling anybody my history. I began as a correspondence-course student and after a year transferred to the regular school. There were some very fine teachers there—Andrei Goncharov and Aleksandr Rodchenko. After I finished at the Institute of Graphic Arts in 1954, I was sent to Saratov as the main artist of the Saratov Publishing House.

RB: *Who sent you?*

ЛЛ: The institute. After graduation we were obliged to accept assignments. So with my family I moved to Saratov. It was a difficult period for me. An apartment had been promised, but we did not get one. We returned to Moscow after a year, and I worked as an architect because I could not connect with a press or a publishing house.

RB: *Were you a member of the artists' union at this time?*

ЛЛ: No. I joined in 1964. I worked on my own a lot, but soon I began a career as an illustrator for publishing houses. By 1957, I also became friendly with some activist painters—Ullo Sooster, who had been discharged from a prison camp, and Yurii Sobolev. He had been jailed for dissident activities. He married a woman from Moscow who was also in the camp. This is why he was able to come to Moscow.

RB: *Were you part of an artists' group then?*

ЛЛ: Yes, we were very active, but more as friends rather than as a specific stylistic movement. Sobolev also graduated from the Institute of Graphic Arts, and Sooster graduated from the Tartusskii Art Institute in Tartu, Estonia. We were particularly impressed by the art at the International Youth Festival in 1957. In the same year an exhibition of book illustrations took place. This was at the beginning of Khrushchev's Thaw, and all of this was important because we could see points of view new to Russians, art that was not conformist, not orthodox. At that time, several artists came to know one another. We met frequently. I rented a studio with Sobolev, and Sooster lived a few blocks away. We drew from models, evaluated each other's works. I got to know Elii Beliutin

and his group. I never studied with him, however, because we had different opinions about art. But some of my friends did, like Vladimir Yankilevsky. In 1962 Beliutin exhibited work with his students. The authorities invited him to take part in the exhibition "Thirty Years of Moscow Art" at the Manezh.

RB: *Did you exhibit at the Manezh exhibition?*

ЛЛ: I did not participate even though Beliutin invited me to exhibit with his group. I still remembered my encounters with the authorities in the late 1940s. I also had some complications, that is, my father had some complications with the government. He was an engineer and was accused for some activity. I did not want to jeopardize his position and create more trouble for him. I knew participation could be dangerous. But Sobolev, Sooster, and Ernst Neizvestny showed there. The exhibition was horrendous. When Khrushchev visited the exhibition and called the artists terrible names, such as pederasts, hooligans, and thieves, it created a bad mood, an awful scene. Afterward, I met my friends and Sobolev said, "Guys, we can't sleep at our homes tonight. Everybody will be taken in." A bit later Sooster and I decided to join the USSR Union of Artists. We applied in 1962. I did it to legitimize my situation, because, as you know, one could not just live freely in the Soviet Union and make a living as an artist. You had to belong to something, to be assigned somewhere. I was accepted in 1964 with great difficulty, but not Sooster, since he had participated in the Manezh exhibition. The quality of his work made no difference to the authorities. Well, this was the basic situation at the time.

RB: *Nobody bothered you from the union?*

ЛЛ: I never showed the kind of works my teacher, Chernikhov, showed me—studies in pure form, constructionist-type pieces. I entered the union as an illustrator of books, not as a painter of pictures. Ilya Kabakov was also a member of the graphics section for book illustrators. Many joined this section—Yankilevsky later, but with difficulty. Nobody entered as a painter. Over the years I illustrated more than four hundred books. This allowed me to feed my family. I worked on my own art after I earned money. We

all did this—earn a living and then go to our studios to paint our own work. At the time I made constructivist works. I tried to find a common language in art that everybody could understand. But I guess it was infected with the same kind of utopian gibberish as that of the old Russian avant garde.

RB: *Did you see Western art?*

ЛЛ: I saw a lot in reproduction. I did see impressionist paintings, however, but I could not see any actual surrealist works. Only in reproduction. I could not see any abstract work. I frequented the international library, and even during the 1950s I was able to see some things there. We each tried to see whatever interested us. We searched, looked, and tried to find something that would speak to us. It was like living in an experimental laboratory. I searched for a form of expression and began to develop a great opposition to Malevich and the Russian avant garde. I opposed their utopian vision of the future. After all, I had had horrendous experiences with reality. And in terms of art, I found Malevich's squares were frozen in space and considered to be ideal. They also appear flat on the picture surface. But reality exists in space, and forms move in space. Things evolve. Abstract form is not flat. Malevich's forms look like graves. But, again, I never showed my abstract works to anybody. It could have been dangerous.

RB: *Did you participate in the Bulldozer exhibition in 1974?*

ЛЛ: Let me explain. In 1973 we decided to leave the Soviet Union on an Israeli visa. We applied for documents on November 30, 1973. I was arrested on December 18. The authorities staged a provocation on the street near my studio. A young woman came over to me on the street. Some voluntary patrol guards ran over to her and grabbed her and began to molest her. They began to shove me near her. I yelled out, "Guys, what are you doing?" They grabbed my umbrella and began to hit me with it. The girl ran away, so I did not have a single witness. I was dragged down to the police station. They beat me up and called me names—"Jew." "You're an artist?" "A Jew artist?" "Wait, we will paint something for you." They used the word *zhid*, which is the same as kike, and

other obscenities. They pushed and shoved me around. In the station there was a picture of Dzerzhinsky [Feliks Dzerzhinsky, founder of the Soviet secret police], and it fell down. They accused me of breaking his portrait, that I did it purposefully, and that I stomped on it. I also had no witnesses at the police station. I was arrested and given three years for hooliganism, for being a street trouble maker. I was clearly set up. It all happened eighteen days after I had applied and submitted my documents for emigration to Israel. But there is more to the story. When I was arrested, the KGB searched my studio and found all my sketches, drawings, and paintings. They also found a book of Chernikhov's drawings from the 1930s. They connected the two of us and came up with the notion that I had plagiarized some of my drawings from Chernikhov. On top of this I was accused of formalism—which was a crime. Clearly, the KGB wanted to pin something more than my desire to emigrate on me so that they could sentence me to more years in prison. I was sent immediately to Butyrskaia Prison. I was able to make several drawings there. But for two years I was tortured and interrogated. They accused me of bribery, of offering bribes to publishers in order to obtain work. My whole family was investigated as well as the publishers. They also arrested my wife, who was interrogated continuously for fifteen months, ten hours a day. My mother, who was to emigrate with us, could take it no longer and died. I became hysterical and refused to confess anything. I was then taken down to the cellar, tied up, and placed in solitary confinement for two weeks. I lay tied up and did not speak. They fed me with a small spoon. Then I was sent to the Serbski Institute, a psychiatric institute, a mental institution, where I stayed for two months. They gave me some kind of drugs for epilepsy which caused amnesia. It is difficult to recount all of this, and I try not to think about it. After all of this there was a trial, and I was put in prison. They put me to work as an artist. So I worked in jail as an artist, painting slogans. I was what they called a house painter. I was more like a slave. I decided to work for them because I could get materials—paints, watercolors—so I drew and made watercolors. They also promised me that if I worked as a

painter for a couple of months, they would release me. Instead, they sent me to a labor camp in the south of Russia. I continued to work there as an artist. I became famous there, and it saved my life. I was able to get food from other prisoners, and I made many drawings and portraits. Most of these were figurative pieces. Now, try to understand this. I was in prison, but still a member of the artists' union. So the union fought for my release and was able to get my term shortened by two months—which is something. When I got out of prison, I asked for the return of my works, which had been confiscated. So both I and my works had been incarcerated. I did get some works back, but many were torn or, in one way or another, destroyed. When we finally left Russia, luckily, I was able to take many surviving pieces with us.

RB: *What happened with the Bulldozer exhibition and the follow up show at Izmailovsky Park in 1974?*
ЛЛ: My wife, Ina, showed my pieces at Izmailovsky Park. It was very brave because I was already in prison. She had many connections at the foreign correspondence center, and she wanted the correspondents to know what had happened to me. So she purposely showed my work at the exhibition. She wanted to create some kind of climate that might lead to help. My name did get out to the West. Hedrik Smith, the *New York Times* correspondent, mentioned me. It was very dangerous, but I was already in jail so it did not matter too much.

RB: *What about the union?*
ЛЛ: After prison camp I continued to work for the union. Strange as it seems, somebody there actually helped get contracts for me with publishers when I returned to Moscow, probably because a union artist, whatever else, was an official public figure. In any event, I continued with my life after prison. Then in 1978 the union held an exhibition to celebrate its fiftieth anniversary and asked me to show some things at the Central House for Workers of Art. I exhibited, basically, book illustrations, but also some of my paintings. Now, people in the Soviet Union, and especially artists, had an inward battle going on against the authorities. Even

official artists wanted somehow to protest, but they wanted to be seen as pure and good people. I believe they did realize that I had suffered under the system. So I was allowed to exhibit. But to everybody's chagrin, the Ministry of Culture denied permission for my exhibition. Nevertheless, it was hung and stayed up for two weeks before it was dismantled.

RB: *Did many people come?*

ЛЛ: Yes, very many. Crowds came to the opening. But after the show closed I stopped getting commissions to illustrate books. I don't know why. Perhaps the publishing houses became frightened. Again we tried to submit our documents for emigration but could not get a sponsor from Israel. But that had to do with bureaucratic procedures. Finally, in 1980 we obtained visas from Israel, and we left in 1982. The Soviets literally kicked us out.

RB: *Do you feel that the authorities wanted you to leave?*

ЛЛ: Yes. They stopped giving me work, and they stopped showing my work, even at book exhibits. Officially, they were letting me know. We never went to Israel. I simply knew that I had to come to America. New York City is the center of the art world.

RB: *Has your work changed in any way since leaving?*

ЛЛ: In some ways. I now find myself in another world from the one in which I accumulated experiences. My attitudes and philosophy have changed. Nevertheless, inwardly I am still steeped in Russian culture, and I can never become part of a melting pot. I consider myself a Russian artist even now, and I don't think that is a bad thing to say. Earlier, I expressed my protest in abstract forms and used language, actual words, in my paintings, as conceptual games. Now I don't have to. I also began to place numbers, denoting measurement, in my work as early as 1971. The idea is that everything and everybody has to be measured, including Americans. If you want to be a member of society, you have to be measured—to have a social security number, or else you are nothing.

RB: *You mean we are each like numbers, to be accounted for?*

ЛЛ: That is the idea. I have developed it considerably since being here in New York. Numbers give us equality. I did an installation here in 1988 called the "Procrustean Bed," the principle of which is that we are all cut to equal size, and this assures happiness, paradise. I worked on this idea before immigrating, but it is stronger now. I couldn't really express this in Russia. I can do anything I want to here. My mind is free. But, you know, relations with other Russian artists are not as friendly here as in Russia.

There is no common enemy any longer.

Leonid Sokov
Леонид Соков

Born in Kalinin, Russia, 1931; Moscow Secondary Art School, 1956–1961; Stroganov Art Institute, 1964–1969; immigrated to the United States, 1980.

A sculptor who works within the sots art point of view.

RB: *When did you begin to study art?*

ЛС: When I was twelve years old, I began attending a special school for gifted students, the Moscow Secondary Art School. Several avant gardists went there—Neizvestny, Kabakov, Bulatov. It's part of the Moscow School of Art and dates back to the time of Peter the Great. It is filled with tradition, and the education there is really professional. It prepared you thoroughly in your particular areas of talent. The same attitude prevailed as in czarist times when students were formed into an intelligentsia to educate the people. The transition from those days to the Soviet period was a smooth one. After my army service I entered the Stroganov Institute. I became well known while I studied there and was officially recognized by the Moscow section of the artists' union.

RB: *What type of work did you do there?*

ЛС: Very realistic work. I based my sculpture on French models such as Rodin and Maillol, more classical than anything else. I

worked in that style for a long time. I believe it was important and good for me because it taught discipline of style and of thought. But I also knew that you cannot apprehend the world around you through that system of training, that you have to invent a new way of perception.

RB: *How did you come to feel that way?*
JC: You could see that everything around you in the Soviet Union was falling apart. There was no relationship between the system and what I needed to do. New methods, new approaches, new forms of understanding, and new forms of expression were needed; instead I was educated in a classical mode. The world was not a classical one. I had to look at everything afresh.

RB: *Nevertheless did you work in a socialist realist manner when you began your career?*
JC: Yes, when I finished the Stroganov Institute. The question of what to do was not a clear one yet. I knew that the world was not as it should be, but I had to earn a living. I was admitted to the artists' union and was well liked there. I was popular and had a good situation for which I had been well trained as a sculptor in the official style. After a time I had a good career in the Soviet Union. I was elected to a position in the sculpture section as a "little boss." This provided the opportunity to get commissions for park statuary. I sculpted animals. I had a foundry of my own. I could do my own welding and forging.

RB: *This was all official?*
JC: Yes. I worked on official commissions for as much as 10,000 rubles, which was a lot of money. There were a set number of commissions given, and I had a studio in the center of Moscow at the Big Sukharevskii. I lived comfortably, especially since I could finish a piece well before the deadline and was able to have some leisure time. Most of us worked in some official capacity. Kabakov, Bulatov, and Vassiliev illustrated children's books. This was the official way to survive. We were all members of the artists' union. Then, we made art that was considered unofficial as a form of self-expression.

RB: *When did you begin to make unofficial art?*

ЛС: About a year after I finished my studies—around 1970. I already had a foundry and made some works that I knew were not acceptable for official exhibitions. I became part of a group of people who were supportive and sympathetic.

RB: *This was around 1970. But did you take part in the Manezh exhibition in 1962?*

ЛС: No. I was in the army then. After 1970 I still worked in an official manner. In 1974 Bular Lazarevich Akhmedov, the head architect of Ashkabad in Turkmenia near the Iranian border, invited three sculptors, whom he considered the best in Moscow, to decorate a building he had designed—Neizvestny, myself, and another sculptor. I was still unknown. We were each given a project, and he was very pleased with my sketches. My project was a large one, too large for one person. It was for a restaurant in a park, in the shape of a pyramid. I had to make the sculpture out of folded sheets of iron. We needed professional help, but that would cost too much. So I was sent to the local prison where I found excellent welders who had to work for nothing. I worked in the prison with them for about four or five months.

RB: *When did you first see Western art?*

ЛС: My generation became acquainted with Western art when I was still in Moscow. We could see journals in the international library, particularly after I returned from the army in 1964. By that time I had a general knowledge of artists like Jasper Johns and Andy Warhol and other pop artists—all from magazine illustrations. The Russian version of pop art, sots art, which I helped develop, began about that time. I began to use folkloric themes, and my work, based on Russian toys, grew into sots art. I found that as I tried to develop a pop art manner, I ended up with sots art. In American pop art objects are important. But in Soviet pop art artists gorge themselves with ideas. My works were loaded with meaning, often based on folkloric tales. I was interested in popular culture and worked with Russian myths that could reveal themselves in my sculpture.

RB: *Say a little more about your unofficial work.*

ЛС: After I returned from the army I began to make sculpture. I really could not show what I wanted to make. That was unthinkable. In 1976 I organized an unofficial show in my studio and also had apartment shows with Ivan Chuikov, Igor Shelkovsky, Valerii Gerlovin, and Aleksandr Yulikov. The magazine *A-Ya* originated from a show with these artists. Shelkovsky began to publish the journal in Paris after he left the Soviet Union. I also had one official exhibit in 1976—at the Begovoy—for one day only. I made an agreement with the authorities to show my work for one day on condition that I could show all of my works. They allowed me to do it.

RB: *Were you persecuted by the KGB?*

ЛС: Not really. I did not suffer more anguish than the average person. Of course, when I had the exhibition, the KGB and the police came. We chatted. This was a kind of warning. I realized that if I continued to make and to show unofficial art that I would really not be making art but taking part in dissident activity. I did not want to be arrested. I did not consider myself a dissident. I did not go to demonstrations or openly rebel. Right now there are many who claim to have been dissidents, but the real dissidents were the ones who actively dissented, who broke the rules publicly. We all knew the rules. If you did not cross a certain line, you were not arrested. Some did openly protest in Red Square, which was not allowed, and they went to jail. Many wanted to become known through dissent. My own form of protest was to do my work. I am an artist. I was opposed to the existing situation, but expressed this only through my art that did not conform to the official party line. Instead, I regarded my work as self-expression. I did not think that my work could affect change. In my youth I though my work might do this, but I found out that this was only part of modernist art theory—like the architects Gropius and Mies van der Rohe who believed that their buildings could change the human condition. I simply wanted to express myself.

RB: *You continued to make official art at the same time that you made unofficial art?*

ЛС: Yes. Many of us did just that. In the evenings, at home, we

did our own work. It was really disgusting. During those years the burden of social protest fell on the intelligentsia, which is the Russian custom. This small group had to express the discontent of the great mass of Russian people. But there were no venues for us, no forms of institutionalized expression of social protest. In a democratic society people can somehow express their discontent, but this clearly was not the case in the Soviet Union.

RB: *You have been in the United States since 1980. Is your work still tied to Russia in any way?*
ЈС: I lived there for thirty-seven years, and it is part of my personal culture. I cannot change this. Others who have come here have willfully tried to change themselves. They left because life was hard, awful, and they want to forget it as quickly as possible because life in America is so easy by comparison. They naïvely believe that living on hamburgers and Cokes will turn their mentalities into American ones and that they will be able to speak English without an accent. This is unrealistic. I—we—are culturally infected with Russian bacteria. This had been hammered into me since childhood. I came here to make art, and I will not likely change, even if I tried to. I work with what I am familiar. There are unpleasant memories, painful ones, but that is part of my authentic self, my existence. I decided that this was the only way I could be interesting to Americans rather than make works about Broadway. Who would be interested in such work? Here is a question: you want to be an American artist, but will Americans consider you as such? You can't change yourself as if you were changing clothing. I can't change my way of shaping figures. Traces of my past are in my work when I combine, say, a traditional figure of Lenin with something based on modern Western art.

RB: *Have your style and themes changed since leaving the Soviet Union?*
ЈС: I helped create sots art with other artists who felt as I did. Those who immigrated have had the opportunity to evaluate the situation and to reflect back on our condition as underground artists. We feel that we had a good sense of the Russian situation. In this country I am very cautious when I work with American icons from popular culture. When I bring together Russian and American icons I try to make certain they are equivalent—like,

say, Stalin and Marilyn Monroe. I might be familiar with American images, but I can't feel them as integral parts of my experience. It is very complex, and I must approach this very cautiously. Many Russians believe that Americans do not have a culture (which I don't believe), and that Russian culture is, by comparison, very spiritual and concerned with ideas. But this is a Russian weakness, this concern with ideas or with The Idea. Even Dostoyevsky knew about this Russian fascination with The Idea without a similar concern for completion of The Idea. I can give several examples. Textures in works are often badly worked out and are wooden. Russians get too enchanted with a smattering of this and that and leave the thought unfinished. In the early days of cubism and futurism a critic brought back from Paris a catalogue with reproductions that were in brown and black. He showed the catalogue to his artist friends and explained that this was the kind of work being done abroad. Two weeks later the artists were producing brown and black images. I mention this to point out that the artists did not make an effort to make sense of what they saw. They were simply enchanted with the catalogue and with the idea that work could be done in this manner.

RB: *Do you have a desire to return to Russia?*
JC: I have family in Russia and can travel there. The Pushkin Museum and the Russian State Museum have even bought some of my unofficial works. But return? For what? I can walk around freely in Russia now. Nobody follows me. I can do whatever I want. But I've never suffered from nostalgia. That is a nineteenth-century illness. I don't know anybody who has experienced nostalgia. Lenin said that the enemies of the people should be sent into exile rather than to jail. Since Lenin spent a large part of his life abroad, he must have experienced great nostalgia and must have decided that exile was a terrible punishment. Now, it is reversed.

Everybody wants to leave Russia.

★

Valery Yurlov
Валерий Юрлов

Born in Alma-Ata, Kazakhstan, 1932; attended Alma-Ata Art School; graduated from the Moscow Institute of Graphic Arts, 1955; lives in Moscow.

Non-objective painter

RB: *When did you begin to paint?*

BЮ: I began to paint when I was about five or six years old. My father was a mathematician and an amateur artist. My mother was a doctor. During World War II I spent most of the time in hospitals for injured soldiers because my mother was the head doctor of one of them. This was in Alma-Ata. Actually I was born there, but I used to say that I was from Moscow. The reason I lied was that my grandfather, an officer in the White Russian army, wanted to escape to China in 1924 and got as far as Alma-Ata. It was not a Soviet city then, but a neutral place. Trotsky was exiled there in 1927 because it was considered no-man's-land. The railroad did not even go there. When I went to school I faced a mountain, and people said that China lay before that mountain. My mother tried to conceal information about her father and had a lifetime of anxiety over it. Actually, I lived with him even before the war started because my mother lived in Moscow then. My grandfather

never revealed his past. As I grew up I realized that the family secretiveness was due to my mother's fears about her father's history. But it was important for me to know why I was in Alma-Ata. When I got older I wanted to leave the Soviet Union for the West, but my mother was terrified that the truth would come out about my grandfather. She died in 1989 (my father died when I was a little boy), and it was only then that I began to travel. She was always telling me how frightened she was.

RB: *Did you study with your father?*
BIO: Only when I was very young.

RB: *Did you study in Alma-Ata?*
BIO: Yes. I was very fortunate in that several artists moved to Alma-Ata when the war started. The Russian ballerina Galina Ulanova and the film director Sergei Eisenstein lived nearby. When Ulanova became ill, she went to my mother's hospital, even though it was a military hospital. It was run better than other hospitals, and there was more food. I started art school when I was ten years old. I had a teacher there named Cherkasky, a fine painter and a student of Ilya Repin, who had fled from Kiev to hide in Alma-Ata. He painted in the same realistic style as Repin. He was very old, maybe seventy, and he seemed ancient to me. He accepted me in his class without an examination. I finished an apprenticeship after four years, but I did not pay as much atten-tion to him as I did to anatomy, which I studied from books. Since I lived at the hospital with my mother, I imitated Leonardo da Vinci and looked at bodies and collected bones as well. Anyway, this began my route to the painting of abstractions. I wanted to know how everything in the body was constructed. My mother had a teacher who was a famous instructor of infectious diseases, an Englishman who married a Russian and remained in Russia after World War I. He collected butterflies and would tell me about anatomy. After the end of World War II, my mother re-turned to Leningrad, my father's native town, but I stayed on in Alma-Ata with my grandfather. In 1949, I enrolled at the Institute of Graphic Arts in Moscow mainly because I was told that the

faculty was slightly off the mainstream. The teachers tried to maintain a low profile so that they would not be disturbed like those at the more prestigious schools [the Stroganov and Surikov art institutes]. One teacher, Petr Zakharov, who had been a close friend of Vladimir Tatlin, was very careful not to raise any suspicion about himself because in my first year there the entire fifth-year class and the teachers were arrested and jailed. This was in 1949.

RB: *Why?*

BIO: They studied some forbidden Western art books that had nothing political in them. We were even forbidden to see anything by Matisse. One girl who was imprisoned for five years continued her studies with my class after she was released. She was still young, but had aged incredibly while in prison. We both finished at the same time. Stalin died in 1953, but a good part of my education had taken place while he was still alive.

RB: *What about the rest of that group?*

BIO: They all died. Nobody has ever told this story. I once told it to an art historian from Barcelona who was writing on Russian art. I told him that it was a small incident, but it had a powerful effect on our understanding of our situation. It was not as if the Soviets were killing enemies of the people. These were young art students, our own people. It was horrifying, but these were the conditions under which we lived. One time I discovered a reproduction of a Matisse in the library. I was alone and found it tucked away in the stacks under lock and key. I simply broke the lock. Before the first World War, Matisse had traveled to Russia and was famous, but my teachers were afraid even to mention his name. I cut out his *The Dance* and hung it on my wall at home. A friend urged me to take it down because I could have been thrown in jail for sedition. Now we can laugh about all of this, and young people can see Matisse freely in the museums. But for me it was frightening. Can you imagine that you could be punished for drawing an arm longer than it should be? That was the situation.

RB: *You liked Matisse's elongated forms?*

BIO: I loved his deformations. My teacher, Petr Zakharov, intro-duced me to Petr Miturich who had worked with Malevich, Tatlin, and Mikhail Matiushin at the Matiushin School. We met as if we were spies. He told me strange and horrifying stories—like you could work in peace only in psychiatric hospitals. There were some fine, clever doctors in Moscow who would give you a room to yourself where nobody would bother you. I never did that. But I considered him my mentor because I learned from him that I could not work in Moscow. Miturich died in 1957, a year after I completed my studies. He used to walk around barefoot or in just shoes because he did not own a pair of socks. His relatives thought he was abnormal, but nobody bothered him. He was involved with wave-movement theory. In the Soviet Union if you were involved with technology, rather than art, you were not killed because you might be able to contribute something to society. He had a big basement where he built strange little metal mountains and rolled things down them. He thought objects moved faster if they moved the way dolphins do. Perhaps the way I work now has something to do with what I learned then.

RB: *Can you describe further the impact that the arrest of the fifth-years students had on you?*

BIO: For instance, an art history teacher who had known and taught with Kandinsky never mentioned the Russian avant garde. He simply referred to "the cosmopolitans." Other old-timers at the Institute of Graphic Arts were gone by the time I got there—murdered. Tatlin remained alive because he had totally renounced his past. I saw him, but he did not allow visitors. He had a barn under a big studio where he kept his constructivist works. Rain-storms made everything wet, and when he died the barn and its contents burned down.

RB: *Did you sell any of your works?*

BIO: I began to make abstractions in the 1950s and sold some to two Americans in the early 1960s. It was rare to take art out in those days. They were involved with Christmas ornaments. They offered me money, but that was too dangerous. I might have been

killed for doing that, so they bought me art supplies. In the end I did not even get the supplies because they sent them from abroad and it was impossible to receive such packages.

RB: *How did you earn a living?*
BIO: Petr Miturich told me there were only two ways to survive—in a madhouse or in politics. Since he was not in a madhouse nor involved with politics, he made art. His advice was that I should go far away and work there. He advised Siberia. I would have gone because I love landscapes, but I preferred a warmer place. My lungs were weak (my father died of tuberculosis), so I went to Guliripschi in the Caucasus where I lived from 1957 until the 1970s.

RB: *Were you able to return to Moscow?*
BIO: I would visit, get the news about my friends, who was staying or leaving. But I was not part of any group and, living away, I did not have any of the pressures endured by the Muscovites.

RB: *Did you have any support group?*
BIO: Absolutely no one. Zakharov died in the 1970s, but by then I had traveled in a different aesthetic direction. Nobody bothered me because I hid all of my works—abstract works—in attics.

RB: *How did you come to make abstract works?*
BIO: I was about seventeen or eighteen when I began to study with Zakharov, and I thought I was quite accomplished. But Zakharov completely turned me around, broke my preconceptions about art, and more or less reduced me to zero. I had to decide whether to stay with him or leave, but I trusted him. He told me that to draw as one sees is mindless, that you have to think first and continue the thought with a pencil. I watched him work, the way he drew lines here and there. I thought that he knew nothing. He told me to conceptualize first. I finally absorbed his message and understood how, for instance, Degas' horses leap out of the canvas. They were created from ideas, not from direct copying. My friends who learned the direct-copy method could

start a drawing from any part of a horse's head. They saw the world as a series of parts, not as a whole. I started out that way and thought I had done many successful paintings, but I ended up burning them all. I have only a few drawings from that period, now.

RB: *Did anybody else influence you?*
BIO: Through a friend I got to know Viktor Shklovsky [a formalist and a theorist]. I had to gain his confidence because people were afraid of each other. We were friendly for about ten years. He told me that Malevich thought Marc Chagall should be shot because Chagall was a Communist. And that Chagall called Malevich a red commissar. They really hated each other, although, both came from Vitebsk. Shklovsky also taught me how to distance myself from my work, to look at it with a defamiliarized eye. He also helped introduce futurism to Russia. He met Filippo Marinetti [the originator of Italian futurism] when Marinetti came to Russia in the early 1920s. Shklovsky went to the station with Vladimir Mayakovsky [the Russian futurist poet], their faces painted, expecting Marinetti to be similarly painted. Instead, they found a little man with a beard, a top hat, and a monocle, a bourgeois fellow. They went into shock. Anyway, Shklovsky talked to me about Malevich. I also met Vladimir Favorsky, also a strong personality. He had taught in Munich and then in Moscow and had known Kandinsky very well. Toward the end of his life he was awarded the Lenin Prize for a work entitled *The Final Say about Igor's Regiment*. I thought this was a betrayal on his part, since he had suffered so much earlier in his life. Why sell out at the end?

RB: *He and others must have lived in mortal fear.*
BIO: I thought that if you were already around eighty years old, there was nothing to fear. What could they do to you? But I knew that all of the artists around me denied knowing many people. I had a teacher who knew and studied the work of El Lissitzky but denied everything, never breathed a word about the artist.

RB: *Did you know artists your own age?*
BIO: Yes. I knew well Volodia Kultunov, a good man who committed

suicide. A poet, Golubkov, also killed himself. Another jumped out of the window. This was during the 1970s. The pressures were severe, then.

RB: *Did you have anything to do with the Manezh exhibition?*
BIO: I did not participate, but I knew several who did take part. I thought that they were just beginning to explore the kind of art I had been doing for years. I felt that at the time I was sort of a wise old man. I did not understand why Khrushchev carried on so, since the paintings were basically realistic. But I was not in Moscow at the time. For many artists the event was a celebration because it attracted attention, but it was unfortunate that it politicized them as well. They drew attention to themselves and their art works as nonconformists rather than as artists. They were seen as artists who resisted the authorities, as a type of revolutionary. I was never interested in politics.

RB: *Do you think they were brave or heroic?*
BIO: As ordinary people protesting against oppression I would say that what they did was admirable. But as artists it was a mistake to get involved. Their task was to work with plastic art. I admire artists who set out to solve problems about art, who ask certain questions of the material. I am interested in how artists choose their own ways.

RB: *You did or did not consider yourself a nonconformist?*
BIO: No, I did not. If I had left for the West, I might have considered myself as such. But I could not leave Russia. My mother threatened to kill herself. I do not say this lightly. She was a strict, orthodox Communist even though her father was a White Russian. (She was even afraid to mention his name.)

RB: *What did she think of your paintings?*
BIO: She did not have a single painting of mine in her house. I saw her infrequently as an adult and could stay with her only about a week whenever I visited. She lived in Leningrad, and I was in Moscow. As a human being my mother was a wonderful person and a great doctor. She was very frightened, however, by modern

art. At times she would ask me, "Tell me, Lera (the name she called me), does anybody else work like you?" She considered me abnormal. I would bring her books to educate her, but she would reject what she saw, claiming that the modernists "were not our people" or that their work was not art. When I would visit her she would instruct me where to sit and to be quiet. She would complain about Leningrad because its intelligentsia was murdered. There were no writers left, she would say, except for Anna Akhmatova. The authorities would systematically take the intelligentsia to a dacha to kill them. We know this because we have found their graves. My mother was aware of all of this and was very frightened by it.

RB: *When did you first see Western art?*
BIO: There was an American exhibition in Moscow in 1960, but I had already been working abstractly since the mid-fifties.

RB: *Are you saying that the political situation did not affect you?*
BIO: Correct. I had nothing to eat, but I ate very little. I didn't show my works to anybody, so I was not afraid. And if I did not get involved with politics or openly incite anybody, then there was nothing to fear. I had no exhibitions in Russia until 1990, when I had a large show at the Tretiakov Gallery.

RB: *Did you have any shows before perestroika?*
BIO: Some friends did want to show two or three of my things in apartment shows, but I did not want to do that because poets and writers who saw the shows never talked about art but about the KGB. I took Miturich's advice to keep myself apart. I keep mentioning his name because I would like to see a monument erected to his memory. It seemed to me right not to talk about what I was doing. I won't say that my work is totally hermetic, but few art critics understand it.

RB: *Did you join the artists' union?*
BIO: I tried to join. My wife was adamant that I join. So I applied and brought my works. Everybody knew me since we had studied together. But I became ill at the interview. I was quite calm and

was certain that I would be admitted. Late at night my wife called somebody to find out what was happening. There were nine secret ballots, she was told, all unanimously against me. I am still not a member. They thought my work was incompetent.

RB: *What happened then?*

BIO: It was terrible. For a number of years I made book and journal mock-ups, or preliminary layouts, because of my experience at the Institute of Graphic Arts. I could buy food cheaply. In the Caucasus I fished a lot, and my wife used to send me canvases from Moscow.

RB: *Were you able to buy supplies?*

BIO: My wife did most of it. I also made a lot of constructions from scraps I found in dumpsters. I devised a Robinson Crusoe-like theory. If a person is alone on a desert island, what could he invent or use? I began to draw with bitumen lacquer, which is used for painting fences. You could get it for nothing. It has a strong odor, but it is beautiful. I painted with it on large rubber sheets, then took long pieces of paper and applied the rubber to the paper. I consider these to be among my best graphics pieces. Had I printed these on an expensive lithograph press, they might not have turned out so interesting.

RB: *Did you have any commissions?*

BIO: One time I worked on a book about animal husbandry in America. I also helped Leonid Sokov construct a maquette for a book he was working on. My wife worked; she is now a journalist, and she supported me. My mother never helped out. She was a regular Cassandra, warning us that we would all perish because of me, because, as she said, I was an unsavory character. She would say, "you are not one of us."

RB: *How do you look back on all of these experiences?*

BIO: With maturity I believe that I am a better person, less judgmental than I used to be. I once accused Favorsky of selling out. Tatlin, too. Now I understand how difficult it was for them with families. But I still don't understand Tatlin—why he did what he did in his late works.

RB: *What about your artistic evolution?*

BIO: I began to work on forms as pairs, starting in 1959–1960. The Americans who I mentioned before told me that Adolph Gottlieb also worked in paired forms, but I had not seen any magazine illustrations of this. They showed me some reproductions, and I was very happy to see them because it confirmed my own ideas.

RB: *Were you involved in the Bulldozer exhibition?*

BIO: I was in Moscow then. Mostly students took part in it. I was not very supportive. Oskar Rabin organized them. I had been working on my own for years, so it was not for me. I think the group mainly wanted attention to become known. They had an insatiable desire to be recognized. My desire was the opposite. I wanted to work more, to make more paintings. The main goal of my life is to work. I want you to understand that. I want to emphasize that I must always work or else I feel useless.

RB: *Did anything at the Bulldozer show interest you?*

BIO: Not really. I would have known had there been some good paintings there and would have regretted their destruction. I remember an American journalist asking a participant, a woman, how many works she had, and she said two. Another painter whose work I liked said he had only one painting. They just hadn't worked long enough. Had I been younger, I might have done the same. I would have wanted to be seen, have my work recognized. Only Rabin was my age, but he did not paint abstractly. I was interested in an artist like Lev Nusberg who did abstract works. He was a friend of mine and used to visit me. I liked the way he modeled a painting. It was fun for me to be with him. He was not involved with politics, but he immigrated to America.

RB: *Did the authorities bother you?*

BIO: There were the odd moments when they did. When I was in the Caucasus I was stopped on the street and dragged in by the KGB. My hair was cut too short, they claimed. They thought I was an escapee, but they knew I was not a hooligan. I was still pretty young then. I found the whole incident curious and even interest-ing. A friend was also taken in because they found his drawing

pad on which he drew women whose breasts were given in centimeters. The KGB wanted to know about these numbers, what they meant. I was left alone, but not my friend. He was very talented, a humorist. His name was Iura Fedorov, and he died a terrible death from alcohol. I was brought in another time when I was at a friend's restaurant that catered to foreigners. It turned out that we were forbidden to go there because of the foreigners. I said that I would not go there anymore. Others who resisted were beaten. I looked upon it with a sense of humor. You know, it was probably a good thing that I did not get into the artists' union. Official art was pretty well organized. This way, they forgot about me, left me alone to do as I pleased.

RB: *Do you have any comments to make about the Sotheby's auction in 1988?*
BIO: I did not participate. Basically it was a gallery set-up. The artists had nothing to do with the selections. The gallery owners went around, engaged certain artists and selected them. Just this winter [1993–1994] I was in Paris and saw an exhibition of Russian émigré art. Once again I was glad that I was not in the show. Artists who had left a long time ago were still painting in their old styles. The experiences of freedom seem to have had no effect. There was no change. My old teacher's dictum held true. Painters need to be disciplined and work all the time. It is not necessary to look for new places. Experience and hard work are all that counts. You grow, you learn from your mistakes. My theory is a simple and healthy one. Not even perestroika affected me. Lately, I have begun to work with glass, large works. I want to make even larger pieces now that I have a big studio. I need financial support though. True, I didn't think of making large pieces before perestroika, but now I can.

RB: *What do you think of socialist realism?*
BIO: Dmitrii Prigov said that the avant garde and socialist realism are one and the same, because avant-garde artists very easily switched back in Stalin's time.

RB: *But socialist realism is built on an ideology, and the avant garde is built on an idea.*

BIO: Exactly. Prigov plays with the two. It is similar to the way children play. They might play with some bones and see them as bones or as a turtle. That is what Prigov had in mind—a game. About socialist realism itself, I never gave it much thought. I was not interested. Right now, however, I do find some things of interest in it. But just imagine, had I brought my works to the Manezh in 1962, they would have put me in an asylum.

**The main thing is that if a person is involved with art
all of his life and loves it,
then nothing else interests him very much.**

Gleb Bogomolov
Глеб Богомолов

Born in Leningrad, 1933; self-taught; member of Association for Experimental Exhibitions, 1975.

Paints in a non-objective style with an emphasis on layerings of pigment.

RB: *When did you first know that you were a dissident artist?*
ГБ: I knew since childhood. I was born and raised in Leningrad on the Vassilevskii Island, very close to the Repin Institute of Painting, Sculpture, and Architecture. There was no charge to see paintings, and I used to go there regularly as a youngster to see exhibitions. This began toward the end of World War II.

RB: *When did you start painting?*
ГБ: I remember always painting. My mother often asked me what I was doing, since I was so engrossed in it. My father was a sailor and he drew and painted seascapes in a realistic style. My mother wanted me to go to art school to be properly trained, but I refused to go. My decision might have been an immature one. In retrospect that must have been my first nonconformist decision because I knew that I could not reconcile myself to what was taught at art school. I knew I wanted to paint nonrealistically. I

was already reading poetry and literature, and, despite the control of culture by the authorities, I found old encyclopedias and old art journals to dream over. For a short time, I attended a painting studio at the Palace for School Children and Pioneers. But I didn't last too long there. I wanted to do what I wanted to do, and I was also bored. The teacher complained to my parents that I was slowing down the class, but at the same time she would show the class reproductions of Matisse that she called funny but also interesting. She tried to explain the beauty of Matisse's colors and forms.

RB: *When did this take place?*

ГБ: The late 1940s, around 1948 and 1949. I liked poetry then, particularly futurist poetry, and I came across the names of Italian futurist artists. At the same time I began to read two different encyclopedias, one published in the late 1920s and the second one, a real Soviet product, published much later. The earlier one was enlightening and illuminated many different things. The second one was critical and ugly and used insulting words like "loathsome," "decadent," "antisoviet." I made comparisons as I read, and, through these encyclopedias, I discovered artists. I looked them up at the library—futurists, dadaists. They caught my attention. I couldn't tell if all of this was a joke or not since the art was so playful. I thought nobody else understood these movements but me. I began to imitate what I saw in my poetry and painting. We had incredible futurist poets, you know, like Velimir Khlebnikov. Even in Russia few people recognize his status.

RB: *Did you study art at any other time?*

ГБ: Well, I studied in school. When I had to choose between the army and the academy, I went to the academy. We often went to the Hermitage to see the Rembrandt and Rubens paintings and the medieval armor, but one day my life was revolutionized in a single moment. By chance, I went up to the third floor and saw the impressionist paintings. They were so close to the poetry of Alexander Blok that I almost died. The paintings took my breath away. Some information about them began to trickle down, but then the

regime clamped down and forbade us to read or see anything outside of the socialist realist canon. Then in the 1950s, during the Khrushchev Thaw, I would go to the Academy library and read about Kandinsky and Malevich. I also looked at magazines from Poland, especially one called *Pol'sha* [*Poland*], and saw reproductions of very strong surrealist works. Another magazine from Yugoslavia was important for us, too. It was like an encyclopedia of all Yugoslavian art—primitive art, abstract art. It was like taking a course in contemporary art. After a while I established some contacts and was able to visit the storage areas of the State Russian Museum and of the Hermitage. I saw works by Malevich, Kandinsky, Larionov. But here was the problem. We lived in a totalitarian country, so our dreams and musings were totalitarian in nature. Everything had to be black or white, right or wrong. We did not know about inconclusiveness. So I lost a lot of time and energy figuring out what art should look like. Should it be futurist, expressionist, impressionist? I tried to understand, and I experimented with the different styles. That was my real schooling, which I did at home.

RB: *Did you have any preferred themes?*
ГБ: I tried romantic themes and then surrealist themes. I played around with colors because I knew something about Jackson Pollock. This was about 1968.

RB: *How did you learn about Pollock?*
ГБ: I worked as an engineer at that time and had access to paints. But of Pollock, we were able to read about him in magazines. Some articles were written by intelligent people who would condemn a work, but you knew they were conveying important information. They would pinpoint what was bourgeois and bad about a piece. So we read between the lines. These writers knew what they were doing. Other writers were just plain destructive, and we knew what they were about. Anyway, I didn't find Pollock all that interesting, but I experimented with paints and this was essential for me. Somebody I knew also tried to experiment with paints, but nothing happened for him. This only affirmed my

belief in myself even though I had what you could call a break-down because I knew I was not using my own ideas. I was in search of a personal style and couldn't quite find one.

RB: *Did you have similarly minded friends?*
ГБ: When I speak in the plural, I have in mind a certain segment of society. We were not necessarily connected, but we tended to agree on most things. We had a bohemian circle in the early 1960s—artists, *litterateurs*, and others, and we were a pretty serious group. Jazz was important to us. It was exotic and spoke to us of some fantastic reality. We had a large auditorium, but it was forbidden to listen to jazz, and we were constantly chased away.

RB: *Who saw your work?*
ГБ: Artists, poets, philosophers, people I liked, but I did not have any apartment exhibits at that time—not until 1976. I was part of a group then called the Arefiev Group which included Aleksandr Arefiev, Sholom Shvarts, and Rikhard Vasmi. [These three artists painted in figurative styles.] We liked the poetry of Osip Mandelshtam in those days.

RB: *Were you also a member of the artists' union?*
ГБ: Never. I was never a member.

RB: *Did any officials see your work?*
ГБ: Well, I did take part in the exhibition at the Gaz Palace of Culture in December 1974. In truth, my big problem there was in selecting works to show. I picked the less avant-garde ones since I thought they represented me the best. After that, I changed manners and styles a lot. Anyway, the Gaz Palace show was the first of its type in Leningrad, and it took place soon after the Bulldozer show, with its scandal in Moscow. It was not politically appropriate for the KGB to shut us down before even opening the show, so the authorities asked the artists to submit work from which the authorities would then select the exhibition. They requested that there be no anti-Soviet propaganda, no pornography, and no religious propaganda. We agreed to those terms. They looked everything over and allowed us to have the exhibition. They did

not ask us to remove anything. I should add that none of my works contained political messages. I did not believe that art should be political. The only rule I followed was that I be able to do what I had to do. Art is like science in that the artist needs to invent, discover, do research, and then analyze what he has done. The authorities did not want us to have that kind of freedom, so our goal was to withstand any kind of oppression. In my case, I was not interested in making caricatures of Stalin. He and others would fall into the abyss without my help. I just wanted to do my own work.

RB: *Any problems after the Gaz Palace show?*
ГБ: At that time I was an engineer with a high rank. I don't know if the authorities came to the institute where I worked to inquire about my activities. They did, however, speak with the director, who seemed anxious and nervous, but I was not affected in any way. In any event there were no repercussions. After the exhibition we artists had a long battle with the authorities. They could no longer deny us, but they couldn't accept us either. So they began to campaign against us and to become more oppressive than they had been in the recent past. They really did try to destroy us. Several of us were banished from the country, some were jailed, and some were forced to join the artists' union. They tried to subvert and annihilate us. It's as simple as that.

RB: *When did you think of becoming a full-time artist?*
ГБ: In 1977 and 1978 I realized that I'd have to quit my job. I did, and then the problems began. The authorities were out to get us and accused us of being bums, hooligans, drunks—you name it. They would ask me, "Hey, Bogomolov, where do you work? You don't work? You know in this country that's not allowed." The harassments went on and on. It was like a circus. I was under surveillance, but I was never arrested nor did they try to "educate" me. It was clear, though, that if I did not get some work, I would be put away. I would tell them, when they asked if I was working, that I had some commissions. This went on for about three or four years. Wait a moment! I do remember once being

summoned by them. They wanted to know what I was doing, what was my business. They began to search for my file but could not find it. I gathered from the conversation that one of the policemen knew the whole thing was stupid, and I suspect that he burned my dossier. Nobody would suspect him. Anyway, I was let go with a warning. The entire experience was very disgusting.

RB: *Some artists have said that this kind of treatment had no effect on them. Others were deeply offended.*

ГБ: It was very demeaning and insulting. It was also dangerous because you never knew how it might turn out. I could have been imprisoned. After perestroika the sense of oppression eased, although it continued for a while. The authoritarian structure had weakened. It was really the KGB and not the militia that initiated all of these tactics, and the KGB operated through the militia, but the latter was not really interested in keeping it up. The militia did not want to harass people. At my last meeting with them my wife came along and told them that my business was basically none of their business. She told them that she worked, so what was the problem? All of this bothered me, but it had an effect. They left me alone, finally.

RB: *Did viewers at the Gaz Palace exhibition understand your works?*

ГБ: The line for admittance began at five in the morning, five hours before opening time. It was winter and it was freezing. Imagine all of those people waiting to get in. The response was tremendous. The exhibition lasted four days. The following year we exhibited at the Nevsky Palace, and this time the show remained open for ten days. My wife, whom I did not know then, stood in a line that was two kilometers long. The viewers were a varied lot. Some knew what they were looking at. Others did not, but knew something important was occurring, a change in the social structure. Painters were able to do something previously forbidden. What was once called stupid by the authorities was now called heroic by the public. The artist became a kind of hero whether he was an important artist or not. In 1976, for instance, I organized an exhibition and a debate at a school at which the

students asked questions and the artists answered. The general public was also invited. This was a terrific thing. The artists were like heroes. They held strong opinions and were convinced of the rightness of their positions. It was all very wonderful until a young woman stood up, her fists clenched, and began to shout, "How can you speak like this when you know it is not allowed." She wept and we were shattered by her outburst. Here was a person who sincerely believed what she was told to believe. She could not absorb what she had heard and was very upset by it. Now, I think she represented the general public, but we were able to begin to get to them. As it turned out, it became something of a tradition to end many exhibitions with discussions on the nature of art.

RB: *This is interesting because we know little about the general public.*
ГБ: After a few years, a large group of viewers was formed who would show up at exhibitions. They were pretty supportive. Also, now I can say out loud, that people from the State Russian Museum would come to our studios in the late 1970s and encourage us, telling us we were doing the right thing. They were morally supportive, and that was important. The museum's director, Aleksandr Gubarev, spent about two hours with me one day in 1978 trying to persuade me to make a gift to the museum. He told me that he couldn't purchase anything at the moment, but if I donated a painting it would remain forever in the museum. It would be important for me. I did end up giving him a painting. The museum now has about twenty of my works. This is all to tell you that we had plenty of support.

RB: *What about the relationship between the Leningrad and the Moscow artists?*
ГБ: I knew several Moscow artists, particularly Oleg Tselkov, who became a close friend. He studied in Leningrad. There were good communications between artists in the two cities. In about 1963 I went to Moscow where I met Oskar Rabin, Lev Kropivnitsky, and Vladimir Yankilevsky, who made a strong impression on me. He seemed to be a very powerful artist. We all got to know each

other, developed close ties, and visited each other when we could through the early 1970s. We would discuss mutual artistic problems, questions about opposing the authorities and about exhibitions. We held some joint shows, and we wanted to set up a biennial of sorts. In the winter of 1974–1975 we had a show at the home of Liudmila Kuznetsova who later immigrated to the United States. When she left Russia she took many of my works with her. In comparing the two cities, I would say that Moscow was by far the more dynamic. New trends appeared there very quickly, but in Leningrad intellectual life seemed to be deeper.

RB: *Did the authorities know about these contacts?*
ГБ: The authorities, of course, were aware of us and kept a close watch. They somehow knew everything, especially after 1974, after the Bulldozer and the Gaz Palace shows. Rabin went abroad then, and they refused him reentry. The KGB had a special division, called the fifth division, to keep tabs on us. We were their main occupation. And they bothered us as much as they could. They were really in a difficult position since we were beginning to attract attention. In effect, we depended on the help of foreign diplomats to keep us out of trouble. I can tell you that. The KGB realized that we needed ties with the West. I would say that they were mostly bored with us, but at the same time we fascinated them. For us it was terribly important to have connections with the diplomats and to maintain lines of communication to the West. In time, we sold many works to the diplomats. But this is how it more or less worked. The KGB would tell us that we shouldn't complain because we did have some freedom to meet with foreign diplomats. In fact they permitted a certain number of artists to meet with foreigners unofficially, or at least not openly. If others wanted to meet foreigners, they would not be permitted to do so and would suffer the consequences. The authorities decided who and how many could associate with foreigners. And they would keep close watch over artists who were given permission. The KGB kept a tight rein; the circle did not widen. We understood why the KGB's fifth division wanted to continue their business. Following us was better than chasing spies. They had a wonderful job, and

they needed us to make trouble for them to justify their existence. If we did not hold exhibitions, they would look for some other pretext to cause a commotion. There might be sudden, unexpected visits from officials who would want to know what we were working on. Once somebody named Volodia called, wanting to visit me. Since I have many friends with that name, I told him to come over. It turned out to be a KGB man who so identified himself.

RB: *What did he want?*
ГБ: He wanted me to be an informer. This happened several times. They were very tactful, but I was usually rude and they would back off. They would say, "Very well, then. Nothing came of our conversation. All the best." I was always scared, though. I did not like to be solicited in this way. A friend once came over quite upset and agitated. We went out for a walk to talk in private, and he told me that he was asked to spy on me. What should he do? He held an important job as an engineer. He feared that he would be fired if he didn't comply. He said he was afraid to say no. What should he tell them? It was truly horrible. My friend was strong and large, but he was very frightened, yet he had enough courage to tell me what he did. It turned out that they realized he did not tell them the truth, so they left him alone.

RB: *How did you get paintings to the West?*
ГБ: Through diplomats. My first works went to Alexander Glezer, who held shows in France, and then to the United States. Other people got out other works of mine. There were more shows in Paris and in Austria in, say, 1979. I had other shows in the 1980s in Europe and America. Diplomats would get them out and then exhibit them. I did not go abroad, however, until 1988.

RB: *Has there been any changes in your work since perestroika?*
ГБ: No, but I am constantly evolving and developing. Perestroika had nothing to do with this, other than that I was able to travel. I did learn that I was not the only painter to use gold in his paintings. I visited America in 1990.

RB: *Do you ever think of immigrating?*

ГБ: A few years ago I was certain that I needed to leave, but they would not let me out. Then I noticed that many good artists were not very successful abroad. Perhaps it was a question of sufficient publicity. I knew that in America you had to work fast and be productive. You needed a strong ego and superhuman powers to maintain a sense of yourself. Picasso could do it, but I haven't seen that yet happening for a lot of Russians. Komar and Melamid are the most successful émigré artists, and they have strong personalities. Although I don't know much about their work, I understood that things were not as easy for them in the West as it seemed. After all, it is not so easy to be an immigrant. I did have the opportunity to stay in America, but I was not convinced that it was necessary for me to leave Russia anymore. Perhaps the best solution is to live here in Russia and in the West.

RB: *It is important for you now to remain in Russia?*

ГБ: Right now there are severe problems, but I know an artist in America who is thinking of returning. He has contacts, but does not have a comfortable set-up. It's all an individual decision to make. Afrika [Sergei Bugaev] is a wonderful artist who has contacts everywhere. He seems to have no problems whatsoever, but that is the type of person he is. Things might not turn out so easy for me. On the other hand, I can work very well abroad—as I have in Switzerland, Norway, Los Angeles—so I don't have to be in a particular place to make paintings. If I had to leave Russia, I would not know where to go. I know I would not go to France, since my paintings make no impression there. American tastes vary, but I am in good collections there. I think I could do better in the American northeast than in California.

But it is all moot now.

★

Ilya Kabakov
Илья Кабаков

Born in Dniepropetrovsk, Ukraine, 1933; Moscow Secondary Art School, 1951; Surikov Art Institute, 1957; member of USSR Union of Artists, 1965; member of Sretensky Boulevard Group; lives in New York City.

Installations artist

RB: *When did you realize that you were a dissident artist?*

ИК: I was not a dissident, and I even consider it problematic that I am an artist.

RB: *In what sense?*

ИК: In the sense that I received an education as an illustrator, but did not feel that I had special talent and an inner drive. I was just a normal man and did not consider myself an artist.

RB: *But are you now an artist?*

ИК: Even now I am not completely certain. But in any case I was not a dissident. I did not fight with anything or anybody. The word does not apply to me.

RB: *What was your attitude to the state before perestroika?*

ИК: In general it was that of any normal person who considered himself in opposition to the authorities, at least in the Soviet

Union. It was a matter of ignoring them, not paying attention, having as few contacts with them as possible.

RB: *Did they bother you?*
ИK: Not in a direct sense.

RB: *Did you make official and unofficial works?*
ИK: These terms do not entirely apply to me because the term "unofficial artist" was applied by others to the artists. It was not the artists' term. In reality, they were just doing whatever their imagination told them to do. They did not feel themselves as being in conflict or denying something or fighting with something. Since these artists could not sell or exhibit their works, me included, we looked for other ways to earn a living.

RB: *Was it possible to make money by selling paintings?*
ИK: Some artists were able to do that, but my friends and I made money in other ways. A large group of us were illustrators for publishing houses, especially books for children. This included people like Erik Bulatov.

RB: *Has there been any change in your work since perestroika?*
ИK: It is totally the same before and after. The ideas, the forms, and the themes are the same.

RB: *Is there any difference between your installations made in Russia and elsewhere?*
ИK: Absolutely none. The same ideas and forms I began in Russia are still being developed. In general, nothing significant has changed, but there is gradual development that has not depended on place or circumstances.

RB: *I assume you had a circle of like-minded friends in Russia?*
ИK: Of course. It provided great happiness. I had several close friends.

RB: *Some artists have said that they were always alone.*
ИK: Yes, there were some lonely artists. Various forms of exist-ence developed in this so-called unofficial life. There were artists

who were very close to each other, who had close groups of friends. Others had just normal, friendly relations, and there were many lonely geniuses and great talents who developed independently. I don't think that one can talk about these groups in the same way that you can in the West where artists might share a very solid or focused artistic program or concept. Nothing like this existed in Moscow during the past thirty years. True, some artists worked together [Bulatov and Vassiliev, Komar and Melamid], and within the different groups there were some close relationships, but each artist within a group developed something of his own. They found mutual understanding and support among friends, but did not share artistic programs like, say, Russian artists of the 1920s.

RB: *Did you sell any works before perestroika?*
ИК: Before 1985 I did sell some works.

RB: *Did you exhibit?*
ИК: I would say that there were almost no exhibitions. But by the end of the 1970s there were some group shows. Sometimes there would be one-evening exhibitions, which did not satisfy the artists.

RB: *How did the viewers react?*
ИК: With complete understanding. You see, the life of the unofficial art world began in 1957, and during the next thirty years it grew pretty intense and intensive. So, besides the artists, the audience developed as well and became our fans. Some in the general public also grew interested. The exhibitions attracted huge crowds. I think the reason for this was that the unofficial artists made paintings different from those of official artists, different from widespread artistic norms. This attracted people because in a regulated world it was exceptional and unbelievable. The crowds came out of curiosity and because of the exotic nature of the shows rather than with calm and serious attitudes.

RB: *Who saw your installations?*
ИК: They weren't exhibited anywhere. I didn't make too many

and they could be seen only in my studio. So only those who came there could see them.

RB: *Friends?*

ИК: Only friends. I should say that the term "general public" did not really apply because our exhibitions were really very short, random episodes in obscure places. So the term "public reaction" does not have much meaning. But we did have our own audience that was close to the artists, poets, musicians, and writers who constituted our world.

RB: *Any scientists?*

ИК: Yes, scientists, as well, especially in the 1960s and 1970s when the scientists were allowed to organize exhibitions in their research institutes. They were very much interested in the unofficial artists. They even bought some paintings.

RB: *Did you participate in the Manezh exhibition in 1962?*

ИК: No. I was out-of-town, and I did not yet have works ready by 1962. Other artists were already famous and very active, but I had almost nothing at that time.

RB: *How about the Bulldozer exhibition in 1974?*

ИК: I did not participate in that show either. I was afraid and considered it dangerous. Others had more courage.

RB: *Did the authorities ever make trouble for you?*

ИК: No. I had only one episode in connection with *A-Ya*, the magazine. I was invited to the union, but nothing special happened. A large group of artists were published in this magazine, and all of the members of the union who were connected with *A-Ya* were once invited to the union offices where the chairman gave us a tongue lashing. But there were no consequences. In any event, it was a wonderful magazine and played a great role in its time. Shelkovsky edited it. He lives in Paris now.

RB: *When did you first see Western art?*

ИК: I can say that I never saw it. I remember that there was an

American art exhibition, but I can't remember if it had any influence on me. I know why you ask this question. You really mean that when we saw Western art our own art began to move somewhere, to develop. This is a question we've been answering for thirty years. But I can say this about myself—that I did not see anything sensational. Life in the Soviet Union itself has had a much greater influence on me and on my art than anything from the West.

RB: *Were you familiar with the Russian avant garde of the 1920s?*
ИК: Absolutely not. We did not see it, and it was not exhibited. But you can't say that we got all of our information from the air. We learned to behave like whales who process a lot of plankton. So it would not be true to say that we did not have any information. We did get some from magazines, from photographs, from George Costakis' collection, which we often visited. So, we had some contact with avant-garde art. But I understand your question. You want to know if any of this influenced me. The answer is absolutely not. It had no significance. And it is understandable why. This art of the 1920s occurred near the beginning of the century and at the beginning of the era of Soviet reforms. The art was connected to utopian visions, to hopes for the future, to the reformation of the world, to the appearance of the new man. Our time is an end-time. We saw the results of this reformation. We saw the new man. So those earlier artists, great though they may be, belong to a different epoch, which has nothing to do with us. It is the same as with Raphael—great, but he has nothing to do with us.

RB: *Were you a student of Elii Beliutin?*
ИК: No. Like Bulatov and Vassiliev, I had an elementary academic education and a complete art school training. I did not need further education.

RB: *Do you travel to Russia?*
ИК: No. I have not been there for a long time. So far, I don't feel the need to do so. All of the past life, its atmosphere, still lives inside me. So I am from morning until evening a complete Soviet

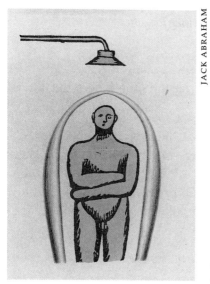

JACK ABRAHAM

Ilya Kabakov, *From the Series: Shower—A Comedy*, number 9 in a series, 1970, mixed media, 22 x 15.5 cm.

person, and all the themes are the same as before. Nothing has changed.

RB: *I have read that you work in the Russian tradition.*

ИК: Russian tradition? No. I consider myself a Soviet artist. Soviet is not the same as Russian. I am a Soviet person, and the Soviet civilization uses the Russian language. My texts are Soviet texts; I don't think they are Russian texts. True, the Russian-Soviet tradition is predominantly a verbal one, but I use lots of words and texts, Soviet texts, especially commonplace, ordinary texts. There are two reasons for this. First, because I don't think that I am talented enough to express everything I want to say in a visual way. So I always mix the plastic with the verbal because I want to add and to explain something using words. This is subjective. And second, the objective part, is that in the 1970s a tradition of verbal comment, reflections about things, had developed. There was a tendency to discuss, describe, and argue about different objects and their connection to reality. And all of this lead to such complexity that these discussions—narratives, explanations, comments, dialogues—together with the object became part of the art work.

RB: *Does image and word come together for you?*
ИК: Yes.

RB: *Did the Sotheby's auction of 1988 have any effect on you?*
ИК: None at all. Maybe it had an effect on some others, but not me.

RB: *How about shows in the West after 1965?*
ИК: It would be better to say that there were group shows of unofficial artists. These shows were organized first by Western collectors and curators and then by Alexander Glezer and Mikhail Chemiakin. But the artists were not present at these shows, and the works shown were what was available. Mostly, my drawings were available.

RB: *In your installations, you seem to explore silence, yet there are active subconscious presences.*
ИК: No doubt about it. An installation, and especially one in an enclosed space, can influence a person in a very active way, on his memories, on his feelings about life in general.

RB: *Silence has something to do with life in the Soviet Union before perestroika. Do you see any parallels here between what is visible and what is not visible, or between an artist working officially and his hidden unofficial self? Do you think the hidden self was more powerful than the one operating above ground?*
ИК: Those are difficult questions. Maybe there is some connection between official and unofficial art in my installations, but in principle I would say that there was no connection to official art. It would be better to talk about ordinary, everyday Soviet life, which exists as a constant, permanent, and major component of all my installations. The ordinary, the quotidian, the everyday in its different forms—communal kitchen, apartment, asylum, orphanage—all of these are present. Official art and culture might be a part of it but only as a part of everyday life. I have to say it this way rather than that everyday life was part of official culture.

RB: *And what about socialist realism? It is all so positive.*
ИК: Well, I cannot accept it as art, but it was a very important part

of Soviet consciousness. Some strong and impressive works were made, especially in the 1950s.

RB: *Do you consider socialist realism to be a lie?*

ИК: Compared to what? There was no lie there. It expressed that hope, the utopia that existed, that joy of life which was an ideal. The word "lie" does not apply here. Look at it this way. When a person dances at night, drinks and eats something good, sings songs with friends, is full of enthusiasm and fire, and wakes up in the morning to see a broken table and overturned chairs, he does not think that the past was a lie. When we listen to the old Soviet songs, they seem filled with real energy and real enthusiasm. And I think, no, I don't just think, I saw the paintings that were also filled with such enthusiasm, with confidence, and feelings of joy. When the celebration was over, when the morning came and the person began to think, then he might have thought it was all a lie. But not necessarily the night before.

RB: *I've read that you like to deal with silence, but that you also like to tell stories. How do you deal with these two antithetical aspects in your work?*

ИК: An interesting question. My installations, especially the "total" installations, are rather complicated. They include visual images and narrative passages. It is as if I am directing a drama and, at any moment in an installation, a scene in this drama is taking place. Some kind of event is happening at that particular moment. The viewer transports himself into a certain moment of that drama and has to reconstruct, as in any painting, what was there before, and what may happen next. So in this sense, there is a story. The viewer knows what he sees and then realizes that the scene at that moment is an illustration of the larger story. So the viewer is a participant. A major requirement I have of myself and a necessary condition of the work is to insure contact with the viewer. I would like to foresee all the reactions and feelings the viewer might have in this interaction.

RB: *Claes Oldenburg made a piece called* Bedroom Ensemble *in 1963.*

You have made installations of Soviet rooms. How would you describe the differences?

ик: First of all, I love the works of Oldenburg. Now, what are the possible relationships? Oldenburg's bedroom has, of course, elements of the grotesque, and it is a parody since the room suffers from a hypertrophy of its parts. It is impossible to sleep on the bed and the lamp cannot be used for light. So the inhuman nature, the tastelessness, and the inability to sleep in this room is expressed and underlined. In other words, he has given an inhuman and terrible face to the commonplace. It is banal and in bad taste. When I make a work of everyday life I also include bedrooms and other rooms. Those are places in which Soviet life takes place. But for me those places are not the objects of parody or of the grotesque. Those are the places of normal life. Those are the places where one must live. On the other hand, of course, it is an unbearable life—an apartment in a toilet. But people try to live there as normal people. You could say that Oldenburg builds a room in which it could be quite possible to live well, but he builds it as a place in which one cannot live. In the Soviet situation, the situation itself is unbearable, tragic, but man lives a normal life in it. He tries to make it warm and cozy. In this respect the installations of Edward Kienholz [the California installations artist] are closer. I feel in him a soul mate, and I appreciate his works very much. They are of the same genre of total installation.

rb: *I think that you and other unofficial artists were very brave and heroic. Did you feel heroic?*

ик: Absolutely not. I felt like a normal broken Soviet person, very average, living an ordinary Soviet life. Very insignificant. Even more than that, I lived a pretty bourgeois life because I made a lot of money and could live better than the average Soviet person.

rb: *All modesty aside, when you look back, do you see an heroic side to your activities?*

ик: There was nothing heroic about it. I am telling you the truth. I felt it was an ordinary life then, and I feel I have an ordinary life now.

RB: *Some artists have said that they miss the past times, that they are nostalgic about them.*

ИК: What can I say? It is typical to idealize the past. There were a lot of nice things. There were close contacts, which were the most positive thing—this atmosphere of understanding and closeness. This is all gone now. No, I would not idealize this, because on the other side there were fear, panic, complete hopelessness, an ugly artistic life because there were no contacts, and you could not see your works exhibited. So there was both good and bad. The same is true for life in America. The friendly contacts are gone, but you can show your work.

The most exciting thing is that there is the opportunity to work very intensively.

Erik Bulatov and
Oleg Vassiliev
Эрик Булатов и Олег Васильев

BULATOV: Born in Sverdlovsk, in the Ural Mountains, 1933; Moscow Art College, 1947–1952; graduated from Surikov Art Institute, 1958; studied with Vladimir Favorsky; member of Sretensky Boulevard Group, early 1960s; emigrated to the West, 1989.

Began in the middle 1970s to make works broadly within the sots art canon of realistic and figurative images overlaid with printed words and slogans.

VASSILIEV: Born in Moscow, 1931; graduated from Surikov Art Institute, 1958; emigrated to the West, 1989.

Works in a variety of media. Explores the relationship of the Soviet social world with that of the "real" world in styles ranging from sots-art realism to constructivist-derived forms.

RB: *When did both of you start to paint?*
OB: I don't remember when, but it has always been a part of my life.

ЭБ: The same. From early childhood.

RB: *When did you become aware that you were nonconformist artists?*
ЭБ: Until about 1958 I had consciously included myself within the tradition in which I was raised. But it became apparent to me that what I had begun to do, and what I intended to do, would not be the same. What I had to do officially was different from what I intended to do. This was a conscious choice on my part. I wrote an essay expressing my fears and anxieties and inwardly tried to dissuade myself from changing direction. But the moment I said this to myself, I knew that I had been moving away from official acceptability. I also knew that my friends and companions were doing the same. I felt we were in the middle of a pond equidistant from both shores, but we continued to swim forward, to the opposite bank. But in retrospect, I realize that even as a boy attending art school I knew that the teachers were watching me, and I tried to please them. At home I did something very different. At home I could work on projects of much greater importance to me than those I did at school. I knew enough to know that I could not show to my teachers the work I did outside of school. At the Surikov Institute in the mid-1950s this separation of private and public thoughts and attitudes became painful, particularly because the 1950s were years of crisis for us. I realized that everything we had learned was a lie and that I really had to start over again, to learn everything from scratch. When I finished studying at the Institute in 1958, I had to face the question: was I a dissident? But I was certain that I did not know anything and that I had to be absolutely free in my development and education. After answering that question, I had to find a way to earn a living, find a position that would have no relationship to my professional work as an artist. I had no idea what kind of an artist I would become, but I had to be absolutely free in my choices and free from the officially accepted art styles.

RB: *And you, Oleg?*
OB: I felt much the same way. I had gone to school and learned to paint. But what I painted had no relationship to what I experienced. My professional training did not parallel my perceptions. So I abandoned socialist realism.

RB: *How did this rupture manifest itself in your work?*

OB: Right after graduating from the Institute, Erik and I were still shown in youth exhibitions. But then we stopped showing works. We needed to earn a living, so I tried different things. I worked as a printmaker, at times as a painter, but under a pseudonym. We began to illustrate children's books. We worked as if we were only one person when, in fact, we took turns making the illustrations and used only one signature. We did this for thirty years. It spared us from being associated with these works. In addition, when I would be making the illustrations I believed that I was helping Erik, and the same is true for Erik. It made the situation bearable.

ЭБ: This was the situation in the Soviet Union. The state was the chief patron, the buyer, and the owner of art. We had no opportunities to sell our own works, apart from the government. All works for exhibitions and all economic exchanges had to be carried out in compliance with governmental organizations. This is why we were forced to become book illustrators. You have to understand this. There were no independent collectors or buyers and no art market at all. Only the government, which acted as the commissioner of art and paid for the art. But in order for the government to buy your art you had to be an artist with a particular mind-set. My freedom was more important to me. I was not antagonistic, but I required inner freedom. Later it became evident that once we adopted this attitude we automatically became part of the opposition to the official artists.

RB: *Would you say that you went underground during these thirty years.*

ЭБ: Only in the sense that we did not show our works officially anywhere. Friends, such as Kabakov and Chuikov, and the poet Seva Nekrasov, did come and look at our art, but we were not in exhibitions.

RB: *Did you belong to a circle within the intelligentsia?*

ЭБ: This is a complicated question. There were circles within circles, and some cut across disciplines to include scientists and writers. But Oleg and I generally stayed away from these groups,

away from the pulse and energy of Moscow. In the 1960s there were two main groups among the unofficial artists. Oskar Rabin was central to one of them, and it included Vladimir Nemukhin, Nikolai Vechtomov, Lev Kropivnitsky, and Lydia Masterkova. Artists in this circle were the first to try to support themselves by selling art, rather than by moonlighting as illustrators or set designers or whatever. But there could be serious consequences from doing this. The only possible buyers were diplomats and other foreigners in Moscow. But since these potential clients did not always have sophisticated tastes, artists had to paint accordingly. This might have put some kind of a mark on their work, but the important thing is that there was such a group, a group that declared itself self-sufficient and independent of the official world. The second group tended toward surrealism, and there was a certain amount of antagonism between the groups. The ideologue was Yura Sobolev, and the group included Ernst Neizvestny, Yankilevsky, and, later, Kabakov. There was also another very loose group, an avant-garde group that worked with mobiles. Francisco Infante was part of that group for a while. And then there were also individuals, like Krasnopevtsev, Oleg Tselkov, and Mikhail Shvartsman, who were important, but shied away from groups. And there were many others as well, such as Anatolii Zverev.

OB: I consciously distanced myself from these groups and all their activities because I wanted to develop as an artist and resolve technical questions first. I did not even take part in the Bulldozer exhibition in 1974.

ЭБ: Nor did I.

OB: I believed that joining the social struggle would harm my work. I would not have been able to split myself in two. I missed something, perhaps, but I worked at my art. My works of the 1970s were largely unknown, and I did not sell anything until the end of the 1980s.

RB: *Did anybody connected with the government see your work?*
ЭБ: Officially we existed as illustrators of children's books. We

were admitted to the artists' union as illustrators. So this allowed us to have a studio and obtain supplies. As illustrators we functioned in the open. As artists we never showed our works except in rare, one-evening exhibitions. I remember two—one in a café and one in a group show at the artists' union.

RB: *Were you persecuted in any way?*

ЭБ: Not directly. There were threats that were not carried out. During Khrushchev's time things were easier. Later, we would be called in by the artists' union, and certain suggestions would be put to us. This occurred particularly at a time when we were written about in foreign periodicals. Our art was hardly seen and did not really interest the officials. It did not upset anybody. We could do as we pleased until we received attention, particularly in the magazine *A-Ya*. This was a very important journal. It was published in Paris by Igor Shelkovsky and was the first magazine to bring to light the nonconformist artists in the Soviet Union. After we were written up, we were admonished by the union. At that time the union imposed a system of supervision, or surveillance, in such a manner that the artists themselves helped implement it. We were not called by the KGB, but those in charge at the union were instructed to frighten us. They were not familiar with our work and did not understand why they were supposed to reprimand us. But they knew they had to do it. One time I was told that the Voice of America discussed my work in a broadcast. The union assumed that since the Voice of America was hostile to the Soviet Union, it was my responsibility and obligation as a Soviet citizen to respond critically to the broadcast. I said that I did not hear the broadcast, so I did not know how to respond. What was I to oppose? Actually, the broadcast was about some of our works at a New York gallery and the New Museum of Contemporary Art in New York. It soon became clear that the officials hadn't heard the broadcast either since it was forbidden to listen to the Voice of America. At least nobody would admit to listening. So nobody knew how I was to respond, but I was still considered to be in a compromised position. The charges fizzled out. But this is how they acted—with threats. They threatened to take away our studio and to exclude us from the artists' union and all the privileges of membership.

RB: *Were you able to see examples of modern art?*

OB: When we were at art school it was prohibited to look at modern art. But in the magazine *America* there would be reproductions. I remember one of a Jackson Pollock painting. During our early development we had some vague inkling of the Russian avant-garde of the 1920s. The teachers gave hints, but we had to find out for ourselves. Erik participated in a near revolt against our professors by students who wanted to find artists who might still be alive. We both ended up looking for them. The most important of these older artists for me was Vladimir Favorsky [an artist who placed considerable reliance on the function of line as an organizing principle]. We visited him frequently, and we even tried to have him hired by the Institute. He was very patient and answered many questions. At different stages in our development, he would answer at appropriate levels of complexity. He was very important for us. Robert Falk and Arthur Fonvizin were also important.

ЭБ: I would say that when we studied at art school we knew nothing about Western art, not even the late-nineteenth century, let alone the twentieth. We had basically no knowledge of our past art history. Even examples of the Mir Iskusstva [World of Art Movement] in St. Petersburg in the late-nineteenth century were hidden from us. They were not in the museums. Only one work by Mikhail Vrubel could be found in the Tretiakov Gallery. [Vrubel, a late-nineteenth-century figure was considered an extreme formalist.] Expulsion from art school was the punishment for anybody who wanted to write about Vrubel. This is why we had no knowledge of Renoir or Monet and others. But right after Stalin's death [1953], some of their works appeared in museums. The process of learning about them was rapid and intensive. Contemporary art was still out of bounds, but late-nineteenth- and early-twentieth-century art seemed contemporary to us, since none of it was familiar. In the late 1950s there were a number of important exhibitions—a small Picasso show, which included some of his late work, and a show of French and American painting. These were important for us, particularly Jackson Pollock's work, which we saw in an exhibition in 1958. The journal *America* was

JACK ABRAHAM

Oleg Vassiliev, *Spatial Composition*,
1986, oil on canvas.

important, and pop art appeared after we finished out studies. But
by then, we could get some information, although with difficulty, about
contemporary Western artists. It is one thing to see paintings in exhibi-
tions, and another to come upon illustrations in a magazine, though.

RB: *What do you want to express in your art?*
OB: I would like my works to reflect my sense of the world. I
search for a correspondence between my work and my world
view. Well, sometimes my world view is a tirade. But, generally, I
have a concrete impression derived from everyday life, from
experience. But it is only concrete in an emotional sense. How this
gets embodied in my work is something I don't understand. But it
occurs when I am sketching. The result should be emotionally
evocative of what I had envisioned, not in a literal sense, but of
what I had perceived. Space is important for me. For example,
here is a canvas. What does it represent? It is stretched on a frame.
It has energy and spatial possibilities. Until 1968 I explored these
properties. After, I began to explore the lateral expanse of the
picture plane and its possibilities. I was after a dynamic space, and
the means to synthesize this space with a representation of what I
saw in the world around me. I wanted to meld together the
quotidian, what I saw as an average person experiencing the

world, with what I felt as an artist. I wanted to energize the ordinary within an organized, geometrical structure.

RB: *And you, Erik?*

ЭБ: My problem was that the life I lived could not give voice to my art. The two were totally separated. Official art provided a false image of our lives. A deliberate deception existed. Unofficial artists like myself found this false image of life to be base. Yet, the worst nightmare of an intellectual or a dissident artist was to be considered not a Soviet person. So we lived this Soviet reality. Our minds, our brains, for better or worse, were formed by that reality because we were fed propaganda since childhood. But if a person was embarrassed by the fact of being Soviet, then he tried not to speak in that language, particularly in the Soviet art language, which, in effect, he saw and spoke everyday. Rather, he wanted to express himself in a more cultured, more sophisticated language he basically did not know. He wanted to learn, but could not easily find the means to learn, the language in which artists expressed themselves, either the language used before the Revolution or the one used by contemporary artists. Before perestroika we circled around both languages, the Soviet and the art languages, and tried to work out the problem in our art. Our art became like a foreign translation of the real language, but there was really no language because we hadn't learned it. It was important to find that language with which this life of ours could be expressed in art. Oleg spoke of this when he said that he searched for a correspondence between his perception of life and its representation in art. The idea was to find a language in which we could think and express our thoughts. This was the most important problem of our generation—to find a way to express our life, to represent it without fear of being suspected as either pro- or anti-Soviet, and, for me, to represent our life without it having any particular signification other than in the way it might be envisioned. That is, I didn't want to express sheer dislike of the Soviet system or of its false picture of life. That would color my images beyond the limits of what I believe art should be. (Actually, life was nightmarish.) I wanted instead to show how life was really lived, and I didn't know how

to represent it. I wanted to be objective, to express life as it appeared before me—not my personal relationship or view of life—to express myself in such a way that each individual in the Soviet Union could say, "Yes, I understand. This is my life. This is reality." I wanted to find a means to express reality as it was, to express it as objectively as possible, rather than as a personal experience.

RB: *What do you mean by objective?*
ЭБ: I knew then that if I represented life from a subjective point of view, I would hold back something so that a painting would not carry much importance. But if I worked consciously and with awareness, there couldn't be any distortions. It's like backing off a bit and asking, "What *is* this, objectively speaking?" I could show the viewer at least one aspect of his reality, and seeing this reality in art could be a liberating experience. It appeared outside the self, literally on canvas. It could provide a way to clear one's mind of the ideology embedded in it. I didn't want to seem like an artist teaching the viewer, but that the viewer and I were the same person, or at least in the same situation, trying to be aware of our situation.

RB: *And you, Oleg?*
OB: I take a different position. My personal view of the world took precedence over what I apprehended or experienced in an objective way. There should be some correlation between the two, between my perceptions and my experiences, but that my percep- tions were dominant, otherwise, I felt as if I were walking down a dark street at night on wet pavement or falling into a deep pit. I had to impose meaning on reality. In regard to the government, we were not activists fighting the system. But if you conscien- tiously did your own work, you were inevitably in the opposition, even if you didn't make anti-Soviet pieces. People who honestly occupied themselves with their work automatically became the enemy and could not show the work.

ЭБ: Immersion in your own work was immediately tied to de- ideologizing the system. But as I indicated, ideology is the death of art, and so by inference we were in conflict with official policies.

OB: Our protest was to assume a professional stance.

RB: *Has your work changed since you have been living in the West?*
OB: Nothing has changed, really, except some Western themes have wedged their way into my work. But this is a natural development. They were painted into the kind of structure I had been developing before leaving Moscow.

RB: *And you, Erik?*
ЭБ: In principle, I always worked with materials obtained from experience. I still do. I have changed through maturing, but this would have happened had I remained in Moscow. I am very interested in American and western-European art, but at my age I am not much influenced by other artists.

OB: Eric and I arrived in the West as mature artists. It is easier to work here because materials are more easily available and opportunities are greater, but our work continues to be based on the realization of the programs we developed in Moscow.

ЭБ: The major change is that we no longer have to work half a year illustrating children's books.

OB: We can work more intensely now. I used to produce four canvases a season, which seemed like a lot. Now, I make four or five works for each exhibition. This is an incredible change.

ЭБ: Since 1989 I have painted almost as many works as I completed in Moscow between 1971 and 1989. In part this is because I don't have to change from one type of work, illustration, to another, painting.

OB: After working together for so long as illustrators, we had to find our own selves once again. We had to reestablish our own characters.

We had to have a lot of patience.

★

Oleg Tselkov
Олег Целков

Born in Moscow, 1934; studied at Moscow
Secondary Art School; studied at the Minsk
Institute of Theater Art, 1945; studied at the
Academy of Art, Leningrad, 1955; gradu-
ated from the Institute of Theater, Music,
and Cinematography, Leningrad, as a stage
designer, 1958; immigrated to France, 1977;
lives in Paris and in east-central France.

Best known for painting "Tselkov" heads
in various permutations.

RB: *When did you know that you were a dissident artist?*
ОЦ: I grew up in a factory district outside of Moscow where my
parents were employed at a secret military factory. Only a trolley
car came to the area in which I lived, so I never went to Moscow.
I had no affiliation with any cultural center and never saw any
paintings or knew any artists. My father had dreams of becoming
an artist when he was young, but those were difficult, hungry
years. He told me that oil paints existed, but this was like a fairy
tale to me. When I went to a pioneer youth camp I met the arts and
crafts director whose work consisted of painting walls for hanging
newspapers, signboards for toilet signs, and posters with state-
ments like "Hail and Thanks to Our Comrade Stalin for Our
Wonderful Childhood." This fellow introduced me to oil paints. I
had no idea what to do with them. I bought a piece of plywood,

because I didn't know that canvases existed, and painted a land-scape on it. The arts and crafts director then told me about an art school where children learn to paint. Since I didn't belong to any group within the Young Pioneers circle, I decided that I wanted to study art. For the entrance exam I had to draw with a drawing pencil—I never once had held one in my hand—for the director of the school. People came to watch this crazy kid, who didn't know anything, try to express himself and compete with youngsters with many years of training, actually children of artists. I got into the school, which was for children of gifted parents, and soon after went to the Tretiakov Gallery for the first time. This was 1949, the time of the "doctors' plots" against Stalin, a terrifying period, which included the struggle with "cosmopolitanism." At school I had never met such people, people with sensitive faces, who could talk about art. In defense I began to formulate my own point of view about art that violated many rules of art. I decided that what you make does not have to look like the model. I also realized that since I had no systematic schooling, I had to be a creator from the very first day. When the teachers said that I should learn first before trying to create, I had no sense of what they were talking about. Of course this was naïve, but I was a barbarian from the provinces. I realized that I had better educate myself as quickly as possible and got as well rounded an education as possible. Well, I was expelled during my second year there but was reinstated. I just had to do things my way, and so I was a dissenter from the start. After that I studied only in short spurts.

RB: *Where else?*

OU: The school I was telling you about was run by the Surikov Art Institute. They had no use for anybody like me, and so they gave me failing grades. Then I went to Minsk to study at a new art institute so that I would not be drafted into the army. I lasted there a year. Then I went to Leningrad, to the Academy of Art, and also lasted a year. Some Chinese students petitioned for my dismissal because they said I made bourgeois propaganda art. They knew of such art from Japanese examples. But this was really an excuse to get rid of me.

RB: *Were you influenced by any teachers?*
OЦ: I never had an art teacher. People thought I had derived my style from somebody, a teacher somewhere, but I never had a teacher. If there had been one to teach me the way I painted, the KGB would have shipped him off to prison or a labor camp. The fact is, I just would not submit to anybody in power. I had decided that for me art was a holy occupation and that I was an artist, and that was that.

RB: *Aside from getting kicked out of schools was this a dangerous policy to follow?*
OЦ: The KGB bothered me for the rest of my life in Russia. The first time I was summoned, I was impertinent. The last time they called me in was because a friend had been arrested. Although I was asked about things I knew, I denied everything and screamed at the investigator that he would do anything to get an extra star on his shoulder straps, even spill the blood of an innocent person. After that I was never called again, but they threatened and terrorized me in different ways. For example, let's say a policemen in civilian clothes might stop me and ask for my passport. Or a person would knock on my door and ask about the person upstairs. It didn't take much intelligence to realize what these meetings meant. They were acts of terrorism against me. The most important thing, however, was not to be afraid. One time when I was leaving Leningrad the KGB told me to sign a document that said they had not talked to me. I said that they had engaged me in conversation and that I was a chatty person who couldn't keep his mouth shut. So I had better not sign any agreement. They answered that even if I wouldn't sign, I had better keep quiet. Immediately, I went across the street to call a friend on a pay phone. This must have been in 1960. On another occasion I saw a man in a brightly colored hat outside of my building when I went out to buy bread. When I left the store there he was, parading up and down. So I gave him the finger to let him and them know that I was not afraid nor was I guilty of anything. Then another time they called my father to the Lubianka prison. "Are you free? Could you please visit us," they said to him. They wanted to know

what I was up to, and he said that I make pictures. They answered that I didn't work and was being a parasite. My father said that I painted at home all day long. Since he and my mother worked, they had enough money for an extra bowl of soup for me. My father got very indignant and wanted to know if they had a warrant to arrest me and if I had stolen anything.

RB: *Your father was a smart man.*

OLI: It's not smartness as much as a peasant type of mentality. This saved him. Besides, none of our relatives were in prison. In fact, my father really didn't know about the labor camps. When Khrushchev exposed Stalin, my father didn't know what to make of it. In any event, I never participated in demonstrations or signed letters of protest. I lived my own life. I didn't rob or steal, and the rest was nobody's business.

RB: *Would membership in the artists' union have helped?*

OLI: Yes. I immediately would have ceased being suspect. As long as I could show a card the KGB and the militia would have been happy, since they were just doing their jobs. They would have as soon spit on me as on the government. I got into the union as a theater painter by organizing a performance, even though I had had no experience in the theater. When the union looked at my paintings, I told them that they were backdrops.

RB: *Did they believe you?*

OLI: Yes. Once in the union I could do as I wished except paint signs like "Down with the Soviet Government." I thought to myself that they could read whatever they wanted into the faces I painted. If they couldn't see their reflections in those faces, well, so be it.

RB: *When were you admitted?*

OLI: Around 1965. But after a few months, I was expelled. I was given an exhibition at the Cultural House of Architects in Moscow. It lasted for a single day because a KGB man told me to close it down at once. I said I had no intentions of doing so. He then ordered an employee to turn off the lights. Everybody in the place

then had to leave in darkness. The following day the union noti-
fied me that I was under interrogation, which meant that I had to
meet with party people at the union building. They looked at me
as if I were an elephant with two trunks. They wanted to know
what happened at the exhibition but never asked to see my paint-
ings. I told them that I had an exhibition there, that I was a theater
painter trying out some new ideas for the theater, that I had
painted circus themes. Their decision was to dismiss me from the
union. They said I had broken regulations, but they weren't sure
which ones. In fact they were told by the KGB to expel me. A friend
in the union later told me that if I had cried or looked remorseful
I might have dissuaded the hardest of the hardliners, but I had
behaved as if I had done nothing wrong. Now *that* was a crime. My
friend also said that my file was a fat one. But since I had done
nothing wrong—I didn't even hang my show since somebody else
had done it—I realized that they just wanted to scare me. Maybe I
would just disappear from view. I might stop painting, and no-
body would come to visit my studio anymore, particularly for-
eigners. They were really afraid of foreigners because they didn't
want us to find out about life in the West.

RB: *Did you know foreigners?*
OII: Yes. Foreigners did visit me. Oskar Rabin seemed to know
almost all the diplomats. His work sold, but my paintings seemed
to frighten people, at least foreigners. Evgenii Yevtushenko, the
poet, once brought Arthur Miller [the playwright] who bought a
piece of mine.

RB: *Did you belong to a circle or group?*
OII: No, but I did have three or four close friends, including
Yevtushenko. Another was a geologist, and the third was Alex-
ander Levin, an engineer, who now has an art gallery in New York
City. He would buy works on installment. Many people came to
my apartment to see my work, including KGB members. Recently
I spoke to a friend whose father, a painter, often visited me. My
friend was astonished that his father was a regular at my studio and
told me that his father had been a KGB agent, a famous KGB agent.

RB: *What was the KGB looking for?*

OЦ: Nothing specific, just information for their file on me.

RB: *Were you involved in the Manezh exhibition in 1962?*

OЦ: I never knew Beliutin, but I knew some of his people. I had contempt for this type of exhibition, as well as the Bulldozer exhibition [in 1974], because neither made any sense to me. If you live in a land of monkeys who jump around in trees, then what's the use of developing new modes of behavior? You know that under the Soviet system these shows were forbidden. Why bother breaking the rules? You are just asking for trouble. Was it worth it to get sprayed with fire hoses at the Bulldozer show? Well, I am a painter, not a demonstrator, and I didn't want to get involved with these things.

RB: *How do you define dissident?*

OЦ: I really don't know. I do know that my literary friends who were involved with political literature were called dissidents. They were openly against the regime, and they openly criticized the authorities. I, too, was absolutely against the regime, but I was also absolutely against criticizing it. How can you criticize a regime of monkeys? My feeling was to let them live the way they wanted to. That was their business.

RB: *Could you obtain materials?*

OЦ: It was never a problem. But sometimes you could wait two years to get something you wanted from one of the art stores—it could take that long for the factories and the stores to get together on things.

RB: *How did you support yourself?*

OЦ: I sold paintings from time to time. Food and rent were relatively inexpensive—a ruble a day for food. I lived on a very tight budget and asked people to bring food when they visited.

RB: *I understand that Malevich was important for you?*

OЦ: When I was young, I would try to get to the Tretiakov Gallery as often as possible to see the paintings there. And I also got to know the guard at my art school who would let me see the works,

still in storage, of old students. These works were entirely different from what we were being taught to do. The guard told me about the storage rooms at the Tretiakov, and I finally got to see what was in them, including the Maleviches. The same thing happened at the Russian State Museum in Leningrad when I studied there. This was in 1957. I copied a work by Malevich, and my copy is still there. When I was working on it, the guard said that if anybody came by, I should say that I was just browsing and then move on. Anyway, Malevich became a role model, along with Rubens, Rembrandt, and Henri Rousseau. But the Malevich I loved was the late Malevich, the one who painted peasants. I did not, and still don't, like Malevich the suprematist. Suprematism is basically nonsense. It expressed a pre-Revolutionary time, something like a continuous futurism. I thought of it as a kind of onanism. There is no life in it. It must have been a bunch of impotents who were involved in that kind of art, but they did it brilliantly, masterfully. Of the late Malevich, I love the fields and skies he painted, and his portraits are phenomenal, unheard of, sheer genius.

RB: *Since you lived in Leningrad, did you see any differences between artists who lived there and those in Moscow?*

OU: I lived in Leningrad from 1954 to 1960. Moscow seems to be a mercantile city and is filled with big, fat people who eat and drink a lot. Leningrad is an aristocratic place where good taste reigns, but it is a provincial place. Otherwise, I saw no differences, except that people were always more fearful in the provinces.

RB: *When did you first come in contact with Western art?*

OU: Interesting that you ask, because the first time the KGB summoned me they asked the same question. But I do remember very well the first time I saw Picasso's work—at a show at the Hermitage in Leningrad. I can't say that I found everything comprehensible, or even interesting, so I didn't spend too much time studying it. The truth is that I am only interested in those things that pertain to me as an artist. Even Cézanne's work, which I saw in 1956, did not enchant me at first. His forms looked helpless and powerless. I tried to like and to understand him until one day I discovered

that he really was a great painter, a painter of cosmic stature. Léger, I liked from the first. I recognized some part of my own work in his paintings. Then, in 1957, there was the exhibition at the International Youth Festival in Moscow. I even had a small painting in that show, a still life. I also had some paintings in a show of young Moscow artists in 1956. Critics called my work "decadent impressionism" and "putrid Western art." But I believe they understood little about art and didn't have a clue about who I might be imitating. My pictures were used as an example of decadent art. Taken altogether, the exhibitions of Western art did not impress me too much. But this is due to the fact that I couldn't tell a lot from a single painting that was supposed to represent an artist's career. At the youth festival I saw a lot of smears, like chickens trying to smear with their chicken legs. They were not like Rubens, who can send chills up and down your spine.

RB: *I assume you don't care for abstract art?*
OU: I just don't find it interesting. The painting by Jackson Pollock at the festival was a very small one. I was able to get very little from it, especially anything about his pouring technique. I needed a room full of Pollocks.

RB: *Did you participate in apartment exhibitions?*
OU: Very seldom. My first show was at the Kurchatov Institute for Atomic Energy around 1965. The physicists had freedoms that were denied to the rest of us. So they had exhibitions at their place, which was in the Moscow suburbs. My show was supposed to last a month, but the KGB made them take it down after a week. They then put on a show of remorse, which they had to do if they were ever to hold another exhibition. They played the game right.

RB: *How were you able to leave Russia?*
OU: It is connected with Oskar Rabin. We all decided to apply for tourist visas to visit Paris. The request was legal since we had received an invitation from friends—immigrants—this was no problem. Everything was going along fine, and on the last day, when we went to get our passports, we were told that we would never get them or our visas as long as the Soviets were in power.

We were then told that if we would agree to leave permanently, we could go at any time. Of course, we said yes. We received a fictitious Israeli visa. I was coached to say who my relatives were in Israel. The official dictated to me my replies—something like distant relatives who had left during the civil war in Russia. Fortunately, my mother actually was Jewish, but the authorities didn't care about that. Another friend also left on an Israeli visa who had absolutely no connection to anything Israeli or Jewish. Anyway, I was able to take out all of my paintings, but only after an official evaluation was made. Naturally, I had to pay. First they gave me an astronomical number. So I went to the minister of culture and told him that he never exhibited my works, that he got in my way all of the time, that he didn't let me paint the way I wanted to, that he never bought any of my pieces, and now he wanted an exorbitant amount of money. I told him that if he didn't change his mind, I would alert all foreign correspondents and diplomats to the fact that I would light a bonfire of all of my paintings under his window. The tax came down quickly.

RB: *And what happened in Paris?*
OU: George Costakis, the collector, had given me some money, and through a dealer, Norton Dodge acquired some paintings. He had already acquired some of my works in Russia. And an Englishman I had known also bought some works.

RB: *Can you tell me something about the faces you paint?*
OU: In the 1960s I found what I call a golden vein. I had found what I was searching for—these faces. They change from painting to painting, and their meaning eludes me, although I feel I have discovered a new way of looking at human beings. But it isn't me who paints them. It is as if some force does it through me.

I paint everyday, but I have no idea where it comes from.

★

Ivan Chuikov
Иван Чуйков

Born in Moscow, 1935; Moscow School of Art, 1949–1954; Surikov Art Institute, 1954–1960; taught in art school in Vladivostok, 1960–1962; lives in Moscow.

A conceptual artist whose works are concerned with ambiguities of space and juxtaposed images.

RB: *When did you know that you were a dissident artist?*

ИЧ: You don't know precisely. You don't decide one day to become a dissident. And even if somebody had said to me that you are a dissident, I would have denied it. Why should one expose oneself to unpleasantness? What does occur, however, is a gradual change. I studied with classmates who became official artists. Now, of course, there are no more official artists. We remained friends for a long time, but then you first refuse invitations. Then you do not want to go to an official meeting of artists. You don't want to show at official exhibitions. Imperceptibly, you turn away. You estrange yourself. I first understood what was happening at the time of the Bulldozer exhibition in 1974. I didn't participate in that exhibition because I was not in Moscow. I was at my parent's dacha and heard about it on the radio program called "Liberty." Like a wild man I went there immediately and it looked something like Woodstock. It was truly an extraordinary event. Only then

did I realize, and became consciously aware, that those artists were working in the same manner that I was. I had never shown my works to anybody, but those artists interested me and I felt comfortable becoming one of them.

RB: *At the same time you made official art?*
ич: No. At that time I earned a living by teaching. Later on, I made decorative works, backdrops for theatrical works on collective farms. I also taught through a correspondence school.

RB: *Did you ever participate in dissident exhibitions?*
ич: Yes, two years later in 1976. There were seven simultaneous exhibitions of avant garde art in studios and apartments that took place on the same day. People traveled from one place to the next. This was a very important and exciting experience for me. It was the happiest moment in my life even though I've had many exhibitions since then.

RB: *Did you get to know the artists then, or did you know them already?*
ич: By that time, I knew many people. I was so overjoyed because it celebrated our endurance even though we were very fearful and scared. I had never seen my works hanging on a wall before. Until then, I worked in a very small room. In addition, we were all of us friends. Nobody argued about where to hang works or argued about whose works were better or worse. I have very warm and clear memories of that time. Of course, the KGB roamed around photographing everything and everybody. That part was unpleasant.

RB: *Did you belong to the circle of people who started* A-Ya?
ич: Yes. I was an active participant at its inception. The circle included the Gerlovins [Valerii and Rimma], Sokov, Alex Sidorov, an editor rather than an artist, and Igor Shelkovsky. When Shelkovsky left for Paris and began publishing the magazine, Sidorov was the most active person of the group in Moscow. At first, I helped out because I knew Shelkovsky very well. He

constantly wrote to me, asking me to pay attention to one artist or another.

RB: *Did the authorities bother you?*

иЧ: Initially, no. We knew they had come to look at the exhibitions in 1976 and that we were being watched. But nothing personal happened. However, after *A-Ya* began publication, the KGB called me in twice, the first time just before the first issue of *A-Ya* appeared early in 1979. They wanted to recruit me for their own purposes. My father was an academic, and they thought I had simply strayed, that I had fallen in with bad company, and that I would agree to work with them. When they realized that I would not, they did not pressure me. They also called in the other people involved. The first issue of *A-Ya* had not yet been published, and they weren't sure if it would ever come out. The second time they called me in it was about the magazine and our contacts with western critics. This meeting was particularly unpleasant. They had some of my letters which I had sent to Shelkovsky. Initially, I had told the KGB that I was a professional artist and was happy when people came to see my work. I said that I show my paintings to everybody and that I don't have any secrets. I also said that I gave copies and photographs of my articles so that I could not control or censor what circulated. But the KGB showed me the three letters—I don't know how they got them—in which I discussed issues in connection with *A-Ya*. The result of this meeting was not good because they caught me in a lie. I then lost my position and it became difficult to withstand their pressure. Afterwards, I realized that one should not lie, that however difficult it might be to tell the truth, one should say it. I should have said that "yes, I submitted materials to this journal as a professional artist, that I did not think *A-Ya* carried anti-Soviet messages, that it was not an anti-Soviet publication, and that our opinions differed." But I didn't say this to them, so it appeared as if I had lied.

RB: *Were you expelled from the artists' union?*

иЧ: They would have expelled us, but this second meeting took

place in 1986, a year before perestroika. There wasn't much time left for such matters. But they did threaten to take away my studio and to expel me from the union.

RB: *It means that they were more afraid of the journal than of your works, right?*

ИЧ: Of course. They weren't concerned with what I did privately in my studio. They must have thought "let him alone, let him draw. If it is his secret wish to play with these drawings under his blanket, nobody will be the wiser." I couldn't exhibit, anyway, since there were no exhibition halls. You were not allowed to sell anything. There were no buyers to speak of. But a journal is on a different plane because it is out there in the public domain. I also believe that like all secret police organizations, they couldn't bear to let something go on without their knowledge.

RB: *What about the artists' union?*

ИЧ: I remained a member, so I could still buy supplies. Even those who were no longer members could still get materials through friends who had a membership card. But now, in 1992, we have a big problem. Art supplies are hard to find.

RB: *Who were your first buyers or clients?*

ИЧ: In 1984 some Swiss diplomats came to look. They came often, but did not buy. Afterwards, somebody who became a curator at the Pompidou Center in Paris came with a Swiss collector. Then, suddenly, many people wanted to buy. I never met Norton Dodge in Moscow. He saw some of my works in magazines and purchased them through an intermediary. But I could not depend upon these sales for a living until after perestroika. Then gallery people showed up. Yet, it was very pleasant and enjoyable. We all gave away many works as presents or for very little money, a few kopecks, because we did not anticipate that everything would change and that we would be allowed to travel, to exhibit, and to sell our works. We let things go because we never knew what might happen—a fire in a studio could destroy everything.

RB: *When did you first exhibit in the West?*

JACK ABRAHAM

Ivan Chuikov, *All Power... (To the Soviets)*, 1985, oil on board, 160.2 x 122 cm.

ИЧ: Shelkovsky exhibited some works. I can't remember the dates. But the Venice Biennial of 1977 was dedicated to dissident artists.

RB: *When did you first see Western art?*
ИЧ: Occasional magazines would appear now and then. You can't say we were acquainted with the journals. But in 1975, Komar and Melamid began to get *Artforum* and some other journals regularly. Some of us, Aleksandr Yulikov, Sokov, the Gerlovins, and Shelkovsky, would get together, and I would translate the articles. We were the ones who exhibited together in Sokov's apartment in 1976.

RB: *What influence did these magazines have on your work?*
ИЧ: The articles had an impact, the ideas much more than the illustrations. I had never read anything about conceptual art. There was nothing like it in the Soviet Union. Local art criticism had nothing in common with this kind of writing, not the terminology, not the ideas, not the methodologies. But since 1969, before seeing these magazines, I was a fully matured artist, so the illustrations did not so much influence me as reinforce the direction

I was already going in. One other source of modern art was the illustrations in the magazine, *Krokodil*. One heading was called "Uncle Sam Draws By Himself." This was meant to denigrate modern art as charlatanism, but it showed modern art. Another work was called "The World Through a Hip Bone," a sarcastic name for a palette knife and a comment on Georgia O'Keeffe's work. Images like these worked at the unconscious level, while the *Artforum* pieces worked at the conscious level.

RB: *Did perestroika change your style and use of themes?*
ИЧ: No. I began my own perestroika early on, beginning in 1969. The term we used was "Moscow Conceptualism."

RB: *Would you call your works of the 1970s and 1980s political?*
ИЧ: I would not call them political, but at the end of the 1970s I began to use Soviet emblems—red stars, hammers and sickles—but not in canonical ways. I guess I profaned these emblems, but not on purpose or as part of a political protest. These emblems represented part of the world in which I lived. They were part of my reality which I incorporated into my art. I tried to send one of these works abroad through a Soviet organization which returned the work, calling it blasphemous. The image was a bit of a profile, a beard sticking out, Lenin's beard. Somebody in the organization must have understood what it was and wanted to know what was the matter with me. But the painting was not meant to be a caricature nor a political statement. The painting was about art.

RB: *Why do you stay in Russia?*
ИЧ: Well, I spend a lot of time in Germany and Italy. So it is difficult for me to say that I have remained in Russia. I vacation there. If it were possible, I would stay there. I like it there and find it interesting to be there. I can't answer for anybody else, but I feel that I should be there. I can't say why, but I want to be in Russia as an artist and as a person. Conditions are very difficult, but it is interesting. However, I can't stay permanently. We have silly and unreasonable rules in Russia. I can't take works out of Russia. So

Vladimir Yankilevsky, *Triptych #7*, 1967–1968, oil on wood, 117 x 93 x 30.5.

Aleksandr Sitnikov, *Abduction*, 1980, oil on canvas, 145 x 149.

Elena Figurina, *Victors*, 1983–1987, oil on canvas, 104 x 129.5.

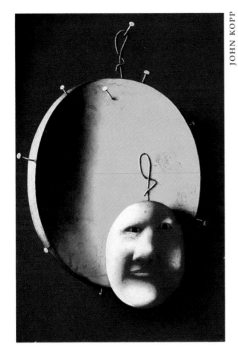

JOHN KOPP

Oleg Tselkov,
Falling Mask, 1976, oil on
canvas, 120 x 80.

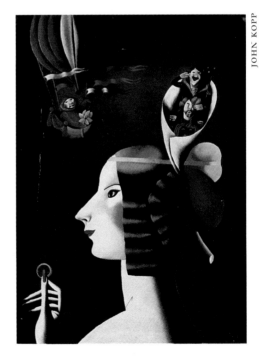

JOHN KOPP

Olga Bulgakova,
Untitled, 1973, oil, 66 x 48.

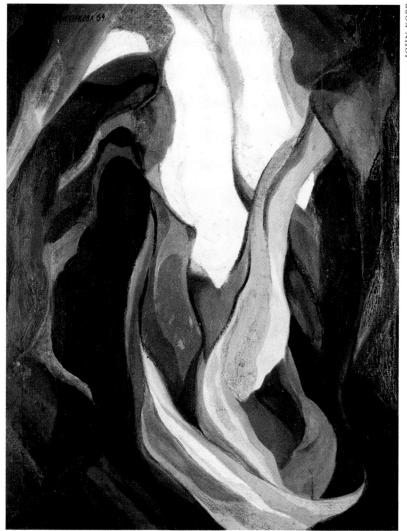

Lydia Masterkova, *Composition*, 1964, oil, 90 x 69.

Leonid Lamm, *The Tree of Life: Great Light*, number 1 from the series *The Signals of Space*, 1974–1977, oil on canvas, 200 x 140.

Oleg Vassiliev, *Stroll*, 1966, oil on canvas, 80 x 119.

Arkadii Petrov, *Times of the Day*, 1981,
oil and gouache, 60.5 x 52.5.

Alexander Petrov, *Untitled*, 1985, oil, 150 x 148.5.

Oskar Rabin, *Untitled*, 1963, oil on canvas, 50.4 x 70.

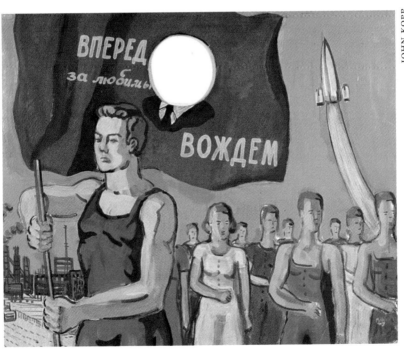

Alexander Kosolapov, *Untitled*, 1970, oil on board, 53.5 x 68.5.

Yurii Dyshlenko, *Concise Guidebook*, 1976, oil, 56 x 71.

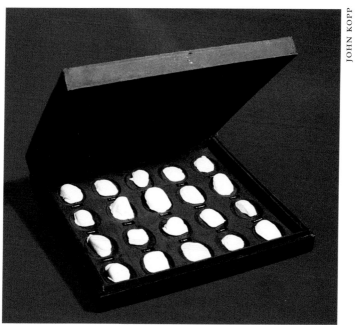

Leonid Sokov, *Problem*, 1976,
paint, paper maché and wood, 24 x 29 x 18.5.

Igor Makarevich, *Box Containing Plastercast
Impressions of Fingerprints*, n.d., mixed media, 5 x 28 x 25.7.

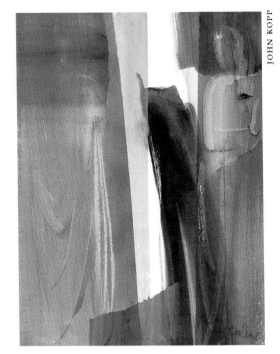

Džemma Skulme, *Untitled*, ca. 1983, water-color and gouache, 65 x 49.5.

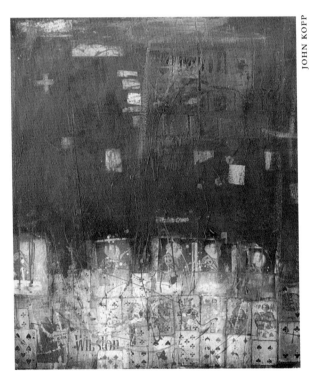

Gleb Bogomolov, *Untitled*, 1982, oil on canvas, 81 x 69.

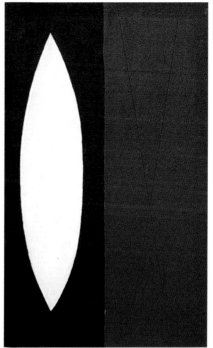

Valery Yurlov, *Counterform*,
1959, oil on canvas, 119 x 75.5.

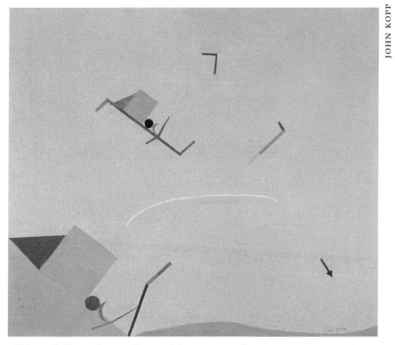

Eduard Shteinberg, *Composition*, 1977, oil on canvas, 50.5 x 60.

Erik Bulatov, *Two Landscapes on a Red Background*, n.d.,
oil on canvas, 110 x 110.

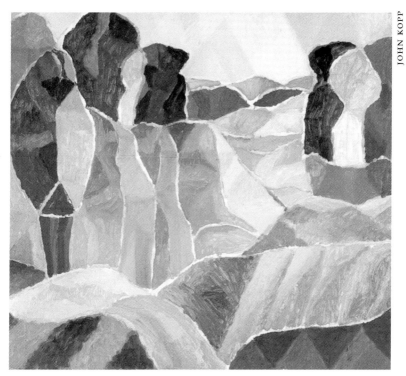

Gennadii Zubkov, *Country Road*, 1978, oil, 60 x 67.

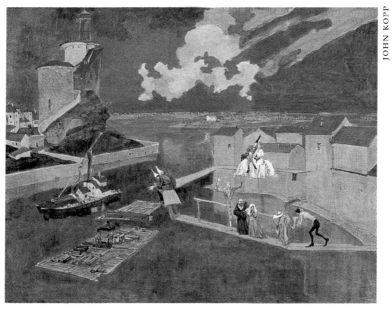

Boris Sveshnikov, *Meeting the Guests*, 1957, oil on canvas, 60.5 x 80.

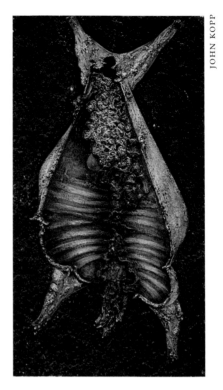

Mikhail Chemiakin, *Carcass*, 1970,
mixed media on board,
143.5 × 79.5.

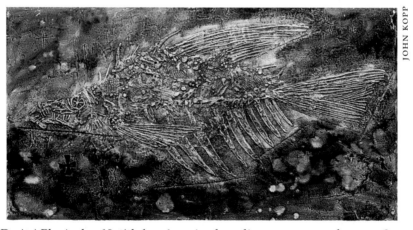

Dmitri Plavinsky, *Untitled*, 1965, mixed media, canvas, wood, 45.5 x 84.

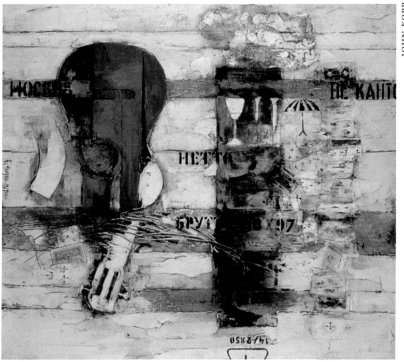

Vladimir Nemukhin, *Still Life with Guitar and Cards*, 1967, oil, 09 x 96.5.

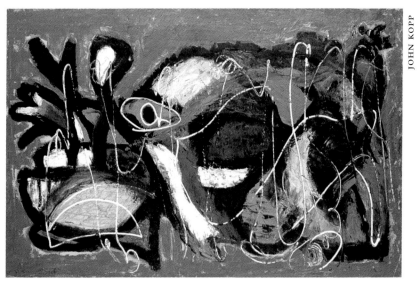

Elii Beliutin, *Landscape*, 1952, oil on canvas, 70 x 107.

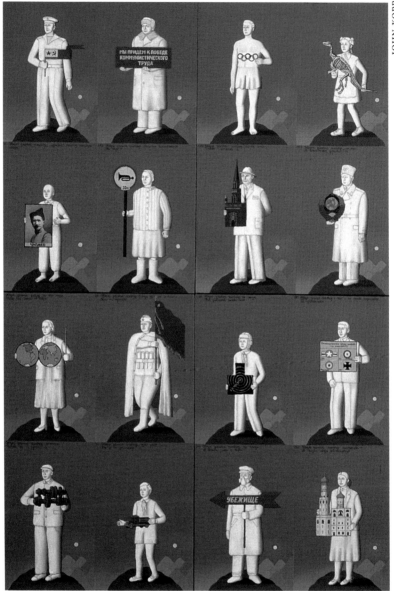

Grisha Bruskin, fragment from part III of *The Fundamental Lexicon*,
1985, oil on canvas, 112 x 76.5.

if I want to show in the west, I must work in the west. That's why I spend most of my time abroad.

RB: *Do you experience a different sense of physical and intellectual space since perestroika?*

ИЧ: On the one hand, everything is much easier now. I can travel and earn a living. My life is much better than it was. On the other hand, the atmosphere that existed in our circle is gone. Everybody has dispersed, gone away. Our mutual understanding and support, the interest we took in each other are gone. Nobody quite needs these things in the same way anymore. Everything has become commercial. In the west, you never had, at least in recent years, that kind of bond with the viewers and friends, that sense of mutual support. Now I work with galleries. My works sell to museums and private collectors. I am sort of back in the same situation before the Bulldozer exhibition where I have to depend on myself. The pre-perestroika atmosphere was an extraordinary occurrence. It existed only because of the oppression and persecution by the authorities. We lived underground. There is nothing like this in the west. We are now like everybody else. We live normal lives now under normal conditions. Then, it was very special, like living in a hot house. Each of us could believe that he was a genius. We confided in each other. We boosted each other's egos. Since we couldn't sell anything, we felt free. We never had to test ourselves in terms of raw talent. Now we are testing ourselves in the world of art. Now we are adults. Before, we were in an infantilizing situation. We lived as if in a nursery school.

RB: *American artists are often identified by groups or movements. Did you belong to a group?*

ИЧ: No. We had neither movements nor manifestoes. We were altogether, although some did call themselves the Sretensky Boulevard Group because they had studios there. The building was owned by the artists' union and artists could buy apartments there. But this was a long time ago. We were later called conceptualists.

RB: *Do you miss those days?*

ИЧ: Yes, I do.

RB: *I think of you and what you did as an important part of contemporary art history. Do you think of yourself as part of history, that you have helped make history?*

ИЧ: I don't know about myself, but I think that the entire dissident movement is a part of history. Perestroika began not only in political dissent, but in art, as well. Maybe I will agree that before perestroika our work had political meaning, but I and others did not think in terms of conscious political protest.

That political meaning is now gone and I try to find meaning elsewhere.

Yurii Dyshlenko
Юрий Дышленко

Born in Novosibirsk, Siberia, 1936; studied at the Polytechnic Institute and the Institute of Theater, Music, and Cinematography, Leningrad; moved to the United States in 1989; died, 1995.

Often made multipaneled paintings of carefully detailed surrealist-inspired forms that remain on the far side of intelligibility.

RB: *Where were you born?*

ЮД: I was born in Novosibirsk in 1936 and lived there for eight years. My family lived in different cities until we settled in Leningrad, now St. Petersburg, in 1954 where I remained until 1989.

RB: *Where did you study art?*

ЮД: At the Polytechnic Institute and the Institute of Theater, Music, and Cinematography in St. Petersburg. I began to draw when I was three. When my mother was at work as a Russian teacher, my father, a professor of mathematics, would sit me on his lap in front of an easel. My serious work dates from 1973. Before that I worked in the theater, did graphics illustrations for books, and read a lot about linguistics and structuralism—authors such as Roman Jakobson and Noam Chomsky.

RB: *When did you become a dissident artist?*

ЮД: I was never a dissident, since I was not engaged in politics. I believe that politics are not for free people.

RB: *Did you exhibit in Russia?*

ЮД: I never had a solo exhibition there; that occurred in 1988 in the United States. But I did participate in the first unofficial art exhibit in St. Petersburg in December 1974 at the Gaz Palace of Culture. It lasted about four days and around fifty, I think fifty-two, artists participated. I was never a member of the artists' union. There were others who also were not members. We were not an organized group, but we did exchange ideas and experiences. We socialized, but not as much as people do in Moscow. Most of my friends who thought like me lived in Moscow, such as Ilya Kabakov, Erik Bulatov, and Ivan Chuikov. So I did not have too many people in St. Petersburg to talk to. I met with my friends during trips to Moscow and during their trips to St. Petersburg. These artists are considered conceptualists, but we are all different. What we share is a concern for the concept, that the work itself should convey the concept.

RB: *Did you have problems with the government?*

ЮД: Of course. Everybody had problems. Each one of us was followed by the KGB, especially after the exhibition. The exhibition lasted four days, and about forty thousand people came to see it. This was the official number. We let people in for about half and hour at a time. We were about fifty-two artists, and each was given a partitioned section. We were extremely grateful to the public, which had to stand in line for up to five hours in cold, wet weather outside the Palace of Culture. When I first came with a friend to hang my works, I left them in a car. I told my friend that I would see how things were, and if I had not returned within ten minutes, he should leave with the works. You see, until the last minute, we could not believe that the exhibition would take place. We knew they would not arrest us, but they might confiscate the works. Well, I returned to the car in a few minutes because I saw that everybody else was hauling their works to their sections in the Palace. I was among the last to leave. I noticed a man, an ordinary

worker, drilling a hole in the wall. I asked what he was doing, and he said that it was for a speaker to play music. Well, how much can you hear from a tiny hole. No, clearly, this was a bug for eavesdropping, and there was one in each section. And if that might not work, during the exhibition, men sat in each of the sections, dressed in civilian clothes, listening intently to all conversations and writing down what they had heard. I exhibited nine works. I made a video cassette of them. The next year, 1975, I took part in another such exhibition at the Nevsky Palace of Culture with about ninety artists. This one looked more like a market place. As far as the KGB was concerned, it would have been difficult for them to understand my work. They did, however, break into studios, usually when the artist was not there. Sometimes they would set fire to the studio, but they would not take anything. After the death of Chernenko, and then with Gorbachev, they had so many problems of their own that they left artists alone. The authorities even tried to make money from us without giving us any official commissions. Rather, they would buy art from us in rubles and sell the work to foreigners for foreign currency. The government middlemen were thieves. For example, I did not receive anything for a series of twenty-four pieces that was sold in this way. I know who bought them, and where the works are, but I never received a penny.

RB: *Now that you are in the United States, can you remain a Russian artist?*

ЮД: Even in Russia, I was never a specifically Russian artist. I was never concerned with the Russian traditions in art, philosophy, or literature. Actually, there is no Russian tradition in art. Icons, for instance, should not be considered as art. They are representations of an entirely different order, but we cannot look at them as we do at paintings. I really think of myself as an artist, simply an artist. At least it says that on my documents.

RB: *Even so, have there been any changes in your work since you left Russia?*

ЮД: I have several problems I deal with in my work, but geographical location is not one of them. These problems go back to

my early development as an artist. But I will say that I found free-
dom in America. I found freedom to the extent to which I need it.
Freedom outside of myself. Freedom in the environment. In
Russia, I was inwardly free, but here I am both inwardly and
outwardly free. The outer perimeters or pressures here do not press
upon my inner freedom. In Russia I had to overcome and to resist
constant opposition because art was always used in the service of
propaganda. If you did not resist, you were in the service of propa-
ganda, in the service of negative power. The propaganda machine
decided which artist and what type of art were good.

RB: *Did you make any art for the government?*
ЮД: As they say in this country, I free-lanced. I did designer
work, graphics book illustration, and before that I did scene
painting for the theater.

RB: *Did you feel a personal loss when you left Russia?*
ЮД: Only for people. In my art, my perceptions and feelings are
my only reality. With these, I am familiar and comfortable rather
than with a reality with which I am not familiar. I paint from that
sense of inner experience, from both my sense of awareness and
from my unconscious. Let me put it this way. I seldom go out on
the street. I don't like being outside my home. There is an old
Russian saying: "At home the walls are helpful." Where I live now
is not an American house, but my house. It is neither Russian nor
American, but simply my house, my world. When I leave my
house, I feel an equal hostility to New York City as I did to St.
Petersburg. The street, wherever it might be, is equally foreign. I
am an alien. Drastic changes, impressions, too many stimuli frus-
trate me.

RB: *So your center is in your mind, not in a place.*
ЮД: Exactly. But I do want to say that I felt very good during my
first visit to New York, in 1989, for an exhibition of my work. I
stayed three weeks. The streets were very exciting—small stores,
crowds of people, lots of color, particularly in Soho, a perpetual
sense of change. When I returned to St. Petersburg, everybody
seemed so depressed. Russian faces look sad in comparison to

American ones. I believe that whereas Americans fear death, Russians fear life. After I returned to Russia my work became valuable, and underground businessmen bought some pieces. They were not government officials. I think they were really unscrupulous dealers who dealt in art as if it were contraband. I would give them a price and they would give me money. I thought I would build a house and studio in the countryside and live peacefully. But I decided that it was immoral to live well amidst poverty. For example, my apartment here in America could only have belonged to a government official, a big thief. Working conditions for me were hard in Russia, as well. I had a tiny studio because I had not joined the union. Paint, canvas, and stretchers were hard to obtain and stretchers might take half a year to reach me. They were also often poorly constructed. This was also due, in part, to the fact that nobody wanted to work. The artists' union had a very small store with supplies, local and imported items, but these were available only to members. For me it would not have been difficult to join since I was a graphics artist, a book illustrator, and had worked in the theater, but I found union members offensive to deal with. I did not want to socialize with them. Morally, I could not do it. I felt that if I spent much time with them, I might lose my manners and start eating with my hands. One of my acquaintances, a sculptor who belonged to the union, told me that a bas relief he had made of Lenin would become immortal because of its association with Lenin. I told him that I would rather have a work live because of my signature. I decided to immigrate to America. We left in 1989, but only after the authorities delayed my family's departure by two weeks.

RB: *What inspires you?*
ЮД: I'm not certain, but process itself interests me. I would say, for example, that what is beautiful is the movement toward beauty. Whether there is an ideal beauty is less important than the process. With the process, we create a model that forms and fills space. It has no end or closure, and that is what I would call beautiful. Meaning develops from process. Knowledge results from the construction of many elements. I leave my work half

finished, in a state of semisynthesis, in a state where meaning is not yet fully attained, where the viewer has not quite gotten the full meaning, but at the point where anticipated discoveries are possible. The separate elements are coalesced into a whole, but the work is not yet fully completed. A work is never fully completed.

RB: *Do you have anything in mind when you begin to make a painting?*
ЮД: I don't have an inspiration. I do have a sketch, though, which I've worked on perhaps as long as a month and which I prefer to leave half finished. A theme emerges, but this pertains to space, not to meaning. I had obtained good technical training at the Theater Institute, so I can work fast. I always know what I am going to do, even when I know I will have to paint over a form several times. Paintings are finished in acrylic, which I began to use in 1978, over a period of time—from two days to three weeks. In my first year in America I made forty-nine works, almost one a week. I guess freedom counts for something.

RB: *Does your work convey any religious feeling?*
ЮД: No. I usually work on a conception, say a yellow spot, that keeps developing. Relationships between forms change gradually until as they merge into some larger concept. I do not pretend that my works are of a spiritual nature or a manifestation of a person's spiritual life, but they obviously can provoke personal thoughts.

They are catalysts, and the viewer can look at my works as I do. With empathy, the viewer might even paint, as it were, a better picture as he completes the painting; better than I might have done.

★

Dmitri Plavinsky
Дмитрий Плавинский

Born in Moscow, 1937; Moscow Regional Art College (known as In Memory of 1905 Art School), studied in the Scenography Department, 1951–1957; first of several trips to central Asia, 1958; immigrated to the United States, 1991.

Makes extraordinarily detailed paintings of disparate objects that are invested with notions of movement through time and space.

RB: *Did you consider yourself a dissident artist?*

ДП: Being a dissident is like having a profession. I don't consider myself as such. Rather, I always thought of myself as a free individual and a free artist. It didn't matter that I was in the Soviet Union. I would have behaved in a similar manner anywhere.

RB: *Did you exhibit in the Soviet Union?*

ДП: We had individual shows in private apartments. We called it apartment art. The government would not give us any space, and, besides, we could be persecuted. My first dissident show was at the apartment of Ilya Ivanovich Tserlin in 1961. Tserlin was an important art critic in Moscow who introduced my work to a group of leftist intelligentsia. I sold a work to George Costakis for 200 rubles, an incredible amount of money then. Usually we exchanged works for clean canvas and oil paints.

RB:　*Did you paint religious subjects?*

ДП:　Lenin tried to destroy religious consciousness in the Soviet Union. People could not go to church, and they were persecuted if they did go. By the 1960s, the antichurch policies had softened, but religious freedom was still suppressed. Of course people protested, and many among the intelligentsia, I among them, turned to art dedicated to the Russian Orthodox Church. I represented what I felt, saw, and experienced. But I did not paint only religious themes. In the early 1960s I traveled throughout the Soviet Union, visiting many cities—Pskov in the north and also Novgorod, where I copied old frescoes directly, which fascinated me. My copies were enormous, and since I had no place to keep them, I threw them out. My intentions were to represent the terrible condition of religion in the Soviet Union. I did not make illustrations based on the Evangelists or on the Bible, but rather my work reflected what I saw.

RB:　*What is, or was, your attitude toward religion?*

ДП:　Well, I do have religious feelings, but I don't subscribe to organized religions. Instead, I try to find commonalities among religions, their universal qualities. I am interested in all religions, in what qualities they share, rather than in their differences. I am still interested in this idea and still make paintings concerned with similarities between religions. I am not the only dissident interested in religion. There was Aleksandr Kharitonov, for instance, who painted many works with religious subject matter.

RB:　*Did the authorities give you trouble?*

ДП:　Yes, there were problems, but when I began to paint such canvases in the 1970s, I was not alone. True, many religious activists at that time—Baptists, Russian Orthodox priests—were thrown in jail because of their religious beliefs. Many extremely intelligent and broad thinking people were arrested. Those who remained in the Russian Orthodox Church were inevitably linked to the KGB. Many priests chose a double path, both to save their own lives and to tell the people the truth. They were often denounced by priest informers.

RB:　*Were you able to see Western art in Moscow?*

ДП: I studied at the Moscow Regional Art College in the theater department with Victor Alexeyevitch Shestakov, who in the 1930s was the chief artist in Meyerhold's Theater. Meyerhold was killed by Stalin in 1937, and, since I was in school during the Stalin era, Meyerhold's name was not allowed to be mentioned. Still, Shestakov would make allusions to Meyerhold, so I picked up some links to the past. I also once stumbled across two volumes of Van Gogh's correspondence and read them, even though Van Gogh was not an officially known artist at the time. It was forbidden to see his art. Nor could we see Picasso's art either, although we knew his name because he had Communist affiliations. His art was considered to be terrible. Modern Western works could not be seen in any museum. They were hidden in basements, and nobody knew of their existence. But on occasion there were exhibitions of works that were given to Stalin as presents. Once I came upon a closed safe at the Tretiakov Gallery where, for the first time, I saw works by Kandinsky, Chagall, and Malevich. The Kandinskys were rolled up and even hidden from view in the safe. To get into these safes was more difficult than getting into the Kremlin. These works had a definite influence on me. Nobody speaks about it, but after Stalin's death, Khrushchev opened up the central public library. We could then see books on the leading Western artists—Henry Moore, Jackson Pollock—but there were no exhibitions. Then Khrushchev allowed exhibitions. In 1957 young artists from around the world gathered at the International Youth Festival. The artists were free to work as they pleased, and this taught us a lot. Around 1960 there were American and French exhibitions. We could also see examples of modern art in magazines.

RB: *Did you meet Western artists?*
ДП: Yes, but more important, we Russians got to know each other.

RB: *What about Western influences on your work?*
ДП: We knew that socialist realism was state art, totalitarian state art, and rejected it before we knew much about modern art. We were cut off from culture, from art, and from a general knowledge of the rest of the world. Each of us who became a dissident tried to

find something in Western art and in Russian avant-garde art of the 1920s. We wanted to pick up something from the past, to link ourselves to it in some way, to develop from it, to find out what had happened in the past. Spiritually, artists like Jackson Pollock and Kandinsky meant a great deal to me. I admired them, but I never became a follower. In the 1960s abstract expressionism made the greatest impact on us, tashism [a French version of abstract expressionism] also. But we really couldn't talk much about these styles.

RB: *Did you experience cultural conflict?*
ДП: No. We had already internally pulled away from the cultural darkness of the Stalin era.

RB: *How had your travels in Russia been important for your art?*
ДП: I lived in several republics. Mostly, I felt an inner freedom, away from Moscow. I was in the east when the Ayatollah Khomeini came to power. I understood this to mean an awakening of Islam. When I returned to Moscow, I did a series of works on Islamic themes.

RB: *What effect did perestroika and your coming to the United States have on you?*
ДП: In the Soviet Union we learned not to believe what was on the surface. We learned to see through all those statues of Lenin and Stalin, all those government buildings, and the newspapers. We learned to seek out a depth in face of all this flatness. Under Communism, we had to dig deep to get to essentials. That which was Communist was external to our lives. Nobody really believed in its ideology. We developed double personalities, keeping our personal identities to ourselves. That is why the Soviet Union fell apart so quickly, and why there are so many crazies in Russia Gorbachev shook up the intelligentsia perhaps more than we realized. Our foundations were really shaken, and we became confused because we did not quite understand any longer what we were to oppose. But perestroika did not affect our generation of artists too profoundly. Even without Gorbachev, artists would have managed somehow because an artist paints within the sanc

tuary of his own house. True, it was dangerous to sell works, but we had to live. Our buyers, in the later years, were correspondents, mainly American, and diplomats. They bought for very little money, but it allowed us to live, pay rent, eat. It afforded us time between paintings. This is why we are all very grateful to people like Norton Dodge. But I also want to say that the artists and the intelligentsia in the 1960s really pushed for greater openness. It came during Khrushchev's regime. Later generations did their share, but people in the 1960s really learned how to deal with political oppressiveness.

RB: *Do you see differences between your generation and later ones?*

ДП: Well, after perestroika, several artists turned to sots art. The main figures were Melamid and Komar. Soon after, Kabakov, who had been involved with metaphysical issues, narrowed his focus and joined them. They are very interesting artists, but sots art reminds me of socialist realism. It is an art devoid of spiritual content. In the 1960s we were not so concerned with money, but more with spiritual matters and with ways to confront our dull and unpleasant lives. We probed culture more. But with perestroika, cultural questions lost depth. Artists echoed everyday concerns too much, and became too much concerned with selling their art. They began to work in international styles that were geared to the West. How many times can you paint Marilyn Monroe?

RB: *What about your work?*

ДП: Many themes that I had begun in the Soviet Union are still part of my work now. However, I do react to my surroundings and have tried to develop an inner relationship with America. Even though I am a Russian, I don't feel like a foreigner in New York. So my themes are changing and developing as I grow more comfortable here.

I might visit Russia someday, but my home is here now.

★

Igor Shelkovsky
Игорь Шелковский

Born in Orenburg in the Urals in central Russia, 1937; studied at the Moscow Regional Art College (known as In Memory of 1905 Art School), Moscow, 1965; settled in Paris, 1976; editor of *A-Ya* from 1980 to 1986, the major dissident art journal.

Sculptor and painter of abstract forms.

RB: *Where were you born?*

ИШ: I was born in Orenburg in central Russia by sheer chance. My father was an editor, in Moscow, of the newspaper called *Komsomolskaia Pravda* and was sent to Orenburg to work as an editor on a local newspaper. At that time cadres were sent from Moscow to work in the provinces. He and my mother settled there, but just three months before I was born my father was arrested and shot to death. After I was born, my mother was arrested and was sent to a labor camp for eight years. So as a child I never saw my mother. My grandmother in Moscow took me in. She was not actually a blood relative since she had been my mother's foster mother. Anyway, I lived with her during World War II. I spent most of my life in Moscow until I immigrated.

RB: *Where did you study?*

ИШ: At an art school called In Memory of 1905 which had two

sections, a theater section and one for teaching. I studied drama because the theater crowd was more intellectual and the teachers were more interesting. When I first enrolled, the department head was a man named Shestakov who had worked in Vsevolod Meyerhold's theater. He was an important link to the past. After he died an artist named Rabinovich became the director. He had been an artist, a formalist, during the 1920s and 1930s and had put on wonderful productions at the Moscow Art Theater Academy of the Bolshoi Theater. The theater fascinated me more than art, probably because of the hegemony of socialist realism, which was a type of academic art that appealed to the Soviet mind and was, therefore, uninteresting to me.

RB: *Did you see any Western modern art?*

иш: After Stalin died you could see things in the Pushkin Museum. Until then it was a place where Stalin's gifts were displayed. After he died we could then see impressionist works, which appeared slowly, one by one. This was in 1953 and 1954. It was a memorable moment in the fall of 1954 when a Matisse was hung there. I went with my friends to see it and met a formalist who had survived the Stalinist era. All of this was so different from what I'd learned in school. I have to say, honestly, that I would not have gone to art school if I had to do it over again. By the time I was in school I had different ideas in my head, different ideals. But you needed a school certificate to get the documents that stated you were an artist. Everything in that system was built on paperwork.

RB: *What do the terms "dissident" and "nonconformist" mean to you now?*

иш: You have to understand what it was like in Russia. In my youth I was a conformist like everybody else. We started out as October kids, then Young Pioneers. But when I turned twelve or thirteen I became critical of everything, dissatisfied with life. This was around the time of Stalin's death. I felt something was happening. I want you to understand this had nothing to do with my personal history or with what happened to my parents. This was not a big tragedy for me. I had no emotional response to it. I had no parents and treated this as a normal condition. I did not suffer in

any special way. When my mother got out of the labor camp she was banned from Moscow and had to live 120 kilometers away in a town called Maloiaroslavets. That's just how things were.

RB: *Why was your father killed and your mother arrested?*
ИШ: Officially they were considered enemies of the people. This kind of cleansing occurred periodically and automatically. People who held positions of a certain rank were shot and killed—when my father was killed, so was the local KGB chief and other important people in town. The next year, the new group of important people were shot. Then there was a pause, and when World War II started these killings stopped. In principle none of the murdered were guilty because all of those who had been put in camps were freed and rehabilitated when the war started. It is sad that many were dedicated Communists, worked hard under all sorts of pressures, and then were killed or sent away. My father was only thirty-three years old when he was shot.

RB: *And none of this had any effect on you?*
ИШ: That's right. No effect. But I began to experience the unpleasantness of the Soviet reality through my understanding of art. I began to discover that before the Soviet madness there were styles other than socialist realism. I discovered the word "impressionism," and found out that it included painters, musicians, and literary figures. This opened my eyes. It was like coming on forbidden fruit. All of this had been hidden from us. Even earlier nineteenth-century Russian art had been hidden from us. I was able to read some things, but on the sly. Officially, we were not supposed to read about any of this art. I developed a great interest in everything that was forbidden. I searched for monographs, anything, on old Russian artists.

RB: *What about the Russian avant garde of the 1920s?*
ИШ: I still didn't know about them in the early 1950s, nor had anybody else in my circle. My grandmother was practically illiterate, and so were most other people I knew. I came to the avant gardists after I found out about the impressionists and post-impressionists. It was possible only after Stalin's death to find old

books on some of the artists—Van Gogh, Gauguin, Matisse, Picasso. I have to say that it was my mother who first took me to the Tretiakov Gallery in Moscow, and I am very grateful to her for that. By 1957 there was a show of French art in Moscow. The same thing happened in Leningrad. The vaults were opened up, and for the first time you could see the full range of post-impressionism and early modernism. I was absolutely enthralled and captivated by French art. I got to know some people who had connections there, including Oleg Prokofiev, the son of the composer. He was a painter, then, and a sculptor, now.

RB: *What about your nonconformism?*
ИШ: It began through art. I realized, after seeing these works that we lived in a prison, in a country shut tight, kept under lock and key, that we were deprived of information, that we were cut off from the rest of the world. We knew something was happening in the West, but we didn't know what. I completely lost interest in Soviet life.

RB: *Did you belong to any groups?*
ИШ: The first group included Volodia Slepian, an artist, Oleg Prokofiev, and Oleg Tselkov who then worked in the style of Petr Konchalovsky, [who worked in a mannered, realistic style]. This was very avant garde at the time.

RB: *Did you participate in the Manezh exhibition in 1962?*
ИШ: No. After secondary school I was not certain how to earn money or even what to do. I worked as a theater artist at the Tulsky Theater, which was for youngsters, but I did not want to continue in that line—as a Soviet theater artist or as a director. You could not be your own master. There were the theater people above you as well as the party organization all around you. I then worked in advertising, graphics, and in restoration where I helped restore ancient Russian paintings—in the Kremlin and in the Rublev Museum in winter, and out of town in places like Novgorod in the summer.

RB: *Were you in the artists' union?*

ИШ: I applied for membership in the 1970s and submitted some works more or less in a realistic style. I knew some official people and was admitted. I did it because I needed papers to show that I had a profession, and then I was able to rent a studio. I never showed them my work again. I was probably the most passive union member ever. I just paid my dues. That's all.

RB: *What are your thoughts about the Manezh and Bulldozer exhibitions in 1962 and 1974?*

ИШ: I did not participate in either show. The incident at the Manezh was trumped up by Khrushchev and his bunch. Khrushchev allowed himself to be used by an anti-intellectual mob. The whole thing was deliberate, hostile, very stupid, and probably speeded up his downfall. Khrushchev's power lay in exploding the Stalin myth, in raising the Iron Curtain, and in establishing contacts with the West. He rehabilitated millions of people wrongly accused and killed by Stalin. My parents were among the rehabilitated. Khrushchev's politics took into account the needs of the people. He should have continued in those directions. The intelligentsia supported him. Even Ilya Ehrenburg, from the old intelligentsia supported him. Young poets supported him. But suddenly, he regressed and became an old-time party boss. He began to build a cult. He began to say that life under Stalin wasn't so bad and that the main thing was to strengthen the Communist Party. Stalin's teachings became important again. Khrushchev surrounded himself with people who were against change, against the intelligentsia, against renovation, against new political policies. He turned against everything that he had initiated earlier. He betrayed himself. He lost everybody's support. Conservatives hated him from the start. Progressives who had supported him turned against him. So did the intelligentsia. When he was pushed out, nobody cared or felt sorry.

RB: *What about the Bulldozer exhibition?*

ИШ: It was a successfully thought-out action. Oskar Rabin deserves full credit for it. It was his idea. In a political sense it was just beautiful, a great success. The whole world spoke about it and knew what was happening in the Soviet Union—that artists were

being sprayed with fire hoses. It was the first successful event of its kind and created reverberations around the world.

RB: *How do you account for its success?*

ИШ: The time was right, and because of the stupidity of the authorities—sending bulldozers and water trucks against the artists—in addition to Rabin's cultivation of the foreign press which immediately spread the news.

RB: *What happened afterward?*

ИШ: The authorities had to reconsider their attitude toward artists. The government suddenly discovered that there really was an opposition, that it was not in control of every situation, that it was not wise to restrain the opposition by throwing everybody into jail and thus cause a major explosion. The good old days had passed. So they tried to co-opt this unruly group. The GORKOM was organized as an alternative to the artists' union. Gradually the authorities began to divide the artist members by categories of loyalty. Artists like Rabin and Oleg Tselkov were pressured to emigrate. The authorities attracted a fair number of people to their side. They paid them off by buying their works. But on the whole the Bulldozer exhibition was a step in the long march forward.

RB: *Do you remember the exhibition at the International Youth Festival in 1957?*

ИШ: Yes, quite well. The art did not impress me that much, even though I looked very carefully. My eye had been nurtured by French art. Abstract art meant Kandinsky and color. So the abstract art at the festival exhibition offered nothing new in terms of form. I remember an American artist there who threw paint straight from his paint jars, but I was too close to the French school, and American art was too unknown to mean much. I knew of Jackson Pollock and understood that he had developed a new method of painting, but I didn't find it convincing. It did not move me in a spiritual way. Even later American shows did not impress me very much.

RB: *What about the Russian avant garde of the 1920s?*

Igor Shelkovsky, *Lagni Vari*, 1971, wood, 55 x 78 x 25.5 cm.

ИШ: I hardly knew anything about it. Only a few paintings were to be seen. I knew about Chagall through some books. I hardly ever saw any works by Malevich. Once, when I was working as a restorer, I got a pass for a group of twenty of us to see the storage spaces at the Tretiakov Gallery. This was very difficult to arrange since we needed a signature virtually at the level of the minister of culture. The restorers were not really interested so I called my artist friends, and we piled into a tiny storage room. That is when I first saw how bright and beautiful the Malevich and Kandinsky works really were.

RB: *You were probably upset at being denied this art.*
ИШ: Yes, this art was the best there was. Otherwise you went to the Tretiakov and saw a bunch of gray socialist realist paintings, and you realized that you are separated by one locked door from the brightest, most colorful and beautiful of contemporary paintings.

RB: *What about your own work during these years?*

иш: I lived with my mother in a single room before I rented a studio in 1970. Then I began to make sculptures because I had befriended many sculptors. Just by chance I had wandered into the House for Creative Sculpture where I met Sokov, Kosolapov, Kabakov, and some others.

RB: *Were you harassed by the authorities?*
иш: They watched me, but I did not experience oppression directly. I was a passive dissident. I knew that I was an artist and not a political activist and that it was senseless for me to wind up in jail or in a labor camp. But I did raise money for *samizdat* publications and helped photocopy Solzhenitsyn's *The Gulag Archipelago*. This was considered a criminal activity, and things could have ended badly for me. So I guess I did take risks, but passive ones for the most part. I never signed any appeals or took part in demonstrations.

RB: *Did you leave Russia voluntarily?*
иш: Yes, in 1976. I received an invitation from a family in Switzerland, got permission to leave, and never returned. Later I went to Austria where I appealed to the Tolstoy Foundation and told them that I would like to live in Paris, which they arranged. I arrived in Paris and asked for political asylum. Since then, I have lived in France.

RB: *How did you manage?*
иш: At first various foundations helped—the Tolstoy, a Catholic fund supported me for six months. Small sums, but enough to survive.

RB: *When did you begin to publish* A-Ya?
иш: In 1977. When I was still in Moscow I met a Swiss businessman, Jack Melkanian, who often traveled to Moscow and who collected art, as well. He was buying Polish artists then. While he was visiting the collector George Costakis' apartment, he bought some of my sculptures. After a few return trips to Moscow we met and I introduced him to my friends, who came up with the idea for the magazine, especially Alex Sidorov who became the Moscow

editor. When I again met Melkanian after moving to Paris he proposed the publication of a journal run by artists that would be printed in Paris but prepared in Moscow. So I undertook this project by myself. With all the planning, I worked at it for eight or nine years. It was to be about artists still living in the Soviet Union and those who had emigrated. At that time we still shared the same ideas and were interested in each other—who was doing what, who was still in Moscow, who in New York, or Rome, or Paris. Most of the material came from Moscow. It was much more important for them to be heard than for artists already in the West.

RB: *How did you get materials out?*

ИШ: It is like a series of detective stories. A text would be written or taped on a microtape recorder. If the latter, the cassette would be placed in a cellophane bag and hermetically sealed. Then the bag would be placed in a jar of jam. Somebody would take the jar out of the country and that person might not even know what was really in it. I would receive the package as a gift and might not know what it contained either. Then later I would know. There were other ways, too, to get material out. Photographs and illustrations also had to be gotten out as well as details about specific works. Quite often things were lost, or my letters would not get there. Everything had to be done underground. Some people agreed to carry items for us but became afraid and would then throw them away. Foreign students were especially helpful bringing things out. Someone would bring a photograph, another person a letter, another some slides. Occasionally a diplomat would bring something out, but they were not too helpful. American diplomats were the worst. They were afraid and did not understand the meaning of what we were doing. They were always worried that we were spoiling détente by putting out an anti-Soviet magazine. They said that they couldn't support such an enterprise. Actually all foreign diplomats tried to stay away from dissidents. Our largest support came from voluntary groups, both on the Left and the Right, who understood totalitarianism. Parenthetically, when I arrived in France I ran into an astonishing pro-Soviet spirit. People did not want to hear about dissidents. So I say

that the young students who helped us had minds sharper than the bureaucrats. Also they had nothing to lose, no careers to lose, nothing to compromise them. Since they lived in Soviet society, not in embassy compounds, and since they socialized with young Russians and with artists, they understood our plight better. The bureaucrats socialized only with bureaucrats. Again, the Americans wanted to please the Soviet bureaucrats and the Soviets knew how to use that. They also brought pressures on foreign correspondents by annoying their families or kicking them out of the country. Nobody wanted problems with the authorities.

RB: *Could you get copies back into Russia?*
ИШ: Yes, very many. I did whatever I could to get issues into Russia. The primary reason for putting out the magazine was to do it for them, the artists. I wanted the magazine to be morally supportive of the artists, especially during the Brezhnev years, the most stagnant and decayed period in Soviet history. Students and tourists brought them in. Some people were detained. Some copies were confiscated, but some got through. I remember that for the second issue a group of French architects brought in about twenty copies. These were placed at the bottom of a pile of architectural designs, which just managed to get through customs when an agent got tired of looking at the designs. There were probably one hundred readers for each copy that got past the border guards. On one occasion I managed to establish a contact in the American embassy, and to this day I don't know if the copies got to Moscow or if the embassy destroyed them. I had contacts in the French embassy, but they categorically refused to help out in any way. But I was relentless in trying to get the magazines into Russia.

RB: *Was it dangerous for artists still in the Soviet Union?*
ИШ: Yes, very dangerous [see interview with Ivan Chuikov, for example]. The authorities knew, so we had to be extremely careful to minimize the danger. Hardly anybody suffered, but there was one moment toward the end of the magazine's run when some of the younger artists were drafted into the army because they

published in *A-Ya*. But maybe because they had been written about in other magazines, too. It is true that many artists were threatened especially right after the first issue was published, and they were called in by the KGB. They were told to write a letter to the magazine and say that they refused to print anything in it. But nobody wrote such a letter. Then it seemed as if the KGB forgot about us. Of course everybody was being watched, and everybody knew what was going on. You couldn't feel free in that kind of atmosphere. In effect, artists had to make the following choices every day: be quiet and people will think you are afraid, or be quiet and nobody will know that you exist, or take a risk and publish in *A-Ya*. These were not easy choices. I felt that the Soviet system could not be changed unless we did it ourselves, not as single, isolated heroes, but as a group quietly moving back the line of what was permissible. You see, there were no laws about meeting with foreigners or prohibiting publication in Western journals. When my mother found out that I had foreign friends, she almost went into shock. She was terrified of what might happen to me. I would tell her that there was no reason to arrest me, but she had her memories. My point is that I was testing the line between the permissible and the impermissible. I pushed, and I felt that if more people pushed, the better it would be. After all they couldn't hang everybody. I felt it was my duty to publish the magazine, that I could do something valuable.

RB: *Would you describe the articles as being political?*
ИШ: Theoretically no, but politics seeped in. The articles were about art, and we also wanted to avoid problems with the KGB. We wanted to protect the contributors as much as possible so that the KGB might threaten people but would have no legal reason to arrest anybody. But since the authorities never bothered with the law, people were frightened anyway. I wanted to give artists an arena in which to discuss problems about art and to share news items with each other, where they could read and voice diverse opinions. I wanted to recreate the times when we met in each others' studios and talked about anything and everything. Even though we were physically impoverished, those gatherings were,

in my memory, spiritually rich and sustaining. I wanted to preserve that conversational tone in the magazine and that sense of enrichment. My favorite articles were those written by artists rather than by critics. On the other hand, since there were no unofficial critics in the Soviet Union who wrote about art for *samizdat* publications, the magazine also helped create a group of critics who began to write for *A-Ya*. So I was pleased that the magazine stimulated new developments instead of just recording what was going on. It was important for people to know that there was a magazine for which they could write new material.

RB: *Did Jack Melkanian subsidize all of the issues?*
ИШ: After the first issue, he disappeared. Dina Vierny, the art dealer, helped. But we had to sell paintings to pay for costs. Norton Dodge was the main buyer to help meet expenses. Several of the paintings he bought were still in Moscow, and it was not easy to get them out. For instance, a painting by Erik Bulatov came out rolled in a carpet owned by an American diplomat who was finishing his tour of duty in Moscow. I had met Dodge, by chance, in Paris. I bumped into Oleg Prokofiev one day on the street, and he introduced me to Dodge, at his mother's apartment. I had a copy of the first number of *A-Ya* with me, and he took an immediate interest and became our chief benefactor.

RB: *When you lived in Moscow, did you know foreign diplomats?*
ИШ: Yes, of course. And I also knew students. The authorities never bothered me, except, occasionally, when a foreigner would leave my place, a policeman or a neighborhood patrol would want to know who had just left. I also knew I was being followed, especially if I was walking with a foreigner. My telephone was bugged as well. My mail was also opened. They tried to control everything. Thank God they never asked me to collaborate and that I was never summoned to headquarters. On the other hand, I was often quite open on the telephone, knowing that they were listening. I would say that if I were summoned by the KGB I would refuse to say anything. I would say into the telephone that they should either openly accuse me of something, the idea being that

they should show themselves, or have no contact with me. The main thing was not to show fear but to hold to formalities of behavior. I was not into heroics, but I wanted them to be clear about my position.

RB: *Why did you stop publishing* A-Ya?

ИШ: The KGB suddenly decided to close it down, probably because one of the issues was devoted to literature. They were willing to let artists slip through their fingers, but literature was too dangerous. So they began to persecute and repress artists. They began to call on everybody and threatened artists with the loss of their jobs and studios. Some artists could not endure the oppression and wrote letters asking us to stop publishing and writing about them. Then the authorities began to set up galleries, to show the artists that they could have shows in spite of *A-Ya*, that they didn't need *A-Ya*. So the Gallery de France in Paris was officially encouraged to buy an enormous number of works in Russia. Artists were promised official trips to Paris, places in official shows, and so on. What the authorities did was apply both the carrot and the stick. The last number of the magazine came out in 1986. And then perestroika came. There was no longer an acute need for the journal. Artists began to travel and to have shows in the West. My task was completed and I had played my part. I then got back to my own work, my art work. Altogether there were seven numbers, plus a literary number, as well as a few booklets and postcards.

RB: *With all modesty aside, how do you feel about being responsible for the most important dissident art journal?*

ИШ: Very happy that I could oppose Soviet oppression and be part of all the small efforts made by an enormous number of people. I hated that system with all my heart. It had to end sometime. It is my good luck to have seen it end in my lifetime. All the radio transmissions from the West, all of the books that were brought in, helped. The entire intelligentsia was opposed, in principle, to the regime. It was a savage fascist epoch. I wish its demise had occurred earlier, and it could have under Khrushchev. We lost

our youth because it didn't. Everything froze for another twenty years under Brezhnev. Actually, we have a seventy-year gap in our history. There wasn't a creative idea in all that time, and there were so many broken lives along the way. My parent's generation was laid in the ground during the 1930s. Their lives came to naught, but my generation witnessed the end of that epoch. It is all tragic.

RB: *Have you been back to Russia?*
ИШ: I went in 1992 and every summer since then. I can't get enough of it.

I enjoy my stays very much.

★

Eduard Shteinberg
Эдуард Штейнберг

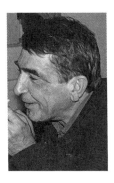

Born in Moscow, 1937; studied with his father, Arkadii Shteinberg; part of the Sretensky Boulevard Group, early 1960s; lives in Moscow and Paris.

Works in a geometric style influenced by Malevich, other suprematists, and constructi1vists. He is particularly concerned with spiritual states of being.

RB: *When did you know you were a dissident artist?*

ЭШ: An artist is always dissident, by nature. Do you mean in relation to the government? to religion? to the family?

RB: *In relation to socialist realism.*

ЭШ: To tell the truth, I didn't notice this socialist realism. I was not interested in it. I was a dissident, but not in relation to socialist realism. It is an art form that has a right to exist because of its historical significance, just as fascism and bolshevism each has the right to exist. In general, an artist always protests, and he does not necessarily have to live in the Soviet Union. Wherever he lives, he is always a dissident in relationship to the state and to certain sociological, political, and cultural occurrences. Artists are always protesting and looking for a place for themselves. They try to find themselves. Artists are people who, at birth, have been given the gift and burden of creating illusions in life. Artists are wounded

people from birth. The better they understand that they are wounded, the more they try to cure themselves of this illness. Artists are crazy, sick people. That is why they want to find a place for themselves. They find it either after they die or when they are still alive, but they must find that place. In reference to bolshevism, which we had here in Russia, I believe that not only artists, but every normal human being with a moral sense was a dissident because this system was the equivalent of fascism. The whole world hates fascism, so why love bolshevism? They are one and the same.

RB: *What was your personal relationship to the state?*
ЭШ: Personally, I hated bolshevism, but as a Christian, of course, I made peace with it. In the Gospels it is said that all power comes from God, not the state. As a person, I hated bolshevism.

RB: *How did the state affect your work?*
ЭШ: I believe that the more freedom artists have, the less of an artist they are. Artists are people who should not live in freedom. It is not my own idea. Picasso said this.

RB: *But why do you believe this?*
ЭШ: Because if there is a lot of freedom it becomes more difficult to be an artist. There are too many possibilities. But if your freedom is curtailed and you live in nonfreedom, then your intuition begins to work and you start to go inward. Living in nonfreedom is an existential condition. You are concerned about your existence. In this nonfreedom into which we were born we had a unique social structure here in Russia. I have lived abroad for four or five years now, and I have yet to see such a structure. We had a unique circle because we were interested in only one thing, and that was to find ourselves. It was not an egocentric quest, but an attempt to find one's own self in the context of our culture and to find a cultural space to live in. It was a kind of protective action. This was before perestroika. Artists in the West experience a different kind of nonfreedom. In some ways it was easier for us. We had a clear picture of our own agency, our physical being, our individuality vis-à-vis the government and

the official culture. There was a clear gap between us. Ours was a different culture, and we erected a monument to the culture of the past. This gave us our energy to live. You know Camus's story, *The Myth of Sisyphus*. This is our story. We were in the same situation.

RB: *Did you see Western art before perestroika?*
ЭШ: Yes. There were several exhibits. I first saw contemporary American art at an exhibit in the early 1960s. I saw Pollock's work then. Yves Tanguy [the surrealist] made an enormous impression on me. There were other shows from Great Britain and other European countries. I thought I was rather well informed.

RB: *Did these shows influence you?*
ЭШ: Naturally they made an impression. On the other hand I was trying to find out who I was, to locate myself in the world, to map a cultural milieu, a structure, which had been lost. But, yes, contemporary Western art, did give me a jolt. I was influenced by the Italian metaphysical school rather than by the Americans. However, Mark Rothko made an enormous impression on me. I liked Rothko a lot. I guess you can say I was split between responding to Western art and locating myself in my own culture here in Russia.

RB: *Did you participate in the Manezh exhibition in 1962?*
ЭШ: No. I visited the show but did not participate. Who would have invited me? There was no room for me in that show. As far as the state was concerned I was a mere insect and did not interest the government. Culture was in the service of the state. The artists' union, the Bolshoi Theater, writers—everybody was in the service of the system. Even well known authors. All of that was not a part of the real world.

RB: *Did you exhibit in the Soviet Union before perestroika?*
ЭШ: Yes, but in the 1960s it was impossible to exhibit. At the end of 1976 I had a one-man show. There were some street exhibitions of dissidents. Alexander Glezer organized them. Norton Dodge also organized some exhibitions. I even tried to emigrate, but I stopped in time. I remember that the KGB called me in. This was a

normal state of affairs—the government bothering us. It was hostile, full of hate. The state annihilated our culture. During the 1930s the Russian avant garde was eradicated. Then Russian philosophy, science, and poetry were destroyed—Mandelshtam, Akhmatova destroyed. The government took arms against its own culture. Thank God it is ended.

RB: *Did you consider your works to be antigovernment?*
ЭШ: In general I can't stand any system. I am an anarchist by nature. Governments and politics are, for me, horrible. Of course, there can be some good governments. I liked Franklin Roosevelt, for instance. I am partial to the American system of democracy. But in principle I don't like politics. Politicians are thieves, but I know that you cannot live without politics. I like simple folk.

RB: *When you had an exhibition, how did the public respond?*
ЭШ: It was an interesting moment in my life. I put together my paintings, and they emerged as a diary. After all, it is important for artists to see their labors hung on the walls so that some sort of critical evaluation can take place. I had scant opportunity to see my work hung together, but when it was hung and I looked at my paintings, I felt alienated from my work. It was as if I had not painted them. Suddenly, I became indifferent to my paintings.

RB: *And the public?*
ЭШ: The reviews were absolutely negative, but they were not to the point. They remained on the political and sociological level of discourse. Thank God nobody bothered me or hurt me. I survived. I could have been arrested if the authorities so desired. I was very frightened. The whole experience was horrible. We had no rights as individuals, as artists. But God had mercy on the artists. In general the authorities could not touch me. Even so, I was not allowed to travel abroad. So I thought—who needs it? There was no way in which I would cooperate with the government. I earned money by working in the theater and by illustrating magazines. My wife, Galina, also worked to support us. In time my work began to sell, and now I earn a living.

RB: *Were you a member of the artists' union?*

ЭШ: No. Somebody tried, with great difficulty to have me admitted in 1988. A person from the Party made a phone call on my behalf. Until then, the artists' union would not acknowledge me nor take me into account.

RB: *Could you buy supplies?*

ЭШ: That was rather easy. We have here a tradition of thievery. For a bottle of vodka you could buy a truckfull of paints. I could buy what I needed for a bottle of vodka. Everybody in the country stole and pilfered. That was bolshevism for you. Now we are reaping the fruit of that time. This country of ours, a wonderful country with a great culture, has turned into a land of low-lifes, thieves, corrupt people, and all sorts of biological abominations. There is freedom now, but corruption continues.

RB: *What do you think about the idea of emigration?*

ЭШ: It is purely an individual decision. I don't consider myself an artist who lives in the West. I live in Russia. It is as if the train has left. I am too old for a new life. To begin anew, to open a new cultural stratum, a new geography—no. I speak now from the point of view of having freedom. This is why I do not leave, although I know that I am an immigrant here. But to be an immigrant in the West means to be an immigrant twice. I can't cope with that. It is all right to live in a country other than your own, but it is not important for me. I would raise a different issue. I am certain that there is such a thing as regional art. We do say that there is an American art, a Russian art. There is socialist realism and there is Western art. An artist should preserve his sense of regionalism. One has an obligation to the place in which one was born. It is important for art. We do say that Rembrandt was a Netherlandish artist, Jackson Pollock was an American artist. We do talk that way. We should not fear it. I do not consider myself a nationalist. But in a good sense I am not ashamed to be Russian, and I insist that I am a Russian artist. The young people who have left for the West have become cosmopolitan. They haven't gotten very far. Perhaps they have some money now, but

all that will burst like a soap bubble. Artists like Komar and Melamid have adapted to the political structure of the West, but where are they now? Here there is a wonderful painter like Krasnopevtsev who never left. He is great and will be recognized some day even though nobody speaks of him now.

RB: *Do you feel differently now that you are no longer a dissident artist?*

ЭШ: In all honesty I feel that I am fortunate to have internalized the tragedy into which I was born. I try to hold on to it and not to forget it, not to free myself from that knowledge. For I can tell you that above all I love this country. My situation is rather exceptional. I live in Paris and in Moscow. I now love Paris and am as attached to it as much as to Moscow, but if for some reason the gates were to close tomorrow, I would definitely return to Moscow.

RB: *What about your work since perestroika?*

ЭШ: There have been periodic changes in my work, but these have been independent of perestroika. I always return to where I started and then proceed forward again. My work is similar to links in a chain. I will say that in Paris I paint large works which I never did or do when in Moscow. Also I want to emerge from a vacuum in which I feel I spend my time. There is a quality in my work that relates to that feeling and I want to break from it.

RB: *Tell me a bit more about your thoughts on large pictures.*

ЭШ: Generally, large pictures are common today, but I prefer to make middle-sized works, room-size and intimate. Ultimately, the size has no significance aesthetically. In the West, there are large pictures in the United States because people have spacious apartments and banks have space for large works. But why complicate matters? We have limited freedom as it is, so it is not really necessary to become oppressed by whether a picture should be large or small. To paint prescriptively deprives one of freedom. For an artist to paint to specification is part of a propaganda tactic. What should occur when one looks at art is a dialogue. The viewer and the painting should enter into a discourse. If this is achieved, then both the viewer and the painting are free. It is the viewer's

task to ask questions of a painting. If the viewer fails to pose a question, then the picture will not provide an answer. However, if we are coerced to paint large pictures to specification, then it is for me a catastrophe.

RB: *Does this relate at all to your aesthetic philosophy?*

ЭШ: First of all, I feel that I am a traditional painter, in a good sense of that phrase. I believe that tradition in culture is most important. Second, I grew up in a society in which love was repressed. Yet, the culture remained because of love. Therein lies a basic concept of Russian religious philosophy, especially that of Vladimir Soloviev. In addition, the word "art" in Russian (*iskusstvo*) comes from the word "artificial" (*iskusstvennyi*). That is why I do not consider the concept of art and life an important concept. For me, creating an illusion is more important than life, and so the importance of art and its function are critical. In my paintings there is always a division between an upward movement and a downward one, or a connection between heaven and earth. I try to unite the two, and in a successful work there is a moment of illusory linking. What I am saying is that my work is about the individual in the universe and his connection to it.

RB: *Do you believe in transcendence in the same way that Vladimir Soloviev, the philosopher, did?*

ЭШ: Of course. Before perestroika my gaze was upward to heaven. Afterward I have been looking down—to the earth. The reason is because of my age and also an interest in the earth as a form. There is always, in my work, an existential moment of suffering, an attempt to represent a contemporary view of life. My paintings are my diaries.

I feel a bit like Stendhal, an anachronism in the twentieth century, and I am not embarrassed to say so.

★

Vladimir Yankilevsky
Владимир Янкилевский

Born in Moscow, 1938; Moscow Secondary Art School, 1949–1956; Moscow Institute of Graphic Arts, studied with Elii Beliutin, 1957–1958; exhibited with the Beliutin Studio Group at the Manezh, 1962; emigrated to the United States in 1989; lives in the United States and France.

Explores a wide range of subject matter in several media. Is concerned with the vagaries of human life as well as a desire to find a unity between humans and the cosmos.

RB: *I notice that many dissident artists worked as book illustrators and designers.*

вя: Yes, many artists, like Bulatov and Vassiliev, needed to make a living, and this was a way to do it. I never sold my paintings in the Soviet Union until about 1986 when the Tretiakov Gallery bought one. My canvases were always large, as they are now. At first I had no studio, only one room in a communal apartment. I painted in the same room where our daughter was born. I made my triptychs there. I couldn't see them assembled because I had no space. I saw them for the first time twenty years later, in the early 1980s, when they were hung on a wall at an exhibition. I can't imagine now how we managed in that one room. In any event, our real cultural life existed unofficially. We had our circle of friends who would

visit our studios and attend our one- or two-day exhibitions. The official culture did everything to destroy and demoralize us.

RB: *In 1962, at the time of the Manezh exhibition, you were only twenty-four years old. Were you part of an unofficial group?*

вя: Yes. We had a small group of about twenty to thirty people. We were very close. It included Kabakov, Shteinberg, Krasnopevtsev, Bulatov, and later Plavinsky and Neizvestny and several others. Here is an example of how the authorities treated us. In 1965 I had an exhibition at the Institute of Physics, a very prestigious organization. The intelligentsia came to the show, even though there were no announcements and no mention of it was allowed in the newspapers. I had no official visibility. In short, I did not exist officially. But foreigners came to know about my work, and I even began to receive invitations to show abroad. These invitations would go to the Cultural Ministry where officials would answer: "We don't know such a person," "He is extremely ill," "He can't exhibit for technical reasons." Nobody from the official world entered into any kind of a dialogue with me, especially since I had not been admitted to the artists' union. (I was finally admitted in the late 1980s.)

RB: *Where you always a dissident artist?*

вя: I was a dissident artist, but not in relation to the Soviet state, not in a political sense. From their point of view, my world view was that of a dissident. I have always recognized a conflict between man's physiological nature and his intellectual capacities, a conflict symbolized by, say, an atomic station, a technological symbol of our civilization, but one which undermines individuality and acts on the individual in a destructive way. The work I exhibited at the Manezh in 1962 was called "Atomic Station." I'm interested in the tension, the conflict, between the individual and technology. I view the individual as a vessel containing both male and female principles, and am interested in how changes and developments are reflected by, and act against, humankind's basic humanity at the most primary level of existence. In my triptychs I explore these issues, not with the desire to strip things to their bare essentials, but to explore, or, suggest, the many layers of

experience and of existence. I do not set up the triptychs in a dialectical manner with the third panel showing the resolution, but rather as markers in a voyage of discovery. This voyage might take place with figures, with landscape forms, or suggestions of cosmic elements. I try to indicate different ways to gain knowledge, through direct cognition or through a theory of knowledge. Perhaps you might say that in some works I play off humanistic and scientific ways of knowing.

RB: *When did you know that you wanted to work in an abstract manner?*
вя: When I studied at school, the training was academic and professional—modeling, drawing from the model, still life painting. There was no apparent ideology at the school. As soon as I completed my training I began to paint from my own vision since I realized that socialist realism was not for me. I learned not to make distinctions between abstract and nonabstract art. All things are, for me, anthropomorphic. At various stages of a work, elements of the visible also represent the invisible, the representational is a continuation of the nonrepresentational. There is the surface level of sensation and the deeper level of perception. I try to merge these elements in a continuum of meaning.

RB: *The state could not accept any of this?*
вя: It was not just ideological differences or disputes with the state. The government was compromised and very corrupt. The officials of the artists' union were like a mafia. They received funds from the government, lots of money, and divided it among themselves. They did not want to allow too many into their circle. If they admitted artists such as myself, they would probably have had to quit their jobs. Then, on another level, the production of art *was* based strictly on ideology, on commissions from the party. They were not interested in whether I agreed with their politics. I was simply "other" to them. I was concerned with aesthetic problems and issues concerning my world view. Politics did not interest me. But clearly my work was not acceptable to them. There were others like myself, who were apolitical and who were also deemed unacceptable, such as Shteinberg, Krasnopevtsev, and Oleg Yakovlev.

RB: *Do you think you were being brave and heroic to exhibit your work? Were you fearful of the consequences?*

вя: I had no fear; rather, I had an incredible desire and urge to see my works on the wall instead of in pieces in our apartment. My urge to see them exhibited was so strong that all else receded. The exhibition at the Manezh brought me endless happiness. I was ecstatic. For the first time in my life I saw my work displayed. I was only twenty-four years old, and I felt myself groping for something, feeling my way. There was a Picasso exhibition in 1957 in Moscow, and some of his influence was present. But I was delighted. I was also young, very idealistic, and foolish. I believed that when everybody would see my works, they would be over-whelmed. But life simply went on in normal ways.

RB: *Did you feel more comfortable when perestroika began in 1987?*
вя: Nothing changed for me because I had already chosen my life's path. Khrushchev, Brezhnev, and the rest just didn't bother me.

RB: *Nevertheless, did you ever want to express something Russian or national?*
вя: I never felt patriotic. Inwardly I was always cosmopolitan. The whole world was the same for me. I always felt like a foundling. I felt as though I were born elsewhere, not necessarily in Moscow. Now I am in New York City and I feel good here. I do not have any feelings anymore. On the other hand, I do believe that my environ-ment did influence me. Russia gave me a lot, what you call here a mental set. Russia gave me a certain sense of space and a realiza-tion of dramatic tension.

RB: *Do you notice Western influences in your work since emigrating?*
вя: This is hard to answer. I never made distinctions between Eastern and Western art. What was important for me were periods in the history of art and large national styles—archaic, Mexican, Egyptian, Indian. These were more important to me than, say, Russian icons or Muslim shrines. The early Renaissance was also important for me. Giotto, Uccello, and Piero della Francesca had more influence on me than any contemporary artist. They were

contemporary for me and through them I enlarged my vision and scope.

RB: *You mentioned Picasso before. Did you see modern Western art in the Soviet Union?*
вя: The first Western exhibition I saw was Picasso's in 1957. I saw works of other artists in reproduction.

RB: *What about contemporary art?*
вя: I did not see any. I had never seen pop art or examples of other contemporary movements. My work developed in parallel ways rather than from contemporary Western influences.

RB: *When did you first visit the West?*
вя: In 1988. I had a retrospective exhibition in Germany and a show in the United States.

RB: *Are there differences between works made in Russia and those made after you emigrated?*
вя: This might sound strange, but the only difference I experienced was one of freedom. I felt freer in the Soviet Union. Let me explain. My sense of freedom came from not being committed to the government or to a gallery. My commitments concerned only me. I did as I pleased and made as many works as I wanted to make. When I arrived here I found conditions were different. Some of my works sold; others did not. I had to prepare for exhibitions. I had to produce a certain number of works regardless of my inner necessity. I have always said that the only freedom for an artist is his or her inner freedom. Materially, I have obviously done much better in the West, but psychologically, it has been difficult. Yet, it is stimulating, and I have a powerful incentive to work here. It is very complicated. In the Soviet Union I was free from outside pressure, since my art was not accepted. But inner freedom was hard to achieve. On the other hand, the 1960s were, in their way, happy times for us, for our generation. There was no pressure to be avant garde since it held no prestige there. One did not make any money and nobody needed us. We did only what

our hearts and consciences desired. True, it was dangerous at times, but we had complete freedom in our art. Now the situation has changed radically, and it is prestigious to be avant garde and to make a lot of money. We are now in the hands of the art market and have lost that earlier freedom. I once wrote an article entitled "Everyone Is a Saint as Long as There Are No Temptations."

RB: *But it is easier to live here.*

вя: Yes. I spent about 80 percent of my life there just trying to survive—to buy provisions, groceries, et cetera. Here I don't lose a moment's time from my work. This makes a colossal difference to me.

RB: *Were you involved in Sotheby's auction in Moscow in 1988?*

вя: It was the most shattering experience of my life. I was at the auction, and right before my eyes all our artistic and financial values collapsed. Before the auction, we knew everything about everyone, who was the better artist, who belonged where in our hierarchy. All of this was completely changed in one hour. It turned out that the least known artist received the most money for his work. Nobody understood why. We had no understanding about such things. We suddenly realized that this was reality. I was sick for three days. I could not communicate with anybody. This taught me how the world operated. Even my experience at the Manezh in 1962 did not prepare me for this. I believed then that people would see and understand how good my works were. What occurred was that Khrushchev and all his people came, looked, and saw nothing. I was shattered (and also young and naïve), but the Sotheby's auction was devastating and demeaning. It was the millionaires who gave value to art, and they were far behind the artists' vision. To me a true artist is a prophet, a visionary. I learned that between the viewer and the artist it is difficult to remain honest over ideals and values. This wounded me deeply, and I still carry that wound inside me. Probably others whom I knew in Moscow in the 1960s and 1970s feel the same way.

RB: *Do you have any desire to return to Russia?*

вя: Not now. Conditions are very difficult there. It is not a good

time for artists. There is too much politicking and too many material problems. Paints are hard to obtain. I always kept a distance from political struggles anyway. And I am loathe to lose time from my work. I am dedicated to my work, and I can work most easily in Europe or in the United States. The most important thing for me is to show my work.

If you were not a dissident artist in the Soviet Union for the last thirty years, you don't know how important that is.

Dmitrii Prigov
Дмитрий Пригов

Born in Moscow, 1940; graduated from Stroganov Art Institute, 1967; he lives in Moscow.

Makes small drawings with semigrotesque forms, has experimented with sots art forms; since 1987 has created installations, writes poetry, and works with words.

RB: *Were you a dissident artist?*[1]

ДП: The question is really about how you define a dissident artist. A dissident artist is not the same thing as an underground artist. A dissident artist was one whose whole life, activities, and work was directed, with conscious awareness, against the governmental system and its institutions. On the other hand, the government, which was a totalitarian one, judged everybody who did not belong to its institutions as dissidents for socio-political reasons, whether their dissidence was in fact socio-political or only aesthetic. The government did not differentiate between dissident or underground artists. Its measure of difference was only one of degree, not of kind. I was never a dissident. The basic issue for me was an internal one, concerning aesthetic and cultural factors. But

[1] For further discussion of Prigov's complex role as an artist of official and unofficial art, see the interviews with Igor Makarevich and Alexander Petrov.

life in the Soviet Union was so constructed that, indeed, I was considered a dissident. But I called myself an underground or unofficial artist, at least before perestroika. With the artists with whom I associated, I discussed esthetics, and we had some very serious differences of opinion. By contrast, dissident artists, as a rule, opposed the state on political and philosophical matters, but on aesthetic issues they did not always depart from established rules. Dissidents might work in the same styles as official artists. At times, official artists could even be more advanced technically. Underground artists could also occasionally find themselves sharing common aesthetic and cultural values with some official artists. It is very complex, but it is true that both we and some official artists were more advanced stylistically than some dissident artists, and at the same time that we underground artists usually had more in common with dissident artists from a socio-cultural point of view.

RB: *What were some of the differences between the dissident artists and the underground artists who were more avant garde in their tastes?*

ДП: Dissident artists often worked in accepted realist or classicizing styles, but they painted real situations, such as drunkenness, or demonstrations, or they portrayed grotesque figures, some with expressionist overtones. The underground artists tended to ignore such thematics, that is, realistic imagery, and preferred to explore directions laid out by Malevich and other abstractionists. I would include here conceptualists and even sots-art artists whose work usually had no direct relationship to social reality. Their art was not a direct criticism of our daily reality.

RB: *Were you able to exhibit your work before perestroika?*

ДП: There were evenings when we would show our work and exchange critiques. One get-together took place on Malaia Gruzinskaia, a street in Moscow, in 1982. Much of my work was not compatible with the general surrealist orientation at that time. Anyway, a hall was hired, and the authorities did not quite know what to do about the exhibition. They understood the thrust of the works and were displeased. But even so, things were beginning to loosen up, and the artists' union began to arrange similar evenings,

official evenings, for exhibitions. I became a leader of a club that organized such exhibitions. We exhibited a variety of artists, but there was also unpleasantness with the authorities from time to time. We exhibited at regular intervals—about twice a month— and included artists such as Kabakov and other avant gardists. These artists were not dissidents nor were they inclined toward surrealism. In the years just before perestroika the state had grown weak and limp. If it noticed things, it would punish, but it no longer had the power to notice everything. Anyway, there were about one hundred artists in the group we exhibited, ranging in age from about nineteen to fifty. At that time, sharing stylistic similarities was more important to us than generational differences because we all experienced inner oppression. Petty differences had little significance. Now, however, generational differences have grown more important.

RB: *Was there much interaction with official artists?*

ДП: Since these exhibitions were sponsored by the union our friends among the official artists would participate. These artists joined the union in their youth and were not thrown out later in their lives even if their points of view had changed. The union protected them, but, in fact, it did not always give them any money. So, these exhibitions could be dangerous, as well. Bulatov, Kabakov, Vassiliev, Chuikov, Boris Orlov, and myself, and many others were all members of the union. This is why we were allowed to organize these soirees of experimental art. And under the guise of experimental art, we exhibited our works.

RB: *How did you find each other?*

ДП: When you are an unofficial artist, you look for people with whom you can coexist. The world of art in Moscow is a tight one, so you automatically find out who is who. You go to poetry readings and meet artists whom find you interesting. It was not complicated. And you bond quickly.

RB: *Where did you study and what styles did you work in?*

ДП: I studied in the sculpture department at the Stroganov Art Institute along with Komar and Melamid one year, then later with

Совесть и традиции

GLASNOST

Dmitrii Prigov, *Glasnost*, 1987,
ink and newspaper, 27 x 21 cm.

JACK ABRAHAM

Francisco Infante, Boris Orlov, Kosolapov, and Sokov. Kabakov,
Vassiliev, Chuikov, and Bulatov studied at a different school but I
knew them from my student days. When I entered art school, I
was a total ignoramus. There were no artists in my family nor was
there anybody with an inclination towards art. At first I saw only
socialist realism, and I liked it. Then at art school I met students
who had artistic backgrounds and were better educated than I
was. Slowly, I evolved. Like the history of nineteenth-century art
movements, I evolved through realism, impressionism, and
postimpressionism. The only style that never interested me was
surrealism. And I worked right up to abstract expressionism, pop
art, and conceptualism. Now, everything is diluted, and there are
no clearly defined styles. What remains is a shared mentality, a
postmodernist mentality.

RB: *What were the relationships between members of the artists' union
and nonmembers?*
ДП: I knew many at art school who became official artists. Many
were very well educated and cultured, and their work was rather
interesting. Socialist realism is more than a style, since it under-
went many changes after Stalin. It was a system that expressed the
relations between the government and the artists. If the state
allowed you to work, then you worked. From time to time, the

state allowed you to work in a different manner. During the last few years of the Soviet government artists inside the union were able to work quite freely. You could find abstract artists, neo-expressionists, and others, but they were dependent on decisions made by the government. For instance, if a decree were issued to paint realistically, then the union members would comply if they wanted to remain in good standing and receive privileges. During Stalin's era, it was more complicated. The government sanctioned a "grand style." Artists were forced to work that way. Some loved it: others did not. After Stalin, society rid itself of this style. Artists no longer felt the necessity to work that way, and the government began to allow a greater latitude of styles. This is why under-ground artists were not necessarily dissident ones, since, toward the end of the Soviet system, unofficial artists might paint the same way as official ones.

RB: *But it was still difficult to be an unofficial artist.*

ДП: Yes. Artists had to work someplace, otherwise they would be considered parasites, freeloaders. If they didn't work, then they did not have work documents, and were easily thrown in jail. A member of the union was obliged to work, and those who were not members were obliged to work somewhere. Part-time work or working at home was not permitted. Artists had to work full-time, and then paint in their spare time. This is why so many artists worked night shifts, as janitors or guards. They could paint or sleep on the job and also do their art work by day. They had their own lifestyle.

RB: *Did you work officially?*

ДП: I belonged to the union, but I could not earn a living by painting. So at one time I modeled clay animals for nursery schools, but unofficially I worked on conceptual pieces. Slowly I began to show these pieces, and my ties with the union began to deteriorate. The KGB took notice. I stopped receiving official com-missions, and then no work came my way. I kept changing jobs and once worked in the post office. As for my own art, I used a typewriter to make visual texts.

RB: *Were you able to see Western art?*

ДП: Rarely. I did see work from the period before World War II but not recent art. Basically, everybody saw this art in catalogues, journals, and books. There was always a huge colony of diplomats, journalists, and foreigners. People brought books, and they knew the most recent art. Sots art, for example, paralleled pop art and conceptualism.

RB: *When did you become aware of contemporary art?*

ДП: It is hard to say. I saw a lot of journals brought by foreigners. We were well acquainted with many people from other countries because we wanted information. These people were of a certain type. Had they been Soviet citizens, then we would never have maintained friendships. These foreigners had a different mentality from ours. For us, it was a self-serving situation. We had an agenda in mind. But if you understand our situation, you would know why it was so important for us to know them. We continued to foster these friendships because these people served as sources of information about contemporary art in the West. Now, of course, I can travel all over the world. I have seen as much as I am able, but I have seen many works only late in my career as an artist. I realize now that there is a major difference between seeing the real thing and a reproduction. Perhaps this saved us, to some extent, from imitation. We ascribed different meanings to many works, and we dealt with certain artistic issues in different ways. We interacted with reproductions, with similacra of works of art, not with real things. Think of it this way; reproductions are like Coca-Cola, real art is like French wine.

RB: *Are there patrons, collectors, and buyers in Russia now? Is there an art market?*

ДП: The art situation mirrors the general situation in Russia. Most buyers come from abroad.

RB: *Why do you stay in Russia?*

ДП: For two reasons. First, I work with Russo-Soviet materials. I need to feel the local life here. I build my strategy for each piece based on the concrete situation that for me is a dynamic one. If I

left for the West, I would have to change the context of my work. Second, I am also a *litterateur*. Language is of great importance to me, everyday language. When I leave Russia, I feel as if I am in a glass box. I write poetry, plays, and prose. I create both literary and visual performances. So I need to stay here.

RB: *Do you still have many colleagues left in Moscow?*
ДП: Many did leave, but that amounts to about only five percent of the artists in Moscow. Of course, it is another matter when close friends leave and when important artists go. Yet, some do remain. Besides, a new generation is coming up. Life is very intense. We are still not commercialized as in the West, so here we can still lead a life of art, and that is important for us.

RB: *How would you characterize your art?*
ДП: I became an artist toward the end of the 1960s when conceptualism and sots art were in the air. Sots art used socialist realism as a point of departure, and it is also related to pop art. And conceptualism, which was known world-wide, was transformed in our own way. I especially worked in a conceptual manner but added Russian elements. After perestroika I was able to travel and exhibit abroad, and this affected the size and scale of my work. I began to work with large spaces, and I began to make installations in 1987. Before, I had never made installations or exhibited in any space larger than my room, which, as you can see, is quite small. So my spatial sense changed dramatically. And now I can use language differently in my installations. Before, Soviet language, Soviet ideological texts, were dominant in my literary-visual works. I used propaganda slogans, and tried to work with them as if they were a kind of language rather than holy scripture. Now, this language has shrunk considerably and has lost its power. I include more actual readings along with citations and literary classics. But I still work with Soviet culture, which has changed a great deal in the last few years. For me, this is mainstream culture. I try to create an image of the mainstream in an artistic way and to show that any mainstream contains strong totalitarian tendencies. I relate to it critically and ironically in order to show that the mainstream is simply a convention and does not contain the total truth. I have

also added elements from our myths of the West, of high technology, and of Americanism. These have influenced my sense of size and scale in the following ways. First, after perestroika we experienced freedom of space, and the size of our works grew to fill the available space, which was larger than our living quarters. Such works were still, say, humanistic in size. But sizes expanded beyond human scale to the scale of, say, banks. This meant that where we once functioned privately in our art, we now had to function socially, in terms of the larger society. This marked a real transformation. Works grew in size and often became filled with lots of detail. Kabakov's installations entail huge masses of detail. I try to fill a room with a number of small things, in part because I cannot accustom myself to large, empty spaces. I need to privatize these spaces. As for content, in my recent installations, I erect shrines or temples with a figure standing as if in prayer. These pieces represent the deconstruction of art as religion. I deconstruct the belief that art is a religion in the sense that an artist does not make a religious art object, but inwardly has to project a sense of devotion akin to religion. Contemporary museums are like temples. They stand in the most prestigious locations and are very expensive to build and to visit. All art critics and museum directors are like high priests who have been initiated into some kind of mystery denied to the viewers who don't always understand what they see. In contemporary art, the viewer is a noncomprehending outsider unless he is steeped in art. The viewer does not even see paintings, but artistic objects that are like relics. Museums have become sanctuaries for artists' relics. Therefore, the viewer need not understand, but rather look with a sense of devotion, or even feel as if he has to bow down before incomprehensible objects. That is why I make compositions to deconstruct the inner or internal idea of art—not to negate it, but to show that art is not a religious reality, but that some religious message is hidden inside. And, as I said, I also think this shows a totalitarian side to contemporary art, and I like to expose it.

RB: *How do you feel about the current scene in Russia?*
ДП: Well, perestroika was not a good thing for many official

artists. The government had been their only sponsor. It fed them and did not let even the weakest artists starve. Now, there is no single sponsor. The government has little money, and rich individuals are not investing in art. It is more prestigious to buy a car, a house, and to have a good time. To be rich these days doesn't mean to have art in your house. Nor do the banks and other large associations find ownership of art prestigious. Besides, the former official artists are often far behind current trends in the art world. By contrast, former underground artists find themselves in different circumstances. They never received money from the government for their art, so they were closer to current trends and Western standards. So buyers from the West are more sympathetic to them. Since life here is oriented to Western tastes, local patrons will sooner support former underground artists than former official artists. This is an ironic turn of events. Artists of my generation have not changed much because the fundamental principles of our art were in place by the time we were thirty years old. And besides, we lived within a structure against which we could take a stand, either positive or negative. Older artists who left, or leave now, are already enmeshed in some aspect of the art world. So it is easier for them to function, and if they return to Russia they will continue to function as artists because their inner framework is already in place. But the younger generation is having some difficulties, since there is no longer a structure of society here. It is hard for them to construct their path. It seems to me that a certain number of these younger artists will become lost, and we cannot help them. Nor can trips to the West help them much when they return to Russia. If they leave for the West permanently, they might find some kind of structure and stability.

I don't know, but the situation is volatile now.

★

Arkadii Petrov
Аркадий Петров

Born in the Don region, 1940; graduated from the Moscow Pedagogical Institute, 1963; graduated from the Surikov Art Institute, 1969; lives in Moscow.

Invokes a primitive or naïve quality in his figures which are based on materials of popular culture—candy wrappers, postcards, souvenirs.

RB: *When did you realize that you were a nonconformist artist?*

АП: I never became aware of this, that I was a nonconformist, because I consider myself a loner. I don't have many friends now nor did I in the past. There are solitary wolves and there are wolf packs. My personality is the solitary kind. I prefer work to words. I would rather work than talk. Usually, when artists get together, they talk and drink a lot. I am not a drinker, and this keeps me at a distance from others. In a drinking group, the nondrinker seems antisocial. I tend to stand to the side, on the periphery. Besides all of this, I did not have an exhibition until 1984.

RB: *No shows at all before that time?*

АП: Basically, I had no shows except for one painting.[1] You know where I was shown? We used to have evenings at the Kuznetsky

[1] According to biographical data in Norma Roberts, ed., *The Quest for Self Expression: Painting in Moscow and Leningrad, 1965–1990,* (Columbus, Ohio; Columbus Museum of Art, 1990), 183, Petrov has exhibited since 1965 in "city, republic, and all-union exhibitions."

Bridge—one exhibition for one night. That is where I showed one painting. You were not allowed to show your work. Wherever I tried to show, the exhibition was taken down.

RB: *Who would do this?*

AΠ: The minister of culture, because my work did not fit the definition of official art. In 1984 I had a solo exhibition. That was just after Brezhnev died, before a new leader took over. I had a solo show on the street.

RB: *Was there no hall?*

AΠ: Yes, there was a hall for exhibitions, but the authorities caused me a lot of suffering. They would not show my work for a long period of time. When my turn came to have an exhibition, they did not permit it because my work was beyond the perimeters of officially approved art.

RB: *What about the union?*

AΠ: I was a member [since 1971], but not as a painter. I was a member as an artist of monuments. I painted on walls. That was how I made a living, otherwise, I could not have survived. I never showed my paintings, nor could I earn a living from them. There were no buyers at the beginning. So, to do my own work, I had to decorate walls and make mosaics. In 1984, when I showed my work, the authorities drove me to distraction. I became ill. Even now, I still suffer. I had a nervous breakdown. They drove me to it. This is what happened. When I hung my paintings, the committee came to judge and to criticize. This is not the way you do these things in the West, is it? Here, before perestroika, the painters hung their works, and the committee arrived to examine them. The members then decided who would be allowed to show and who would not. Well, for my show, a committee arrived and told me to leave the hall. I was ordered out. When I left, the members told people there that even before they would look at my works half of them would have to come down. Either that or the show would be closed. The people in the exhibition hall said that they would take down half the pictures so that there would be a show. All of my paintings of nudes were removed. But about one small

nude, I was told to put pants on her or she would have to be removed. I then drew little panties on her. When the committee returned the next day, they said that the painting was worse than before. So I had to cover up her panties with a piece of paper. The show opened, but I called it "a castrated exhibition." About fifty works were removed. Many people came even though the hall was far away from the center of Moscow. But after the show, the German collector, Peter Ludwig, bought two works. Then some of my paintings went to the United States. In fact, the bulk of my work is in the United States.

RB: *Who were the buyers?*
AП: They live in Florida, Washington, D.C., New York, and other major cities. Norton Dodge bought many pieces. I even once worked at the University of Florida. For some reason, I have had several shows in the United States. I don't have any connections in Europe, although some purchasers live there.

RB: *Did any Russians buy your work?*
AП: Nobody bought here until recently.

RB: *Did the authorities harass you?*
AП: I became very ill after the show in 1984. I was unable to work for about five years. You can imagine what they did to people. It wasn't only that they taunted us, but they could make a person a nervous wreck. Their mental torture was insupportable. You can't imagine what it was like. When the committee came, my friends had to hold me so that I would not lose consciousness. In such a totalitarian system, everything depends on some silly lady. There was, for example, some woman who came in from a bazaar with bags, and your fate depended on her judgment. It was a tragedy. It must be difficult for you to imagine this. Everybody suffered. These women were set up by the Ministry of Culture.

RB: *Then they would denounce you?*
AП: Of course they denounced me. But they did not really have an awareness of me. I did not exist for them as a person. In general, artists did not exist for them. We were considered as cattle. For

Arkadii Petrov, *Aunt Niusia*, 1981, oil on fiberboard.

instance, a woman might enter the exhibition hall without even looking in the artist's direction—he was invisible. She would usually go over to the government official, but the artist remained invisible to her. And these were the people who made decisions about what was to be exhibited. They decided for everybody, regardless of anybody's wishes. It was a totalitarian system dictating that everybody be the same. This was what life was like. We had no value, or we were undervalued as people, and this gave us a terrible inferiority complex. They held reign over us. My generation suffers from fear because we were pursued and watched. We were all afraid. Now that we have freedom, we still experience fear. We have internalized terror. Who knows what or who is watching? One stops breathing from terror. When my exhibition opened, I knew that they were following me. They constantly wanted to know where I had been and what I had done. It was awful. I have been to the West. Your world is free and beautiful for me. It seems like paradise. I was in France for the first time in 1989. I felt like I was in heaven. It seemed as if I had always lived there.

in that paradise. It was very strange, as if I had some remembrance of having been there before. I understood that that was my world, the Western world, a world close to me. I am a very sensitive person and I experience the world as good and evil. I thought I had fallen into goodness. Perhaps I am mistaken, but the Western world appeared to me as "good" and "light." That is because everybody smiled. People rarely smile at you in Russia. Everyone is gray and sullen because of the life here. The food, the clothing—everything is grey. It leaves a powerful impression. So I really liked the United States when I first traveled there. It seemed that people smiled more, were friendlier than in France or England. I was embarrassed at times and lowered my gaze so as not to stare at people. People were very friendly, especially in Florida. As soon as you look at someone, they begin to greet you, and I would become embarrassed. In Russia strangers do not greet each other. I was not accustomed to it and felt strange, confused, as if I had landed in a different dimension, a different planet. I was upset and amazed. It was like a discovery. Literally, it was paradise to me.

RB: *How did this affect your work?*

AП: It had no affect whatsoever, because my place is here in Russia. I am Russian, and as an artist I have to be in touch with what is happening here, so that I can do my own work. To work in America, you need to be American, or a Frenchman in France, in order to experience that world.

RB: *Many Russian artists have emigrated or live half a year in the West. Would you do anything like that?*

AП: No. I am very Russian. Even a Jew can be very Russian. What I have in mind is not nationalism, but something about the earth, the one from which you emerge and where you were born. That is your country; this is my country. For me to create a painting, I need to stand in a queue, look at the old ladies who sell old clothing or bread on the market. I need to ride the buses and trains and hear the curses and feel the shoves. This is my culture and my life. The heroes in my paintings are ordinary people, just as you might find in any country. They are the ones who represent the basic structures of a state. They are my inspiration, the people

nobody notices, not the scholar or intellectual, but the laborer. I have to be where I get cussed out. On the other hand, I might like to go abroad to work for about two to three months.

RB: *I am assuming that you were too young to participate in the Manezh exhibition in 1962, but did you take part in the Bulldozer exhibition in 1974?*
AⅡ: No. I was a member of the artists' union at the time, but neither the union nor the people in charge of the exhibition wanted me. As I told you, I am a loner. I always sat between two chairs. I have few friends, not because I want it that way. It just happened. I know one thing; I have to work, I have a need to work. I work in Moscow, usually, from December through March, and then I work in isolation in the country.

RB: *Did the union provide you with work before perestroika?*
AⅡ: Nobody gave me any work. I found it for myself by traveling to different cities and towns. I would ask in factories, in halls, and in culture clubs if they needed an artist. I worked in churches and I was told to keep quiet about it. My earnings allowed me to do my own paintings. I was not afraid of anybody because nobody bought my paintings. Or if something did get sold, it was sold in secret.

RB: *Where were you educated?*
AⅡ: I studied geology at the university and then went to art school for five years. Then I completed six years at the Surikov Art Institute [these numbers do not coincide with biographical data listed at the beginning of the interview]. At the Surikov, people were angry with me and wanted to throw me out. When I finished, I immediately forgot everything they taught me. I began to work as I wanted to. The basis of my work is kitsch—the marketplace, the bazaar. I am interested in what poor people sell, like candy wrappers. Their culture interests me very much. Mass culture is my culture because I am a product of that culture. I come from a coal mining area deep in the provinces where coal miners, drunks, and murderers live. My grandfather and my parents were coal miners, the dregs of mass culture, the lowest level of ordinary

culture. I feel as if I am a representative of that culture. That is why, whenever I see or find something representative of mass culture, I don't look at it as an object, but I see inside the object. I see what is hidden in it. I see my relatives and my parents reflected in that object. For me such an object holds an inner condition or state of being. It is not a superficial thing, and I am often disturbed by it. It can touch me deeply.

RB: *How did you get to Moscow?*
AП: The ways of the Lord are mysterious. When I was young I wanted to come to Moscow and knew that I would some day. Life was hard for me here and I even contemplated doing away with myself. But I knew what I wanted to do. Art was not a choice, but a necessity.

RB: *Why do nudes interest you?*
AП: The nudes have one peculiar feature in common. That is, they, like us, were deceived—as I was deceived—by seventy years of Soviet rule. We were fed a continuous lie. We were deceived, exposed, and left naked. But despite the fact that they left us vulnerable, we were able to maintain something special within ourselves, something that they could not take away from us. But this is not the only reason for painting nudes. I believe that a person's inner life can be shown by having him undress. Then everything is basic and clear. I always aim at showing the inner condition. In my earlier works I used lots of color, but now less color to say what I want to say—which of late might be, symbolically, a cry or a scream. Earlier, they were silent, probably because of the political situation. Now, they scream. I don't know if they would scream today, had the political situation remained the same.

RB: *How does Western marketing practices affect you?*
AП: Commercial enterprises do not affect me. I have been asked to paint in earlier styles, but I can't paint the way I did twenty years ago. Galleries cannot depend on me. They might invite me to work and might expect a certain product, but I might surprise them with something different. I feel I must keep experimenting. I

always have to do something new. In this way, I don't think perestroika has affected me. Many of our artists have begun to work in the West. I don't like the kind of thing where we work so that you can buy. I won't go down that path. I work for myself, not to specification or demand. Some of our artists have come back from New York and say they do not want to work that way, but prefer their freedom to money. Fortunately, people do come and buy my works now. But I must say that our generation has suffered damage, and that is why we are not doing so well, even in good circumstances. It is true that we are much better off spiritually and psychologically. We can breath as freely as people in the West now. On the other hand, art supplies have become hard to get. I paint on oil cloth and with cheap quality paints. My brushes are bad ones, too. And I live in a basement. It is cold here in winter, and even in summer I wear winter felt boots and a vest. Sometimes the stove makes it too hot and stuffy. I can't open windows because passers-by spit, cats climb in, cars make noise, and people watch. I have been here for twenty years. Yet, there is no guarantee that good conditions make good artists. American studios have wonderful facilities, but there are plenty of mediocre artists. We should not have to live the way we do here, but that is our situation. I was much more productive when I was in Florida. Here, it gets too stuffy after four or five hours. But great art can be made in basements under difficult circumstances.

RB: *Did you see Western art before perestroika?*
AΠ: Only in museums and in books. Otherwise, there was a curtain. Imagine what it was like to see only reproductions. I had no real teachers here, but I call Cézanne and Van Gogh my teachers—and the marketplace, and the bazaar. But art can never be suppressed whether under fascism or communism. Even democracies are capable of repressing artists.

But art is the only thing that nothing can suppress.

★

Gennadii Zubkov
Геннадий Зубков

Born in Perm in the northwest Urals, 1940; Herzen Pedagogical Institute, Leningrad, 1968; studied with Vladimir Sterligov beginning in the mid-1960s; lives in St. Petersburg.

Paints in an abstract style.

RB: *You were born in Perm. Did your parents live there?*

ГЗ: No. My mother was in transit from Krasnoiarsk to Leningrad and obviously didn't make it. In Russian we call somebody like that a highwayman. Because of the war, we spent about a month and a half in Leningrad and then were evacuated to middle Asia, to a small town called Chinek, near Tashkent. I still remember the place even though I was only a little boy, and in retrospect I understand now the hardships my mother endured with two children. My father was a pilot during the war, and after we returned to Leningrad my father taught at the military academy there.

RB: *Were you educated in Leningrad?*

ГЗ: Yes, thank God. My parents died young, and my guardians put me in the Suvorov Military School in Tuli, but I did not want a military career. My whole being rebelled against it.

RB: *You were a rebel even then?*

ГЗ: Not exactly. Being a rebel distracts from one's inner calm, from one's sense of introspection. Anyway, I am too lazy to have been a rebel. I had the opportunity to have a military career, but I preferred the civilian life.

RB: *How did you start painting?*

ГЗ: I began to paint as a youngster, and I would say that it was in response to a spiritual state of mind. It simply happened. I never studied at an official academy of art and therefore, did not study Soviet art. I consider myself fortunate in this regard because I was not corrupted by an official art education. I received my education at the Herzen Pedagogical Institute in Leningrad and, beginning in 1963, from Vladimir Sterligov, who had studied with Malevich at his Institute for Artistic Culture in the mid-1920s. By 1960 Sterligov organized his own system of painting based on curved cupola-like forms.

RB: *Did you meet him by chance?*

ГЗ: Sterligov would often say that nothing happens accidently in life, that there is no such thing as chance. Everything is predetermined from above, and our task is to fulfill what has been or-dained. Before I met Sterligov a very polite KGB representative spoke with him and asked him not to meet with advanced students. He said that young people are very susceptible to all sorts of unhealthy influences. Better they should receive a real education and later they could do what they wanted. My sister, who was interested in art, met a man who knew Sterligov, and Sterligov repeated to him the KGB warning that he should no longer teach. But an artist has spiritual and creative needs, and it is impossible to keep these repressed for very long; like a quiet stream of water, they will find their way out. So he taught, and I joined a group of five or six artists who met at his home once a week during the winter months. He would pose a problem to us, we would spend the week working out the problem and meet the following week for a critique. This was my real art education and was the time when I became really serious about art.

RB: *Did you know any artists from Moscow?*

Г3: I know little of the art world, but I can say that the Bulldozer exhibition of 1974 had a shattering effect on us. This show made public the covert artistic activities of the period. It was also the first official exhibition I participated in. We had never seen such lines of people coming to see art. But my first exhibition took place in 1968, in an apartment of one of Sterligov's students. My works were exercises in Sterligov's technique in which plastic motifs were to connote the spiritual condition of mankind. He called it the cup-and-dome technique, which implied the union of purely plastic problems with the spiritual.

RB: *Were there visitors?*

Г3: Only Sterligov and his students knew about it.

RB: *What about the show in Leningrad at the Gaz Palace in 1974?*

Г3: That was the place where I first had trouble with the authorities, even though it was an official exhibition—but of unofficial artists. It lasted for four days, and afterward official artists and critics—some were bureaucrats, really—met in judgement. Only two critics, Yurii Novikov and Evgenii Kovtun, were in any way sympathetic. Generally, they wanted to belittle us and demean the importance of the exhibition, but they really couldn't. So the Leningrad Union of Artists ended up asking some of the unofficial artists to join their union.

RB: *What about you?*

Г3: I knew that it was impossible for me to do so. In order to apply for admission you needed to have paintings that conformed to socialist realist standards. In truth nobody knew exactly what they were, but I knew that my work did not fit into any acceptable category. Socialist realism was really an art of ideological illustration and political sloganeering anyway, and I wasn't going to make that kind of art. So I never joined the union. I made a living as a designer for the Museum of the Institute for Botanical Research. I minded my own business. But I want to tell you that one day in 1983 a woman came up to me and asked me how my show was doing. I had never had any solo exhibitions, so I told her she

was mistaken. She then said that she had heard it on the Voice of America broadcast, that I was having a show in New York City at the Contemporary Russian Art Center of America. I went into some kind of shock because some catastrophe could result if you were mentioned by name on a Voice of America broadcast. I thought that this was it. I'd be summoned by the KGB. But you know nothing happened. Nobody called or threatened, perhaps because I had a steady job.

RB: *What about in the 1960s and 1970s?*

Г3: We had incredible difficulties then. Life was hard, but I had no confrontations with the authorities even though I did experience some oppression and certainly stress. For example, toward the end of the 1970s there was supposed to have been an exhibition near the Peter and Paul Fortress, but the local authorities decided to ban the show for no reason at all. I had taken no part in this exhibition, but somebody got to the director of the institute where I worked because he urged me not to participate in it. Although there were no confrontations, since I hadn't planned to participate, the situation was still an unpleasant one. You mentioned the Gaz Palace show a moment ago. Well, the authorities were very repressive and removed and confiscated all of the paintings. I went to the Gaz Palace show full of hope, and when I got there everything was blocked off by the police. They stood there like a solid mass of black ravens. In order to get our work into the palace we had to show it to representatives of the militia, the KGB, and the administration. We had to show them our passports, and they took down whatever information they found in them. It is comical that we had to go through such an ordeal to show our art openly. Some people were frightened and left. I stayed on, and I felt very nervous. We were given to understand that it would be better if we did not participate. [See Yurii Dyshlenko who had a different experience at the Gaz Palace.] The next year, in 1975, I brought my paintings to the show at the Nevsky Palace of Culture, and, happily, things were easier. But this is why I never participated in unofficial shows. I believe that the authorities wanted to give us no options about participating,

but at the same time they could not continue to oppress us. So they lightened up a bit. Just the same, unofficial art could be exhibited only if we censored anti-Soviet and religious themes. The Department of Culture was very strict about this. At one exhibition at which practically all of the works were removed, artists said that it was impossible to cooperate, and so the exhibition was closed down.

RB: *Did your works contain religious or metaphysical themes?*

ГЗ: This is not a simple question. Since I studied with Sterligov, who was a religious man, I learned that the spiritual and the moral were the essential foundations for art. We thought a great deal about this matter, since the icon plays a central role in Russian art and is part of our tradition. Should we copy these images or make modern interpretations of them? Sterligov would say that today we needn't paint the icon as it is, but that we should paint a landscape or a flower so that it could awaken in the soul of the viewer a sense of the beautiful and prompt the viewer to ask God what he is doing in the world and how he can make it a better place to live in, a place as beautiful as the painting. I thought this way about my art, and so painting was a spiritual and even religious experience. I saw my art invoking such thoughts as these: My Lord, I will truly show how wondrous is the beauty of Thy house. Thoughts such as these had an astonishing effect on me. I still paint out-of-doors, and sitting in nature cleanses my soul. I believe that everything is spiritualized and alive, that everything that grows has a spiritualized nature. It is important not to cause any pain or harm to anything or anybody.

RB: *Even though the authorities didn't bother you, was it difficult to get supplies?*

ГЗ: The choice of colors was limited—then and certainly now. Back then I had a friend in the union who would buy supplies for me whenever he could. But even union members had quotas, and stores kept records of prior purchases. But now I can go abroad and bring back paints and other supplies. It is a serious problem for young artists who can't afford to travel.

RB: *How did Leningraders relate to artists from Moscow?*
ГЗ: I traveled frequently to Moscow and participated in some events. But being a dissident was not a central condition for me. I was more concerned with problems of existence than with social issues, more concerned with the gap in our art consciousness after the 1920s when the repressions began. You know, everything was hidden away. We lost touch with that past. My whole being protested against this repression of knowledge, but I did not protest in an open way. In that sense I never considered myself a dissident, but internally I was.

RB: *What about your Moscow experiences?*
ГЗ: In the late 1970s I sent works to an exhibition in the apartment of Liudmila Kuznetsova, and I regret that I was not there when a confrontation occurred. Other Leningrad artists participated, including Yuri Zharkikh who told me about it when he returned to Leningrad. Evidently, the police blockaded Kuznetsova's apartment—quarantined is a better word. Nobody could get in or out. When I finally did go to Moscow I was not involved in any incidents.

RB: *When did you first see modern Western art?*
ГЗ: Somewhere in the mid-1960s during the thaw. The blockade on information was lifted, and we began to see magazines and catalogues of shows in the West. It was only in the early 1990s that I saw original Jackson Pollocks. But the truth is that I was so influenced by Sterligov that it was not until the 1970s that I began to respond to contemporary art, particularly the work of Robert Motherwell.

RB: *In the mid-1970s many artists and intellectuals were thrown out of Russia. Did this bother you?*
ГЗ: I knew many such people, some who really suffered. For instance, Vsevolod Nekrasov, a conceptual poet who now lives in America, was banished from Leningrad. If he had decided to stay, he was told that his children would be harmed in some way. Another artist I know, who had come from the Ukraine, was told to leave within twenty-four hours. His fate was to be sent to

Dniepropetrovsk, in the Ukraine, where he had to wait for a long time before being able to return to Leningrad. This was a kind of internal exile. Knowing about experiences like this makes you become very careful and dissuade you from playing the role of an activist.

RB: *How about perestroika? Did it have an effect on you?*
ГЗ: Yes, an enormous effect. For decades the entire creative and intellectual community had been kept in moth balls. We were denied access to information as well as to knowledge about many world problems. The deprivation was a monstrous thing; we were made deaf and dumb. We had no knowledge of the language of art used by other artists. When we finally were able to get information, we were shocked, particularly the younger artists. They began to imitate Western styles in order to catch up and to learn how to resolve certain artistic problems they faced. As for me, Motherwell was important. I didn't imitate him, but I began to see things in a different way.

RB: *The kinds of experiences you had before perestroika must have had an oppressive effect on your spiritual life.*
ГЗ: Undeniably so. So perestroika accomplished a great deal for us, especially the ability to travel, to see art, to have exhibitions, to have cultural exchanges. This was an enormous accomplishment.

RB: *Has your art changed as a result?*
ГЗ: I make larger paintings now even though I still paint in a small space that is part of a friend's studio. I have never had a studio of my own.

RB: *When did you first travel to the West?*
ГЗ: I was allowed to go in 1988—to an exhibition of my work in Finland. I was shocked that I was given permission to go since I did not belong to any group. I was able to pay the taxes on the sale of my work there, so nobody could accuse me of being a parasite. Yet, permission to go was delayed and delayed, and I had to miss the opening. The red tape over getting my travel documents was such that I thought I could never get out. The whole process made

me feel helpless. But I finally got to Helsinki even though the show had already closed. Nevertheless, being there was like a fairy tale. All I knew was limits and rules and arbitrary decisions. This was the normal situation. I even felt that I would not be allowed to stay in Helsinki, that somehow I would have to return. You see, I had to register at the Soviet consulate there, and what if they insisted I return immediately to Leningrad? But they stamped my passport and the official asked me if I wanted anything else? I gasped and left at once. I stayed for two months, and for the first time experienced freedom and complete independence. I traveled again after this experience, and I can tell you that it changes the structure of your soul.

RB: *Do you plan to remain in Russia?*

гз: I don't have an answer to this question. Without doubt the West has had a strong impact on our artistic and cultural life. This was necessary so that we could reshape our lives. Yet, I thank God that I met Sterligov, and through him I was able to learn about the Russian avant garde of the 1920s. Things are bad in Russia now and the cynicism is unbelievable, but I think it is important to remain connected to my own culture, although, for young artists this is not as big a problem.

Many go to America, which is the center of the art world now.

★

Viacheslav Koleichuk
Вячеслав Колейчук

Born in 1941; Moscow Institute of Architecture, 1960–1966; member of Dvizhenie [Movement] Group, founded in 1966.

Kinetic sculptor concerned with synthesizing light, sound, movement, and color.

RB: *Can you tell me about your experiences before perestroika?*

BK: When I was a student at the art institute, I became part of a group called Dvizhenie. At that time I wanted to get involved with experimental work, and my association with the group became the basis for my future artistic interests. I also studied architecture, so my education reached beyond traditional limits. Actually, I studied kinetic art as a parallel to architecture. My education was twofold—one, official and one, personal. I was young and very energetic at the time. During my parallel life, as it were, I worked as an artist and a designer. But even earlier, I remember the Khrushchev Thaw of 1956 as a time of hope and dreams. We experienced a certain amount of freedom, relative, of course, to what existed before. At that time there developed all sorts of groups made up of left-wingers, right-wingers, unofficial groups that served as alternatives to official culture in the arts. We were each involved with our own problems, especially trying to cope

with different problems of the moment. For myself, I realized that nobody would bother with my type of art and that I would never be accepted in any artists' union. So my work was unofficial because it did not fit in anyplace. I just would never make anything considered official. That was clear to me. So I studied science and became a science researcher while at the same time making art on my own time. I worked at the Institute of Architectural Theory and the Institute for Technical Aesthetics. These were official institutes, very solid and serious. I never went underground. In fact, the reverse happened. I looked for a place where I could make a living, find a job on a theoretical level, but also work in my basement studio for myself. This sort of double life gave me the opportunity to work and experiment on a large scale. All of my life I have studied the way forms are created. I guess this makes me a formalist. I was paid to study formalism, but on a theoretical and experimental level. I was useful to the institutes in that regard. I also had a certain amount of freedom there because of the nature of my research and because my co-workers were cultured and intellectual. In effect I did official science, since there is no unofficial science. I worked in this dual or parallel way with great self-control, maneuvering between the possible and the impossible. I can't say that I rebelled. I did my job. The paramount idea for me was to be able to do my own work. In this sense, I did not waver in my intentions.

RB: *Were the authorities aware of you?*

BK: Yes. Everybody knew that I was involved with my own work. To be polite, they would say that they did not understand what I was doing and that I should just go ahead and keep doing it. Their hands-off attitude was based on the fact that they did not consider my work to be art. And if it was not art, why bother? So I did not have real confrontations with the authorities like other artists. For me, art is a positive, creative act. To make something means that it cannot be against anything or for anything. Against what? Official art? My work existed, then, parallel with my position at the institute. I simply knew that socialist realism was for

me the Other and that I could not make it. I had the brains to do it, I just couldn't do it.

RB: *But did you have any confrontations?*

BK: The simplest imaginable. For instance, on one occasion three or four of us organized an exhibition for a day at the Kuznetsky Bridge. I showed collages. The show was held behind closed doors except for specialists and professionals. An hour before the opening, a group of comrades, as we used to call them, arrived. They came from the KGB and from the union and closed the show and took away the works. They returned the works later, but they wanted to see who we were. In the interim we would have meetings and talks. It was a nightmare, a madhouse. This was the typical routine. Or, once I organized an exhibition at the House of Science. Everything was running smoothly and the works were hung properly. Then, suddenly, I got a phone call on the morning of the opening and was told that all of my works had been removed. I ran to the building and, once there, an official of the Department of Exhibitions told me that everything was to come down. I looked around and saw about half the works were already down and facing the wall. I begin to maneuver and I said that there would be a great scandal if the exhibition is canceled. (This is already 1978, mind you.) The official told me that some people came by and told him to take down the entire show. I asked him if he might wait a bit. Perhaps some committee will arrive. In the meantime, another person was walking around with a scissors cutting all of the strings from the backs of the paintings. It took us a week to hang the show, and they took it down in minutes. This particular show included Francisco Infante, Ivan Chuikov, and the Gerlovins [Valerii and Rimma]. Eventually a committee did arrive. The members walked around and selected which works would have to go and which could stay. One guy pointed to a landscape by Chuikov and asked what it was. Somebody said a water stain in the corners of the canvas. So it was taken down. I thought it would have been better to have said nothing because they would have left it alone. Their choices had nothing to do with

quality or theme. They simply wanted to set an example, to show their strength, to teach us a lesson, to let us know that the authorities were watching. "Take this down, leave that up." There were variations of this scenario all the time. Militia and KGB people came to keep an eye on us. They might form lines so that nobody could enter an exhibition. They might surround us. They might let us or not let us show. I really don't know what to call this. It is not understandable. You can't imagine what it was like—an entire world in another sphere. But I tried not to get caught up in it. I am psychologically very stable. God gave me a healthy psyche. Some would have taken to drink. But I was single minded and had one goal—my work. Another instance. I had a solo show in 1975 at the Museum of Architecture. I organized it entirely within what was a system of sanctions, of approvals and permissions. Everything had to be submitted and approved—working papers, tickets for traveling if you needed any. There was an inner censor at the institution and an external one as well, an entire apparatus of censorship. One day one of the censors dropped by on her way from work. She was carrying groceries. Suddenly, the director of the institute appeared, entirely by chance. The censor turned to the director and wanted to know what my work was all about. He said it was design stuff. The censor said it was foreign and incomprehensible, but she was embarrassed and left. In the end she did not give the show the stamp of approval. What I learned form all of this is that governments are the same in any society, socialist or capitalist. The state is the enemy of the artist, of his sense of freedom, of his imagination. There are situations in which the artist can't work. The reasons might be different, but the results are the same. That is why I never said that it might be better or worse to be elsewhere. Governments are created so that they can rule over individuals. An artist, however, cannot conform. He must make his own decisions. Nobody knows or understands what he is doing. So there is no reason for the state to believe him or trust him. I simply asserted my position and understood my situation very well. It saved me. I always had confidence that I was not evil and that I was not doing anything wrong, that I was not a bad artist. I understood that the public was not yet ready,

JACK ABRAHAM

Viacheslav Koleichuk, *Möbius*,
1975, bronze and wood,
64.5 x 50 x 22 cm.

psychologically, to accept something new. So it couldn't find meaning in my work. Of course I wanted to be understood, but it was not necessary.

RB: *Did it help you to have a supportive groups of friends?*

BK: We were a tightly knit family of artists. When the centrifugal forces of power became more aggressive and surrounded us, we drew closer together. We tried to answer commonly held questions about art, about what the next move should be, or what should be our code of behavior, or what type of exhibitions to put on, and how to get permissions. The atmosphere was congenial. We all had awareness and understood the issues. When we did apartment exhibitions, for instance, we might occupy seven or eight apartments for our one-day shows. This took cooperation.

RB: *Who came to these shows?*

BK: The viewers were basically an elite group of people, the same people who also came to our public shows when we were able to get permission to hold them. But the audience for the apartment shows was more restricted—friends, other artists, the intelligentsia, the "fear-sympathizers," we called them, the ones who suffered on our account. You'd never find a peasant or a day laborer there.

RB: *Did you ever try to join an artists' union?*

BK: I tried once, but they shoved me aside. They did not understand my work or what I was doing. I should go to the union with a piece of metal? I didn't even try again. Once I tried to participate in a union show but was turned away immediately. Since they didn't allow me to show, they wouldn't allow me to join. But I became a member of the union of architects, a professional organization.

RB: *Were you able to obtain materials easily?*

BK: This was a big problem, but if you had money, you could buy what you needed. Or you could find somebody with access to materials. I was able to buy pipes or tubes then, but not since perestroika. At the moment things are pretty grim. It's much more difficult to get materials now. This might appear to be a trifle, but it is an important issue, especially when I have an opportunity to be in an international show.

RB: *Were you able to leave the country for these shows?*

BK: I was invited a few times to shows in the West, but I could only send my works. I was not allowed to leave, and nobody ever tried to arrange a trip for me. I remember one, now humorous, incident. At the institute where I worked, a group of five or six people was invited to England to design something. A place was available for one more person, and two of us were considered— myself and a young architect. They took the architect and he never returned. They wouldn't let me near the group, but it was the man they chose who defected.

RB: *Did you participate in the Manezh or Bulldozer exhibitions?*

BK: I was still in school in 1962, and in 1974, when the Bulldozer exhibition took place, I was in Bulgaria. I was invited to take part, but I was away.

RB: *Did you have any collectors?*

BK: No, not here. I gave my work away for practically nothing. It was odd to get paid. People might want my graphics or my paintings, but not my sculptural constructions. Not even in the

West. There was little demand for constructivist-styled works. It is a very particular kind of style. So I never expected to get rich. There was no market in Moscow except for the diplomats, but they rarely came. I can't even remember how they found me. Local journalists would come with them and they would say that your art is for diplomats, not for the people. Since there were no local collectors, the market was extremely narrow. It was not fashionable to pay for my type of art, so I basically made gifts of my work.

RB: *Could you see Western art?*

BK: When I was still in school I saw magazines. I also saw an exhibition of American graphics in the late 1950s. By the 1960s and 1970s we were able to see original works. But at school there were still teachers who remembered the 1920s. They were constructivists and told us a few things about the past and about modern art. All of this was normal but kept very quiet. There was nothing official about it. One famous architect who survived from the 1920s was Konstantin Melnikov. He had us to his house and discussed things with us. We also met guests from abroad who would bring catalogues and records from the West—music by composers like Xenakis, very advanced stuff.

RB: *When did you first travel to the West?*

BK: Not too long ago. My first trip to Germany was in 1990 in connection with an international conference on Tatlin. I delivered a paper. And I showed in Germany that same year. I was exhibited in France later. And I gave a lecture in Canada. Along the way the authorities did bother me a little. One does not live in an isolated space. But I usually fell into good situations. I worked in a prestigious scientific institution and that was very helpful. I knew what to do, and I knew what the boundaries were. I have a friend who was denounced and spent six years in jail, in part because of his art. Afterward, when I saw him I asked him if he thought his art was worth it. I told him to paint Lenin in one context and do what he wanted in another. As for me, I thought it was not worth the time to do something good for these awful people or even to record them in one's work. I did not want to paint generals or

presidents. They simply are not worth it. One has to experiment, to make up new symbols, a new language. That is what interests me. Otherwise, the government could use your art for its own purposes. One time the government sponsored a show in New York City. It was in their interest. I was asked for a piece to certain specifications. That is called "engaged to participate." But my piece was not specifically made for the show. It was a composition that I made for myself, and I liked it. That's all. If somebody from the government should want something from my studio I would not kick him out, but I would make a piece only if it were interesting for me to do.

RB: *Is it important for you to stay in Russia to find your new language?*
BK: Yes it is.

It is more interesting here now, more original.

★

Vladimir Ovchinnikov
Владимир Овчиников

Born in the Ural mountains, 1941; attended the Leningrad Secondary Art School; lives in Leningrad.

Figurativist who works in a manner and style akin to Breughel.

RB: *When did you first begin to paint?*

BO: I started to paint rather late, when I was almost twenty years old. I never had official training and did not finish art school. I was lucky enough to be in the right places at the right times. I first began to work at the Kirov and Marinsky theaters as an artist's helper. My supervisor was Kiril Borisovich Kustodiev, a theater designer and the son of Boris Kustodiev, the famous artist. This, by itself, was wonderful schooling, and after such an experience I did not think I needed further training. After my work at the theater I was employed for a long time as an artist in the provinces for the Russian Orthodox Church.

RB: *Did you have commissions?*

BO: Yes, I had a large circle of acquaintances among the clergy.

RB: *Did the government know or interfere?*

BO: They knew, but didn't bother me. I simply had to pay income taxes and declare what I was paid for. Toward the end of the 1960s and for all of the 1970s, this was really no problem.

RB: *At the time did you consider your work to be unofficial?*
BO: It is hard to say, because work for the Church was within the canon and could not be considered official or unofficial. You might want to consider it unofficial, but I was not consciously a dissident. I believe that I always felt an inner freedom to do what I felt necessary. However, they did know about me because from time to time I tried to participate in exhibitions, which only rarely took place.

RB: *Such as?*
BO: The first exhibition of what you could call unofficial artists took place a long time ago in 1964. There is a tradition at the Hermitage that every two or three years workers at the museum who are artists can have a show. At that time, a group of us who were laborers, maintenance people, and restorers, including Oleg Liagachev, who lives in Paris, and Mikhail Chemiakin, who lives in New York, organized an exhibition. It caused a big scandal even though it was an internal affair not open to the general public. But we did invite people to the opening. I still have a copy of the invitation. It reads, "We invite you to the opening of the exhibit by the following artists, Ovchinnikov, Liagachev, [Vladimir] Ufliand, [Valerii] Kravchenko, Chemiakin. The exhibition opens at the Hermitage in the Rasstrelievsky Gallery, March 30," et cetera. We also added that this would be the first time that such an opening would take place. Since there were usually no opportunities to exhibit, we had no unifying theme or conceptual idea about the show. We were just happy for the space.

RB: *What was the style of your work then?*
BO: In the 1960s I was still experimenting with a variety of styles of expressionism. I painted all types of things.

RB: *Had you seen impressionist paintings at the Hermitage?*
BO: Yes. The first impressionist exhibition took place at the end of

the 1950s—in 1958 and 1959. And there were some pieces by Matisse and Picasso.

RB: *Were you threatened by the government after the 1964 exhibition?*
BO: Not really, but we had to leave our work at the Hermitage. I did not experience any special persecution. I did have problems later, though, in the early 1970s, during the time of the Bulldozer exhibition in Moscow and during our first contacts with American art. Unfortunately, since I was not in Moscow at the time, I did not take part in the Bulldozer exhibition.

RB: *What about the shows in Leningrad—the one at the Gaz Palace of Culture in 1974 and one at the Nevsky Palace of Culture the following year?*
BO: I organized the Gaz show [52 artists and roughly 250 works]. It was the first *official* exhibition of *unofficial* artists. You have to understand that this country was absurd.

RB: *Any problems then?*
BO: Conflicts began when we began making contacts with foreigners, but usually nobody came to bother us. What would happen was this. We would be invited to come to a large building the KGB occupied. They would start conversations like, "It is not allowed to make contacts with foreigners because they are the terrible enemies of Russia, and you as Soviet citizens are obligated to remain Soviet people and not fraternize with some horrible Americans, let alone sell your works to them. This would be utterly despicable and forbidden and not possible." Understand, in the 1970s, when there were no longer blatant repressions, these were conversations, not threats.

RB: *How did you respond?*
BO: I spoke up and told them that I didn't feel that I did anything wrong or anything that might hurt the Soviet Union. What is more, I told them I believed that if more foreigners were aware of the existence of the Russian artist Ovchinnikov then it would not be bad for Russia, but just the reverse, that it would be better for Russia. They, of course, said that I was wrong and not thinking the

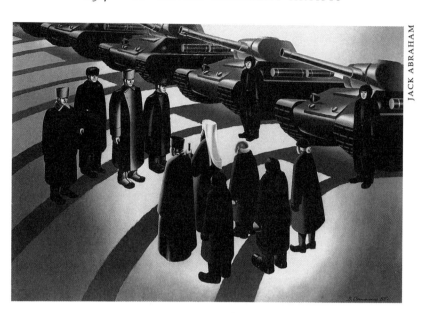

JACK ABRAHAM

Vladimir Ovchinnikov, *Handing over Command of Dmitrii Donskoi's Tank Column Which Was Established with Contributions from Believers, March 7, 1944*, 1985, oil on canvas, 99 x 140 cm.

right way and that I didn't have to work for the Church. They spoke to me as if I were a five year old instead of a thirty year old.

RB: *Had you ever joined the artists' union?*

BO: I have never been a member, and now it is no longer necessary. But it was a strange system. You couldn't just become a member, particularly if you had no formal art education. Then, in order to become a member, you had to have participated in two or three major exhibitions, official exhibitions, but at the same time you couldn't be in a show if you were not a member.

RB: *Did you have trouble obtaining supplies?*

BO: It is harder now. But then, even if you were not a member of the union there were ways to get supplies.

RB: *Through friends?*

BO: Yes. Artists in Leningrad knew each other. We also had contacts with artists in Moscow and the Baltic countries. In Leningrad we established a network of apartment exhibitions in the 1970s. We would select a large apartment and organize an exhibi-

tion there. Many friends and acquaintances would come to these shows, and we would make contacts with other artists and writers as well as people interested in the arts. An unofficial culture developed as a result.

RB: *Was this support important psychologically?*
BO: I believe so, although I am not a person who needs contacts with others. Nevertheless, it was important to have a social group of like-minded people.

RB: *When did Leningrad open up to Western art?*
BO: In the 1970s. The Hermitage had exchange exhibitions with some museums in Europe and with the Metropolitan Museum of Art in New York and the National Gallery in Washington. Contemporary paintings would be shown, and that is how I first saw works by Rauschenberg and Lichtenstein—as part of larger exhibitions.

RB: *What was your response?*
BO: This is very complex. These works were entirely new to us, but we saw only two or three by these artists. We had no context for them, so the impact was not straightforward and obvious— like "wow, I saw a Lichtenstein. Now I'll go home and paint like him." But, subliminally, somewhere in the mind something happens, and an impact does take place. Later, after I was able to visit the United States and France and go to the museums I did not start to paint in a new style. Nevertheless, I learned a lot. I would say, though, that my work did change toward the end of the 1970s, and it has evolved since then.

RB: *When did you begin to exhibit in the West?*
BO: People interested in Russian art had bought my works and exhibited them without my knowledge. And there used to be a governmental organization in Moscow, the only one in the Soviet Union, that had the right to sell works of art to the West. They sold contemporary art and old icons. (This I saw with my own eyes, so I know.) I sold works to this organization for an agreed upon price, and then my works would be sold to Western galleries or collectors. All of this took place at the end of the 1970s. My first

one-man show was at the CASE Museum of Russian Art in Exile in Jersey City in 1986. I learned about the show when I received a catalogue.

RB: *What kind of artistic statement are you making now?*
BO: I don't consider my early works to be political statements, nor my current work. I am certain that I would have continued to work as I have even if perestroika happened in 1965. Now, I know that some people think that since characters in my paintings are identifiable as having a Soviet frame of mind, my work must be political. But I don't think so at all. I can't say that Rembrandt or my beloved El Greco were political artists. Yet they painted their contemporaries.

RB: *Do you consider the past more congenial than the present? I ask that because one or two artists seem to miss the old days.*
BO: I am not nostalgic for the 1960s or 1970s. People say that times are bad now. But I believe that what has recently occurred here is not yet entirely comprehensible to us, nor is how important and how wonderful it is. So I am absolutely positive about the present. That is why I am not nostalgic.

RB: *Do you plan to stay in Russia?*
BO: For a while I thought about leaving. I might have left around 1980. In the end I made the right decision to stay. I can't exactly say why. Now I can travel as I please, especially when I have a show abroad. And what has happened here is of great importance. And I think it is also important for an artist to stay put. There are no particular problems. I do not feel particularly poor. I have enough to live on. Of course, I could have earned more money in France or in the states. But I don't value that highly. After all, I can live three or four months in the West, earn some money, and then return to Russia.

I would have to say, as I think about it, that being here is absolutely necessary for me.

★

Alexander Kosolapov
Александр Косолапов

Born in Moscow, 1943; Moscow Secondary Art School, 1950–1961; Stroganov Art Institute, 1962–1968; co-editor of *A-Ya*, 1975–1984. emigrated from the Soviet Union, 1975; lives in New York.

Sculptor and sots artist.

RB: *What sort of education did you have?*

AK: Our education was a classical one, a traditional nineteenth-century one. It was like getting a Ph.D. degree. We had to study anatomy extensively, then there was instruction in painting, drawing, sculpture, architecture, and composition. I wanted to be an artist since I could remember, and I wanted to get as much information as possible from my education. Basically, you were trained to get various state commissions that were, of course, based on your having accepted the approved style and ideology. You were held to a certain standard in this regard, a Soviet standard. But I felt I lived in two different worlds. One was that of the school in which the professors demanded that I follow a certain aesthetic, and the other had to do with my individual interests. When I graduated from the Stroganov Institute, I went to work for a sculptor in Moscow. The state was the only employer, and I worked on commissions for kindergarten classes, workers' clubs,

state institutions—things like that. The preferred themes included images of Lenin or some aspect of political doctrine. I tried to do works more civilized in content with less ideological baggage, but it was impossible to avoid the ideological.

RB: *Were you always a dissident?*

AK: Now I can talk about my second or underground career. When I was a student, I began to experiment with three-dimensional objects, which I did not show to anybody. I guess this makes you a dissident. But I tried to join the union, so I prepared work that met the appropriate standards. But I never mastered all of the Soviet standards, which included a combination of technical skills and ideological correctness. I had the skills, but not the ideology. I wasn't so good at that. So when the immigration of Jewish people began in the 1970s, I began to dream of going abroad, of leaving Russia for America. New York City was my dream, to get there, to be in the avant-garde capital of the world. I applied for a visa in 1975 and left soon after. I had been in contact with other underground artists like Chuikov, Kabakov, Komar, and Melamid—you know, the group that did not share the official positions of the authorities. We discussed leaving, but you only revealed as much as the depth of your friendship permitted. At that time, it seemed like all of the Moscow intelligentsia was discussing the possibility of leaving. But this always reduced itself to a personal matter concerned with family, nationality, particular interests.

RB: *Did you exhibit in the underground world of Moscow?*

AK: I had one short exhibition. It lasted one night. I put my works in a car, then on a wall, then there was a short discussion. Next morning the works were gone. This was in 1974. Around that time I began to plan an underground show with Komar and Melamid, but it never took place. The organization that owned the space we wanted to use decided not to let us have it.

RB: *Did the authorities bother you?*

AK: Not personally, because I was not very visible. They did not spot me, or at least they didn't come after me.

RB: *Did you experience anti-Semitism, or hostility to Jewish artists?*
AK: Well, this is a habit in Russia, not just anti-Semitism, but the inability to appreciate other nationalities. This includes Ukrainians, Lithuanians, and others. You are like a second-class citizen, not quite 100 percent acceptable or qualified. If you are Jewish, you are more suspect, you raise more suspicions. But this did not take place on the official level. We knew that there were quotas, for example, for Jews in the Academy of Sciences even though there were far more Jews in it than the quotas required. Something like only 5 percent were supposed to be Jewish, but the actual percentage was much higher. Jews were also well represented in the intelligentsia, more than their percentage of the entire population. Officials were not pleased by this, but documents were never seen or published to indicate their displeasure. There were even supposed to be percentages for artists. What it comes to is that you could smell anti-Semitism, but there was nothing overt. My mother was Jewish and my father was Russian, and because of my looks I might have been considered Jewish. Clearly, there were racist feelings in Russia, but there are such feelings everywhere.

RB: *What was your work like in Russia?*
AK: At first I sculpted, then I began to work in a sots art style. I worked on objects and installations.

RB: *Were you able to see Western art?*
AK: We knew very little, something about cubism, but hardly anything about dada or surrealism. We knew about Dali and a few others, but next to nothing about, say, Man Ray or Magritte. But we had our own traditions. There was a tradition in Russian literature that could be called dadaist.

RB: *Were there any models you respected more than others?*
AK: I was always independent. I created my own standards, and, like all artists, I am a little suspicious of others because of my own competitiveness. You always think that you can do better than others.

RB: *Did you see examples of pop art?*

AK: Some examples, but very little minimalism. We had some information about pop art, and we learned from it something about America and Americanisms. American pop art was very appealing to me, especially an artist like Andy Warhol, because it fueled a dream of America as the land of freedom and free expression. But all of this was seen through publications in the library or in catalogues that circulated through the underground.

RB: *When you left Russia, did any style of art have a particular impact?*
AK: Throughout my life everything has had an impact on me. One deals with new experiences by filtering them through old ones. You combine the old with the new. For example, I thought I could be—wanted to be—a Western artist, but I realized after I left Russia that I would never become an American artist. I guess what you are is in your experiences and in your genes. In the end, I am Russian and know my own culture. All prominent Russian artists were influenced by Western culture, but they were also formed by their Russian experiences.

RB: *Since you immigrated, do you feel some loss of your past history? I mean, do you feel that you are international now?*
AK: This is very complex. When I first showed my works to gallery owners in America, I had one bad experience after another. I was rejected because of my nationality, because of the type of work I did. I was told that nobody would understand what I was doing, that it was too Russian, that Americans were neither interested in nor did they share the problems I presented. Galleries tried to impose certain standards of acceptability. Since at least 90 percent of art in this country is sold through galleries, this can become a problem, unlike, say, in Germany where the system is a bit different. An artist can be more independent there. And in the 1970s critics were not interested in Russian art. They wrote about something sensational that might have happened in Russia, like the Bulldozer exhibition, but they were not interested in the art for itself. But, in time, interest did grow. On the whole, however, I did have some negative experiences because of my Russian background. I was also New York editor of the magazine *A-Ya*. I remember asking curators and dealers to buy works by artists like

Bulatov to raise money for the magazine, but there was basically no interest. It is true, though, that Norton Dodge bought paintings to help raise money. Igor Shelkovsky edited the magazine from Paris. At that time he was very modest and very poor, and he also got nowhere when he tried to raise some money in Paris. But after perestroika in 1987 Russian art got more trendy. Just the same, dealers would then go after certain artists in Moscow, but there was no support in a general cultural way.

RB: *Has your work evolved since you left Russia?*
AK: When I left Russia I really began to explore what you can do with sots art. But after five years in America I was not in such good financial or emotional shape. I was influenced by American artists and my American experiences, but my Russian memories were also present. So I worked within the parameters of sots art and pop art. Andy Warhol was important for me, not only his paintings, but his writings too. I think he is one of the greatest American artists. After a while, I grew more comfortable in America. I began to share experiences in downtown New York City. I really liked, and still like, contemporary American art. I no longer feel pure Russian, so I call myself a Russian-American artist, now.

RB: *How do you relate to older artists such as Bulatov and Kabakov?*
AK: Every artist reflects his own generation and responds to whomever has inspired him or to the art he has experienced. I had different experiences from that generation, so my art is different. Actually, Andy Warhol has inspired me more than Bulatov and the others.

RB: *Did you see any Warhol works in Russia?*
AK: No. Only in America.

RB: *Can you discuss any of the images that have inspired you or any particular notions that inform your imagination?*
AK: Take for instance the Marlboro Man. He represents for me the last American hero, always going West. He is heroic. Now, in my childhood I saw many heroic statements reflected in public art. This art was addressed to the average person, and the images were always of heroic people. The Marlboro Man grew close to me

for that reason. The image was more important than who the man actually was. For a comparison, Malevich was a cultural hero, but what he painted was less important than the heroic gesture he made. The Marlboro Man replaced Malevich for me, as if this were a conditioned response on my part. This reflects both my Russian background and my American experiences. So I can say that Lenin was always projected in a heroic way with heroic images. It doesn't matter how I feel about Lenin, but in my subconscious he is there as a hero. It all blends together, my past and my present.

RB: *The Marlboro Man represents the American desire to sell a product and alludes to the old Soviet desire to sell ideology.*
AK: Yes. I also did a work with Lenin and the Coca-Cola image. When I was a youngster in Moscow, I saw an American exhibition, probably the one that took place in 1957 at the International Youth Festival. The Coca-Cola company gave away free samples. This was like dreamland for me. This was American culture—not just the glass of Coke, but the beautiful images of the country, the appliances, and the big cars. The taste of the Coke was like the milk of paradise. Then I left Russia and began to drink Coke. And I really couldn't drink too much of it. Like a prodigal son, I began to think of what kind of paradise I had left behind. I saw the image of Lenin in my mind's eye. Somehow the two paradises came together in that work with Lenin and Coca-Cola. I found in them a memory of paradise—one, a paradise lost, the other, not quite found. I tried for a big billboard effect and even wanted to get it built in Russia, but nothing came of it. Recently, when I visited Moscow, I saw the big MacDonald's restaurant, which is located near where I was raised. This seemed like an invasion from America, a cultural invasion worse than if there had been tanks. There should be MacLenin's, not MacDonald's there. These are the sorts of things I explore through sots art. So my work is a kind of social commentary, of trying to reconcile the paradoxes of being American and Russian at the same time.

RB: *What about a Disneyland in Russia?*
AK: A Frenchman said to me apropos the French Disneyland that he had his own childhood experiences and did not want to share

somebody else's? But now my own cultural heritage includes Coke signs and MacDonald's. So I guess I am creating from my own experiences, but through an American language—something like the writer Vladimir Nabokov. A Russian abroad is different from a Russian at home.

RB: *What about the proliferation of advertising images?*

AK: I did a series of urinals which was based on a Western dada image of Marcel Duchamp and was also intended as an ironic comment on the Russian avant garde. Back in the 1920s artists wanted to transform everyday objects by using modern forms. They thought that they could affect life, make it better. The idea was to start your day with a good design. But all of this reflects my basic position, that my work is not theoretical, but experiential, observant of the particular scene and somehow a combination of my old and new heritages.

> But all of this reflects my basic position that my work is not theoretical, but experiential and observant of the particular scene. And somehow a combination, now, of my old and new heritages.

Vitaly Komar and Alexander Melamid
Виталий Комар и Александр Меламид

KOMAR: Born in Moscow, 1943; graduated from the Stroganov Art Institute, 1967; invented sots art with Melamid, 1972; left the Soviet Union for Israel, 1977; moved to New York City, 1978.

MELAMID: Born in Moscow, 1945; graduated from the Stroganov Art Institute, 1967; invented sots art with Komar, 1972; left the Soviet Union for Israel, 1977; moved to New York City, 1978.

Both work in the sots-art manner and are also involved in performance and conceptual art.

RB: *What gave you the courage to show your works before perestroika?*

K-M: In 1967 we graduated from the Stroganov Institute. It was an interesting time for us because we were searching for a way to humanize socialism. We thought we could develop, as the saying goes, socialism with a human face. The same thing was happening in Czechoslovakia, the same ideas, the same search for answers. In 1967 it was possible to exhibit unofficial art. There was an organization called *Siniaia Ptitsa*, or Blue Bird, after the name of a café. This café formally belonged to the district *Komsomol*, or Young Communists League, and that is where many artists were able to show their works. But we were restricted to exhibiting for one evening only. At these gatherings people argued and criticized and evaluated the works of art. Life there was like in a nineteenth-century bohemian café. Artists drank wine and held lively discussions. Some people read poetry. But everything had to fit into the framework of the socialist experiment. We exhibited there in 1967. Soon after, in early 1968, Bulatov, Vassiliev, Kabakov, and others showed there. The council of the café had its own jury, and it invited artists whom it considered to be interesting. A man named Sobolev played an important role. He was an art editor of the magazine *Znanie Sila* [*Knowledge is Power*] and acted as a sponsor for many talented and original artists. He gave them work for his journal and allowed them to illustrate fantastic novels. The magazine was well known because it printed science fiction novels. The artists could exercise some freedom and imagination because they could work in a surrealistic style. Discussions at the café were about surrealism, conceptualism, and pop art. You might say that the beginnings of conceptualism and Moscow pop art took place at the café, maybe as early as 1965.

RB: *What happened after the invasion of Czechoslovakia?*

K-M: That effectively stopped the cultural thaw and our search for socialism with a human face. The Blue Bird café stopped functioning for a while. Artists stopped showing their works as often. Before the invasion, the artists' union had begun to organize an exhibition of younger artists. A youth committee was formed under Dmitrii Zhilinsky, a liberal official artist. We were part of

the committee and became, so to speak, members of the youth commission of the Union of Young Artists. But when the invasion began, the works that had been selected and already installed were removed. That happened the day before the opening. This was the so-called "Eight Exhibition of Young Moscow Artists." It was to take place in the Kuznetsky Bridge, an exhibition hall of the artists' union. Zhilinsky and the union confiscated our works. Artists came to see the show, and the door was closed. Guests arrived, and the door was still closed. It was a huge scandal. They told us that a new jury would organize the exhibition. Zhilinsky disappeared, and a new person became head of the youth committee. The new jury was very strict. We began to experience repression and a clamping down on our cultural advancement.

RB: *Could you exhibit anywhere else?*
K-M: About that time, in 1967 or 1968, we were invited to have an exhibition in Puschino, a city of scientists—biologists—on the outskirts of Moscow. These scientists had their own clubs, independent of the Ministry of Culture, and they would organize shows and concerts. These shows were not in apartments; that happened in Moscow. In these special cities there would be clubs with their own circles of people. A club could have a restaurant, a library, an exhibition space, a movie theater, and an all-purpose room. The whole thing was like an intellectuals' camp, where they lived and worked. The people there knew everything of interest that was going on in Moscow, and they purposely invited unofficial artists. They had their own funds and were totally independent of the artists' union and the Ministry of Culture. For example, in Puschino, they showed Fellini films, which the average Soviet citizen could not see. There was also an academic village in Novosibirsk. We were invited there and went and painted many portraits. But in Moscow artists began to have a rough time because of stricter control of exhibitions. We were not allowed to show our things anywhere even though we were members of the Youth Commission. Sometime later, in 1973, we petitioned to have an exhibition. We were told to show the commission our works first. These were then looked over, and, instead of getting space,

we were expelled from the commission. After that, we were left without the hope of ever showing our works. Then we went to Oskar Rabin who proposed the following—since we could get no hall or gallery, we should show our work on the street. We wrote a statement of request to the MOSSOVET [the Moscow Deputy Council of Labor] in 1974 to let us show our works on a vacant lot. We gave them several choices of lots and said that if they objected to those, then perhaps they could suggest another place. We hoped that they could not refuse all of the places. They did not withhold, nor did they give, permission. They simply did not respond. We then exhibited our works on September 15, 1974. Rabin was the organizer. Instead of the usual viewers, we saw the militia dressed in the uniforms of the voluntary peoples' militia as well as in civilian clothing. They began to break up the works. They broke the double self-portrait that we made, right in front of our eyes. They threw it in the trunk of a car and took it away— maybe to a garbage dump outside the city. (Later, we made a copy. It's the painting in which we resemble Lenin and Stalin in profile.) The militia had no interest in anything there. Rather, they were against everything, even the works of a woman still-life painter. Her name was Nadia Elskaia and her painting was called *Fall Flowers*. That was destroyed, also.

RB: *Were they opposed to the exhibit itself?*
K-M: Yes, to the idea of the exhibit, not to the meaning or content of the works.

RB: *Were you the first to invent the term sots art?*
K-M: Yes. The name derives from sots realism or socialist realism and from pop art. Until that time, the word "art" was not used in the Russian language. We had the Russian word for art, *iskusstvo*, but not the word "art" itself. We merged "sots" from socialist realism and "art" from pop art. We spelled "sots" in Cyrillic and "art" with a western rather than Cyrillic "r," which looks like a western "p." Immediately, articles appeared and this is probably how the expression became incorporated into the Russian language. Zinovii Zinnik was the first person to use this term in a

Russian article, which was printed in a *samizdat* sheet because he had no other place to publish it. This was in 1974, but in 1979, he published the article in a magazine called *Sintaxis*, published by a fellow named Siniavsky in Paris. Hedrick Smith, a reporter for the *New York Times*, wrote about sots art in English, in 1974. He transliterated "соц" into the English "sots." So this is why, in English, it was hard to get the full meaning of the term sots art. In 1973 Herbert Gold came to Moscow and wrote an article for *Playboy*, also published in 1974. He spelled it "soc art," as if it were a slang expression. But after our show at the Ronald Feldman Gallery in New York, the articles about it in the art magazines, and Margarita Tupitsyn's show called sots art held at the New Museum of Contemporary Art in 1986, the term sots art became the accepted term.

RB: *Tell me more about the Bulldozer exhibition. You said that you and Oskar Rabin were the organizers.*

K-M: We had ten people present who participated. In our book you will find a reproduction of the invitation and the names of all the people who participated.[1] I'll tell you what happened. Oskar Rabin was a very brave and daring person. He was the only one capable of organizing the artists. For instance, when Rabin asked Kabakov to participate in the exhibition, Kabakov said, "All my life I have crawled on all fours. I stand up on four feet. And you are trying to stand like a normal person on two legs." And he said that we should stand on our hands as if upside-down with our legs in the air. He said that he had become used to being on all fours, like a dog. Rabin truly was brave and, unlike Kabakov, was not scared. They were two old men, but Rabin was the only person we, of a different generation, could unite with and gather around. He played the part of an organizer and a speaker. He spoke to the authorities in the name of the artists. After the exhibition he appeared, when everybody was afraid and shook with fear and

[1] "O. Rabin, E. Rukhin, V. Nemuchin, L. Masterkova, M. Elsky, Y. Zharkikh, A. Rabin, B. Steinberg, A. Melamid, V. Komar, V. Sitnikov," in Carter Ratcliff, *Komar and Melamid* (New York: Abbebille, 1988), 20.

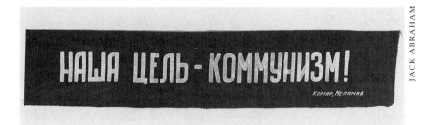

НАША ЦЕЛЬ - КОММУНИЗМ!

KOMAP, MEЛЯMИD

JACK ABRAHAM

Vitaly Komar and Alexander Melamid, *Our Goal Is Communism*, 1972, oil on cloth, 39 x 194 cm.

did not know what would happen. We were afraid of being arrested. He *was* arrested and held for two days. When he was let out, he figured that there was some trouble inside the government. The BBC radio station—we all listened to its Russian program every evening—announced that a debate had taken place in the Kremlin between Andropov, who was head of the KGB, and Shelkovsky, from the police. It was about who chased the artists away. Andropov claimed that the police action was an error after he became worried about the amount of publicity the show had received in the West. Andropov called Shelkovsky's conduct despicable and said that it would cause a loss in international prestige. In the Congress in the United States, a senator said that he did not want to have detente with a country that sends bulldozers to destroy an art exhibition. The BBC said that many civil servants in England would have been happy to send bulldozers against modernism, but the law did not allow it. In fact, the first secretary of the party for the section that gave the order to send in the bulldozers was removed from his position and sent to Vietnam. His new post was considered to be like a black hole, very far away and not at all attractive. All of this is probably why Rabin was released from jail in just two days, without a trial. It was a sign that the government was showing its vulnerability. After he got out Rabin said let's go to the same place tomorrow with paintings. He wrote a statement and all of us signed it. The next day the authorities called him, and they said that he should not insist on showing works the next day. They wanted to meet and talk about a time and place. So a meeting was set up with the head of the Union of

Professional Culture Workers. What was this union? All artists were admitted to it. So there were two unions, the official union of artists, which was not at all like the Union of Professional Culture Workers. The latter was smaller and had been started in the early 1920s. The members were mainly draftsmen, graphic designers, and artists who drew for newspapers and magazines. We can't equate the two unions. They were two separate organizations. The Union of Professional Culture Workers was a small organization and had little power and importance. Its only real purpose was to provide artists with opportunities to work without having to show up for work. This afforded the artists protection from accusations of freeloading, because in Russia, there was a law that you had to work, or you might be arrested and sent to a labor camp where you would be rehabilitated and reeducated. Most of the members of this union did not have constant work but could be hired on a temporary basis by magazines. All the unofficial artists were admitted to this union. They were told that since they now had a union, they could have exhibitions in an exhibition hall. The union always had a place for exhibitions but showed mostly small drawings, book designs, letterings, et cetera. This is why there were two unions of Soviet artists. But, of course, the Union of Soviet Artists was big and rich, and the other union was small and poor. Just the same, they were equally corrupt. Well, within the small union a jury was organized, and we were allowed to set up a show under its jurisdiction in the Izmailovsky Park. So we had the show three weeks later, without any censorship. It was the very first show without censorship. Everyone brought their works. I [Komar] spoke then and said that, finally, we have been able to create a new tradition and that we will hold similar exhibitions in the future. The presiding officer of the union then told us that this was a mistake. This was a one-time-only event because of the world-wide attention given to the Bulldozer exhibition and that we would never have another outdoor exhibition without censorship. In the future, juried exhibitions would be shown in union halls, period. It was really because of the rift between Andropov and Shelkovsky that we had the uncensored exhibition at all.

RB: *How were the artists selected?*

K-M: Just friends. We were a small circle, and we knew each other. Some people were invited and refused to come. For example, Rabin invited Kabakov, but Kabakov refused. He said "I don't want to because participation in the show is a position of a normal person, and I am not normal. All of my life I have behaved as a slave." Another artist, Mikhail Brussilovsky, agreed to participate, and his name was included on the invitation, but at the last moment he called Rabin and wanted his name crossed out. And that is how it is in the invitation. His name is literally crossed out. Perhaps someone called him up at the last moment and told him that things would be bad for him if he exhibited.

RB: *How did you become dissidents? What is a dissident?*

K-M: There is no clear definition of that word. If you study in a state-run art school, then you can't be a dissident, otherwise you would be thrown out. Several dissident artists did not complete their education at art school. Oskar Rabin, for instance, studied for only two years and did not obtain a specialized education.

RB: *Was he expelled?*

K-M: We don't know what happened. In general things like that were extremely complicated. Many unofficial artists did not have a specialized education. We did and so did Kabakov. We lived a double life. At art school you did what was required in order to graduate. In your free time you made works for your narrow circle of friends, friends with whom you met over tea and wine to discuss art. These were the underground circles. There were many such circles. Often, you could find a person who in the daytime was an important official artist who might be drawing a portrait of Brezhnev. And later, at home, at night, he would paint something entirely different—maybe a landscape or even an abstract work. But what he did at home he would show only to a very small group of friends. Students all over the world tend to live a double life. American students, for instance, use drugs out of school, but not all students use narcotics in class. This is a similar division between the private and the public spheres. This is why everyone

was a dissident in Russia. Even Kosygin spewed un-Soviet rhetoric in the privacy of his own kitchen. He said things that others feared to say. But, like other Party members, he had the liberty to do so, to express unofficial thoughts to his close friends, even to give unofficial speeches, though not at conferences. Officials said things that Solzhenitsyn said, but he was thrown in jail. The whole country led a double existence. Everybody was a dissident. When we speak of dissention, we have to ask who said it? and what did they mean by it? A dissident is an individual who was determined to break the double standard, a person who had decided to say "I will do openly that which I do in a small group." Such people are dissidents. That is as close to a definition as we can get. That is, everybody was a closet dissident, but at a certain moment they tired of living this double standard and came out in the public squares and, say, marched against the Russian invasion of Czechoslovakia. The Bulldozer exhibition held a similar meaning for us artists. At that moment we became dissidents. We opened ourselves up and we did it—in a true sense—officially.

RB: *When you both were expelled from the artists' union, were you able to get supplies?*

K-M: We lost the opportunity to buy art supplies, but that did not mean that we could not buy them. After all, we were a tight group and we were all friends. We could always call somebody up and ask for materials. Anyone would do this for you.

RB: *When did you first see contemporary Western art?*
K-M: In Soviet museums. There were many early impressionist works as well as paintings by Van Gogh, Matisse, Picasso, Derain, and Cézanne that were collected by Sergei Shchukin and Ivan Morozov before the Revolution. It was possible to see their works until the end of the 1930s. By the end of the 1940s, all impressionist paintings disappeared from the museums. Our parents and artists of the older generation had seen these works and could even receive magazines from the West in the 1930s and 1940s. But the problem was that German and French art turned conservative because of Hitler. The same thing happened in America. Art deco,

the official style in art in the late 1930s, was an antimodernist movement. What is interesting is that official artists in Russia who remembered early modernism thought that art deco was the present style, and so they believed that sots realism [socialist realism] was the latest style in the West. My generation didn't see any modernism. When Stalin died, modernist paintings reappeared. There was a huge Picasso show in 1956. Other paintings could be shown during Khrushchev's years. We saw them for the first time when we were in our teens—about fourteen or fifteen years old. Until then we had no knowledge of modernism or of the Russian avant garde. We simply knew nothing. Then we could see journals in the International Literature Library—magazines such as *Art International*. At the library we could find a journal called *Pol'sha* [*Poland*]. A great deal of information came to us through Poland, since Polish journals could be bought easily. Abstract artists returned there from Paris after Stalin's death, and abstraction became official in Poland in 1955. Just as the realists had done earlier, the abstractionists now put the realists out to pasture.

RB: *How did all of this affect your work?*

K-M: We were then just being formed. We believe that our conceptualism is eclectic and that we combined classicism with modernism. It is a reflection of our youth that we participated in the collision of these two major directions in the art world.

RB: *Did the KGB persecute you?*

K-M: At our show at Ronald Feldman's gallery in Soho, in 1986, we were followed by somebody who might have been with the KGB. But in Russia the unpleasant episodes that we endured were caused mainly by the militia. For instance, the official story or theory about the Bulldozer exhibition is that the militia caused all the problems, not the KGB. But we can't verify it. Perhaps this is all misinformation. Our biggest confrontation with the authorities occurred three months before the Bulldozer incident. We had organized a performance in our apartment, a large performance. We were six, and there were many viewers. Suddenly, some people arrived wearing civilian clothing and then some people

dressed in police uniforms came in. They arrested all of us. We were jailed over night and released the next day without explanation, but it was not the KGB who kept us. Perhaps the people who came to the performance in civilian clothing were KGB men. Perhaps it was all a provocation by the KGB. All we know is that we did not know what was going on. Maybe anti-Semitism was involved. Even though it wasn't government policy in the 1970s, anti-Semitism was everywhere. No question about it. The government was afraid of world opinion, but not afraid of the people on the street. You know, many of the unofficial artists were Jewish. But this does not mean that only Jews were against Communism. In the 1970s many Jews were members of the Communist Party. But maybe because Jews are an intellectually active minority, they participate in any kind of opposition movement. When Communism was the opposition, Jews participated, and when anti-Communism was the opposition, Jews also participated. Anyway, when we were arrested during the performance, a friend of ours heard a policeman say over the telephone that they had arrested a lot of Jews. They did not say "artists" or a word like that. Maybe the police thought that we were involved in some kind of ritual performance. Part of the performance was about refusenicks going to Israel. We used red paint on a huge red canvas and put a few drops on the floor. Maybe the police thought it was blood, that maybe somebody had been killed. For us the whole thing was fun, but for the police it must have seemed odd to see people sitting on the floor and listening to strange music. But our work was not antigovernment—no more than Warhol's portraits of Mao Tse Tung are anti-American. The Soviet government interpreted things in its own way, however. Of course, we believe that nobody in any country loves the government. But what we did was nothing like an artist we knew who depicted Brezhnev with a fork in his head. He was sent to prison immediately.

RB: *What is your background? I ask this because several unofficial artists seem to come from privileged families.*

K-M: Yes, you can say that some of us do come from such families. [Melamid's] father was an academic, a historian whose field was

German history. His mother is a German translator. [Komar's] parents are lawyers, his father a military lawyer. What all this might mean is that we had more opportunities, more access to information. In the Soviet Union the most important privilege was access to information and the level at which you had access. In [Komar's] case, his parents were divorced, and even though his mother was a lawyer, she was not necessarily privileged. In 1949 she was expelled from the public prosecutor's office and for three years could not find a job because she was Jewish, and only because she was Jewish. Later, when [Komar's] parents established contacts through friends in military circles, she was able to work in a military organization as a lawyer.

RB: *What about your development since immigrating to the West?*
K-M: When we were still in Russia we made several works dedicated to America, some of the most interesting, we believe, were examples of post-art, that is art that looked as if we were seeing it from a perspective of a thousand years from now, as if it were in some kind of Pompeiian museum, works that were made to look ancient, slightly burnt around the edges, with holes, works that looked as if they had been restored after a fire. We did some of these works after paintings by Warhol and Lichtenstein. When Warhol saw our copy of a Campbell's soup can, we were told his face turned ashen. After, he wrote a letter to us and drew a picture for us. We were the first people in Moscow to have an authentic Warhol drawing. We believe that our work was important because America was our theme while we were still living in Russia. We also continued to paint famous museums, but with a view of them from the future—for example, the Guggenheim Museum as if it were ruined after an atomic attack. When we came to America, we further developed an idea we had had in Moscow, the idea of buying and selling human souls. We organized a company and issued forms to be filled out by customers who would announce that they were selling their souls. We even placed a large advertisement in Times Square. Souls went for any price. It was all a kind of conceptual performance. The prices ranged from a million dollars to eighty cents. We sold and took orders. Even though we

conceived the project in Moscow, it had to be carried out here in America because it is the land of capitalism. Then, something totally unexpected happened to us. We grew nostalgic for our youth because we had become very isolated and felt very alienated in this country. Not since the war in Afghanistan, around 1980, had we experienced such profound alienation. Also, we could hardly speak on the phone to anybody in Moscow in the early 1980s. Earlier, we could dial directly or place a call through an operator. But from the early 1980s until perestroika we sometimes had to wait two days to get through. During those years we began to experience Russia not as it was, but as a series of memories from childhood. So Russia was less a geographical location than a state of mind, a period of time from our childhood. We created a series of dark paintings titled *Nostalgic Socialist Realism*. We fictionalized our childhood as we had been taught in school. We consciously reconstructed the lies, fairy tales, and mythologies on which we were raised and educated. We worked with our own style of sots art based on sots realism. This series lasted until about 1984. Since our contact with Russia had virtually been severed at this time, the country became for us a mythical, faraway land. And when contacts became easier again, we returned to conceptual pieces. So our work changes frequently.

**For us, any kind of change in regard to Russia
has fruitful effects.**

★

Leonid Borisov
Леонид Борисов

Born in Leningrad, 1943; graduated from the Higher Technical College, 1968; lives in St. Petersburg.

Nonrepresentational sculptor

RB: *Did you belong to any group?*

ЛБ: No, in general I did not belong to any group. I began to work in the tradition of the avant garde [of the 1920s] in the mid-1970s. My style evolved independently. I first saw abstract art in 1956, at an industrial exhibit in Moscow that included an exposition of American art [probably the exhibition at the International Youth Festival in 1957]. I remember a painting by Rothko, *Old Gold on New Gold*. I have to say that I did not understand abstract art then. Nobody taught it, and it was not popular in Russia. Somehow, my own work began to lean in that direction later, and then, of course, I began to understand. But abstract art had no influence on me. My perception of painting was shaped by my upbringing. We were taught that painting had to be realistic, that it is not to be considered in formal terms, but rather in literary terms, as linear narrative. There was to be a literary thread; it was to be understandable.

We were not taught to see art as a specific visual language, a color language, the way music can have its own language. Later on I came to understand the language of art on my own. Professionally, I was a radio engineer. But I always studied art, and I had many talents. I was very capable. I had an instructor of art named Aleksandr Leonov [now living in Paris] who had studied at the Academy of Art but did not complete his studies there. I met him while I was still a student. He was involved with formal problems in art and was interested in the ideas of Pavel Filonov concerning the intuitive and intellectual aspects of art. I also came into contact with Vladimir Sterligov, a pupil of Malevich and his circle of students in Leningrad. My first studies, however, very complex compositions that I made in pencil, were in Filonov's style. But I came to my style independently, through experimentation rather than though the influence of the Russian avant garde of the 1920s. It was only after I formed my style that I saw albums of avant-garde art. I was also interested in avant-garde music. It seems to me that contemporary art summarizes that which is already present, and it encompasses within itself the past as well. I began to understand traditional art better because it is a part of contemporary art, but basically we evolve rather than regress.

RB: *Did you always work in an abstract manner?*
ЛБ: My earliest works were still lifes done in watercolor. But, later, when I became an engineer, I thought that I had little time to waste on studio painting. I felt the necessity to realize quickly the ideas that flowed from my mind. If I did not get them out, then nobody would be able to say anything about them, and I also feared that I would become blocked and would dry up.

RB: *Was a circle of artists important for you?*
ЛБ: It was important insofar as it gave me the opportunity to get together with other artists, but I was not influenced by anybody. Perhaps the reverse is more truthful. I did have contacts with Moscow artists such as Leonid Sokov, for instance. and Viacheslav Koleichuk and Vladimir Nemukhin. In fact I own a portrait by Nemukhin. I am of the same generation as Ivan Chuikov and Ilya

Kabakov and consider myself to be part of that broad group of artists.

RB: *What about artists in St. Petersburg?*

ЛБ: Unfortunately, I don't relate to them, even now.

RB: *Did you have buyers for your work?*

ЛБ: By the early 1960s, during the Khrushchev Thaw, we had opportunities to meet buyers, basically foreign buyers, diplomats, because our own public wasn't interested in purchasing advanced art. After the Bulldozer exhibition in 1974 it became possible to hold exhibitions officially because the authorities thought it might be cheaper that way. A few weeks later, the authorities permitted an exhibition at Izmailovsky Park. It was a lovely fall day, and people were in a holiday mood. But the artists who showed their work were still fearful because the imprint of the Bulldozer exhibition had not been erased. After this experiment, the authorities decided to hold an exhibition in an enclosed space. This took place at the Gaz Palace of Culture in Leningrad in December 1974. I saw the show, but I didn't take part in it. I was a beginner then, a fledgling artist, and I was not certain yet of my capabilities. That the exhibition took place was surprising because nobody thought that it would really happen. But it did. Some people came up from Moscow for the event, and later the show was exhibited in Moscow in the Beekeeping Pavilion under the auspices of the Exhibition of National Economic Achievement of the USSR. After that show, there was another one in Leningrad at the Nevsky Palace of Culture in September 1975. I entered this show because I had some ideas that I thought were interesting. When the show was proposed there was a camaraderie among the artists. They met, formed a small committee whose judgement was trusted, and decided who would participate. I brought my drawings to this committee, and they told me that I was definitely in the show. At that moment I felt that something very important had entered my life, that something had changed. I thought that since I could exhibit at this show, why not realize other sketches I had made. When I showed my friend, Aleksandr Leonov, my work, he was

very surprised because he thought my work was spiritually re-
lated to American art, especially to Charles Demuth's *I Saw the
Figure Five in Gold* [The Metropolitan Museum of Art, New York,
1928]; I was not familiar with any literature on the subject. Any-
way, exhibiting at the Nevsky Palace gave me confidence as an
artist, and I continued to work in this style even though a critic
said that my works could be turned upside down and that you still
wouldn't see anything. I took this more as an advertisement for
my work than as a criticism.

RB: *How did the authorities react to your work?*

ЛБ: There was no reaction because my work gave no hint of any
association with ongoing events. And when they did comment on
my work, they said, "Look at this Borisov. He is fooling around
with us." There was an incident in 1976 or 1977 when the authori-
ties decided that there would not be any more shows of this kind.
They had had enough. So the Leningrad artists decided to put on
a show at the Peter and Paul Fortress similar to the one in Moscow
at the Izmailovsky Park. The artists applied to the Ministry of
Culture for permission and received no reply. We had an unwrit-
ten law in those days that silence meant consent. So artists started
to set up the exhibition but were met by the militia. All of the
artists were taken to the police station where representatives of
the ministry and "responsible art critics" talked to them, one by
one. Then the artists were allowed to go home. We were asked
such questions as, "Why are you organizing such an activity?"
The authorities decided that they wanted to put on exhibitions
instead, and so they began to organize small showings. I partici-
pated in some of these exhibitions. Then I applied for a permit to
put on a solo show, since there was precedence for such a thing.
There had been three in the past, one by Anatolii Belkin, one by
Evgenii Mikhnov-Voitenko, and one by an artist named Golethkov.

RB: *Yours was an official show?*

ЛБ: Yes, but in truth nobody could get to see it. There were no
advertisements, no information, and it was held in an inaccessible
place. I had to nail something up about myself so that people
would know who I was, but the authorities took it down. Some

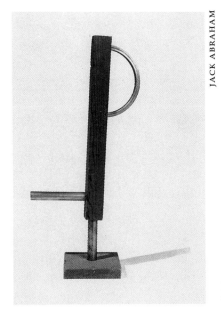

JACK ABRAHAM

Leonid Borisov, *Untitled*, 1980, wood and metal, 59 x 24 x 15 cm.

artists came, mostly school boys. At the time I was putting my show together there was an official agreement that a committee would be mandated to remove a few works regardless of content, even if every painting contained an image of an official or a leader. It did not matter; the committee had its job to do. I thought I could fool the committee by giving them an extra work, and they removed it. I was testing them. It was a game designed to make them feel important, but I benefited from it as well. As a whole, the people in charge of our shows were total incompetents in art. They were bureaucrats who were probably better at deciding about some pseudo-ideological struggle because this was the way they approached the exhibition. One result of these endless conflicts between artists and bureaucrats is that we have such unattractive public spaces.

RB: *Did all of this oppression affect you?*

ЛБ: For me it was an unpleasant situation that got in the way of my work. But it had no direct effect because when I first began to make art works I became aware that this was to be my fate. I made no compromises, so that government control and censure were

more a matter of inconvenience than anything else. But in addition, one had to make a living and be considered socially useful. Being a professional artist takes a lot of time and energy, but making my constructions was not considered labor. Even the exiled poet, Joseph Brodsky, worked as a professional translator; now he is a Nobel laureate. A few years ago there was an item from the newspaper about Brodsky entitled "The Dissident Was Awarded for Services" that included a photograph of him receiving the Nobel Prize. But it appeared as if he won the prize for services rendered rather than for his poetry.

RB: *Did anything serious happen to you?*

ЛБ: Well, they had ways to educate artists. The fact that we were not recognized was a punishment in itself. The authorities claimed that our work lacked socially redeeming purpose, that it was not healthy for society. Yet, when we took our works out of the country, they were assigned a specific value. But the KGB never visited me. The only incident occurred after I began to sell my works and no longer needed a job. Then they forced me to take a position. Since I was an engineer I was able to get a job, so I wouldn't be accused of parasitism. This law was used against dissidents. In effect the government turned me into a dissident. But in truth I was no dissident. I stayed aloof from politics and political philosophies. My work has no political elements in it. I express an ideal of abstraction, a pure idea with no associations of any kind. That is why I like the work of Viacheslav Koleichuk and similar artists. My interests are strictly about art, especially about that moment when a transformation occurs in an object that turns it into a work of art. Man's most important task is transmitting ideas, which can be expressed in different ways. An idea is central to a work, but the idea has to find a compatible form to find expression, to find its realization. As I mentioned before, there are different languages to express ideas—literary, musical, and visual.

RB: *Were you a member of the artists' union?*

ЛБ: No. In 1975, during the nonconformist days, we founded the Association for Experimental Exhibitions [TEV], but it, of course,

never achieved official status. But this kind of, how can I say, official yet unofficial organization came into being in Moscow. It was called the GORKOM, and it held a few shows in Leningrad before it was closed down. Through this organization, the authorities were signaling to the diplomats and other foreigners that they were aware of new developments.

RB: *How about obtaining supplies?*

ЛБ: They were available. Somehow, one could make a deal and get things at official stores where union members went. Materials were relatively inexpensive. Now, items are much more expensive, like in the West. Russia is a very strange country. We can arrange everything. I would get acquainted with a vendor, make a deal, give a gift of chocolate, or flowers, or money, and buy supplies.

RB: *Has your work changed since perestroika?*

ЛБ: Not really. When I first began my work I had a period in which I generated many ideas. Now, I am in a different stage—reworking and exploring older ideas. I have gone through several stages, including minimal art, assemblages, and constructions. I feel my work is deeper now.

RB: *Do you show in the West?*

ЛБ: I have had shows in Finland, Austria, France, and California. Whether my work is seen in Russia or abroad, I divide viewers into three categories. One group understands and these are usually artists. The second group doesn't understand, but wants somebody to explain the works. The third group doesn't understand and doesn't want to understand. People in the third category are pitiful, but it is with this and the second group that I try to interact.

RB: *Did you have viewers before perestroika?*

ЛБ: I participated in the first apartment exhibitions in Leningrad—mostly group shows. But people began to emigrate. Some left on their own; others were advised to leave.

RB: *Why do you stay in Russia?*

ЛБ:　Well, there are different types of people. Some can live any place. Igor Stravinsky, for example, was very productive and created Russian culture wherever he went. Others suffer. As for me, I never earned enough to leave Russia. I also believe that a person cannot shed his or her problems by leaving a country. Many Russians who went abroad and had some success do not especially want to move back to Russia, but grow very nostalgic when they return for a visit or for an exhibition. Also, to leave my country, at my age, is no simple matter. Every region of the world has its own rules and games, and you have to become accustomed to them wherever you go. There are many things missing here, I know, but I do not relish changing my location. There is another thing. Let's say that when an artist first comes in contact with foreigners who show an interest in his work, he develops the illusion that if he is admired in Russia, he would receive great attention abroad. He would be treated with kid gloves. But the reverse has happened. I heard a story about a dissident artist who left for America and now paints fences for a living. He tried to engage in some kind of political activity in America, but nobody was interested in his politics. He was interesting and useful in Russia, but not any place else. As for me, I've always had schemes for large scale works, for public spaces, but the state has no need for them. It is a true and unpleasant fact that we have not been participating citizens for most of our professional lives. Our efforts were not heeded by our society or our government.

Whatever my talents, society could have benefited from them.

★

Igor Makarevich
Игорь Макаревич

Born in Tbilisi, Georgia, 1943; graduated from the Institute of Cinematography, Moscow, 1968; became a member of Collective Actions, 1976; lives in Moscow.

Participates in performances and makes assemblages.

RB: *How do you feel about having been a nonconformist or a dissident artist?*

им: I believe that during my time very few artists could exist in isolation. I was friendly with, and was always around, a group of like-minded people with whom I shared ideas and experiences. Perhaps I did so consciously. It needs to be said that we formed an alternative existence to the official art world. As far as I can recall, I did not experience a sudden break in my consciousness because since the days of my earliest professional education I was always part of a group of artists who shared my views. This started in the high school for art studies where most of the important artists of my generation studied.

RB: *But you couldn't let your instructors know how you felt.*

им: The situation in the Soviet Union was a difficult one. Everybody who lived through those years understands it well. It bred in

us a duplicitous way of thinking. We lived a double life intellectually. There is something wrong with that, and it affected our upbringing and development. A whole generation of people had to think in a double way. It permeated our bodies and our blood. It became a part of our very marrow. Now, the younger generation of artists is free of this oppressive, psychological condition. Everyone around me, older ones and younger ones, shared in this bizarre psychological doubleness. Rarely could you find any individual who opposed uncompromisingly the official structure. It was impossible to take a stand and resist without risking compromise in some way. So we found ourselves isolated but also professionally dependent on the government. We could not exist unless we assumed a double role and masked who we really were. If one did not comply officially, one stopped existing. One was blotted out, erased. If you consider serious resistance or protest against the authorities, you probably have in mind a free society in which such dissidence is tolerated, a society that does not marginalize you, put you outside the frame of life. Here, a writer, say, like Solzhenitsyn, could live a dissident life, but it did not work for an artist. An artist requires physical space, materials, canvases, brushes, paints. If these tools are taken away, then the artist ceases to exist as a material person. A writer can manage; an artist cannot.

RB: *How did you manage?*

ИМ: Neither my friends nor I were fighters. Rather, we endured. I include such friends as Ivan Chuikov, Ilya Kabakov, Erik Bulatov, and Edik Shteinberg. But by the 1970s the governmental machine had weakened, so we learned how to get around the system, how to deceive the government. This would have been unthinkable in the 1930s. You would have been killed. But liberal tendencies emerged in the 1960s. Even so, some who were not willing to compromise were killed or destroyed in some way. One, Anatolii Zverev, existed purely as an artist. In a different society, he would have been considered a hero, a fighter. But most of my friends assumed a neutral position in regard to art. We worked as book illustrators or set designers. We felt that this did not sully us morally. These were respectable professional occupations. I worked

as a book illustrator and in the decorative arts. I painted lampshades. As a result I could survive materially and physically. As far as exhibitions go, well, we really couldn't show our art until the mid-1970s. I showed in a placed called Club Exhibitions, a club for sculptors. We were allowed to show paintings and graphics there because it was supervised by a liberal unit of the Union of Soviet Artists headed by Dmitrii Prigov. It was not a permanent place, but we could exhibit there on occasional evenings.

RB: *Did you belong to any formal groups?*
ИМ: My wife, Elena Elagina, also an artist, has played a major role in my life. We frequently work together. We both belonged to a group called Collective Actions, which we joined in 1978. We got together periodically. Our activities took place outdoors, away from Moscow, in spaces that acquired sacramental values for us. This led to something called The Moscow Archive of New Art, which originated in the early 1980s, a circle of people who shared common ideas. Our ideas were close to those of other conceptualists, especially Ilya Kabakov's.

RB: *Did you participate in the Bulldozer exhibition in 1974?*
ИМ: No. I always was attuned inwardly. Although I supported the activities of my friends, I lacked the impulse for action, even though I know that one cannot function in the world without action. It was a conscious choice on my part, not a failure of courage. There are simply people with different temperaments.

RB: *When did you realize that you were a nonconformist?*
ИМ: I did not have a sudden or sharp break in awareness. I was not tempted to move from one type of work to another. I was always rather even, and I was lucky to find friends with whom I shared similar ideas. These included Alexander Kosolapov and Leonid Sokov.

RB: *How did your work reflect your nonconformism?*
ИМ: This concerns the ways ideas or chance encounters affected me. For instance, at one time I became interested in words, for and by themselves. Then, images grew more important. I have always

been interested in the interconnections between art and art history. I have also been interested in space—how objects exist in it, how life exists in it. How space even reaches beyond the boundaries of life to the world of the dead. In the early 1970s I worked with metallic objects that glimmered in strange spatial relationships. Then I worked on a large still life called *Surgical Instruments*. There is a story behind it. One day I found a box of surgical instruments on the street. These captivated my imagination. Their form intrigued me. Their luster and the strange, predator-like metallic rods, saws, and tongs interested me visually. I painted the work, much larger in size and scale, on a canvas. Later, a doctor I knew told me that the instruments were used by a gynecologist. That is, they were used for delivering babies and for abortions—for life and for intercepting life. Unwittingly, the painting turned into a frightening world, confusing the viewer and introducing the notion of death in the midst of life. This marked an important moment for me. I believe that nothing happens by chance. The box must have been thrown away by a doctor who had purchased the instruments in the 1920s, because they had a prerevolutionary stamp from a foreign firm on them. Such instruments were no longer used under the Soviet regime. The doctor must have hidden them for many years. It was as if somebody else's life had been resurrected when I found them. Before I found the instruments, I had painted a triptych dedicated to death. Afterward I became even more interested in the world beyond the grave. In the triptych, I had used found-photographs of the corpses of French communards who had been shot. In the middle of the work I placed a cross with my own epitaph on it so as not to be outside the experience of the photographs. I became depressed to think that I was using and enjoying the death of strangers. So I included myself in the process. I made that piece in 1978.

RB: *Let me interrupt for a moment. Did you show the piece?*
ИМ: I showed it in an exhibition by three graphic artists, since, officially, I was a book illustrator. I tried to exhibit strictly as an artist, but the authorities came running and told me that I was subverting and misleading my friends with this piece.

RB: *Did the* KGB *question you?*

ИМ: No, this was no longer like the old days, but I was "talked to" by officials from the Ministry of Culture. They told me that my work was so glum and so depressing, it would spoil the exhibition. They promised that I could have another show to exhibit anything I chose. I thought of rejecting their proposal. I wanted to destroy my paintings as an act of protest. In any event, only the corpses of the communards remained in the exhibition, since it had something of a revolutionary theme. Interestingly, viewers came with flowers as a symbol of eternal life. At that time, I also completed a work called *The Dispersion of the Soaring Soul,* and another called *Changes.* In the latter piece, there is in a wooden box, a mutation of a human face that goes through a series of transformations from a plaster mask to a shattered substance. It seems to go from life to nonlife and back to life. I found the images reminiscent of Dürer and Cranach, the Northern Renaissance artists.

RB: *Was this approach typical of your work of the 1970s?*

ИМ: I tried to get a feeling of heroic pathos and of suffering and death. To some extent these themes represented a passive opposition to official art. By the mid-1980s I became more concerned with visual images without strong literary qualities.

RB: *Do you think your concern for life and death had any connection to the historical moment?*

ИМ: In general, I would say yes. The theme of death was forbidden in the face of official Soviet optimism. Art was supposed to represent positive aspects of life. Any attempt at serious analysis was suspect. Anybody who tried to do so was automatically placed outside of the official structure and was subjected to some persecution, or was not noticed at all. On the other hand, the power of death was a most luminous, powerful, and engaging force. For me it had the meaning of a protest, but at the same time I also did not feel the need to protest because I had already immersed myself in the life of my unofficial art. I had become more interested in questions of art and esthetics. Again, the double life.

RB: *Did you have trouble buying supplies?*

ИМ: Not at all. Here one should praise some aspects of Soviet life. Today when I run into friends who are now drunkards, you hear them say "We lived all our lives under Communism, and we didn't notice it." This is both a half truth and a half joke. We now realize some aspects of socialism had a place. We were not aware of the positive aspects, and we did not value socialism. We believed it was a lie, a deception by the government, a monstrous government. But it did try to build a socialist society. Everything was financially inexpensive. We had paint. Even a school boy could afford it and buy it without problems. By the late 1960s certain paints were more difficult to obtain. As usual in Soviet society, the system of distribution was secretive. One needed to know which kiosks to go to. You could buy as long as you were a member of the artists' union, but friends could get supplies for you. In the 1980s prices rose shockingly. Now, supplies are very expensive. By comparison supplies were abundant and cheap in the 1930s. Artists subsidized by the state lived in luxury, had dachas, but they created nothing. The quality of their socialist realist works was hideous—they did not produce art—but they showed in sumptuous halls.

RB: *When did you first see modern Western art?*

ИМ: Let me break this down into two periods—first, from the impressionists to Picasso and then more recent styles. We were not encouraged to look at the earlier works. Even Picasso, although a Communist, was forbidden. In a phrase of the time, "in the Soviet Union, we are happy to look at Picasso the human, but not Picasso the artist." He was a member of the French Communist Party, but, according to the Soviet authorities, he painted poorly. The impressionists, however, were acceptable. We also were able to get information about the surrealists through certain exhibitions and book exhibits. The first large American exhibition took place in 1957 at the International Student's Festival. The catalogue became our bible. It was a powerful influence, but also incomprehensible. Picasso we understood, since we viewed his work as a continuation of traditional art. But an artist like Mark

Rothko was difficult to understand. His work was too compli-
cated for people who did not participate in contemporary culture.
We tried to understand it, but we had nobody to explain it to us.

RB: *When did you see American minimalist art?*
им: Much later, toward the end of the 1970s, but only in books
and reproductions. Recently, there have been some wonderful
shows in Moscow—Francis Bacon, but still no minimalist shows.
So the magazines were our education. We really saw nothing after
surrealism. That is why artists of my generation have a strong
literary interest in dada and surrealism. Since there was no con-
tinuation of culture, we had to figure things out for ourselves.
Conceptual art was very complex for us and difficult to under-
stand. We needed preparation, a widening of cultural informa-
tion, access to cultural resources. We were very much behind.
Now, of course, it is different.

RB: *When did you first show in the West, and who were your buyers?*
им: Norton Dodge was my first client. There were some others,
but we rarely sold any art, and it was usually by sheer chance. It
was at the level of selling and buying souvenirs. Many of us gave
away works so that they would not perish here. It seems to us that
the West was a huge bank or some kind of archive. Anything that
would reach the West would somehow be saved and not de-
stroyed as it might have in the Soviet Union. We really lived in a
very closed society, and we gladly sent our works out. Money had
a strange meaning for us. We couldn't save the money we made
from sales. It had to be hidden. What could we do with it?

RB: *How do you view your work now?*
им: I want to stress again that my works never had any political
or dissident meaning. Inwardly I was not an activist. My works
were simply my works. They were concerned with questions that
interested me alone. Perhaps my position was one of isolation. I
value, perhaps too much, my desire for comfort and the ability to
live as an individual immersed in my own world. That might be
detrimental to one's being, but it is my life. I tried in the past to get
a modern and heroic pathos, a spirituality into my works. For

instance, toward the end of the 1970s I made a painting entitled *The Cross of St. Ignatius.* The saint, who has always fascinated me, was an early Christian martyr, torn to bits by lions. The painting has an heroic nature. It is made up of a collection of masks in the form of a cross, which was illuminated. I also included a shield or metallic screen. Somehow, the work is meant to stand in opposition to emanations of evil. My last work [1992] is also about St. Ignatius, but from a different perspective. It is more ironic and nonheroic in character. Its reading is less clear. I am less inclined to heroic contemplation now.

RB: *Why do you remain in Russia?*

ИМ: I was never really tempted to emigrate. I never had a longing to do that. Now that I have traveled in the West I think it is important to live in my own country. Earlier, I did not think so. In fact, I thought it a good thing to emigrate in order to save my life, since, here, we experienced a type of annihilation, a lack of hope. There was no future here. I advised all of my friends to emigrate. I have learned now that emigration is a very complex matter. You lose something from inside your being. I have also seen that very few artist friends have been able to get into the mainstream of Western life. Many return after trying to become Western artists and develop a new twist on their Russian origins. Perhaps it is easier for younger people to emigrate now.

But for me it would be too hard, too difficult.

★

Mikhail Chemiakin
Михаил Шемякин

Born in Moscow, 1943; entered the Repin Institute of Painting, Sculpture, and Architecture, Leningrad, 1957; left the Soviet Union for Paris, 1971; immigrated to the United States, 1981; lives near Hudson, New York.

Paints and sculpts in a personal surrealist manner.

RB: *Where did you spend your youth?*
MШ: My father was in the military and was stationed in Germany beginning in 1945. I was in Dresden when it was in ruins. The only remaining buildings were those that had been occupied by the Gestapo—solid and strongly built structures. We lived in one of those buildings, and my school was there as well. Everything was strictly guarded.

RB: *Did you attend a German school?*
MШ: No, a Russian one for children of high-ranking military families. We lived very protected lives because it was dangerous for us on the streets. Germans invariably attacked Russians.

RB: *When did you return to the Soviet Union?*
MШ: In 1957. I went to the Leningrad Secondary Art School, part of the Repin Institute. There were no higher levels there.

RB: *When did you become aware that you were a dissident artist?*
MШ: At school. I was about fifteen or sixteen years old. I was summoned to the department of ideology—each unit had such a department—and was talked to by KGB people. They said that I was a bad influence on my friends because I told stories about the German artist Matthias Grünewald. We were forbidden to read about him or look at illustrations of his work because he was a mystic. It was also forbidden to have an interest in old Russian icons because they were considered a digression from the "righteous" path. The impressionists were also a forbidden subject. They were considered representatives of capitalist art. When I paid no attention to the KGB warnings, I was expelled from school. I was expelled from the middle school, and so, I have no official diploma.

RB: *What had you seen when you lived in Germany?*
MШ: Well, I very much liked Hieronymus Bosch and Pieter Breughel. By 1959 I knew about Francis Bacon. But we were not allowed to talk about any of these artists nor look them up in the library. Even Picasso was forbidden. Friends from abroad sent me information, and I made friends with young, pretty librarians. After hours, I would sneak in and look at the forbidden books. These books were for the art professors who made special marks on them. A red circle, for instance, meant the book was especially dangerous. A square meant dangerous. A triangle meant only a little dangerous.

RB: *And you discussed what you read with your friends?*
MШ: I certainly did!

RB: *Would you call this dissident behavior?*
MШ: Your question is more appropriate for politics. We were simply nonconformists. But later, a clique developed with definite political ties. Since art was considered an ideological weapon, we were labeled, therefore, ideological saboteurs. This is how we fell into the category of political dissidents. You have to understand that any representation that might appear to express a hint of pessimism or a feeling of isolation was considered incompatible

with socialist realism. Even Dostoyevsky was not respected in those days. Most of his writings were forbidden, and some things were not even allowed to be in print. But we read him anyway, in old editions. This was not a problem for us.

RB: *Even heroes in novels had to portray positive qualities.*

MШ: Yes. A type of optimism was the prevalent ideology. We all had to look at the world through rose-colored glasses. Generally the Soviet person was supposed to be immortal. Death did not touch him. He was uninterested in sex. Babies were brought by storks or found in cabbage patches. We grew up in a strange and complicated world.

RB: *It is interesting that the Soviets were so puritanical.*

MШ: Except that the top layer had a certain kind of life-style, like in ancient Rome during its decline. We were all aware of what was going on and of the duplicity.

RB: *How would you describe the differences between the Leningrad and Moscow artists?*

MШ: There were big differences between Moscow and Peter, as we called Leningrad. We seldom called our city Leningrad, but rather Peter, or Petersburg, or St. Petersburg. Even before perestroika. I have drawings from 1961 entitled *St. Petersburg*. When I was placed in a psychiatric hospital that year, where they tried to cure me of my attraction to modernism, they asked me why I signed my drawings "St. Petersburg."

RB: *Why did they put you there?*

MШ: I was arrested and that's where they sent me. A madhouse. I painted pictures that were unlike other pictures. They decided that my work was that of a schizophrenic. This was a classic ploy on their part.

RB: *How did they see your work?*

MШ: In communal apartments during a search. They photographed everything and later submitted the photos to psychiatrists for inspection. According to their judgement I was really sick. I was institutionalized for half a year.

RB: *Were you declared cured at that time?*

MШ: No. I was sentenced to two years in jail, but my mother arranged bail with great difficulty. It was quite a scandal. She took me home as an invalid under her care and protection.

RB: *I read that there was a special psychology called "the Leningrad psychology." What was it?*

MШ: It was a particular type of Peter mentality. The city was closed off, for the most part, and the KGB was especially vicious. There were no foreign embassies or consulates, no diplomats or foreign correspondents, so the KGB could be more brutal than in Moscow. None of this got into the Western press. Moscow artists cultivated the press and became friendly with diplomats, and so they lived better than us—materially, I mean. Foreigners purchased their works. For instance, if Oskar Rabin or some other Moscow artist was arrested, even for one hour, there would be such a noise, a clamor, by the world's newspapers. The reaction would be instantaneous. Also, the Moscow artists lived under entirely different conditions, in a more dynamic atmosphere than we did. They had access to information from the West because the diplomats constantly brought material into the country—books, records. They were more free and easy there. In Leningrad we lived in a more retiring atmosphere, more somber and closed off, like in the novels of Dostoyevsky. Conditions were very fearful and frightening. We were more inward-turning and introspective. Our language is also different from Moscow Russian. We express ourselves in a manner closer to that of Old Russian, and we observe some old syntactical rules. We called Moscow speech the speech of the bazaar. Our art is also different. We were not as influenced by the West. We Petersburgers tend to stew in our own juices. We wallowed in our pain, and suffering, and self-pity. But because of all this we produced some fascinating people. Joseph Brodsky comes from Petersburg. We can boast a brilliant school of poets.

RB: *How about support groups for the artists?*

MШ: We had a tightly knit group which we called the St. Petersburg Group. We produced our own manifesto and called it "Meta-

physical Synthetism." We composed it with the art historian Vladimir Ivanov who is now the most important specialist of icons.

RB: *How many were you?*
MIII: Seven. [Oleg Liagachev, Vladimir Liagachev, Evgenii Yesaulenko, Anatolii Vasiliev, Vladimir Makarenko, and Vladimir Ivanov.] We studied the Old Masters as well as ancient, African, pre-Columbian, and aboriginal art. Russian icons were important for us. We attempted to draw new forms from these sources. We also added a religious element, in that we were concerned with spiritual and metaphysical matters. Since all religious questions are metaphysical ones, we used the term "metaphysical" for our group. Again, our sources came from icons and from religious images all over the world. From all of this we created a synthesis. So that's how we came to metaphysical synthetism.

RB: *Did your paintings have a religious content?*
MIII: Not in a literal way. It was simply an attempt to express in some new form, something that had ties to a higher metaphysical realm. I never painted images of Christ or of Mary even though I am a Christian. Others have painted religious subjects, but my concerns were different.

RB: *Were there any experimental groups in Leningrad when you left?*
MIII: I was banished in 1971, so no groups had formed yet. It was still too dangerous to organize one because the authorities would immediately perceive of it as a political conspiracy. As for the metaphysical synthetism, we had a lot of nerve to form it. We got together and went to the head of the Communist Party in Leningrad, a man named Tolstikov. We handed him our manifesto and said that we had created a group. We said that we had come to notify him officially. His mouth dropped. He was speechless. The very next day, we found ourselves talking to the KGB. They wanted to know what we thought we were doing. They were dumbfounded, and couldn't imagine such a horror. They did not understand us and were panic-stricken. What we had done was just too daring for them, too unexpected for them to comprehend. How could some young painters have such nerve to create a manifesto?

RB: *When was this?*
MШ: 1967. It was a dangerous time. The screws were tightening up. We were really crazy.

RB: *Was this after the art exhibition by workers at the Hermitage?*
MШ: That was in 1964. We were accused of ideological subversion. The director of the museum [Professor Artamonov] was fired.

RB: *What position did you hold there?*
MШ: I shovelled snow, chipped ice, cleaned spittoons, took care of garbage. We all did that kind of work. We were called scaffolders.

RB: *What prompted you to organize a show at the Hermitage?*
MШ: We were asked; it was the museum's bicentennial. In honor of this celebration, someone had to sing, dance, read poems. If someone knew how to paint, then why not let him show his paintings? So we showed our paintings. The union officials came and found the work subversive. They realized this was not the work of simple laborers. They called us bandits and said that they had known about us for a long time. We were not arrested, but the paintings were confiscated. Later, parts of the paintings were returned. They had been vandalized. We were fired, and then the authorities tried to arrest us because nobody would give us work. This was dangerous because of the law against freeloaders. If you didn't work for ten days, you could be sent 100 kilometers away to work in a special labor camp.

RB: *How did you earn a living?*
MШ: I worked as a mailman. I painted posters with lines like "to a bright future." I worked at whatever was available. Just about all nonconformist artists worked at some kind of government job. At night we painted. That life had no resemblance to the life we lead today. I've been back to Russia and cannot recognize her. Despite all the difficulties, there were some positive aspects, which have been lost. It was a romantic period, we lived a kind of night life. We would gather together and listen to music. We helped each other as best we could.

RB: *Why were you banished from Russia?*

MШ: I had planned to escape by sea, as two other painters had done. But the KGB watched me closely. I was caught in Sukhumi on the Black Sea near the Turkish border. They said that they knew my plans. I denied everything, of course, that I was not going to swim to another country. They agreed not to discuss anything, but I had to return immediately to St. Petersburg and appear before the KGB. They told me then that I had to leave Russia in a matter of days or I would be back in the madhouse or in prison. I was not allowed to take anything with me, not even a suitcase, nor tell anyone, not even my parents. They arranged special papers. I had to call the French embassy because I needed a country to go to, and I already had a good reputation in France. Dina Vierny, the gallery owner, had seen my work in the late 1960s in Russia and took some of my graphics work out in her suitcase. She gave me a show, which was a big success. The KGB said that it knew of my exhibition there and that Dina Vierny was a person with some influence. They did not want a scandal; they just wanted me to get out of the country. They said that they valued me as an artist but that there was nothing for me in Russia. "Try your fate in the West," somebody said. The general who interrogated me became one of my first collectors. He wanted a painting as a souvenir. His name was Oleg Sakhanevich.

RB: *When did the authorities start harassing you?*
MШ: When I was about fourteen or fifteen. Once they noticed you, they were aware of you forever. It never stopped.

RB: *What bothered you so much about the government?*
MШ: I never bothered with politics because we thought of it as a filthy business. I became involved only after leaving Russia, especially with the war in Afghanistan. We always hated Communism. I am a convinced anticommunist. We believed that the KGB fought against us, but that was not entirely true. It might be said that the KGB was an instrument in the hands of the artists' union. When we had the exhibition in 1964 at the Hermitage it was the union that called the KGB. I knew many KGB men who kept saying that they did not understand why they had to close down the

show. "We were told that it is bad, but we like it," they said. The struggle was really over pieces of the pie, since members of the union wanted to keep their privileges—something American artists can't even begin to understand. The union members had free studios, could travel abroad, had a constant sponsor through government purchases. They lived in the lap of Christ, as we say in Russia. So when we appeared on the horizon and they understood that we could draw the attention of the public, and especially the intelligentsia which had grown tired of poster art, the official artists wanted to suppress us as quickly as possible.

RB: *When was your first exhibition?*
MШ: As a nonconformist, in 1962 at a club of the journal called *Zvezda* [*Star*]. The club was located in the house of a former prince, Prince Shakovski. The exhibition was a sensation because it was the first show in St. Petersburg by somebody who was not a socialist realist. Even though it was basically a solo show, my work was exhibited with that of two official artists, Krestovsky and Kochetkov, to make it look as if it were a three-person show. Many people came, but in the end the KGB closed it down. Later, in 1965, I had another show at the club, but the KGB closed that one down the very next day. The next year, in 1966, I had a show that [Mstislav] Rostropovich, the great musician, protected from the KGB. It was held at the Rimsky-Korsakov Conservatory of Music in St. Petersburg. Then, in 1967, I had a big show in Novosibirsk, which opened simultaneously with an exhibition of works by the avant-garde artist El Lissitzky. After that, I had no more shows in Russia. The organizer, Mikhail Makarenko, who had also put on the first Pavel Filonov show, was imprisoned for eight years for these crimes. He lives in Washington, D.C., now.

RB: *It's amazing that you were allowed to show your works.*
MШ: This is true, but I showed in a conservatory and other unofficial spaces. So the KGB first had to find the exhibitions which they usually did through other painters who informed them.

RB: *You left Russia in 1971, but did you know anything about the exhibition at the Gaz Palace in 1974?*

MШ: I tried to bring it to the world's attention when I published the art almanac *Apollon-77* in 1977. It was the first dissident almanac. I dedicated it to the Moscow nonconformist movement, since most of the nonconformists were in that city. Many artists mentioned in the almanac had to do a lot of explaining to the KGB as a result. By then, 1977, things were difficult. The Khrushchev Spring in the early 1960s lasted, really, only about half a year. People read poetry in the streets; there was a Picasso exhibition at the Hermitage. But then under Brezhnev there was severe repression, not as bad as in Stalin's time, but bad just the same. Many artists were put in mental asylums and made up perhaps half their populations.

RB: *Was the title of your almanac picked to honor the old symbolist journal* Apollon?

MШ: Yes. In spite of the repressive atmosphere, I had a show in 1977, in Moscow, called "Six Years of Absence." I sent a large number of lithographs with some diplomat friends. The KGB closed it down almost at once, blocking off the street and saying that the building was quarantined because of disease. I have a photo showing guards with rifles on the street. A few days later the exhibition opened, probably after word came down from the authorities.

RB: *Were you a member of the artists' union?*

MШ: No. Never. Nor did I ever have a studio. I painted in the communal apartment where I lived. I had two rooms, which was considered large at the time. Even so, I could not make big works. Some thirty-eight people lived in the communal apartment. As the song goes, "Thirty-eight people and only one toilet." I led a special type of life. You can't even imagine what it was like, what a communal apartment means. This was not a commune, as one American woman thought, and it was not interesting.

RB: *Did the authorities bother you?*

MШ: They would search my place frequently and arrest me constantly. They took me to the madhouse to educate me—with the help of drugs.

RB; *What about apartment exhibitions?*
MШ: Those started after 1971, after I left Russia.

RB: *Did you know artists from Moscow?*
MШ: Mainly I knew Kabakov, Yankilevsky, and Iulos Olster, who is dead now. And of course Mikhail Shvartsman, who had an enormous effect on our group. He is a major and most important artist. He was interested in a search for new religious symbols. Kabakov was important for us because of his avant-garde ideas, his theory of the absurd, of the joke. I consider him an original thinker. He is not so much an artist as a thinker, a thinker of irony. But he is a brilliant graphic artist. I love his illustrations for children's books. When I visited Moscow I would stay in his studio. I would stay for a week or two, even though officially by law we could not be gone for more than three days.

RB: *Did the Manezh exhibition in 1962 have any effect on you?*
MШ: We felt repressed, especially in St. Petersburg where every-thing was more traditional and conformist.

RB: *Were you familiar with the Russian avant garde of the 1920s?*
MШ: Yes. Pavel Filonov had the greatest impact. We saw little o his work, and we had no access to the storage rooms where hi: work was kept, but there was a small catalogue with black-and-white illustrations of a show of his, which never opened, tha allowed us to grasp the essentials of his art. His sister, who wa still alive, would also show us some of his works. What I got from him was the principle of how to construct a painting and th emphasis on the harmony of a work. I often lecture on his theorie:

RB: *Is the work you do now a continuation of earlier work?*
MШ: Some ideas go back to my youth, but I was very young whe I was banished from Russia, only twenty-seven. After my show ¿ Dina Vierny's gallery, I helped Kabakov get a show there. I als helped Bulatov and Yankilevsky. When she was in Russia, befoɪ I left, I literally dragged her to artists' studios and told her to giv them exhibitions. And I also organized with Alexander Glezer, tɦ first large exhibition of nonconformist art in Paris in 1976.

RB: *Did you go directly to Paris when you left Russia?*
MIII: The authorities offered me any country as long as I agreed to leave. I still work on the carnival series that I had started in St. Petersburg.

RB: *Did you read Mikhail Bakhtin on the carnivalesque?*
MIII: In Russia he is like a god. I read him.[1]

RB: *When did you begin to work in large sizes?*
MIII: Well, in Russia, a work about fifty inches long was considered large. Dina Vierny once tried to bring one about that size out of the country and was arrested. You can't work large in a communal apartment. Also, there weren't the materials available to do so. In France apartments are also pretty small. I wanted to work large, so after ten years, I left France for America. I am very happy here. Actually I am a sculptor by profession, and I enjoy working in large formats. And I certainly enjoy the freedom. But I should say that the artists' union in Russia has a similar effect to the American auction houses and business people who invest in art. Important artists like Leonard Baskin have been abandoned. He said he was, in effect, buried twenty years ago. For all serious artists the situation here is no less frightening than it was in Russia.

RB: *What are your reflections on nonconformism?*
MIII: I had the same opportunities to prostitute myself as did other artists. It would have been no problem to earn money illustrating communist books. I even had offers. But I would have preferred to have frostbitten hands—to be a free man. The feeling that you are leading an honest and honorable life gives you a lot of strength. Being part of an underground society unified all of us. We lived in a state of heightened awareness. We were aware of the dangers, but we did what we believed was right. We read *samizdat* literature. We lived on a different planet from other Russians. We lived in a state of internal exile. We were disgusted with the Soviet intelligentsia and despised people who dealt with the

[1] See especially Mikhail Bakhtin, *Rabelais and His World*, trans. Helene Iswolsky, (Bloomington: Indiana University Press, 1984).

Communists. We would never socialize with them or even with former friends who showed any sympathies for them. We were rigid and held to a superpuritanical attitude. We would not legitimate Communists in any way.

This was our law.

★

Natalia Nesterova
Наталья Нестерова

Born in Moscow, 1944; studied at Moscow Secondary Art School, 1955–1962; studied at the Surikov Art Institute, 1962–1968; lives in Moscow.

Figurativist who paints people, often engaged in leisure activities, in an expressionist manner.

RB: *As a member of the generation of the 1970s, how would you characterize your situation in the Soviet art world?*

HH: We are different from the earlier generation in that we had greater freedom. When we left art school, we no longer had such severe limits and boundaries. We could even sell our works, but when I first began to paint my own independent pieces, I had to turn them to the wall or put them up on a shelf, and works were still removed from exhibitions.

RB: *Before I ask you about the commissions, tell my about your teacher, Dmitrii Zhilinsky.*

HH: He is a decent, very nice person, a follower of Italian Renaissance art. He concentrates on the sketch and on drawing in general. He usually paints portraits of his friends. I follow his line of thinking that art should be based on nature but not an imitation of it. It should go beyond the obvious, since imitation is not art. He and I are still friends, today.

RB: *Tell me about the commissions. Were they from the union?*

HH: Not from the union, but directly from an officially run enterprise in Moscow. There was a list of subjects from which we could choose—like a landscape of the Middle Ages or of any other period. Many artists were involved. They received a guaranteed advance, a monthly salary. It was 200 rubles, which at the time paid rent for my studio and my apartment, but today 200 rubles is not worth anything. We were able to work at the level of our talent or inclination and world view. I selected the simplest themes because, to the officials, a painting was a painting, nothing more. But a painter who wanted to have a career had to make works close to the precepts of official art. But the people to whom I gave most of my works were friends. There really were not many collectors. I remember one from Leningrad. Later, collectors from the West appeared.

RB: *Would you characterize your work for the Moscow enterprise official or unofficial?*

HH: I did not make official works in the strict sense of the phrase. My subjects were, and still are, based on the flow of human life, leisure time activities, amusements, games, vacation scenes, the quotidian, the everyday life as I see it. The thaw of the 1970s made it easier to paint these kinds of scenes. My philosophy of art is that I would like my art to help people live, to lighten their lives, make life more agreeable and pleasant, and to give them some aesthetic pleasure.

RB: *Do your works carry other meanings?*

HH: No. I believe that the subtexts are in the viewer's observations. If you see something or read something into a painting, it reflects your own desires. All I can say is that my subtext is at a deep level of my own feelings and experiences. I can't say how they come out in my paintings. I never accepted socialist realism because it seemed to me to be a temporary fashion, a style that worked only in a certain situation, and when the situation would change it would become obsolete—which happened. For this reason I prefer traditional art. To the extent that the term "dissident artist" developed in Russia, I would have to say that I don't

fit that description. True, I was a member of the USSR Union of Artists, but if we are speaking of inner thoughts, then I would say that I was, and still am, a dissident, a person who thinks for herself. But I would never march in demonstrations no matter how just because I hate crowds. Generally speaking, artists ought to be somewhat solitary and work alone. If they are part of a group or a crowd, then they are in danger of becoming part of the crowd's slogans, posters, and publicity.

RB: *I assume then that you did not participate in the Bulldozer exhibition in 1974?*

HH: That's right. I don't like to be on display with my own works. I find it difficult to stand there, as it were, with my own works. It is really beyond my endurance. I am shy, and even now I am embarrassed to be at my own exhibitions. I do understand what the Bulldozer exhibition signified, however. I went there and looked, but did not participate. It is not my nature to have done so. But I spiritually supported the artists, and I believe that it contributed to the freedom of artists as any social-political action would.

RB: *Did it affect your life in any way?*

HH: I don't know. It must certainly have affected the lives of those who did exhibit. It contributed to their popularity and made them more famous.

RB: *Did perestroika affect your work?*

HH: No.

RB: *Were you brave or did you simply not give it much thought?*

HH: I didn't think about it. I simply did what I had to do. What preoccupied me the most was the quality of my work—purely professional matters of color and composition. Since then I have become a better artist. Earlier I included horrific characters, and now, perhaps, I have learned to control myself. My characters are not frightening now.

RB: *I've seen religious themes in your work.*

HH: That's one of the themes I pursue. But these are filtered through my personal fantasies. There is really no narrative in the

traditional sense. My work doesn't copy reality, but reflects what is inside me, in my head and mind, and that is what I express. But sometime in the 1970s the Tretiakov Gallery asked me to donate a work. The theme was The Last Supper; they called it *Dinner* or *Meal*. It is still in storage.

RB: *When you were a student, what was your relation to the Soviet government?*

HH: A negative one. Always. I don't think anyone persecuted me, but I was what you might call "educated" or "corrected." We were treated like young children at school. That is, we were dictated to, told what was and wasn't allowed. We were taught to behave and to be obedient. When I first entered the Surikov in the early 1960s, Solzhenitsyn`s writings first appeared—*One Day in the Life of Ivan Denisovich* and *Matrena's Yard*. Our teacher was enthralled and praised the works. After a few days, Solzhenitsyn was declared anathema, and the teacher began to retreat and say the opposite of what he had first told us. In effect, he recanted. I asked him how that could be, how could he contradict himself? An art or literary critic in the class said that the highest principle of the Party was to change one's world view to coincide with the Party line. I was awestruck. When I finished art school, I was afraid of life. Perhaps today we see a repetition, that life really is terrible, because we are not certain of anything. Anyway, some time after graduation, when I was asked in a discussion about such literary works as Solzhenitsyn's, I said, "Why are you asking me? The system is responsible for all of it." Immediately, doors literally were closed so that nobody would hear the discussion. I was, of course, not allowed to leave the country after that. I don't think things have changed that much, even today. So I don't like the word perestroika. I was once asked what I thought of Gorbachev. I answered that I had no relationship with him. Politicians do not interest me. I am more interested in musicians, artists, writers, and actors, people in the creative arts. Unfortunately, it is the other kind who control the country. I had no respect for the Soviet government nor much for this one because what is happening in the country is awful. But we are getting to know more about what happened in the past.

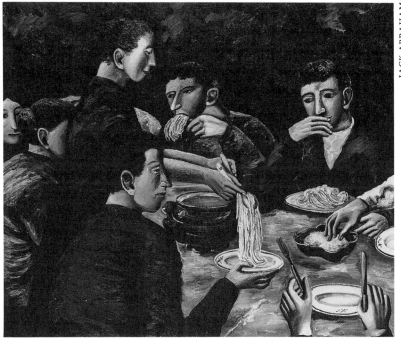

Natalia Nesterova, *Spaghetti*, 1985, oil on canvas, 100 x 120 cm.

People were made to feel unworthy, beaten down, and the best part of their lives was destroyed. All of this is irreplaceable.

RB: *Did you discuss these issues with friends?*
HH: Yes. I always had a circle of friends. We tried to be supportive of each other so that the world would not be frightening to us.

RB: *Is it important for you to live in Russia?*
HH: Yes, again. If you ask me if I want to leave Russia, my answer is that the possibility came rather late. I was forty years old before I had the opportunity to go abroad. But I do believe that each person is born in a particular place, as if God had foretold it. People draw on their resources of knowledge and feelings that are bred into them from early childhood. It could be that I am a true descendant of the intelligentsia, for I believe that knowledge of one's literature, art, and music and Russian roots are important. Art cannot be separated from music, literature, or poetry. It is

important to know as much as possible. As the saying goes, "Even the walls help in your own home." There are things that are handed down from generation to generation—photographs, furniture, scraps of memory. It might be strange, but it is important, important for my inspiration.

RB: *Some Russian artists tell me that they do not like the gallery system, particularly when they have to paint for an exhibition. They say that, in this regard, things are easier in Russia.*

HH: I understand what you mean. But then it is our habit and experience to work haphazardly, whether we have an exhibition or not. We had total freedom for creativity. Yet, the gallery system forces us to have a goal and gives us time limits, we have to work whether we feel like it or not. It gives us time frames. As a form of slavery, it is not such a terrible thing.

RB: *You said before that you used to turn your paintings to the wall. What did you mean by that?*

HH: They did not represent joy. There was no joy of life in them. I painted blind people in a tea house. This did not beautify reality and was against the principles of socialist realism. I guess this is what made me an unofficial artist. At times I was asked why I painted freaks. Just the same, small provincial museums were interested in my work. I had a few infrequent exhibitions. I did exhibit in official shows, though, in the 1970s. These were organized by the union and took place in the fall and spring. I also showed at the Kuznetsky Bridge exhibition hall. I painted, basically, the same way for the official and unofficial shows, but there might have been some slight alteration in form or style. However, the content remained the same. I believed that it was impossible tc make one thing for them and another for myself. A person doing such a thing would become a split person and not be able tc complete his work.

RB: *What kind of impact did Western art have on you when you firs saw it?*

HH: My grandfather was a painter who studied with Alexande Kuprin and was a follower of Cézanne. So we had reproduction.

on the walls. I also saw Western art in a beautiful albums. Since childhood I looked at works by artists like Matisse and Leonardo. Later, in school, we were taken to the storage area of the Tretiakov Gallery where we saw some art of the 1920s. I consider art of the 1950s, abstract art, to be the mutilation of art. I was horrified when I saw such works at the Lenin Museum. I don't even like to look at abstract art, although I consider it to be high art. Perhaps I have not yet grown up sufficiently. However, I find surrealism much more compatible. I traveled to the West for the first time in 1984 and felt very sad for myself. So much had passed me by. I looked at everything. After all, art is meant to be seen in real life rather than in reproduction. We were deprived of seeing so much. In this sense I feel I suffered a real loss. But contemporary art has not influenced me. I find it interesting, but my own way of thinking is different.

RB: *I want to ask you a question as a woman. How do male artists respond to you? Were and are you considered as an equal or as a woman artist?*

HH: My relationship with artists has been as an artist. I never painted infants. I am a soft-spoken person and, in general, people have respected me and my work. My great grandmother was widowed when she was nineteen years old. She was the wife of a priest, and she was also a doctor. She lived her life alone, raised a daughter, and then a granddaughter, who is my mother. My great grandmother was a powerful lady who came from nobility. Her name was Sofia Alekseevna, an admirable person. Then my own grandmother, whom I consider to have been a most excellent and fantastic teacher, taught literature and language. Unfortunately, she became prematurely deaf and could not continue in her profession. My grandfather was a painter and art teacher, but could not make a go of it, especially in the 1930s. My mother is a fine architect. She has designed several structures in Moscow and a house in Magnitogorsk in which she was a pioneer in the use of large panel construction. She has also taught interior design at the Stroganov Institute in Moscow. My mother is a totally independent person of deep intelligence. I have a son, and in this way I

have disrupted the female line in the family. The women in the family always worked, and we did whatever we wanted to do. We have all derived great satisfaction from our work.

RB: *A strong line of women.*
HH: Yes, a very strong line. But I do think that one can question women in the world of art. Women get side-tracked by household chores and children. I am also of the opinion that women lack the faculty of mind to think abstractly. It is much more a male characteristic.

RB: *Don't you possess the ability to think abstractly?*
HH: I don't know. I am a realist. Of course there are exceptions, the poet Marina Tsvetaeva, the highest level of genius. In painting we had Natalia Goncharova, a marvelous artist, and Varvara Stepanova, and Nadezhda Udaltsova, very highly esteemed and talented artists. But their numbers are small. There are some physical impediments.

It is much harder for women.

Grisha Bruskin
Гриша Брускин

Born in Moscow, 1945; graduated from the
Art Department, Moscow Textile Institute,
1968; lives in New York City.

Conceptual sculptor and painter.

RB: *When did you know that you were a nonconformist?*

ГБ: We didn't call ourselves by such names as that. Rather, we
were just not interested in official art. I tried to find my own way,
which, then, could be considered criminal. But all of life could be
called criminal. I read forbidden books. I didn't like Communism.
I discussed all of this with friends. So all of one's private life,
including making underground art, was probably criminal.

RB: *Some artists made official art for the public, but at home made
unofficial works. You've said that you did both, that they were the same
for you.*

ГБ: No, what I meant was that to earn a living I tutored some
students and prepared them for advanced study at an art institute.
Second, I made drawings of fairy tales for nursery schools. I liked
doing that because these works had no ideological message. I
thought of them as the works of an artisan. It was very important

to me that they carried no messages of any sort and that I would not make any works for the union. These works were not actually commissioned by the authorities, but there was an organization called Art Front, which was not part of the union, that helped artists get some work. Illustrators of children's books and graphics artists like Lamm, Bulatov, and Kabakov did the same. I thought of it as a way to earn money on the side. I think that Komar and Melamid did make ideological works for money, but my extra funds were made by illustrating fairy tales with no ideological content. Later, around 1984 or 1985, there were a few sales to private collectors. These were quiet sales. Some collectors took my works out in suitcases. I had a small studio then, so my large paintings were made in small units and then put together. A friend once bought nine small canvases and took them from my studio in three trips. When he left the country his luggage was x-rayed. He said that he had bought the works at a street fair for a few rubles to show his children how Soviet people lived. The airport official did not believe him and called somebody from the Ministry of Culture. The collector, a German, spoke some Russian, with a heavy German accent similar to the funny accents I remember from old Russian movies. Ultimately, they let him leave with the paintings.

RB: *What kind of subject matter did you explore in your unofficial works?*

ГБ: I explored two themes, one connected to the myth of Judaism and the other to the myth of socialism. My very first experience with art was concerned with Jewish themes. I am Jewish and lived in Russia, and to be a Jew in Russia was forbidden. Until I was five years old I did not know I was Jewish because my parents and family were not religious. My father was born in a little shtetl and spoke only Yiddish until he was thirteen. He came from Pustoshka, a town on the border between Belorus and Lithuania. Everybody there spoke Yiddish, even the Russian population, which was in the minority. When he was thirteen he moved to a big city and became assimilated. My mother's story is more or less the same. When I was five, somebody on the street told me that I was a Jew

and said it in a pejorative way. I was shocked and asked my mother about it. She said that of course I was Jewish and so were my four sisters. I have a typical Jewish face, and because of Russian anti-Semitism I was made aware of my Jewishness through-out my childhood. I suffered because I felt like everybody else, but, at the same time, I knew I was not like everybody else. And when I became older it became important for me to understand what it means to be a Jew. So I read books. The first book I read, when I was about fourteen, was the Torah [the first five books of the Hebrew Bible] in Russian translation. It was forbidden to do so, but I began to read it. The more I read, the more I became involved. And as I look back, I think that it was a very Russian thing to do. If I had been born in Israel or in the United States, I would never have ended up making the kind of art that I make. The reasons are that, first, this was a way to identify myself, second, to deepen my identification, and, third, as a kind of protest, a dissident thing to do. I did not show my art to very many people because I had to be very cautious. Also, exploring Judaism was a way to find something positive when everything was nega-tive, or a fake, or a lie, especially the Communist propaganda. For my second theme, I looked at the myth of socialism through talmudic eyes, that is, to consider socialism, to analyze it, and to understand that a lot of it was taken from Judaism. Socialism was like a fake religion. So I wanted to create art about the myth of socialism, not to take the mask from the face of socialism, but to put another mask on the myth.

RB: *You did not want to rip the veil off, so to speak.*

ГБ: Yes. It would be too simple and primitive to say something negative about this myth. That was not enough for me. It was more interesting to analyze and play with it. It was a dangerous game. Let me explain further. Judaism is a fundamental system that explains everything under heaven—about the world and about people. Socialism tries to do the same, to explain every-thing. I once made a painting called, *Fundamental Lexicon* made up of two canvases. Altogether there were one hundred and twenty evangelists in squares, and each figure was like a typical Soviet

sculpture. At that time, the entire country was filled with such sculptures, bad sculptures, made from plaster and painted in oil, and representing Soviet archetypes—the pioneer, the war hero, the agricultural worker. Such sculpture was in every city and town square, on buildings, in the subways. It was like in ancient Greece. Lots of statues of different gods. Some of these gods were personal, like Stalin in my childhood. I remember that opposite my home there was a big statue of Stalin in a garden. And around him were sculptures of sportsmen and sportswomen. Stalin was made of bronze and the others were of plaster and painted with oil, and made, by the way, by German prisoners of war. The statues were terrible, just terrible. But Stalin was like a marshal, like a general, with his army of sportsmen and -women following him. Now, in my work, *Fundamental Lexicon*, I made a similar collection of people, but of Soviet types, Soviet archetypes. I colored them white which related them to bad Soviet sculpture. My idea was to create a kind of lexicon of the socialist myth related to the descriptions of idols in the Bible. I wanted to look at my figures, not from inside the system, but from outside, from heaven. It was like looking at a dead society. The feeling is like when I now go to the Metropolitan Museum in New York City or the Pushkin Museum in Moscow and I see all of those Egyptian figures, strange gods and strange figures. It is like a message from the cosmos, from a dead time. My goal was to look at socialism from the future and to create a fundamental lexicon of Soviet types. I also did a similar work in sculpture about the birth of a hero, the new type of person, the *Homo Soveticus*. I used material that was not beautiful at all. I wanted an inhuman, very cool material, stainless steel rather than bronze. My point was to make sculpture that, although made by human hands, looked like it fell from the moon or like a foreign object that would be found in the future. I began to do these kinds of works when I was still in Russia. Now that Communism is dead, these works really seem to be from the future. When I made them, however, I thought that the system would go on forever. It was so strong, so all controlling. There was no real opposition, no political movement. We thought we were

going to die under the system. That is why nobody took Gorbachev seriously. After all, he was a Communist.

RB: *Why do you create works today with large figures in front of Jewish script?*
ГБ: The basic idea in just about everything I am now doing concerns the Jewish mentality of being the people of the Book. The idea is that we read the Book and then know how to lead our lives because everything is written in it and is prescribed for us. The Book is the Word and vice-versa. My idea was to put art between the Book and the Word, and to present art as fragments of the Book. I use script as a symbol of the Book. So script is as important as the figures. Usually I take the texts from books I love using— books on Lubavitcher Hasidism, for example. These books are difficult to read, and my texts are like magic texts written against a background of fragments. If you cannot read the background texts, they become magical. If you can read them, they are only fragments and not the entire text. It is the same when I use Russian texts which are also filled with fragments. You know it is Russian, but it is like a blind text.

RB: *Perhaps it is a way of hiding. You don't want your text or your thoughts to be found out. To change the subject, did you have any shows in Russia?*
ГБ: I had two shows, the first one in 1976. It lasted one night at the House of Artists. I was not allowed to invite anybody.

RB: *Who chose the show?*
ГБ: Within the union there were different clubs or sections—one for painters, one for graphics artists, and so on. When I was allowed to have an exhibition, the person in charge was named Liuba Rabinovich, a Jew, but also a Communist. She even dressed in somewhat of a military style, like people in paintings from the 1920s. On the list she gave me of people invited to the opening all of the Jewish names were crossed out. When I asked her about this, she said, in so many words, that she was afraid of being accused of aiding some sort of Zionist plot. For my next show I was invited by the Lithuanian union of artists to exhibit in Vilnius.

This was in 1982. After the show opened the secretary responsible for ideological correctness closed it. He wrote a letter to Moscow describing my work. Soon the Moscow union called me in to discuss the list of paintings. Now, you have to understand, I joined the union in order to survive, to be able to get supplies, and for not being accused of parasitism. I was a very young member, only twenty-three years old. It was a rarity to be such a young member, since the older members did not want to share anything with young artists. The average age of the membership was about sixty. Anyway, I went to the meeting. About twenty-five people were there, all the bosses. It was like a trial. I was afraid about one painting I showed in Vilnius. It was of a *golem* [in legend, a man-made, quasihuman] in Russian military uniform carrying a synagogue from which people were falling. The background was red in color. This kind of painting was beyond acceptance then, a criminal painting. Its name was *In the Red Space*. I was supposed to bring this painting to the meeting, but I substituted another, also with a red background. They showed me a book in which visitors to the exhibition had written their opinions. There were two main themes in it. For example, an old Jew wrote that he was proud to see the show, but the other type of opinion was more common. People wrote that I would go to prison in my red space, that I should be machine-gunned. Normal people do not write like that, so I assumed that these opinions were part of a campaign to discredit me.

RB: *How did you have the courage to show this work?*
ГБ: I thought it was a good painting, and I showed it because I wanted to. This was my way to live my own life. My art was my way to survive, to protect my dignity. I understood the risks and was ready to go to prison at any time. The painting I brought to the meeting instead showed three inhuman men in uniform placed against a red background. When I was queried about it, I tried to answer in vague, philosophical terms. But they said that it was strange, existential, and did not reflect the Soviet point of view. They also asked why I used red, the color of the flag, for the background. They said that this was dangerous, even unpatriotic,

because Americans could begin a war at any time. The point is that they stressed negative things about me. Later, a few told me in private that they were really trying to defend me because they were ashamed of the manner of the attack against me, but that I had spoken too much. They said that some wanted to expel me from the union, but the first secretary said he would resign if I were expelled. His reason probably had more to do with the fact that they did not like to expel members because it would be too threatening and discomforting for everybody. Soon after this confrontation I had an exhibition in the House of Artists, which the union didn't know about. Now, this building had two big halls, one held my paintings and the other was to be used as a meeting room. The day after my show opened, just by the wildest chance, a seminar, sponsored by the Communist Party of Moscow, on the topic of ideological enforcement in the visual arts, was held in the other room. One of their chief items for discussion was my show in Vilnius. During a break in the seminar they all walked over to see the exhibition in the other room. And there it was. My show. The secretary for ideology was beyond fury. He became insane when he saw that it was my show, but none of the authorities had known this beforehand. My show was closed instantly, of course. The exhibitors and administrators were fired at once. After that, nobody would even say hello to me. I became a dangerous person, and I knew that I could never exhibit again in the Soviet Union. My next show took place in 1987, the first show without censorship in Russia. It was chosen by artists, to exhibit artists who had not been able to show officially. That was the only criterion for the exhibition. It was a first step in liberalization, but it was still a tricky moment in Russian history. The authorities threatened to close the show if certain conditions were not met. Two of the conditions were to remove my work as well as the work of Yankilevsky, which was considered scatological. I told the artists to go ahead without me, but they insisted on our inclusion or else there would not be a show. The union called the minister of culture to find out what to do about it. The minister knew nothing about art. He had his instructions to let the show

open because, as part of Gorbachev's liberalization policies, people like Yoko Ono and Milos Foreman, as well as religious and scientific figures, had been invited to the opening. Nobody wanted a scandal at the last moment. The authorities then brought in bus loads of workers to write their opinions in the opinion books. They wrote that they would kill us, that we were spies of international Zionism, that the exhibition was a Zionist plot against Russian culture, and so on. But it did not work. Milos Foreman bought a work of mine.

RB: *Could he get it out of the country?*
ГБ: To do that, you had to go through a KGB organization geared for export, the same organization that sold weapons to the Middle East. But Foreman got the painting out. About that time, the Kunst Museum in Berne wanted a painting of mine for a show of underground artists. The director came to my studio and chose one, but things were still uncertain with the authorities. Of course, all paintings had to be shipped through a special unit in the Ministry of Culture. I was advised by the unit not to ship that work. Glasnost, I was told, does not mean that everything is allowed; my painting showed society in a bad light. But I wanted to show that piece [now in the Citicorp collection in New York City]. So this is what happened. First, the restorer of the Kunst Museum photographed the thirty-five panels of the work. I then put soap over the work and painted over it with gouache and water. I painted stupid things; it did not matter what. The ministry finally approved the loan and let the work out. Once in Berne, the painting was cleaned and hung.

RB: *What about sales in the United States?*
ГБ: About that time, I met an art dealer from Chicago, the first dealer I had ever met. He was one of the first to come to Moscow. He wanted some of my work for a Russian booth at the Chicago International Art Fair. He, and other dealers, were shown official art by day, and at night they made the rounds of the unofficial artists. That is how this dealer from Chicago found me. He then had to visit me with a KGB agent who told him that my prices were

too high. (They had nothing to do with the prices the dealer had already discussed with me which were even higher.) But the works were sent anyway. The newspaper, *Izvestia,* then published an article about the dealers and, using Stalinist language, called them ideological spies.

RB: *What about the Sotheby's auction in 1988?*
ГБ: It ended censorship. It was like an earthquake. The authorities realized that art meant money, that art could produce money like oil, but without a fraction of the effort, and they became very greedy. The market was good then, so any art could be sold, junk art, anything. But about the auction. Sotheby's made a list of underground artists they wanted in the auction. The Ministry of Culture insisted on including official artists and not including anything of mine. Sotheby's said that works by official artists would not sell, so the compromise was that some works by official artists would be included along with my things. A painting of mine was on the catalogue cover. I had seven paintings in six lots, which sold for about $900,000. The results startled all of us. We didn't understand what had happened, and many people became bitter.

RB: *Did the auction break up old underground friendships?*
ГБ: Well, to a certain extent. People in the official culture ignored me, as usual. There was lots of gossip—that Israel had bought all of my paintings, that it was a plot of international Zionism, that a rich uncle from Canada bought my work, that special organizations in the west wanted to get a huge sum of money into Russia to finance anti-government movements, that I was the front for all of these things. But, you know, I never got any money from the auction. The government took all of it. They would never let an underground artist keep any money.

RB: *Why did you leave Russia?*
ГБ: Well, I like to think that I live in both New York City and in Moscow. The art market is in New York. Moscow has very little. Also, there is no museum of contemporary art in Moscow, nor can

artists take their works out of the country. If things would improve, I would spend more time there. Living there under Communism was like living in prison. It was important to be able to visit places and participate in the international art processes. The authorities thought we disliked Russia because we wanted to travel, but that wasn't the point. In any event, we both loved and hated the country. But the main negative feeling I have about Russia is that I was always made to feel guilty, guilty for being Jewish, for being an artist, for wanting good food, for wanting free expression. Everything I wished for was considered wrong.

RB: *The authentic you was judged to be wrong.*
ГБ: Yes.

In the United States, I don't have these feelings because I am not guilty of anything.

Alexander Petrov
Александр Петров

Born in Kuibyshev, 1947; graduated from the Stroganov Art Institute, 1971; immigrated to the United States via Belgium and Italy, 1992; lives in New York City.

Paints in a hyperrealist style

AΠ: I was born in Kuibyshev, a city of about a million people on the Volga River. I lived there until I was fourteen when my parents sent me to study in Penza, about 160 miles away, which had an old and famous school. It had a five-year program that covered painting, drawing, and composition as well as the humanities. It was a school for gifted young people and young adults. Many famous painters came from there, and artists like David Burliuk had studied there. In the 1920s a famous art show was organized there by Vasilii Kamensky, Vladimir Tatlin, and the poet Vladimir Mayakovsky. One teacher named Valuikin, who taught drawing, remembered stories about Tatlin and Mayakovsky, who conducted futurist experiments at the school. When I was there I remember seeing a dowel with an iron hook hung in the center of the auditorium. A still life arrangement could be put on it so that students could see it move through space.

RB: *When did you come to Moscow?*

AΠ: After finishing at Penza I began to study in the design department at the Stroganov Art Institute. Our rector, Bikov by name, had been a student of Aleksandr Rodchenko, and he would give us projects like making some kind of sculpture in the constructivist style—really having us combine abstract forms. This was in the years around 1966 to 1968. Soon after, Bikov disappeared, probably because he was too far Left for the authorities. In any event, in courses in the Department of Sculpture we were made to understand that we were industrial designers. But this meant using abstract shapes in projects that ultimately might be used for machine designs.

RB: *Did anybody study with you who is now famous?*

AΠ: Let's see, the film director Adabashian, and the artists Andrei Volkov and Stepenev. I knew Sergei Sherstiuk who is a little younger than me but who started at the school about seven years after I graduated in 1971.

RB: *Did you consider yourself a hippie as Sherstiuk did?*

AΠ: I skipped the hippie period. To be a hippie one had to leave the school and just be busy being a hippie. I was busy painting.

RB: *When did you start painting unofficial pictures?*

AΠ: At the institute. I even helped organize an exhibition of unofficial works of students in the higher education department. We did it at the club of the Institute of Energy, a leading technical institute that trained electrical engineers and physicists. The show lasted for a day before it was closed down without explanation. This was in 1968, a period of relative thaw. We persuaded our instructors and monitors to let us do the show. We explained that Lev Nusberg and other abstractionists were being exhibited and had won prizes in India. The monitors didn't understand much about art, but let us exhibit anyway. They got into a lot of trouble after a party leader came to see the show. But during that one day many people came, artists explained their works and answered questions, some mean-spirited, but most were pleasant.

RB: *Did you consider yourself a dissident at the time?*

AΠ: I believed that artists should not be activists, unless they really want to fight. If that were the case, then they should get a

grenade and fight, or use their influence, if they had any. On the other hand I felt that an artist should paint and develop spiritually. This aspect was important for me.

RB: *But since your paintings were unacceptable, then weren't you making political statements?*
AΠ: I can't say that I was a dissident even though I was not admitted to the union at first. I had many friends who painted abstractly in order to sell to foreigners. To me this was not much different from selling-out to the Communists. I did not want to do either of these things. My task was to be interested in myself, to sit quietly, and do my work. The rest did not interest me. But in retrospect, since I didn't have the freedom to exhibit my work or earn a living, then I guess I was a dissident, an internal dissident, a silent dissident. I rejected violence but not the idea of dissidence. We called it "kitchen dissidence" because we would gather around the kitchen table and have anti-Soviet debates. You have to understand that it was not easy fighting the Soviet machinery.

RB: *Did you make what could be called unofficial works?*
AΠ: Yes. I worked in many directions. I tried everything, and showed these works only to friends. There was no point in doing otherwise, and besides it could be harmful. In a certain sense the situation is similar in America where you have to show galleries either your realist work or your abstract work, but not both. It is better to show only one style.

RB: *Why weren't you admitted to the union?*
AΠ: I was accused of having Western inclinations. My work wasn't seen as Soviet or socialist. I tried to enter a youth section, but I was turned down. After exhibiting in some shows, I was finally admitted in 1971. I had wanted to enjoy life more, to show my paintings, to get responses. The structure of the union was not uniform. Members—there were about twenty thousand—ranged from absolute dissidents to committed Communists. One of the more advanced members noticed me and sponsored me. Nobody argued with him because he was considered a "solid" painter. In 1981 I was admitted to the USSR Union of Artists.

RB: *In what style did you paint in to cause such negative responses?*
AΠ: It was called hyperrealism in Russia, but I called my work transrealism. My inspiration came from the Dutch little masters, not from American photorealism, which I hadn't seen yet. Transrealism means that there is more of an emotional response to the subject. I don't just copy from photographs; I get more involved in compositional problems and alter forms to suit my emotional purposes. I try to transcend realism, per se.

RB: *Were you involved in the Bulldozer exhibition of 1974?*
AΠ: I showed some small pieces. It was still fashionable then to paint in what was called the severe style, which included large paintings with socialist themes, and I was opposed in principle to big decorative pieces and to anything monumental in scale. In those years critics fought endlessly over styles in art, except abstract art, which all of them were against. Eventually artists of the severe style, which had naturalistic elements, together with the formalists were considered to be the same by conservatives. But the socialist realists had to allow room for the severe style as an expression of official art.

RB: *What about your earliest efforts?*
AΠ: My first works were objects close to pop art and surrealism, which somehow evolved into my mature style. My first official shows started in 1972 with small paintings like the ones I showed at the Bulldozer exhibition. They didn't attract much attention. The authorities came and took down some paintings, but not mine. I also showed paintings in exhibitions in scientific villages.

RB: *Did you have a supportive group in Moscow?*
AΠ: Yes, people like Andrei Volkov, Sergei Bazilev, and Sergei Sherstiuk. I also exhibited with Sitnikov and Bulgakova, Tatiana Nazarenko and Victor Kalinin. On one occasion in 1981 the critic Alexander Morozov selected works by twenty-three artists and exhibited them under the unofficial title of "Artists of the 70s" at the Kuznetsky Bridge exhibition hall. Everything was installed when the authorities insisted we take down the show. They said that since it was in the center of Moscow it would attract mobs and

all sorts of riffraff. So we moved it to the Central Building of Artists on the Crimean Quay. Just the same, we had long lines and huge crowds. I sold my first painting from that show to the German collector Peter Ludwig.

RB: *Were there any Russian buyers?*
АП: No private buyers, but there were people, who simply took paintings for themselves. We knew these people, and we wanted to get our work into their collections, which were good ones.

RB: *Did the authorities bother you?*
АП: One time after visiting an artist friend who painted in a German expressionist style, a KGB guy came over and beat me up. He told me never to visit that friend again. You know, the KGB beat up on everybody in those days.

RB: *When did you first see Western art?*
АП: I was always interested in Western art and would buy books in which Western art was attacked. This was the only opportunity to get information, since the authors would illustrate the works they attacked. They explained why the art was bad, but of course we saw things very differently. It was like getting underground information. They said one thing; we knew another. But they really didn't write in such a hostile manner anyway. They were given a job to do, and they more or less did it. Often, by the end of an article or a chapter in a book the diatribes would really taper off. They would begin with a sharp attack and then end up just giving the reader basic information. It was clear to us what they were up to. This was how I came to transrealism, after seeing examples of pop art and surrealism.

RB: *Did any Western artists impress you?*
АП: Andy Warhol and some others.

RB: *Did you travel in the West?*
АП: I first visited America in 1987 in an artists' exchange program. After an overnight visit in America, we then spent twelve days with the Americans in Iceland. My wife, Elena, and I visited again in 1990, made arrangements with a dealer, which fell though

because of the war with Iraq, and finally left Russia in 1991. We lived for a time in Belgium and Italy before coming to New York City.

RB: *Do you think it is important to keep ties with Soviet culture?*
AΠ: Well, there are many Russian artists here, but we also enjoy the international flavor of the city. There are artists from all over. But you can't get away from the Russians who like to keep in touch with everybody.

RB: *Has your work changed since leaving Russia?*
AΠ: I have never worked so hard in my life, or as well.

RB: *I know it is hard to earn a living here. How did you manage in Russia?*
AΠ: Fourteen of my paintings are in Russian museums, bought on commission. Things worked this way. Then there might be commissions from the ministries of culture of the Soviet Union, of the Russian Republic, and of Moscow, as well as from the USSR Union of Artists, the Russian Union of Artists, and the Moscow Section of the Artists Union. What is interesting is that all of these organizations hated each other. I managed to sell one painting through the Russian Union of Artists and one through the Moscow Section of the Artists Union. I was a member of the USSR Union of Artists, but that union and the Moscow Section really didn't like my work very much.

RB: *Can you elaborate?*
AΠ: In 1981 I applied for membership in the USSR Union of Artists Critics, and historians were upset that I had not yet been granted membership since my work had already been included in thirty exhibits abroad. A letter was sent to that union by three leading critics—Kamensky, Kantor, and Morozov. The USSR union realized that a mistake had been made at the level of the Moscow section, which had initially turned me down, and so I was admitted to the union. I joined because if you wanted to be a professional artist and live by your art, you had to be a member. There was a law that if you didn't work you could be arrested and detained for a period of one month to a year without any other

pretext. If you didn't work, it meant that you didn't earn a living through honest labor. Therefore you deserved to be jailed. Even as a member of the youth section of the union you had the right not to work anywhere. You could sit home and nobody would bother you. So if you just wanted to paint and not have to work somewhere, then you joined the union. No members had to work all week long at some job and then paint only at night, dead tired. We lived in Moscow because of the union. If you belonged to the USSR union, then you also belonged to the Russian Union of Artists and to the Moscow section. Each major city had its own branch of the union, but the Moscow section was the largest and most powerful. Out of about twenty thousand members in all of the Soviet Union, about ten thousand lived in Moscow. As a result, many artists wanted to live in Moscow. Even though the unions were supposed to be united, there was fighting between them and within them. For example, in the Moscow section there was a subunit for monumental art, which was more left of center than the main body. And the umbrella union, the USSR Union of Artists, was more to the Left and progressive than the Russian Union of Artists because its membership included the unions of the Baltic republics and of other republics that were always more liberal. It was possible, if you knew what you were doing, to deal primarily with the particular union that you preferred—Soviet, Russian, or Muscovite. As a result, I hardly ever exhibited with the Russian union. What makes all of this so complicated was that the Ministry of Culture of the Russian Republic was also more to the Left than the Russian Union of Artists. And the ministry, like the union, also supported exhibitions and had its own collections. Even art critics who worked for the Russian union sometimes had confrontations with critics who worked for the USSR union which, because of the membership of the other republics, was more liberal. It was not easy to keep everything straight.

RB: *How did the KGB figure into all of this?*
AΠ: I think the KGB wasn't that interested in the artists. Things happened at the initiatives of the district committee of the Party or, as far as I know, of individual Communist leaders. The people

who closed exhibitions might come from the KGB, or from some commission set up by the district committee or some other organization.

RB: *Was it easier to exhibit as the years of the 1980s went by, as perestroika approached?*

АП: Yes. Let me give you an example. Dmitrii Prigov was not a union member, yet, through the Central Committee of the Komsomol [the Young Communists League], he was able to set up official exhibitions that might include unofficial artists. The authorities realized that it was stupid, by this time, to forbid exhibitions. The situation had grown a bit beyond their control. So they gave artists more freedom, and all of the unions and ministries began to sponsor exhibitions they probably wouldn't have allowed a few years earlier. By the mid-1980s it was no longer possible to imagine anybody being thrown in jail. But the situation was not stable, so you never knew what might or might not be hung in an exhibition.

RB: *Were there any other benefits in being a union member?*

АП: Once a year you could get money from the union to live on. Once a year you could also go for two months to a special house for artists in some beautiful place like the Crimea or one of the Baltic republics. Everything was paid for, and you could meet other artists, make connections, see what other people were doing.

RB: *How did you get your paintings out of the country?*

АП: Since 1975 I had turned over my work to an export salon, the only organization through which we could sell works to the West. The director was a woman named Bakuleva. So Western organizations would come to Russia and select artists they liked. For instance, in 1986 a Swiss company saw my work in Peter Ludwig's collection and offered me a show in Zurich. Under the auspices of the export salon I began to prepare for the show. Then you want to know what happened? An organization called The International Book, an organization involved with the export of art, told the export salon to give the show to Ilya Glazunov instead. Can you believe it? Only in the Soviet Union would a group want to substitute one artist for another. They tried to bargain with the

gallery in Zurich, but the gallery held firm. I wanted to contact the gallery, to explain things, but I was given the wrong name so that I could not reach them directly. And then I asked to go with my wife Elena to the opening, even though I knew that this was not allowed. The authorities said they would send their own representative and that the show would be canceled if I insisted on going. And, in fact, it was canceled. We later found out that we were done in by a Russian critic from the journal *The Literary Gazette*. Anyway, The International Book was a shady group, which nobody understood very much about. All of its workers traveled abroad at least twice a month and were paid in foreign currency. Everything depended on them. For instance, not even the director of the export salon could write a letter directly to the gallery in Zurich. He had to send it through The International Book, and they would then forward the letter. Nothing escaped them. The whole art market depended on them. The book market, too. This situation had existed since, I think, the late 1960s.

RB: *Could you ever get paid for work sold abroad?*
AП: Officially you were paid in rubles, but you received only ten percent of the sale price, minus the sales tax, which was calculated at a special currency rate. In the end you received very little or you lost money in the deal.

RB: *What is your method of creating a painting?*
AП: I never make sketches because I believe that the energy of the painting is what counts, that there is an energy that comes off a canvas that the body feels. Before I begin a work I concentrate intensely, to build the energy of and for the canvas. True, I do use photographs and make some preliminary drawings of certain details, but the main energy is saved for working directly on the canvas itself.

**It is easier to work up this energy in New York City
than in Russia.**

★

Olga Bulgakova and Aleksandr Sitnikov
Ольга Булгакова и Александр Ситников

BULGAKOVA: Born in Moscow, 1951; Moscow Secondary Art School, 1969; Surikov Art Institute, 1975; lives in Moscow.

Paints in a surrealist manner.

SITNIKOV: Born in Iva, Penza region, 1945; Surikov Art Institute, 1972; lives in Moscow.

Paints in a surrealist manner.

RB: *When did you know that you were a dissident artist?*

AC: A true artist is always a dissident artist because the artist is always in opposition to the existing social order. We considered ourselves artists from the moment we began to think differently, when we realized that our perceptions were different from those who were ruled by that segment of society which lives by conventional social rules. Artists are governed by rules different from the norm. They are free to select ideas from the myriad of events in which they happen to find themselves. And we stay here in Russia because it is interesting to be in the thick of events in which our lives are intertwined. Even with our grim political and social situation, our lives are interesting. I would say that the current situation is probably more interesting for a writer than for a painter or a composer.

RB: *Can you elaborate a bit?*

AC: I believe that artists work really hard when their nerves are on fire. Our society right now is on fire.

OB: I feel a bit differently. Artists evolve regardless of their current situation. This is a complex process that operates at a deep level, and so personal development is more important than external events. An artist's evolution is independent of the flux of social and political events, of outward conditions. It is the rich inner life of the artist that I consider most important. Seldom does it coincide with the existing official point of view. This has always been so and will continue to be so.

RB: *Was it possible to show unofficial art?*

AC: Such exhibitions occurred rarely—at the Small House of Artists and at the Kuznetsky Bridge.

RB: *Did you participate in the Bulldozer exhibition in 1974?*

AC: Let's see. I saw the Manezh show in 1962, but I did not participate in it because I was too young and not yet part of the art world. Nor did we participate in the Bulldozer show. We had not yet joined the world of art. My first exhibition took place in 1966. It was an unofficial exhibition of young artists, but organized by

the authorities. For quite a long time the works of young artists were forbidden in official shows. Then, things eased a bit. In 1967 the seventh youth exhibition of young Moscow artists took place, and the eighth exhibition took place the following year. At that show my works were removed. Again, there was a ban on exhibitions by young artists. In 1972 things loosened up again, and we had regular shows, more or less.

RB: *Who was responsible for all of this?*
AC: Mainly, the board of directors of the GORKOM. I never found out why my works were removed in 1968.

OB: Although I am younger than Alexander, I had similar experiences.

RB: *How were you able to cope with such unpredictable behavior? Many artists have told me that they suffered immensely when their works were inexplicably removed.*
AC: It was very difficult for everybody. Artists whose works were not exhibited often experienced considerable anxiety. It was painful to see. An artist would get ready for a show, which often took three years to prepare. They wanted others to see what they had accomplished. They wanted to share their works, and then, bam! without reason or warning, works would be removed or simply not selected to be shown. Some artists became really despondent.

RB: *Were you ever directly threatened?*
AC: The government is a well run and powerful organization, and therefore, has no need to threaten directly nor does it have to tell you directly what type of art is acceptable. It can communicate all of this by rejecting your work, thus showing its displeasure. For example, if a young artist held an exhibition, the authorities might simultaneously organize an official exhibition with official artists. These exhibitions were controlled by the Party and were synchronized with the Party line and ideology. Often, these official exhibitions were scheduled to coincide with a national celebration of some sort. Officials would commission artists to paint specifically for these fêtes, particularly for the celebrations of the

Belshevik Revolution of 1917. Most artists knew very well what was needed to be selected for such an exhibition. The same painters were selected year in and year out. More than that, they would be awarded government commissions, which would be agreed upon by the Ministry of Culture and the USSR Union of Artists. This gave the artists financial stability and security. As Olga said earlier, artists should reflect their personal and innermost concerns, particularly if these concerns have universal value and affect all humanity. When that happens, artists turn toward representations of universal suffering and to the painting of problems in history. Of course, the government and the Party had no use for such problems or such representations. A work of art that did not conform to the canon of praise and glorification of Party ideology had no place anywhere. If the painting was a slight bit off, then the artist was deemed superfluous to those who dominated the cultural structure. Any work of art, in any medium, had no right to exist if it violated the prescribed parameters of the Party line. A painter would not be shown and would receive no commissions. He was forced to support himself by different means.

RB: *How did you earn a living? Were you union members?*
AC: Yes, we were members, me since 1975 and Olga since 1976. It was clear to us that we had to join. Membership was essential for the exhibition of our works. I had some difficulties getting into the union and was not accepted right away. It took two tries on my part. I had to write appeals. Since I had already participated in many exhibitions I thought I was qualified for membership.

RB: *Does this mean that you painted both officially and unofficially?*
AC: One did not necessarily have to paint official works. Being members helped us earn a living by getting commissions. For a while I was busy illustrating a journal.

RB: *Olga, what did you do?*
OБ: I painted all of the time. Some works were shown in official exhibitions. I always submitted paintings that I considered authentic and that I honestly liked. At times they were removed, but at other times they were hung for some miraculous reason.

RB: *Did you show your unofficial works to friends?*

AC: This was a very popular way to meet with fellow artists. Since we could not see officially the works of other artists of our generation, we could at least say that we were in the mainstream of whatever was happening unofficially. I didn't agree with every opinion I heard. I had and have my own opinions. So I can't say that the artistic environment in which we lived had a concrete influence on our development. I have always believed that an artist needs to keep a distance from commonly held ideas. An artist should not become entangled with those ideas because they might be illusory or transitory, even if they might lead to a spurt of creativity. I have seen artists change their approaches according to the current situation or to the state of the art market and this disturbs me. I see artists cater to the West, especially to the New York art market. Their work seems to depend on what is happening in the West, in America, and in New York. Let God judge these artists; I have no right to sit in judgement. As for myself, I believe that the most important thing for me is to guard and maintain my integrity and independence whether I get paid or not. Above all else an artist has an obligation to himself, and his goal basically should be to become a messenger of a larger idea, of a grand historical or universal humanistic idea.

RB: *Do you represent general humanitarian ideas in your painting?*

ОБ: That is a hard question for him to answer.

AC: It is a difficult question, but if I provoked the question then it must mean that I am in search of an answer. Olga said that an artist exists only for himself. I am not entirely in agreement. I believe that the environment does exert pressure. I can't be complacent about what I see happening around me, on the streets, in my neighborhood, on the trams, in the metro. You immediately come in contact with information that has an impact on you in a creative fashion, particularly at this time in our history. One can't help interacting with people standing on a queue or in the metro. We are in a ready-made documentary situation that informs our art. If we were to leave Russia at this moment we would not have the

same artistic experiences. This is one reason why one should not leave the country now. There is no other city in the world where such a documentary situation exists as in Moscow. In my own city I have an entirely different relation to the people than if I were elsewhere. I hear them. I see them. It is unlike any experience I would have abroad. These are people like ourselves, born here, who are accustomed to this reality, to our perception of reality. I otherwise could not dig into my deep spiritual resources to inspire my art. Here I meet with familiar, wonderful people everywhere. I need this culture, this environment. This does not mean that I go out on the street and behave like everybody else. Not at all. However, the environment acts as an impulse for my art. I sometimes regret not being an author of books because then I would be able to say much more than as a painter with a brush.

RB: *When did you exhibit in the West?*

AC: In the latter part of the 1970s. There was a lull in the art world, and we were not being disturbed. Even when exporting art was banned some artists managed to exhibit in the West. Somebody would arrive from the West and would issue an invitation to participate in a show. Of course we artists had no rights to lend our paintings. There was no direct transaction between artist and buyer or gallery person. Nothing like this ever happened in Russia as it does in the rest of the world where a painter has a right to select from his own works and send them to an exhibition of his choice. We were not allowed to make transactions. We had to make such arrangements through the governmental superstructure, through the union, and the Ministry of Culture, through official channels. The authorities would make the agreements with people from the West. The authorities would choose the artists, and even after making their selections, they would still randomly exclude some paintings. No explanations would be given. When that happened, it was really depressing. If one asked, they would simply lie and rob us. There were a few times when I had to beg them to return my paintings from shows to which they supposedly had sent them. One time I sent some paintings to an exhibition through the union, and when the show closed I asked

for their return. They said "soon." A year went by and still no paintings. They told me that the exhibition was a great success and that sort of thing. I figured out that something was not quite right, and by chance I had to go to the storage rooms, and there were my paintings leaning against a wall. They had never been sent in the first place.

RB: *You must have been upset.*
AC: It had no effect on me, but it was rather awful. There wasn't much I could do about it.

RB: *When did you first have buyers?*
OБ: When I finished my studies in 1975. After my first exhibition people were interested in buying my work and came to my studio.

RB: *I know what you said about the nature of your work, Olga, but did perestroika have any effect on it?*
OБ: No, not on my style or ideas, or thoughts. At least nothing noticeable. A lot has changed in Russia, but in art, I don't think so. I have always worked with themes that interest me, and I hope always to work that way, regardless of changes for better or worse.

RB: *And you, Sasha?*
AC: Clearly an artist changes daily. He reconstructs and tries to improve his ideas until they are finely tuned. They get solidified and find their confirmation in the painting that will follow. It is a thought process, and each new painting is an affirmation of a change, of a new concept. This is a continuous process. Our world view and our philosophy change because of all that surrounds us. All of this is reflected in the artist's style, which reflects the current situation. My earliest paintings, for instance, might be considered simple and lyrical in relationship to the works I do now, as our world is also more complex now. I am only speaking for myself, you understand. I do not deny another artist's reality, another artist who might want to take a bucket of paint and pour it over a canvas. I like to delve into every detail very meticulously. I require an exhaustive explanation—methodological, metaphorical, and

metaphysical—of everything that occurs. I make use of metaphors and mythology, perhaps a new mythology emerging from contemporary Russia. This is the way myths are created. There already is the grounding for a new myth based on existing metaphors that underlie our contemporary reality. These metaphors may have a cultural base or have literary characteristics. There are some images that have purely plastic properties. One can use all sorts of numbers and words in any variety of combinations, all of them generating objects that are recognizable and that evoke in the viewer his own understandings of the message I try to transmit. Generally speaking, I try to communicate my perception of the world. An artist can only generalize from his own experience, refine it, and bring it to completion. And I also believe that an artist should remain independent of what is happening around him, remain at a distance from social and political change. The artist must always stand in opposition to any power, otherwise he digs his own grave. If an artist's reaction to the new ruling power is self-serving, if he behaves in a manner that leads to favors for himself, then he becomes a slave to the new power structure. Any government thirsts after an art that would be pleasing to it because every government recognizes that art is a potential vehicle of service to itself.

RB: *If the government is repressive?*
AC: The state is always repressive. That is why it exists, especially totalitarian governments.

RB: *Does the artist then have to go underground?*
AC: The artist who opposes prescribed rules of art has to go underground.

RB: *Could you be a member of the union and be a dissident at the same time?*
AC: Yes. Joining the union was voluntary. Each artist who joined had to adhere to the rules and basic principles, as well as follow the tenets of socialist realism. Each artist had the right, I believe, to follow his own way. But official exhibitions contained only socialist realist works. Even titles of exhibitions reflected this point of

view, such as "In Honor of the Twenty-Seventh Congress of the Party." We all knew what was required of us to participate in those shows.

OB: An artist did not necessarily have to compromise to exhibit in official shows. He could show the exhibition committees whatever he wanted to and they would decide. The artist was free to do anything he wished in his studio. That is why I believe that changes in style and subject matter should not be dependent on what goes on outside of the studio. If an artist does change in this manner, then the work is not deep or serious.

AC: The union did not intrude into our studios. Nobody had the right to enter them and to look around. There was no way to check up, although, in some instances, something like this might occur, but there is no factual evidence to support this assumption.

RB: *Do you feel nostalgia for the past?*
AC: No, God forbid that the past should repeat itself. But I don't think that the present government is, qualitatively speaking, much better that past ones. The same people are still in power. They have simply exchanged costumes and put on new masks. The former Communists have only freshly painted faces. I like the present and I am happy about all that has occurred. I am glad that we are alive at this time and that there will be no turning back.

RB: *When did you first see Western art?*
AC: Western art made a great impression on us the first time we saw it. The first Western exhibition took place in 1957 at the Seventh International Youth Festival. This occurred when I was still quite young. We were fascinated with what we saw and tried to figure it all out. Suddenly we were flooded with all types of new information. Art journals appeared in second-hand book stores. They were not as expensive as they are now. As a student I would go to the Lenin Library, and for four rubles I could go to the rare-book room where someone would get me an art journal. I could see any artist I wanted to see except our own Russian painters. They were banned. Chagall was banned, for instance. We could

not ask for art books until the 1960s, and only then could you see a book on Chagall. Any artist who was not lazy could go to the library and see art books and magazines.

ОБ: Well, we were not entirely free to go and look. It is true, though, that our first contact with Western artists was only through reproductions in books and journals.

RB: *What effect did this have on you, to see works that had been forbidden?*
ОБ: It is hard to say, but it is true that seeing these works had a serious impact on us. Had we not seen them, our works would not be what they are today. Our work was formed under the influence of those impressions.

AC: Yes, these works had a tremendous impact on the younger generation. I was still a student then, training as an academic painter because that was the only kind of training you could get. Our teachers were all laureates of Lenin prizes. Although our training was academic, I can't say that we continued to paint like nineteenth-century Russian humanists. Western art had an effect on all contemporary Soviet artists. But only the rare artist really affected us or could be considered a spiritual mentor. Kandinsky and Chagall are my spiritual Russian teachers, and Malevich and Pavel Filonov were also essential to me. I must admit that I had a very difficult time with my teacher at school because he wanted to expel me. I had to leave for a time, and it was very difficult.

RB: *What about Western artists?*
AC: Dali, Picasso, and Miró, all Spaniards, were important. I do see an American influence on the younger artists, but I don't think that American art has a tradition, no clear, weighty tradition, the kind we have in Europe.

RB: *What about, say, abstract expressionism?*
AC: I forgot to mention Jackson Pollock. I admire him a great deal. I also respect pop art, but my style is so different. I think pop art has exhausted itself. Each artist chooses a direction, or I should

say that the direction finds the artist who will fulfill it. That artist is forever beholden to that direction or movement or else he finds himself rushing after anything that is new.

OБ: I doubt that one can dictate to an artist what he should do and who or what he should follow. A painter should do as he feels at any given moment. If he wants to change, then so be it.

RB: *Do you like Jackson Pollock?*
AC: Yes. He found answers for his psychological and spiritual condition in his canvases. If it is at all possible to express yourself totally in art, then Pollock did so. Most artists can't express more than ten or fifteen per cent of their ideas and thoughts.

RB: *Have you traveled abroad?*
AC: Very seldom. My first trip was to Norway in 1980, to an international seminar conducted by the English artist Allen Green. Somebody else was supposed to go, but the situation got extremely complicated what with the Olympics and the war in Afghanistan. Unexpectedly, I was permitted to leave.

OБ: Then perestroika happened. Sasha traveled abroad frequently. This was probably the most important effect of perestroika—that we were suddenly allowed to travel.

RB: *You indicated before why you want to remain in Russia, but let me open the question again.*
AC: I am happy to stay locked in a room and paint. Other people have different needs, of course. I find that the West is not a simple proposition. I observed this when I was in New York City. It is not just enough to move there and realize your ideas. There are huge obstacles everywhere. I admit that the public is the same there, in that art exists, really, for a very few people, for those really interested, for specialists. The visual art industry in Soho is grandiose, stupefying. You arrive and you are amazed at how much there is of everything. Soho is very seductive for artists, but one needs to be multitalented—be creative, have organizational ability.

OБ: This is from the artist's point of view. We are not only

painters, but Russians. It would be difficult for me to sever ties and transplant myself someplace else.

AC: I know some who left out of fear, fear for the safety of their children. They were worried about thieves and murderers. Many of our friends left for Milan and New York City.

> **But the majority of those who left are Jewish;**
> **they were afraid to stay in Russia.**

<div align="center">★</div>

Svetlana Kopystianskaia and Igor Kopystiansky
Светлана Копыстянская и Игорь Копыстянский

KOPYSTIANSKAIA: Born in Voronezh, Ukraine, 1950; graduated from School of Architecture, Polytechnic Institute, Lvov; immigrated to the West in 1989.

Conceptual artist who works with objects and literary materials.

KOPYSTIANSKY: Born in Lvov, Ukraine, 1954; graduated from Institute of Applied and Decorative Arts, Lvov, 1977; member of the Group of Six, 1980–1985; immigrated to the West in 1989.

Superrealist in style, creates "destroyed" works, often in a three-dimensional space.

RB: *Since both of you are of the generation of the 1970s, I would first like to explore the differences between you and artists of the previous generation. Then, we will discuss your work.*

ИК: We grew up during the Khrushchev era, so our childhood years were not spent during a time of total, paralyzing terror. As we were growing up, society gradually began to free itself from an all encompassing fear. Our generation, compared to the older one, lived in an entirely different psychological situation. But there was fear, make no mistake about that. There were various types of oppression and repression, but nothing like during Stalin's time. One could be expelled from art school, it could be unpleasant, but rarely would you be jailed unless you were an activist.

CK: Yes, one had to have been involved in political activities to be put in jail. But nobody was jailed for painting pictures that were not seen or exhibited or were not a part of the official culture.

ИК: You could lose your job for painting in an unprescribed manner. Your studio would be taken away, but you were not arrested or jailed.

RB: *When did you first know that you were nonconformist artists?*

ИК: It occurred early for us. We felt separate from official society. It began in school, when we were teenagers in the late 1960s and early 1970s. I can't say that we were literally doing anything dissident in nature. There was nothing overtly political in our art. Rather, we felt independent, that we were individuals, and that we wanted to realize a sense of artistic freedom. We never had the desire to participate in the system. Art, for us, grew from inner necessity. We simply wanted to make art. What was important for us was not official art, but the state of the arts and of the individual artist. Such artists, who were inwardly free, had no opportunity to exhibit, of course. Being excluded from the world, from society, meant that you were both the author of the work and either its only viewer or one of its very few viewers. You were both the creator and the spectator. So certain questions began to interest us, like how do such works differ from official works, are they really works of art, are they just material objects with certain properties

of size and color. As a result, we made several series of actual works and performances, one of which was called *Communal Domicile*. Svetlana made the first one in 1972. We began to work together in 1979 after moving to Moscow and began to exhibit in private apartments, attics, even staircases, in that city and also in St. Petersburg and in Tallinn. Some exhibitions also took place in the open air and in the woods. An early exhibition series was entitled *Art without the Audience* [1980]. Many exhibitions had no viewers, at all. We did performances, which we photographed, that reflected the impossibility of communicating with viewers.

RB: *Did other artists participate?*

ИК: No. Works like *Art without the Audience* were our own projects. Later we made similar works with viewers. We would exhibit in populated places where people might stroll by. Situations and opportunities presented themselves when we came into contact with viewers, who, most of the time, would tell us that they would call the militia and denounce us. We were sometimes threatened, but some encounters were peaceful.

RB: *What about the* KGB?

ИК: Everyone had some problems with the KGB.

СК: Yes, they bothered us. When I was a student I belonged to a group that called itself The Sybarites. We were under surveillance and all of our works were confiscated—all works from the years 1970–1974. The group published a magazine, a handwritten one, and also held a series of humorous performances. The journal was confiscated, its supporters expelled from art school, and the men drafted into the army. There was a "trial" in a kind of a court, a people's court formed by citizens.

ИК: I did not participate in the group because I studied at the Institute of Applied and Decorative Arts, not the School of Architecture where Svetlana studied. Anyway, we exhibited in 1982 at the Kuznetsky Bridge exhibition hall for a one-day show. There was also a four-day exhibit at the Center of Technical Esthetics in Moscow. It was conceived as a symposium on scientific matters,

so we were able to hang our works there. So did Kabakov, Chuikov, and many others. Art critics and historians came. We knew the KGB would be there or at least one informer. This did not bother anybody.

CK: We did not think of our work as political statements, but we knew it was entirely different than official art. We tried not to show it to anybody. We discussed it only with our circle of friends, a very narrow circle. We were very secretive about our art, particularly at the places where we earned our living. Igor designed ceramics, and I worked as an illustrator for children's books. (Since I wasn't in the union, I was paid less for each book than, say, Kabakov and Bulatov were.) We led a double life. One life was social and open; the other, the creative life, was secret. We fenced ourselves off within our island of freedom and made a place there in which we felt like normal human beings, people with normal, authentic, and sincere reactions and responses. Our art was ourselves. The social life was outside of our true interior lives.

ИК: We were very friendly with what you might call the conceptual circle in Moscow—people like Bulatov, Chuikov, Kabakov, Makarevich, Monastyrsky, and others. They were very important for us and were our spectators as we were theirs. We were each other's audience. We were never members of the union, so we had difficulties in obtaining studios and materials, such as canvases and paints.[1] You could only buy art supplies in special kiosks, not in regular stores. The kiosks belonged to the union, and you needed a union card to get materials. Not belonging to the union affected literally all aspects of our lives—from having a studio, to getting commissions, to participating in exhibitions. Certain benefits, like traveling for vacations, were denied to us. But we had friends, wonderful people like Ivan Chuikov, who used his union card to buy supplies for us.

[1] A short biographical summary of Igor Kopystiansky's life indicates that he belonged to the Youth Section of the Russian Artists' Union. See Norma Roberts, ed., *The Quest for Self-Expression: Painting in Moscow and Leningrad, 1965–1990* (Columbus, Ohio, Columbus Museum of Art, 1990), 180.

RB: *When did you first see Western art?*

ИК: We had little information, but we were nurtured by friends from unofficial circles and by the tradition of Russian avant-garde art. We did not see actual works until the mid-1980s. But information trickled down from books.

RB: *Did you know any artists from the past, and was Malevich important to you?*

CK: Actually, our works are a reaction to Malevich's very strict spatial and figural arrangements, but the culture of the 1920s was very important for us. Its culture and language contradicted the culture of socialist realism, which made no use of the language of art. The socialist realists did not express their ideas clearly, but illustrated, instead, socialist ideas. That is why the earlier period was so important to us, and the Soviets tried to hide it from us.

RB: *How did you find out about the 1920s?*

CK: In bits and pieces—some handwritten brochures that we passed around, and the writings of Malevich and Velimir Khlebnikov [a playwright and futurist poet]. Basically the culture of the 1920s existed in books. Sometimes a Soviet critic would write about the period in a pejorative way, but we could see through such writings and find the cultural and historical facts we were looking for. We also found out about Western culture in this way. So we filtered out the harsh criticisms and tried to understand the facts.

RB: *What was your relation to socialist realism?*

ИК: Our generation was much more independent from it than the older generation that grew up under Stalinist culture. Socialist realism was more distant from us. We don't think that we ever internalized this culture. Sots-art artists, for instance [Komar and Melamid], used socialist realism's cliches ironically and playfully. It was important to them. Our generation was interested in other things. We believed that Russian visual culture contained many different traditions. We considered the avant-garde culture of the 1920s as a continuation of traditions that always existed in Russian culture. Socialist realism also grew from indigenous traditions,

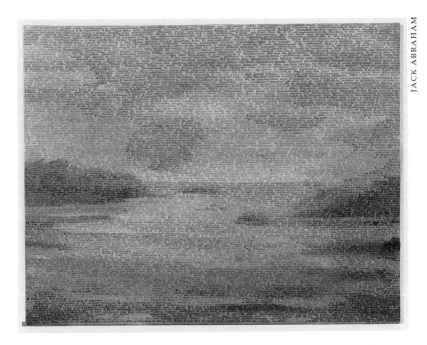

JACK ABRAHAM

Svetlana Kopystianskaia, *Landscape*, 1984, oil on canvas, 69.5 x 89.5 cm.

but not from the same ones as the avant garde which went under-
ground during the Stalinist era. There were those avant gardists
who felt the need to conform and turned to socialist realism. You
must understand that it was a terrible time, and people tried to
save themselves and their families. It is interesting, however, to
realize that the avant garde of the 1920s and socialist realism were
examples of attempts at European communality. But socialist
realism was not a typical Russian style. It had elements more in
common with Nazi art. It was an art of mass culture with self-
serving purposes.

RB: *Even though your situation was different from that of the previous
generation, what was it like to work in a repressive society?*
CK: I always had a feeling of the absurdity of the situation, that I
lived in an absurd universe complete with lies and that you had to
be deceptive in order to survive. All of this was reflected in my
work, in which I tried to transform the culture into objects. I used,
and still use, books without titles for decorative purposes—books

as facade. I often had this kind of feeling about books, especially when I would walk into a bookstore filled with them, but I couldn't find the book I was looking for. Or the book would be there, but half the text would be censored out. It meant that you read what you found—a whole book or half a book. It meant that the books had been transformed into political commodities.

ИК: Let me follow up Svetlana's thoughts by describing how one aspect of my art originated. Let me invent a situation. The studio of an unofficial artist begins to fill up with works that nobody buys, that nobody wants, and that cannot be exhibited. Let us say that this artist dies at a young age or even at an old age. In any event, his work will probably be thrown out or will perish in some way. This actually occurred with many works of the avant garde— works thrown out from private and museum collections. Anyway, the thought occurred to me—why wait? It's not worth waiting for somebody to destroy my works. I'll do it myself in order to preserve my dignity. It would be something like committing hara-kiri. So I damaged one of my own works. Then I began to copy works that already existed and damaged them. I now had a whole series of damaged works made, in effect, for destruction. Questions then arose in my mind. How much of a work can you destroy? When does a work of art cease to be a work of art and become a piece of canvas with paint on it, empty of spiritual substance, a substance I believe present in every work of art? So I accumulated a series of restored paintings, with renewed spiritual substance, that had first been very damaged. This pseudo-restoration did not restore the painting to its original appearance, but made it into something else. I also thought that this whole procedure reflected the destruction of cultural treasures, an irreversible process, because cultural objects cannot reestablish or restore themselves.

CK: For me the text is a fragment. I write different types of texts from Russian literature, such as from famous nineteenth-century authors. Then I deconstruct a particular text. It becomes an evaluation of culture, but since that evaluation is only a version of history, I do not present the text as a whole, but as a part of history, hidden in mystery.

RB: *Does this relate to the kind of history you were taught as a child in which the truth was repressed?*

CK: Yes. We were given only one version of the past. The rest was mysterious, hidden away from us. I don't destroy texts. I deconstruct them. The result is one big absurd history that we can't read clearly. We literally can't read the physical text, and this shows the impact of censorship on culture. I also want to say that this relates to the tradition of the absurd in the Russian culture of the 1920s and to the theater of the absurd.

ИК: The author as manipulator is always present in our works. Initially, the author composes the ur-text. Then the author, who is also the censor, tampers with the ur-text. What we see, then, is the result and effort of at least two people—the author as author and the author as censor and manipulator. We never really see the ur-text. So the general meaning of the ur-text is affected in ways we don't fully understand or know about. In my own work I have tampered with existing paintings and have transported them into a different context which then has its own impact on general knowledge.

RB: *In effect, both of you are saying that your work is a metaphor for the system in which you grew up—the world of half truths, deceptions, rewritten history, an inability to get too close to whatever it is you want to call truth or authenticity. Does any of this relate to your regard for the avant garde of the 1920s?*

ИК: I feel that it is possible to continue the tradition of the 1920s, but on conceptual rather than imitative level. It is possible to have a dialogue with the past, but one that reflects our own times, our own points of view, and our own kinds of experiments. For instance, we are very interested in the idea and problem of utopia. It is fascinating to observe the tension between the utopian ideas of the 1920s, of making art useful and functional and of making art in and of itself. The desire to make art useful came from an inner necessity. But society always tries to impose its own sense of usefulness. The entire history of socialist realism was geared to subjugate art to political purposes. By contrast, the avant gardists approached this problem differently. They wanted to know the

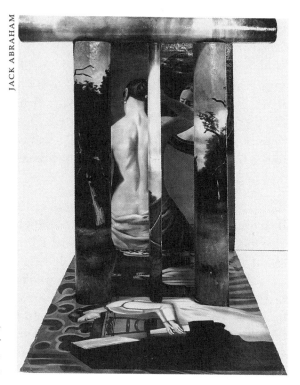

JACK ABRAHAM

Igor Kopystiansky,
Construction, 1985–
1986, oil on canvas,
180 x 240 x 180 cm.

purpose of their art, how it should be useful, and for whom it should be useful. Today, we look at this problem differently. In the end, art is not useful except to guard art's own spiritual energy and value. Art has to protect itself from attempts to use it politically. I am not saying that art has to be apolitical, but art has to be conscious of tendencies to usurp it for other purposes without first asking the artist about his interests or opinions or by forcing the artist to serve causes other than those of his art. Other generations, of course, considered these issues differently.

RB: *Were you able to sell any works in the Soviet Union?*
CK: We never sold even a single work.

ИК: We gave works away as gifts to our friends. There was never a market. We first exhibited in the West in 1988, but we were not allowed to leave the country at that time.

RB: *Who organized these shows?*

ИК: During perestroika, a salon called Polianka was organized to sell art works in order to bring in foreign currency. Works by official and unofficial artists were included. It was a new type of enterprise in the Soviet Union. Some of Svetlana's work was bought by a private collector, a German, and shown in New York City. My works were also bought by a private collector and were exhibited in Madrid. By chance an official of the Venice Biennial saw those paintings and wanted to show them in Venice in 1988. He selected two other Russian artists, Kabakov and Bulatov, to participate in the Biennial. The official also asked the union to contribute some official paintings. The reply was a strange one. The union said that Kabakov and Bulatov were members, but I was not. So the union said that if I were to be included at the Biennial, seven official artists had to be included, too. The Biennial people rejected such a deal, and insisted on their right to select the artists. In the end, the union agreed to let my work out, but I was not permitted to go to Venice.

RB: *Despite difficulties such as these, did your work change as a result of perestroika?*

ИК: We have developed and grown, but I don't think you can say that perestroika changed us. We have always been interested in questions concerning art and its manipulation for various purposes, these have universal interest. They are not specific to the situations in which we found, and still find, ourselves. Obviously, variations exist, depending on local conditions, and we are very interested in comparing how these questions have been handled in the past and are handled today. So in a sense we work with historical materials that already exist in the form of books, manuscripts, and paintings, as well as our own personal history, but perestroika has not changed anything for us.

RB: *Why did you leave Russia?*

ИК: We would gladly have stayed, but the artist's task is to show his or her work. We have exhibited in Moscow and we're planning future shows there. But we also want to exhibit internationally,

like all artists. The situation is still difficult in Russia right now. There are serious bureaucratic problems in getting works out of the country, and we still need to ask permission to leave the country ourselves. Sometimes we have to wait three months. We are still the property of our government, and we cannot leave as easily as you can leave your country. There is even no guarantee that we can obtain a travel permit in enough time to see an exhibition abroad.

RB: *Does not being in your own country have an impact on your work?*
ИК: I don't think so. We have deep roots in Russia, and we continue to develop ideas we had there. We also have many friends whom we know from our past and whom we can now visit. Before, we couldn't see them. Since we have many Russian and American friends, I don't feel as if I live abroad.

CK: I find it much easier to work in America because I can complete works that I could not finish before. It is easy to buy materials here. Financial aid is also possible here. In this sense it is very good. But it is another matter when it comes to feelings and experiences. It is hard for me because I am in a foreign space and have to use a foreign language. I do know English, but in an elementary way, so conversations are difficult. This is one of the reasons I would like to live in Russia. But we have made many friends—Americans, Germans, many in the Russian intelligentsia who live here. In that sense we feel very comfortable. But we do experience a duality of feelings. We exist in some undefined space because we no longer live in Russia. We cannot recreate a former reality and our new reality is not yet developed. Here we still have not become full human beings who can experience their own full authenticity.

Right now, we exist in a space between this world and the other world.

★

Sergei Sherstiuk
Сергей Шерстюк

Born in Moscow, 1951; trained in graphics at Shevchenko Art Institute, Kiev, 1964–1970; studies in theory and history of art, Moscow State University, 1974–1979; member of Group of Six, 1980–1985; lives in Moscow.

Paints in hyperrealist style.

RB: *When did you first know that you were a nonconformist artist?*

CШ: Almost from the beginning, when I was fifteen years old and studying in art school. I had an unpleasant experience there. I had decided to become Picasso, and for an exhibition I made a version of one of his African cubist figures. I received a very poor grade. This was a lesson for me because I realized, at that moment, that my interests and the school's interests did not coincide. I decided that for the rest of my life I would live in conflict. The word nonconformist had no meaning for me then. But later, in the 1970s, I certainly understood what it meant. I organized some performances and experimented with all sorts of art forms that had no bearing on, and did not interfere with, life under the system. Everything was covered up. This was pure nonconformism. In time a group of us became known to each other, and we energized each other. We decided that we would force the authorities to deal with us. Our activities, our performances, became acts of defiance.

I am in spirit an underground person, regardless of the society. I work independently of social structures. I knew this in the 1970s and had to be smart to stay out of trouble. I became a hippie. My friends and I understood the differences between real and fake. My friends knew that mass culture and everything connected to it were fake. We would have nothing to do with it. Many of my friends perished because of their activities. Because of crackdowns by the authorities some jumped out of windows to the music of Jimmy Hendrix and our much loved Jim Morrison. It was also tragic for us when Jim Morrison died because we began to calculate how much time we had left. Some of these hippies who survived the period live in New York now.

RB: *What was your work like at that time?*

CIII: I felt my mind was connected to primordial images—like graffiti that would, in my mind's eye, disintegrate into abstract shapes. I guess these images must have reflected the conditions of our lives. I was still young then, searching for something, but these abstract forms, or universal forms, that I had envisioned fell apart as soon as I began to work on them. They became undecipherable signs. I examined them endlessly, their cracks and scratches, as if they were ancient tiles. But they remained unknowable to me. My academic education prepared me for something entirely different—to work in a hyperrealistic manner. I was drilled by our wonderfully monstrous teachers to draw in an academic manner. Our training was so precise that you learned to draw even a minute speck in an eye. Remember my Picasso story? When I told my teacher that I was Picasso, he said, "Good, you can be Picasso, but he knew how to draw, so let's draw so that you can get somewhere." He wanted me to draw something for him to see what I could do.

RB: *Was being part of the hippie generation a way to distinguish yourself from the older generation?*

CIII: Yes, I am younger than artists like Igor Makarevich. We were part of the last wave of the hippies of the late 1960s. Much later, the hippies I met in New York city seemed older. I looked at them

and felt that we were from a different world. In Russia there were more hippies in my generation than in the previous generation. We would gather at festivals. We'd come from various cities and go to various cities, like Sochi on the Black Sea. These were not just music festivals. All sorts of people showed up. There was a certain toughness about us. Although we considered ourselves hippies, life was hard. Also, I don't know anybody of my generation who was able to connect his life to his art. We organized performances and spectacles that were separate from our lives. We tried to turn our lives into art, to elevate them into art. But it did not really work. The actual lived life and art did not mix. We were also constantly fleeing from the KGB. They swarmed all over us. After a while, we paid no attention. We did not have that much to fear like people who were involved with politics and political dissidence did. Politics for us was a soiled thing. We aspired to a natural life condition, to have no connection with politics. We had no conflict with dissidents, but we did not share the same interests. For instance, they might send along some underground information with one of us. I remember once carrying some literature from Kiev to Lvov, dissident literature. But I did not read that type of material. I looked at the books and got instantly bored. I would rather have listened to Jim Morrison. I had great respect for the dissidents, for their courage, and their art. I was in awe of them, but their activities did not interest me.

RB: *Do you have in mind people like Bulatov and Vassiliev?*
CIII: Yes, the older generation. I tip my hat to them, and I know what brave people they were. To say that I made contact with any of them at our hippie festivals would be ridiculous. I felt that they were mature people, like older relatives. They were jazz, we were rock and roll.

RB: *When did you first see Western art?*
CIII: We went to libraries and could see everything in magazines. But I did not see actual pieces until 1975. It was then that I first saw works by Chuck Close [the American who works from photographs whose paintings were seen at the show, called "Contemporary

American Art," organized by Armand Hammer]. His giant self-portrait had a shocking effect on me, more so than the works of other artists. No reproduction could prepare you for the real thing. Close completely upset me. I went to see my professor, Dmitrii Vladimirovich Sarabianov, and told him that I felt awful, and that I probably would prefer to look at Van Gogh, who would calm me down, instead. I just didn't want to look at Close. My professor then said to me that I would be a hyperrealist. Well, Close influenced me for about a year and a half. I continued to paint my abstractions, but then I decided that Close was like a mentor. I never imitated him, but I felt like a disciple. I became, not a photorealist, but a hyperrealist. Photographs were always just one of my materials. My interest was to affect the viewer directly.

RB: *Would you describe your social milieu before perestroika?*
CIII: We were a friendly group. We were like family to each other. It was an odd situation in that while we felt secure amongst ourselves, we felt insecure politically. With each other, we could discuss anything we wanted. Even our exhibitions had a family character to them [probably meaning exhibitions of like-minded hyperrealists who made up the Group of Six from 1980 to 1985]. We realized that our works would serve no purpose; we just wanted to have them seen by somebody. Most of the viewers were friends. Our closeness was very important to us because society was fractured into different groups and clans. Looking back, I'd say that there was something positive here. It was not necessarily a bad climate in which to create art. If art could exist in a vacuum, then it would have. Anyway, during the period of perestroika, various groups emerged openly—the conceptualists, the sots artists, the hyperrealists. Things began to improve politically, but the different circles began to fall apart. We entered the world and lost our artistic families. In our group, the hyperrealists, there was even a schism. Had there not been evaluations, no market forces, no museum exhibitions, then the situation would have been very positive. The reality of it, however, was very different. Until that time our behavior was considered to be scandalous because we

SERGEI SHERSTIUK ★ 359

did not focus on official art. Among the hyperrealists, our main concern was to exhibit, to be seen regardless of the existing ideology. We had to live with the hierarchical system that included people from the Ministry of Culture and the artists' unions. These organizations controlled our cultural lives. They appointed curators who belonged to the various branches of the security system. It was really ridiculous because the curators were officials who knew nothing about art. They were simply appointed, and then they passed judgement on our art based on their ideology, which for art was socialist realism. Artists of, say, the generation of the 1960s, who painted unofficial art and who might not be union members considered the official position with irony and would not discuss anything with the bureaucrats. But we would come to a meeting as a group, openly carrying our works. This created a scandal because we showed courage in doing so. It also created a lot of gossip, which consisted mostly of fabricated stories. We wanted the officials to engage with us. We wanted to talk to them, make demands, holler, scream, stomp our feet, throw tantrums. We would hang our works and then let them remove our paintings if they wanted to. In this sense you could say we were activists, that we took a stand. In any event, it helped. Our works were exhibited—but not too often and with little ceremony. Mostly group shows rather than solo exhibitions. All of this took place between, roughly, the end of the 1970s and 1985. But the authorities could still make trouble. In 1983 or 1984, at a meeting of the Academy of Art, the minister of culture, a man named Demichev, announced to a group of artists who grew up in the 1930s, 1940s, and 1950s that a certain artist named Sherstiuk attracted a group of artists to himself and that he needed some disciplining, some educating. He did not openly say that they should hurt me, but that a reprimand was in order. This meant that I would be barred from official exhibitions. My work was no longer to be shown. Nobody official could buy any of my works. But within a year or so, there was a sudden turn of events. Perestroika began, and this Demichev disappeared. I was not thrown out of the union, which I joined in 1980, but I basically disappeared, ceased to exist. I was supposed to think things over. Now we can laugh about it, but at

JACK ABRAHAM

Sergei Sherstiuk, *Islands*, 1982, oil on canvas, 140 x 180 cm.

the time it was very painful because of the total isolation. At that time, however, I was, in effect, rescued by Norton Dodge and Elena Kornetchuk [a collector and dealer in Soviet nonconformist art who has a gallery in the Pittsburgh area] who helped me.

RB: *Did you have any other problems with the authorities?*
CIII: I have many stories that involve the critics and the police. My work was mostly hyperrealist when I had my first show in 1980. The critics wrote that I had no connection to artists, spelled with a capital "A," who functioned at a higher level than I did. They said that I was a shady character, some kind of an amoral person. This is what they really said. Well, it was a lucky break for me because many people came to see my works, which were really modest but, I think, pretty good ones. But at that time they provoked a lot of hullabaloo and excitement, as well as alarm. One painting, *Television*, created a big stir when it was shown around 1982 or 1983. Even students came to see it. The painting is a calm one about watching television.

RB: *Why was the reaction so strong?*

CIII: I believe it showed that nothing was happening, that it was symbolic of our lives. The painting is of a woman with her back to us watching a TV screen. I painted in a simulated tear in the canvas, as if somebody had slashed it. The officials were very annoyed that I represented some pathos. Our art was supposed to represent positive situations. It was supposed to convey good moods. But in this and other paintings I made, the mood was harsh, one of emptiness. From my point of view, the painting was entirely normal. It was about the mass media, about mass culture. I did not mean it as a critique of our culture, but, rather, I wanted to show the emptiness of our world as a fact of life.

RB: *Were you ever threatened?*

CIII: Everybody has his or her own experiences. I tried not to react too much to things that came in my direction. At one time or another I was yelled at and told that I would die in the gutter. But people in my generation had no use for this kind of abuse. At other times, people might have fallen apart or become depressed, but we spat on these threats even before they were delivered. We tried to ignore them. I did not see these responses as purely political because, as I look back, I realize that we did not conceptualize such responses. They just happened. But clearly we were against socialist realism. I remember one incident that occurred around 1983. The authorities broke up a group of dissident economists. This was probably the last group to be persecuted. After that, nobody was thrown in jail. One of the dissidents came to my studio to hide. I had a small two-story place, so the upstairs was safe, and since I had not seen him for years, nobody would look for him there. When I would paint, he would come down and ask what I was painting. He wanted me to make sots-art works and tried to convince me that Bulatov was a better artist. I would tell him to be quiet or to tell me why the authorities wanted to put him in jail. He said that his group had developed the concept of perestroika, which would come someday. In retrospect, this is amusing, but other stories are more somber. One time I was in the Crimea with a friend. We were arrested for spreading fascist

propaganda. We had been with friends from Prague, painting at the House of Art. Afterward, we got drunk. An artist friend, Viktor Popkov, had an encounter with the police when he was urinating at the curb. A policeman yelled and began to beat him. Later, we got bored. We found some iron pipes and began to run around in trenches, screaming "bang, bang," and yelling German at each other, as if we were in a movie. We were arrested, not for hooliganism, but for the fact that we were wearing fascist clothing—camouflage green, American military clothing. It was the style at the time, but we were still charged with spreading fascist propaganda.

RB: *Were you ever arrested because of your art?*

CIII: I was arrested one time, accidently, by the KGB. They didn't put me in jail, but they harassed me. I was walking on a street with a friend, carrying some paintings. We did not have our passports, so they arrested us. Since I couldn't prove the paintings were mine, they said we had stolen them. Actually, the KGB tried to bother me for a long time. But I had experience with them when I was a hippie. I would throw a tantrum, but you had to be careful or you might end up in an insane asylum. You only wanted to be difficult enough so that they would want to get rid of you. One person once came to my studio after an exhibition and wanted to recruit me as a spy. He began to threaten me by accusing me of socializing with foreigners. I threw him out. A few day later, I saw this same person at an opening talking to some artists. I called them together and told them who he was. He left quickly. I did this openly so that he would know to leave us alone. Then I began to get phone calls telling me whom I had had a drink with. It turned out that somebody in our group—there were only ten of us—was a stool pigeon. I was told that if I cooperated, I could travel abroad, paint whatever I liked. They wanted me to be a provocateur. This was a normal request—act up, gather people around me, and turn them in. This kind of thing went on for a few months. Frankly speaking, I had a nervous breakdown. But that is how it was. They were very active and insidious. They wouldn't let up. We artists even had printed brochures telling us what to do in case

the police harassed us. It was scary. I suffered from insomnia. You could get very paranoid, the fear was so strong. You knew the police could do anything they wanted to do to you. They would call, then not call for several days. This, too, was frightening. You can't begin to imagine what they might have found out about you. Even though I was summoned before a committee, I did not go. They didn't use force then. I left town instead—which was a whole business in itself. I thought they would forget about me if I left town because I wasn't so important. So I left and got lost for a while. Some of these experiences were difficult ones, particularly since my father was a scientist. The authorities would come to me and say that it was not just my father but that foreigners had come to me to get my father's secrets. I didn't even know what he did— something with rockets—let alone tell anybody anything. They would say that I could be charged with espionage, that I was passing secrets on to the Pentagon, that they could find me guilty unless I cooperated.

RB: *Were there any places where you could exhibit in relative peace?*
CIII: There were several exhibition halls in Moscow where young artists were able to exhibit and were allowed a certain amount of freedom for experimentation—more when we were very young. But the best were the academic villages where the scientists living there would invite artists to exhibit. These shows were all unofficial. The scientists would issue invitations, and we would not ask the union or the Ministry of Culture for permission or advice. The scientists' organizations were official, but they did not ask permission either. They enjoyed a unique status, and their officials were disgruntled and unhappy physicists and chemists. Many artists exhibited there.

RB: *With all of your problems you were a member of the union.*
CIII: Yes. I joined in 1980 and still am a member. Many of us were admitted then. They didn't know what to do with us, and I don't think they knew why they let us in. The union was not as bad as it might have been. Think of it this way. In the hierarchy, the union ranked at the level of a sergeant rather than a general. You can negotiate with a sergeant, even talk back.

RB: *Were you able to obtain materials?*

CIII: The union provided materials at no cost. I think most of us joined to get supplies in the special art stores. One could register at one of these stores, get a permit, and obtain all sorts of things. These stores are still in existence, but they are empty. We had no money then, but these days, even with money, we can't get supplies. Now, when I travel abroad, I bring back suitcases filled with supplies.

RB: *Did you think of leaving the Soviet Union?*

CIII: Yes. I wanted to go somewhere so that I could earn a living. I did not just want to travel to see the world. The early and mid-1980s were a bitter and tragic time in my life because of my problems with the authorities. Later perestroika more or less broke up our groups. We had been like soldiers in a war or like a pack of gray wolves. All of that ended. I did travel to, and work in, New York City and Chicago. I also visited western Europe. I would have liked to leave for two or three years, like many of my friends, but I could not stay that long. My wife is a famous actress [Elena Maiorova], and she cannot be away from the theater for more than a few months, the Moscow Art Theater. Actually, I like being away for a few months in a city like Chicago. It is very pleasant because I work and exhibit, and my life is more integrated, more normal than in Moscow. I do notice a change when I am in America. I work more rapidly because I have a contract with a gallery. I receive a certain amount of money and can paint uninterrupted from morning to night. By contrast, in Moscow, I am constantly involved with one thing or another. Our life is more complicated than it is abroad—all sorts of domestic problems, difficult living conditions, things that have to be fixed. Materials are hard to get or are incredibly expensive, even material to build a fence. But in America, where these problems don't arise, my work assumes a brighter quality. It is less glum, less somber. In America, I surrender to gentler breezes, as if sailing on a yacht. Even technical aspects of my work are easier to handle in America. I spend as much as four months a year in the West, but I am not a great admirer of the West. If I travel and don't work, I get edgy.

Cocktail parties bore me. But when I work I am energized. I can live a normal life like other people in the West.

RB: *Tell me about your development as a hyperrealist.*

CIII: After the abstractions of the late 1970s I began representations of natural phenomena that were totally fictitious. These were my own inventions that came out of my academic training. The viewer had to decode the underlying meanings and had to penetrate my world of illusions. With perestroika, this illusory world began to annoy me because it was not real or honest. Several of us became tired of our so-called artistic freedom. We felt we did not exist as artists because we were painting fictions rather than painting honestly. My work had been more or less in the socialist-realist style, which had permeated everything, everywhere. I wanted to stop making fictitious paintings, so I became more interested in myself as an artist, more involved with my own individuality. I immediately assumed an oppositional stance, particularly to sots art, although, I certainly share certain elements of its style. There were already too many sots artists; I mean, the followers of the classic figures, like Komar and Melamid, whose work had socialist realism's stylistic characteristics. I decided to be more secretive, eccentric, esoteric, and also more universal.

With hyperrealism, I was able to get beyond the concrete.

Irina Nakhova
Ирина Нахова

Born in Moscow, 1955; graduated from the Moscow Institute of Graphic Arts, 1978; lives in Moscow and abroad.

Makes installations.

RB: *When were you first aware that you were an unofficial artist?*

ИН: In the beginning this did not occur to me. Early in life I met a group of people with whom I've remained friendly. I was about thirteen or fourteen years old when I met Viktor Pivovarov and got to know him and his wife. I often visited them. Art had an astonishing effect on me. Even before I met the Pivovarovs I knew that I would be an artist. In that sense, I was very lucky because I didn't have a problem figuring out what I wanted to do with my life. But I did begin to draw rather late, not like many children, who begin around the age of four. I began in adolescence. It was a stroke of good fortune that I met a group of artists through the Pivovarovs. I guess as you grow up the world gets narrower, and you find others like yourself. The group included Kabakov, Bulatov, and Shteinberg. Also Yankilevsky, who was a major figure in that he had made serious and large works in the 1960s. So because of Victor Pivovarov, I entered this group of artists, and we are friendly to this day. The atmosphere was different then. It was like a dream of a golden age. None of us worried about showing art

publicly. That didn't even cross our minds. It was like a closed group of people passionately interested in each other. Contact was very intense. People helped each other in material ways and, more importantly, we lived a communal spiritual life. Later on, the group became known as The Moscow Hot-House Spiritual Group. I met these people in the early 1970s. At the same time, I also met a group of young people about six or seven years older than I, with similar interests. This is the time a group of second generation artists was formed. I married (for two years) Andrei Monastyrsky, who organized a group called Collective Actions. He was, at the time, also a marvelous poet. Later on, the group expanded and Andrei surrounded himself with philosophers and conceptual artists of the second generation. But he was the center.

RB: *Where is he now?*

ИН: In Germany. We were united by common interests, desires, hopes. For me, it was the best time of my life, a real throbbing, creative life—the exchanges of ideas, the interest in each other's works. Nothing now comes close to that time in our lives.

RB: *You studied art during this period?*

ИН: Right after I finished grade school I entered the Institute of Graphic Arts. It was the most liberal school around. I already knew that I didn't want to waste time on courses that did not and would not interest me, such as the history of the Communist Party. The Graphics Institute also had correspondence courses, which meant that you could go there only twice a year to take exams and not bother with lectures. I studied in this fashion for six years. In fact, I spent only one month there, when I took my exams. During all that time, I painted and wrote and socialized and was basically involved with art and the art scene. I did not want to put in time on material that did not interest me.

RB: *What about making a living?*

ИН: None of us, after graduating, imagined that we could earn a living from art. We simply did not have any idea of it. All the exhibitions and presentations took place in homes of friends. I earned money by following in the footsteps of Pivovarov, Bulatov,

and others, by illustrating children's books. At that time it paid very well. It was also possible to work on one book for only about two months but make it seem like a year. So I had plenty of time for my own work.

RB: *Did the authorities bother you?*

ИН: The situation was very odd. Everybody knew that the government could threaten you. That was its role, so nobody thought about exhibiting publicly. The first breakthrough was the Bulldozer exhibition in 1974. It was the first time that artists hoped they could break through the barriers, even though they thought it was an impossibility. As a result, many did not try to exhibit. I know that at first I did not think about or attempt to show works in that exhibition. At that time I was more involved with my spiritual life. It didn't even occur to me to get involved in politics. I mean showing one's work was a political statement. For me, it was more a time to collect experiences. However, when Alexander Glezer began to organize the Bulldozer exhibition, I brought my works to him. I was still a teenager at the time. This was the only time in which I got involved in anything overtly political. Glezer had made a list of about twenty artists that included my name. The KGB had a warrant out for him, and somehow it got hold of the list. So before the show was put up four KGB agents appeared at my parents' apartment. They asked my parents if they knew that I was getting ready to participate in this exhibition, and then they told them that this would not go unpunished. "There will be repercussions," they said. They frightened my parents horribly. My father worked at the university, and my mother worked in a publishing house. Like just about all Soviet people, they lived with fear. My grandfather had been shot. But when you are with a group of friends, then the terror is lessened. So the thing to do was to go ahead. (At that time, I was already with Andrei Monastyrsky.) My parents panicked. They were terrified, and since we were still young, they managed to take us to their dacha, as far away as possible from this "dangerous" event. This is why I did not participate in the Bulldozer exhibition. My works had even been taken to Glezer's place, but my parents were able to retrieve them. This was my first encounter with the Soviet authorities. I guess,

basically, we always came up against the authorities. Clearly we drank it in with our mothers' milk. Everyone knew what was allowed to be expressed and what was not. It was all kept on a subterranean level. Among friends, among one's inner circle of friends, we were free and open. Outside one's circle, nobody ever thought to say anything. An early break came in the late sixties when some people read their poetry at Pushkin Square and Mayakovsky Square. This sort of thing was truly a political action. Artists first came out in open defiance at the Bulldozer show and at the show a few weeks later in Izmailovsky Park. I didn't participate in that show either, since I was still out of town.

RB: *Did you show in apartments?*

ИН: I began to organize apartment shows in my own home. These were my first installations, although I didn't know at the time what they were called. I called them rooms. Originally, I was partial to painting, but I was always interested in space—not objects, but objects in space. So I turned from two-dimensional work to three-dimensional pieces. I began to make paper installations. I never had a studio, so room installations seemed a natural development for me. I still don't have a studio—something between an apartment and a studio. I would make a paper installation in one of the rooms of my apartment, maybe spend two to three months on it, install it in completed form for two or three days, and then take it down. I needed to continue to work, so I had to disassemble each "room" or installation. Friends, of course, saw my work. Photographs, slides, and some writings are the only records, now, of those installations.

RB: *Was it dangerous to do this kind of work? Were you afraid of being found out?*

ИН: Basically, everything was a threat to the government, everything that was out of their control. Any free thought was a potential threat. I do believe, though, that we are where we are today because of what we did then. We tried to experience as much personal freedom and freedom of thought as possible. What is occurring now is the result of that earlier thinking and action.

RB: *How did you learn about installations?*

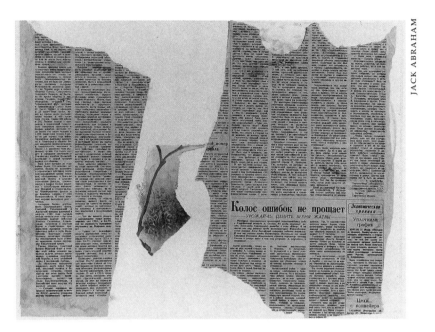

JACK ABRAHAM

Irina Nakhova, *Untitled*, n.d., collage on paper, 36 x 48 cm.

ИН: I literally had no idea that installation art existed. It was my own act of discovery. Then, maybe three years after I began, I learned of its existence. To me it was a parallel development. Personally, my installation art was my own achievement, and I am proud of it. Nobody in Moscow worked in this manner. I was the first one to do so, and people found it very interesting.

RB: *Why did you visit the United States?*

ИН: Around 1988 I began the life of a wanderer. It must be my fate, although now I get somewhat tired. I lead the life of a gypsy; I'm almost homeless. I stay in Moscow about three months a year. At my age this is getting somewhat difficult. At times, I long to be in a place I can call home. On the other hand, as soon as I get back to Russia, I get restless and want to leave, yearn to leave. Perhaps you get used to constant moves. But after the Sotheby's auction in Moscow in 1988, things began to fall into place. I began to get invitations from abroad.

RB: *What kind of works of yours were in the auction?*

ИН: Old pieces were chosen, youthful, immature works, mainly paintings. By 1988, my work had changed entirely, and what Sotheby's chose was not at all representative of my new interests. Perhaps the auction people knew something. Just the same, the auction was a pivotal moment for many artists. It marked an important opening to the West for us. Possibilities for travel, invitations for shows soon followed. For me, I am very grateful to friends, galleries and noncommercial organizations, such as museums, for helping me do my installations. These are not commercial, you know, and it is hard to sell them. Even though I still paint, my main interest is to create new kinds of spaces in various media. Different kinds of materials were not readily available to me in Moscow, and, therefore, I could not really experiment. Now I can, and I can get plenty of space to work in and to set up my installations. I truly admire the courage of the people who show my work because there is no profit in it. For me this support is colossal because I can continue to work. I feel that I am in an extremely productive phase right now. I feel enormous energy and I must work or go crazy.

RB: *Was it easy for you to see Western work in Russia before perestroika?*
ИН: There were no exhibitions of contemporary art in the 1970s, so we learned things from magazines and books. We also learned from the few Russians who went abroad in those days. Some of us also had good contacts with people in Western embassies, who were able to get us books and magazines.

RB: *Has your style changed since you have been traveling?*
ИН: My style is always changing. It is boring for me to repeat myself. So I would be changing regardless. When I first started going abroad I discovered many artists, but I still like the major artists I knew beforehand. My preferences have not changed. Now, I feel very cosmopolitan. I feel at home in New York because it has the same energy that Moscow had fifteen to twenty years ago. At the same time, I feel as if I have never left Russia. Ideally, I would like to be a woman citizen of the world. I don't feel tightly connected to any one culture. My main interest is art history, the only true history for me. I feel as if my true life is in Greek and

Roman art, Islamic art, or whatever. I appropriate all art history to myself, and my installations are filled with references to past art.

RB: *What about your Russian experiences?*
ИН: They are crucial. I felt like it was life at the edge. You feel history there. In the last few years you felt that it flowed so rapidly that you couldn't catch it. That is why art history, for me, is a more truthful history. If you view history through artifacts, it will last forever. Real history is so hard, so painful, but nothing remains from it, from the flow of it.

RB: *Does this kind of thinking influence the way you conceive of an installation? Do you have an image in mind when you begin? and how does it relate to history?*
ИН: Yes. I do have the whole idea and the basic image in mind. I do not know exactly what the installation will look like, but I have a good notion of how it will turn out. Parts in my pieces have a look of being restored. Some parts have a nineteenth-century feel to them. So I don't just suggest everyday junk in my installations, rather something like kitsch, instead. So I mean to say something in my work about alienation from the past and from the present, from a sense of the whole, from a sense of the unity of things. My work is like a meditation on history.

RB: *You appropriate the past conceptually rather than through individual items.*
ИН: Yes, something very much like that.

RB: *Do you think that being Russian and having lived through such historic changes has anything to do with your intense awareness of the past?*
ИН: It was probably easier to be aware of such things in Russia. But I think it was also part of me, of my individuality.

**I also hope that at the other end of the world
people can also have such awareness.**

★

Elena Figurina
Елена Фигурина

Born in Ventspils, Latvia, 1955; moved to Leningrad, 1970; graduated from the Aviation-Machine Building Institute, 1979; member of the Association of Experimental Visual Art (TEII); lives in St. Petersburg.

Figurative painter.

RB: *When did you first know that you were a dissident painter?*

EФ: It is strange to be called a dissident. It was a name given to us by the authorities. We labeled ourselves differently—artists who paint honestly, work honestly, and reveal ourselves as we please. As a result of our sense of freedom, we appeared as dissidents, as if we represented a second culture, a nonexistent culture.

RB: *Can you discuss the relationships between your generation and the previous one?*

EФ: I am an artist of the second wave. I never participated in the famous exhibitions at the Gaz Culture Palace in 1974 or the Nevsky Palace of Culture in 1975. I was to be included in a group exhibition, my first showing, only in 1978, but the authorities canceled it. I finally exhibited in 1980.

RB: *What happened in 1978?*

EФ: We have to retrace our steps here. There were repressions

after the big dissident shows of 1974 and 1975. At least one person was even arrested as a result. The artists of the first wave remained active, but they went underground. People began to exhibit in apartments. A younger group began to emerge—which included me. About seven or eight of us formed a group called The Chronicle and began to look for ways to exhibit. The show of The Chronicle artists was the one that was closed in 1978. The images did not conform to the censor's ideas of acceptability. At that time we looked for people who shared our views and ideas. We were aware of the existence of other groups of young people, and by coming together in one larger group we were able to support each other. This is how we came together in 1981, in the unofficial group called The Association of Experimental Visual Art. We also supported the older artists. At first, however, we remained at a certain distance from them. Only later did they join us. At first they wanted to know what our goals were and how serious we were. After a time, any divisions between us disappeared. After the prohibition of the show in 1978 we organized a show on the street. We also held a few shows in the suburbs. We always thought of ways to hold exhibitions. Whenever we held one we would pass the word around about the location only at the last moment. One time we had a show, here in Leningrad, around the former Church of Kirill and Mefodii in which we rented studios. We were very guarded about the date of the opening, but, as usual, the KGB knew about it ahead of time. A busload of militia came and took away all of our works. Some were broken. This was the usual story.

RB: *Were you threatened?*

ЕФ: Oh, yes. They, the KGB, called us in one by one. They came to my house and wanted me to write an article for the newspaper about my relationship to unofficial art. They wanted me to say that I had reevaluated it, recognized my errors, that I would never again participate with unofficial groups, and that I rejected that art completely. I had just completed my studies at the Aviation-Machine Building Institute and was to begin a new job a week after graduation. The KGB said that I would never find any work if

I did not agree to write the article. Well, I certainly did not write the article, but I did go to work. So, everything turned out all right in the end. There were many such incidents.

RB: *Did you work long as an engineer?*

ЕФ: I worked for several years, until about 1988 when I was able to live on the money I began to make selling my works. While I was an engineer, I gave my salary to my family and bought art supplies from money I made as a teacher of classical guitar in night school. But I haven't played in a long time. I am just too busy.

RB: *What happened in the Leningrad art world in the 1980s?*

ЕФ: A big show was held in an apartment on Bronnitskaia Street in 1981. All the unofficial artists who shared a common discourse were there. We got dissidents together from all over the city who wanted to unite with us and to demonstrate their right to work as they chose. About a hundred artists took part.[1] The exhibit lasted a few days, and of course the KGB got involved. They disconnected the electricity, and they barred viewers from looking at the exhibition. This was part of the usual atmosphere surrounding an apartment show. After this exhibition, a group of like-minded artists got together to find ways to influence the authorities in the organization of art shows. We were able to mount two shows a year that would last about a day each. It cost us a lot of energy, but we had to prove ourselves, that we had rights to exhibit what we wanted. We were encouraged by the diplomatic corps, and perhaps they really helped us. But our power lay in the fact that we artists were all of one mind. This helped sustain us and helped us to survive and to protect ourselves. Now, things are much simpler, and the group has fallen apart. We no longer put on shows together. I look back on that time with great nostalgia. As I said before, we had to be conspiratorial about apartment shows, secretive about dates and places, and notify people only a few hours before an opening. As a rule, paintings would be carted to an

[1] In his essay, "Post-Petersburg Art of Leningrad: The Eighties," Sergei Kovalsky says that sixty-one artists participated, in Selma Holo, ed., *Keepers of the Flame: Unofficial Artists of Leningrad* (Los Angeles: University of Southern California, Fisher Gallery, 1991), 28.

apartment. Then a group from the council of artists who were responsible for hanging a show would move the works to another place in order to confuse the authorities. (We were about forty-eight artists at the beginning, but the group grew to about a hundred and forty within a few year's time.) The interesting thing, though, is that there were always many, many viewers who would show up at the exhibitions. How they got the information is still a mystery to me. Clearly, it was word of mouth, a human radio transmitting service.

RB: *Why do you think so many showed up?*

ЕФ: It was perhaps the only breath of fresh air they were able to get, a feeling of freedom that they experienced. I don't know why else people would queue up for hours to see an art exhibition.

RB: *It must have energized you.*

ЕФ: Yes, it helped a great deal. Let me explain. It was rather odd and complex to be involved with one's friends and family and colleagues at work, all of whom shared the official point of view which I disagreed with. They believed that I was entangled in dangerous and unnecessary activities. I did experience psychological turmoil, and I often felt strange and mixed up in my head. So the crowds at the openings certainly helped validate my activities and give me strength to continue.

RB: *What type of paintings did you make then?*

ЕФ: Figures, more or less as I do now. For one show, the authorities censored a self-portrait. I was amazed and asked the cultural committee that organized the show why my painting was banned from the exhibition. They said that the work was antihumanitarian. This is how such things occurred. There would be a committee of cultural representatives together with people from the KGB. They decided which paintings were to be included in a show. They had three criteria. Works could not show religious propaganda, pornography, or anti-Soviet sentiment. Somehow, these committees decided arbitrarily which works were anti-Soviet. Any symbol could carry anti-Soviet messages. A fish could be perceived as religious propaganda since it symbolized Christ. They could see

in the smallest star or abstract shape or title of a painting an anti-Soviet message. They did as they pleased. Our own group of artists tried to defend the exhibitors, and there would often be a last minute struggle with the authorities. Because we resisted them and tried to negotiate, we could get compromises. For instance, we would say that we would change the title of a painting, but the painting must be hung in the show. Once, in 1984, the censors demanded the removal of several works. We refused those conditions and closed down the show. We thought it was better to refuse to exhibit than to submit in this way. Things did not always work out this way, but we protested and stood up for ourselves in whatever ways we could.

RB: *Was anybody arrested in that particular instance?*
ЕФ: By 1984 nobody was arrested anymore.

RB: *Can you tell me how your works were interpreted by the authorities?*
ЕФ: They had a difficult time interpreting my works politically, so they rejected my things for antihumanitarian reasons. It is difficult to find religious propaganda or pornography or anti-Soviet elements in self-portraits. Maybe they objected to my desire for self-expression above all else.

RB: *How would you describe the meaning of your works?*
ЕФ: I still paint in the style I began with, and my images and ideas have remained little changed except for developments in color relationships and technique. I would say that mine is a discourse in self-exploration in which I try to understand myself, my place in life, my relation to others, and to uncover eternal mysteries.

RB: *How did you get supplies?*
ЕФ: It was not easy. You were considered an artist if you belonged to the union, and to be a member of the union you had to have graduated from an official art institute. I am self-taught, so I was not in the union. You could only get supplies in a union art store, not in ordinary stores. So I got things through speculators, acquaintances, or on the black market. Basically, we do the same thing today.

RB: *When did you begin to sell your paintings?*

ЕФ: Around 1987, mostly to foreign visitors.

RB: *When did you come into contact with Western art?*

ЕФ: Mostly when I began to travel abroad in 1988. I visited museums, galleries, and artists' studios. Our museums did not exhibit contemporary art. Or, art stopped with the postimpressionists and Matisse. If we were lucky, we could see some contemporary art in journals. We really lived in isolation.

RB: *Why do you remain in Russia?*

ЕФ: It is a conscious choice on my part and not simply because I have lived here all of my life. I believe one has an obligation to one's country in difficult times. This is, for me, a matter of conscience. And also I don't think external conditions can really change you. It is what is inside, and location doesn't matter so much.

RB: *Has perestroika changed your art?*

ЕФ: Only indirectly. We have been asked if perestroika opened the door to total freedom and allowed the artist to work more freely. But that is not necessarily how artists have responded because it is not the political situation that determines the sense of inner freedom. I think more important is the end of our isolation and our ability to travel now. I feel I have a broader point of view now, and this probably has had a deeper effect.

RB: *Can you say something about yourself as a woman artist?*

ЕФ: Being a woman has certainly affected my works—perhaps in the delicacy and fragility of my forms, perhaps in an idea. It has not been difficult for me to work as a woman artist because divisions were not based on male-female distinctions but on official-unofficial differences. The problem here is that life is hard for women. That is why there are so few women artists. Perhaps this is why I don't have a family.

I am constantly busy with my work.

★

Georgii Senchenko and Arsen Savadov
Георгий Сенченко и Арсен Савадов

SENCHENKO: Born in Kiev, Ukraine, 1962; Kiev Institute of Fine Arts, 1987. Lives in Kiev.

Works with Savadov on paintings and drawings often based on eighteenth- and nineteenth-century drawings.

SAVADOV: Born in Kiev, Ukraine, 1962; Kiev Institute of Fine Arts, 1987. Lives in Kiev.

Works with Senchenko on paintings and drawings often based on eighteenth- and nineteenth-century drawings.

RB: *When did both of you complete your education?*

C-C: We completed our studies in 1987, around the time perestroika began. We both studied at the Kiev Institute of Fine Arts.

RB: *Were there any connections between your school and art schools in Moscow? Were you able to meet artists from Moscow?*

C-C: We did have friends in Moscow, but we must tell you something very important about the distinctions between our school and the Moscow schools. Our school was the most conservative one of them all. The educational system had not changed since the nineteenth century. So we had an extremely traditional academic upbringing. As a result, we had some serious problems with the school.

RB: *How so?*

C-C: Basically, our problems concerned matters of form. Realism meant classical realism with antecedents in ancient Greece and Rome. To follow such modes of painting at the end of the twentieth century created some complex problems. Even the Soviet museums exhibited works from the impressionist era and afterward.

RB: *Did you ever see impressionist or even cubist works?*

C-C: Yes, just like students raised on the collections in the Pushkin Museum in Moscow or the Hermitage in St. Petersburg.

RB: *Who took you to museums?*

C-C: Our parents. Both our fathers were artists, one is a stage designer and the other is a book illustrator, and they shaped our artistic inclinations and development. So it was actually our parents, rather than the art school, who had the strongest impact on us. Thanks to them we were not saddled with theories of socialist realism. We were able to grow normally, like almost everybody else.

RB: *How did you deal with socialist realism in school?*

C-C: We were frequently expelled because of our resistance to conformity. But somehow, miraculously, we were always reinstated, given another chance to continue our education. Other-

wise, we lived in fear of being drafted into the army. This was a serious problem for us, since we would have had to serve two-year terms and would not have been able to graduate from art school. As a result, we would not have been given our certification, and then we would have lost our qualifying diploma forever.

RB: *Did the authorities threaten you?*
C-C: Yes. It would have meant six years of education down the drain. They used threats as a way to humiliate us, but otherwise those were wonderful years of study and learning.

RB: *How did you know that you were unofficial artists?*
C-C: Most likely since the fifth grade. Our situation was such that it was easy to be nonconformists, since we were born in the early 1960s. We were born at a time of a change in the Soviet mentality. We couldn't even imagine what it was like before our time. The art before our time was not art, and this was to our advantage. We really had it easy, and we didn't have to follow the line of the various youth groups or of the party when we were growing up.

RB: *Did you engage in any activities like those in Moscow? Dissident exhibitions?*
C-C: The situation in Kiev was different. There was no underground culture nor counterculture. There was practically no unofficial art. We had some artists who worked in a contemporary spirit, but they did not get into conceptual art at all. They were from a much older generation than ours. And even for them, things were not easy. So it was entirely different in Kiev than in Moscow where a tradition of conceptual art existed in the 1980s. An art-historian friend of ours observed that the art of perestroika arrived in Kiev with a splash of energy that caused an abrupt break from the old culture. It was a new type of art borne by a new, youthful culture.

RB: *You are saying, then, that there were no unofficial artists of an older generation in Kiev.*
C-C: We did not know any. We knew only our own generation of artists. In fact, we were well acquainted with contemporary art,

since we came of age with different sets of spiritual and psycho-
logical values than the ones we were fed in school. Just the same,
there was no true counterculture in Kiev. There were many artists
whom we respected as people, but not as artists. There hadn't
been an artist in Ukraine since Mikhail Vrubel. We had no under-
ground, since interesting individuals kept leaving for Moscow.
Perhaps some of them painted in a style close to hyperrealism,
such as Sergei Bazilev, a teacher here, who also went to Moscow.
Sergei Sherstiuk also left for Moscow. But we did not know them
very well, except for Bazilev, just before he left in 1982.

RB: *How did you learn about contemporary art?*
C-C: We took advantage of opportunities. We could learn about
both Russian and Western contemporary art because we had
access to modernist literature. We begged anyone who traveled to
America to bring us art books and magazines. A lot of information
came out of Poland, but it was less interesting. We also knew
about an official institute that processed information from the
West. It did not circulate material, but we did have access to the
huge abstracts on culture and philosophy it distributed. Also,
Kiev had the best *samizdat* publishing house in the Soviet Union. It
published nothing on art, but did publish material on philosophy.
Even Moscow did not have such a powerful publisher of such
material. We are telling you all of this to emphasize that we could
get a great deal of information on the avant garde right at home.

RB: *Does this mean that you were politically more free in Kiev?*
C-C: No. In fact things were more difficult, but the harder it was,
the greater the resistance. For example, a strange incident hap-
pened to a friend of ours in 1982 or 1983. He decided to read a
samizdat publication on a trolley car. By chance, a KGB agent was
sitting behind him whose job it was to suppress such publications.
He got into a lot of trouble.

RB: *Did the KGB bother either of you?*
C-C: Yes, even as late as 1987. You might say that they entertained
us for a long time. They warned us that our associations with
foreigners were, ah, what they called undesirable. If we continued

such associations, the KGB would want to know all about them, what our business was with them. This was at a time when embassies were opening up in Kiev.

RB: *They objected to your associations with foreign diplomats?*

C-C: Yes, that was part of it, but they also wanted us to become informers. Actually, we came on the scene at the tail end of all of that. Let us tell you a story. One of our paintings was exhibited in Moscow in 1987, at an exhibition of young Russian artists. This was still at a time when remnants of the Soviet system were still in place. Some people, clearly from the KGB, showed up at the exhibition expressly to remove our painting. Just by chance, immediately before their arrival, the painting was acquired by a French gallery, so the KGB did not succeed in removing our work. Had they arrived a half an hour earlier, the painting would have come down. The incident gained notoriety all through the art world. And a year before, we had an incident in Kiev. We showed a large painting at the Ukraine Museum that was removed by the minister of culture. The exhibition was an important one, and works were shown simultaneously in several exhibition halls. Then the minister took down another work of ours from one of the other halls. Afterward, we decided not to show our works in Kiev for about six or seven years. We did not have a single exhibition there in all of that time. We dealt only with Moscow and even sold our work through people in Moscow.

RB: *What was the objection?*

C-C: It is complicated and concerns a society that lacked any perception of contemporary art and that was artistically undeveloped. There was no way to measure or evaluate contemporary art. Critics had no understanding, no sense of visual perception about such art. Our work simply did not correspond to their standards of what art was supposed to look like.

RB: *What was the theme of your painting?*

C-C: The theme was pseudomythological, but very subjective. The painting was shocking for the time, but today it would seem mild.

RB:　*How did the officials in Kiev relate to your work?*
C-C:　Very poorly. Even though we used, and still use, Ukrainian mythology in our work, we consider ourselves part of the international art community, and we work in that spirit. We are internationalists. So we are really not too concerned with a specific national mythology. Perhaps this is not such a good idea. Right now, there is a strong sense of nationalism in Ukraine, but we don't think that it will turn into a radical movement. There are just too many problems here right now. In 1984 we began to use photographs, strange types of things. Neither then, nor now, can our work be called nationalistic. Perhaps for that reason it is very difficult for us to exhibit in Ukraine. The left-wing press has accused us of abandoning the country and says that we no longer belong there. We have been accused of becoming too Westernized and of destroying the art school. But we think it was the older generation that destroyed it.

RB:　*Are these accusations dangerous?*
C-C:　No, not dangerous, but not pleasant either. It is rather odd to be considered a destructive force.

RB:　*Did you ever have a solo exhibition?*
C-C:　Never. We participated in large exhibitions.

RB:　*Who were your first buyers and when did they begin to buy?*
C-C:　In 1987 a small painting of ours was noticed in Moscow. The Gallery de France bought it immediately. Later, the painting was sold to the famous French artist, Arman [Fernandez], who installed it in his New York studio. We were then invited to Paris where we sold more paintings. We had to do all of this through an export salon, a currency salon, in Moscow run by the Ministry of Culture. At the beginning of perestroika all of the artists had to work with this salon. We all sold our works through this organization.

RB:　*How about sales in Kiev?*
C-C:　None. Even now, nobody is buying. But some Russian banks have begun to collect art. Some Russians buy now.

RB:　*Were you invited to the Sotheby's auction in 1988?*

JACK ABRAHAM

Do you prefer the seaside or the mountains? You are stretched out on a meadow in the mountains. Everything around you is quiet, the blue sky is above you, and the sun shining brightly. You are stretched out on a meadow in the mountains. Everything around you is quiet, the blue sky is above you, and the sun is shining brightly. You are looking at the sky, your glimpse catches a light cloud, ease and tranquillity envelopes everything. You feel very peaceful. You smell the scent of the pine trees. You are relaxed. You are not preoccupied by the idea of the imminent war.

Georgii Senchenko and Arsen Savadov, *Untitled*,
n.d., 100.5 x 101.5 x 10 cm.

C-C: We were invited, but the painting Sotheby's wanted had already been sold to the Gallery de France.

RB: *Was there a like-minded group in Kiev when you were still students?*
C-C: We worked in solitude, in isolation, when we were students. But from the moment we began to exhibit in Moscow, a huge group of young people materialized around us. They were very supportive and encouraged the direction in which we were headed. At the same time, a group of young artists from Kiev found immediate acceptance in Moscow. After we began to exhibit our work a group of about seven to ten artists formed a close association with us, and we, then, formed a group that is still in existence. They were all born in Ukraine, but they are not necessarily Ukrainian artists. You see, art in Moscow was considered to be conceptual and cool, whereas art from Kiev had a tendency to be more intense. But now, everything is intertwined. But the issue is complicated by the antagonism between Moscow and the other

republics even today. Moscow still has a totalitarian relationship with the republics.

RB: *Is it because of the split up of the Soviet Union?*
C-C: Well, the situation could be characterized as the politics of art rather than the politics of state. For instance, Kabakov is from Ukraine, but Ukraine never did anything for him. Generally speaking, there exists an antagonism—it has not always been pleasant—that became evident when artists had begun to be invited abroad. The Moscow artists did not inform foreign committees of art outside Moscow or tell them to travel to, say, Ukraine. The Moscow artists were very self-serving.

RB: *Where do you live?*
C-C: We still live in Kiev, but we get many invitations from the West and travel a lot.

RB: *Do you plan to stay in Kiev?*
C-C: Yes. We have no need to have the experience of moving. And we think that it is important to remain in Kiev.

RB: *Did you join the union or was it too late for you?*
C-C: We had no choice. We were forced to apply or else we would have had problems in getting a studio and all the supplies we needed—canvases, paint brushes. Now, of course, it no longer matters. Still, it was an interesting experience. In order to become a member of the artists' union of Ukraine, one had to pass through a preparatory stage, like an initiation into the youth group. This we did when we completed our studies so that we could obtain supplies. Now, what is interesting here, is that we had to pay, but we did not have to stand in a queue. But we never joined the union itself. Right now, we need to have an exhibition in order to become members.

RB: *Were there any ties between your union and the unions headquartered in Moscow?*
C-C: Yes, both were very conservative and very guarded. Kiev had to follow Moscow's orders to the letter and was completely subordinate.

RB: *When you paint, how do you begin building a work?*
C-C: Most of the time from conversations. These are spontaneous. Then comes the development.

RB: *How do you collaborate? There do not seem to be too many who are together like Komar and Melamid.*
C-C: On the contrary, we found several artists in New York who work in pairs. We have been impressed by the idea of the death of the author, the disappearance of the poet, that has been written about since the 1960s. The idea that the text becomes an actor more than the author is important for us. All of this really made an impression on us when we began to travel in the West. We began to understand questions about the personality and presence, or lack of presence, of the author or the authorial voice in the work of art. We also began to understand the machinations of the art world in the West. Slowly we came to the conclusion that it is no longer important to think in terms of individual artists, whether it be Savadov or Senchenko. It is not important if the artists are in the work or not because the work cannot be personalized to any great extent. This became a key factor in the construction of our work, as if each piece were a production, like the product of a business firm. We feel that we carry less responsibility for the individual piece this way. We began to work this way even before we visited the West. We thought things through as philosophically as we could. In Russia it is normal to work out a philosophical base first.

RB: *What do you mean by philosophically? Whom do you read?*
C-C: We had to start reading Marxist-Leninist theories, but right now neo-Marxianism is very popular. This is due to the fact that there is a wave of bourgeoisification all over the republics. Something awesome is happening. Some people are becoming outrageously rich. Neo-Marxianism means a return to subtle socialist values, to stability in art. Each person is a citizen equal to all others. So the societal aspect of neo-marxianism is not bourgeois. But we don't want our work to become didactic.

RB: *Some artists have said that they experienced more freedom under*

the Soviet system because they did not have to work for galleries. Now they feel that they have exchanged one type of a boss for another.
C-C: That is really a problem for all of us. It concerns our emotions, our spiritual existence. It is very complex. But under no circumstances do we want to create a system. The last thing in the world we want is to be tied to a system.

We want to be connected to something larger.

Sergei Bugaev "Afrika"
Сергей Бугаев "Африка"

Born in Novorossisk, 1966; helped form ASSA, 1983; lives in St. Petersburg.

Multimedia artist and sots-art artist.

RB: *Do you consider yourself a dissident artist?*

CБ: Lately, the term dissident has negative connotations for me. In the 1960s and 1970s, dissident artists played an important role in helping to stabilize the socio-political system. But towards the end of the 1980s the dissident movement became destructive. So I don't want to consider myself part of it.

RB: *You belong to the last generation of nonconformists. Did you belong to a group of like-minded artists?*

CБ: The group included musicians and writers as well as visual artists. It was a singular circle; I associated with people such as Sergei Kulukhin, a well-known intellectual leader of his generation. He was part of a group called Klub 81. I was also close to Timur Novikov, the artist, and I have many friends among the older generation of artists, such as Gleb Bogomolov. Somebody like Igor Zhurkov is also a kind of dissident. He left for America in the mid-1980s, but returned because he couldn't acclimate himself to the country. He is one of those who cannot adapt to conditions wherever they are, and he lives rather in a state of dissention. This has to do with a persons's sense of inner space more than anything else.

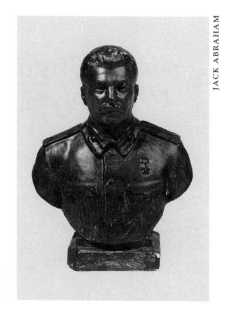

JACK ABRAHAM

Sergei Bugaev "Afrika," *Stalin*, 1986, plaster and tempera, 20 x 15.5 x 7.5 cm.

RB: *What is your artistic philosophy?*
CБ: Lately, I have been interested in the problems of translation and in the linguistic problems raised by [literary theorist] Roman Jakobson, particularly in regard to the appearance of so many texts in visual art presentations. So many artists, particularly Americans such as Jenny Holzer, Barbara Kruger, and Richard Prince, use texts as commentaries to explain their works. And now there are artists who explore pure textuality. I am fascinated by the existence of these texts, by the problematics of their existence, especially, say, examining the process of deconceptualization and reconceptualization in reworking Richard Prince's works from the English language into Russian. It would appear as if something new and original had been created.

RB: *Do you think that this interest is sparked by the amount of traveling that you do?*
CБ: Oh, yes. One reason lies in my interest in a central aspect of that Slavophil tradition concerned with a united society of people, a unity of mankind. It is utopian, but maybe there is the possibility to realize such a unity through a common language, which seems to have existed in the early 1920s.

RB: *When did you first exhibit?*
СБ: I managed to show my work in the last exhibitions held in St. Petersburg by the Association of Experimental Visual Art [TEII]. It is a wide-ranging organization that included many people from the unofficial culture—musicians, writers. Members were selected for their interest in the unofficial culture rather than for their particular artistic or writing styles. The latest shows exhibited works by many artists [186 in the 1988 show] not necessarily united by aesthetic philosophies, but by their community of interests. The last art shows I participated in were still held under the auspices of the KGB, which was still closing down shows as late as 1986 [there were also shows in 1988 and 1989]. But as complex as these shows were, we still held them. They were, in effect, official exhibitions. All shows until the end of the 1980s were under the KGB. The special committees that ran them consisted of three or four people—a professional artist who was a member of the artists' union, a representative of the Ministry of Culture, and a representative of the KGB—who would try to oppose ideological diversity. The exhibitions were hung by artists, but after they would leave the exhibition hall, a committee would arrive to look over the show and decide which works should be removed. The last time this occurred was in an exhibition at the Palace of Youth in 1988. After some works were marked for removal, the artists insisted that either all works be included or there would be no exhibition. So, there was no exhibition. The artists brought their works into the street, there were discussions with officials of the Ministry of Culture to avoid a scandal, but the exhibition was canceled anyway.

RB: *Were you prosecuted?*
СБ: Not then, but I did have some problems before. I was approached and asked to collaborate with the authorities who wanted me to act as a secret agent under certain conditions. At the time, I was very young and would not compromise myself, and, besides, I was not interested in such things. Perhaps now such work might appeal to me because of my interest in theoretical aspects of how the ideological system functioned and controlled our life. I would

like to study more about it, and being on the inside would have provided the opportunity. If I had the chance now, I would probably take it, not because I have become a conformist, but because my tactics have changed, as has the strategy of my work.

RB: *Has your style changed since perestroika?*

CБ: Perestroika was a special moment, but my style changes each month or every time I complete a series of works. I try to do something different each time, something that is not identified as a particular characteristic of my work. In my opinion, a "formed artist" who has worked out a personal style is in danger. The term "formed artist" has the ring of rigidity to it. The very idea acts as a repressive agent as well. This brings up the notion of ideological controls that can be self-imposed. An artist should take care not to find himself in a repressive situation. But also many artists use their personal lives, their autobiographies, as their themes of representation. They want to transfer their personal experiences to the surfaces of their paintings, and in this way influence the viewer. This is why I am interested in those works in which the author erases himself from the work. Again, Richard Prince comes to mind. And this is why I am interested in the translation of texts from one language to another, particularly when the texts come from newspapers, magazines, et cetera, where the statements are not personal to the artist.

RB: *Why do you stay in Russia?*

CБ: Some leave Russia to change their circumstances or to change the means of their struggle to preserve a particular style. These are the easiest ways to survive. But for me, the struggle is continuous, everywhere. It does not matter where I am, since I believe that the universe has stopped existing with fixed boundaries. I feel at home everywhere and try to develop within myself a mood of rootedness, of belonging. After all, we all sit in our apartments and watch CNN on television. We all get approximately the same information about world events, so we can no longer identify purely as nationals of a particular country. To leave Russia is basically an escape from the self, then. And to run away from oneself is a very complicated matter.

RB: *Do you stay in St. Petersburg all of the time?*

СБ: No. I try to live in New York two or three months a year and a month in Los Angeles.

RB: *Why are you nicknamed Afrika?*

СБ: It goes back to a time when my friends and I tried to establish the origins of the Russian language. We developed the idea that the language assumed its importance via Africa, the reason being that the first modernization of the Russian language was done by Pushkin, who was descended from an African prince, and who served Peter the Great. For a while, I found examples to support this idea, and friends gradually began to call me Afrika.

RB: *When did you first see Western art?*

СБ: The first time was through illustrations in albums, newspapers, and magazines in the 1980s. But actual objects, only at the end of the 1980s. I saw some Warhol, some Rauschenberg. Little by little.

RB: *Did their works have an impact on you?*

СБ: In general, everything has an impact on me.

RB: *What kind of relationship do you bear to figures of the older generation such as Bulatov and Yankilevsky?*

СБ: You know it is a complex issue to label somebody a dissident because such a person has some kind of relationship to the government. Kabakov, for example, was engaged with problems of the communal [life in communal apartments]. He and others played a very important role in Soviet and in Russian art.

I respect them very much for what they did.

★

★ GLOSSARY ★

Styles, Events, and Groups

ARTISTS' UNION: When mentioned by artists in the generic sense, which is usually the case, the various unions are referred to as the artists' union. More specifically: the USSR Union of Artists, founded 1957; the Russian Union of Artists, founded 1960; the Moscow Section of the Artists' Union, founded 1932; the Leningrad Section of the Artists' Union, founded 1932.

ASSA: An underground group founded in Leningrad in 1983 which explored a variety of media. Sergei Bugaev "Afrika" was a member.

A-YA: The magazine of the dissident movement, founded in Paris by Igor Shelkovsky and published between 1980 and 1986.

BULLDOZER EXHIBITION: A major event in the history of nonconformist art, also known as the First Autumn Open-Air Exhibition, which occurred on September 15, 1974, in Moscow. Key organizing figures were Oskar Rabin, Vladimir Nemukhin, Evgenii Rukhin, Vitaly Komar, and Alexander Melamid. The event received international coverage when foreign journalists reported the strong-arm tactics used against the artists and the destruction of several of their works by the authorities. The Second Autumn Open-Air Exhibition was permitted to take place during the afternoon of September 29, 1974 in Izmailovsky Park.

COLLECTIVE ACTIONS: A conceptual group founded in 1976 by Andrei Monastyrsky noted for its performances in rural areas. Other members included Nikita Alekseev, Nikolai Panitkov, Georgii Kuzevalter, and Sergei Romashko.

DVIZHENIE (MOVEMENT) GROUP. An organization founded by Lev Nusberg in 1962 with Galina Bitt, Francisco Infante, and others, devoted to exploring kinetic constructions.

GAZ PALACE OF CULTURE EXHIBITION: An officially sponsored exhibition of unofficial artists which took place in Leningrad on December 23–27, 1974.

GORKOM: The Associated Committee of Graphic Artists connected to the USSR Union of Artists that exhibited works by union and nonunion members in Moscow and Leningrad, especially in the 1970s, in part as a way to co-opt the dissident movement.

GROUP OF SIX: A group of hyperrealists that flourished in the early and middle 1980s. Founded by Aleksandr Tegin, it included Igor Kopystiansky, Sergei Sherstiuk, Sergei Geta, Sergei Basilev, and Nikolai Filatov.

INTERNATIONAL YOUTH FESTIVAL: The seventh such festival held in Moscow and the first in decades to exhibit modern Western art.

IZMAILOVSKY PARK EXHIBITION: See Bulldozer exhibition.

LIANOZOVO GROUP: A group of artists who lived in Lianozovo in the late 1950s and early 1960s centered around Oskar Rabin, Valentina Kropivnitskaia, Vladimir Nemukhin, Lydia Masterkova, Evgenii Kropivnitsky, and Lev Kropivnitsky.

MANEZH EXHIBITION: An exhibition in the Manezh Exhibition Hall in 1962 marking the thirtieth anniversary of the Moscow Section of the Artists Union which Khrushchev attended and at which he condemned dissident art. Popular theory has it that conservative official artists staged the "confrontation" to discredit the dissident artists and to bolster their own cause.

METAPHYSICAL SYNTHESISM: Founded in 1967 by Mikhail Chemiakin with V. Ivanov, an art historian, and concerned with the study, the transformation, and the synthesis of the original sources and roots of art through time. Close associates or members included Evgenii Yesaulenko, Oleg Liagachev, Vladimir Liagachev, Anatolii Vasiliev, Vladimir Makarenko, and Alexander Nezhdanov.

NEVSKY PALACE OF CULTURE EXHIBITION: An officially sponsored exhibition of eighty-eight unofficial artists in Leningrad in September 1975. This was the largest exhibition in the 1970s.

SEVERE STYLE: It developed in the middle 1950s within official art circles and has been defined in the following way: "The most visible new trend [in the middle 1950s], no matter what the subject, was toward simplicity. The constant use of forced pathos in art works disappeared. Instead, artists began to describe genuine gloom and mute incomprehension in the face of suffering and death. Eventually this new approach developed into what is now called the Severe Style, in which dark colors and the pathos of life became the principal focus." See Elena Kornetchuk, "Soviet Art and the State," in Norma Roberts, ed., *The Quest for Self-Expression: Painting in Moscow and Leningrad 1965–1990* (Columbus, Ohio: Columbus Museum of Art, 1990), 19.

SOCIALIST REALISM: Since 1934 and until perestroika, the official style in art of the Communist Party.

SOTS ART: Developed in the early 1970s by Komar and Melamid in which the artists created works in the style of socialist realism, but which spoofed both the style and the ideology behind it (by, say, painting their own heads in place of portraits of Lenin and Stalin). Other artists, such as Alexander Kosolapov, Leonid Sokov, and Erik Bulatov used folk-art elements, Soviet posters, or variations on American pop art to comment on the sterility of the communist culture.

SRETENSKY BOULEVARD GROUP: An informal group of artists during the 1960s that included Erik Bulatov, Viktor Pivovarov, Vladimir Yankilevsky, Eduard Shteinberg, Oleg Vassiliev, and Ilya Kabakov.

TEII: The Association of Experimental Visual Art, founded in 1982 in Leningrad.

TEV: Association for Experimental Exhibitions, founded in 1975 in Leningrad.

✸ INDEX ✸

✭ A ✭

A-Ya, 83, 117, 145, 156, 172, 173, 190, 200–202,257,260,395

Abols, Ojārs [1922–1983], 66

Afrika, see Bugaev, Sergei

Akhmatova, Anna [1889–1966], 127, 207

Akhmedov, Bular, 116

Aleph, 5

Altman, Natan [1889–1907], 41

Anechkin, Evgenii, 56

Arefiev, Aleksandr [b. 1931], 135

Arefiev Group, 135

Arzhak, Nikolai see Daniel, Yulii

Association for Experimental Exhibitions, 5, 132, 282, 397

Association of Experimental Visual Art, 5, 373, 374, 391, 397

✭ B ✭

Bacon, Francis, 291, 294

Bakhchanyan, Vagrich [b. 1938], 34n

Bakhtin, Mikhail [1895–1975], 303, 303n

Baskin, Leonard [b. 1922], 303

Basmadjian, Garig, 32

Bazilev, Sergei [b. 1952], 326, 382

Beal, Diane, 32

Beekeeping Pavilion exhibition, 27, 279

Beliutin, Elii [b. 1924], 4, 7, 31, 36–43, 56, 87, 95, 107, 108, 146, 167, 211

Beliutin Group Studio, 211

Belkin, Anatolii [b.1952], 280

Big Sukharevskii, 117

Blok, Alexander [1880–1921], 133

Bogomolov, Gleb [b. 1933], 11, 132–141, 389

Borisov, Leonid [b. 1943], 277–284

Bosch, Hieronymus [ca. 1450–ca. 1516], 294

Braque, Georges, 18, 39

Breughel, Pieter [ca. 1525–1569], 251, 294

Brezhnev, Leonid [1906–1982], 33, 79, 80, 102, 199, 203, 214, 228, 271, 274, 301

Brodsky, Joseph [1940], 282, 296

Bruskin, Grisha [b. 1945], 17, 313–322

Brussilovsky, Mikhail, 271

Bugaev, Sergei, 16, 141, 389–393, 395

Bulatov, Erik [b. 1933], 4, 6, 8, 11, 12, 13, 13n, 15, 17, 19, 33, 114, 115, 143, 144, 146, 152–161, 180, 201, 211, 212, 220, 221, 261, 265, 286, 302, 314, 347, 353, 357, 361, 366, 367, 393, 397

Bulgakova, Olga [b. 1951], 14, 14n, 326, 332–343

Bulldozer exhibition, 5, 56, 64, 70, 82, 87, 88, 96–97, 98, 101, 109, 111, 129, 135, 139, 145, 155, 167,

(Bulldozer exhibition *continued*)
171, 177, 194–195, 232, 237, 248,
253, 260, 268, 270, 272, 273, 279,
287, 307, 326, 333, 368, 369, 395
Burliuk, David [1882–1967], 323

★ C ★

Cézanne, Paul [1839–1906], 168,
234, 272, 310
Chagall, Marc [1887–1985], 125,
187, 196, 229, 340, 341
Chemiakin, Mikhail [b. 1943], 7,
7n, 8, 12, 12n, 22, 96, 148, 252,
293–304, 396
Chernikhov, Yakov [1889–
1951], 6, 87, 106, 108, 110
Chikmazov, Ivan, 46, 48
Chuikov, Ivan [b. 1935], 7, 23, 46,
117, 154, 171–178, 180, 199, 220,
221, 245, 258, 278, 286, 347
Close, Chuck [b. 1940], 357, 358
Costakis, George, 18, 26, 82, 85,
146, 170, 185, 197
Cranach, Lucas [1472–1553], 289

★ D ★

da Vinci, Leonardo
[1452–1519], 31, 121
Dali, Salvadore [b. 1904], 79,
259, 341
Daniel, Yulii, 57, 57n
Delacroix, Eugène [1798–1863], 50
della Francesca, Piero [ca. 1420–
1492], 214
Demuth, Charles [1883–1935], 280
Derain, André [1880–1954], 272
Dimiters, Juris [b. 1947], 67
Dodge, Norton, 1n, 2n, 3n, 14n,
20n, 21n, 25–35, 82, 89, 170, 174,
189, 201, 206, 229, 260, 291, 360
Duchamp, Marcel
[1887–1968], 263

Dürer, Albrecht [1471–1528], 289
Dvizhenie (Movement) Group, 5,
243, 396
Dyshlenko, Yurii [1936–1995], 7,
179–184

★ E ★

Ehrenburg, Ilya [1891–1967],
61, 194
Elagina, Elena [b. 1949], 287
Elskaia, Nadezhda, 88, 97, 267
Ernst, Max [1891–1976], 20, 21n

★ F ★

Faibisovich, Semyon [b. 1949], 33
Falk, Robert [1886–1958], 6, 41, 157
Fedorov, Iura, 130
Feldman, Ronald, 32, 268, 273
Fernandez, Armand [b. 1928], 384
Figurina, Elena [b. 1955], 373–378
Filonov, Pavel [1883–1941], 46,
278, 300, 302, 341
Fonvizin, Arthur, 157
Fraumeni, Richard, 32

★ G ★

Gauguin, Paul, 193
Gaz Palace exhibition, 5, 135, 136,
137, 139, 237, 238, 253, 279, 300,
331, 373
Gerlovin, Rimma [b. 1951], 14,
14n, 172, 175, 245
Gerlovin, Valerii [b. 1945], 14,
14n, 117, 172, 175, 245
Giotto [di Bondone], 214
Glazunov, Ilya [b. 1930], 330
Glezer, Alexander, 2n, 3n, 5, 5n,
12n, 17n, 62, 82, 87, 93, 140, 148,
206, 302, 368
Golomshtok, Igor, 2n, 3n, 12n,
17n, 37

Goncharov, Andrei
[1903–1979], 106

Goncharova, Natalia
[1881–1962], 312

Gorbachev, Mikhail [b. 1931], 33,
77, 102, 181, 188, 308, 317, 320

Gorokhovsky, Eduard [1929],
33, 34n

Gottlieb, Adolph [1903–1974], 129

Greco, El [1541–1614], 256

Green, Allen, 342

Gropius, Walter [1883–1969], 117

Group of Six, 344, 355, 358, 396

Grünewald, Matthias [ca. 1455–
1528], 294

Gundlakh, Sven, 15

★ H ★

Hammer, Armand, 258

Hermitage exhibition, 4, 252, 298,
299

Hoffmann, E.T.A. [1776–1822], 93

Hofman, Nina, 84

Holzer, Jenny [b. 1950], 390

★ I ★

Infante, Francisco [1943], 155,
221, 245, 396

Iskatel [The Searcher], 87

Izmailovsky Park exhibition, 5,
56, 88, 97, 99, 101, 111, 270, 279,
280, 369, 395, 396

Izvestia, 320

★ J ★

Johanssen, Boris, 3

Johns, Jasper [b. 1930], 3, 117

★ K ★

Kabakov, Ilya [b. 1933], 4, 6, 9, 9n,
13, 14, 21, 22, 22n, 31, 32, 46, 48,
82, 105, 108, 114, 115, 142–151,
154, 155, 180, 189, 197, 212, 220,
221, 225, 258, 261, 265, 268, 271,
279, 286, 287, 302, 314, 347, 353,
366, 386, 393, 397

Kalinin, Victor [b. 1946], 326

Kamensky, Vasilii [1864–1961], 16,
323, 328

Kandinsky, Vassilii [1886–
1944], 38, 39, 42, 46, 54, 58, 80,
86, 123, 125, 134, 187, 188, 195,
196, 341

Kharitonov, Aleksandr
[1931–1993], 35n, 186

Khlebnikov, Velimir
[1885–1922], 133, 248

Khudiakov, Henry [b. 1948], 34n

Kienholz, Edward
[1927–1994], 150

Koleichuk, Viacheslav
[b. 1941], 243–250, 278, 282

Kolodzei, Tatiana, 26

Komar, Vitaly [b. 1943], 5, 6, 10,
15, 97, 141, 144, 175, 189, 202,
209, 258, 264–276, 314, 348, 365,
387, 395, 397

Konchalovsky, Petr
[1876–1956], 193

Kooper, Yuri, 50

Kopystianskaia, Svetlana
[b. 1950], 7n, 14n, 344–354

Kopystiansky, Igor [b. 1954], 7n,
14, 14n, 344–354

Korczak, Janusz, 52

Kornetchuk, Elena, 3n, 32,
360, 397

Kosolapov, Alexander
[b. 1943], 15, 41, 197, 221, 257–
263, 287, 397

Kosygin, Aleksey [1904–1980],
81, 272

Kovtun, Evgenii, 237

Krasnopevtsev, Dmitrii
 [1925–1995], 26, 34n, 60–64,
 155, 209, 212, 213
Kravchenko, Valerii, 252
Kropivnitskaia, Valentina
 [b. 1924], 56, 86, 87, 396
Kropivnitsky, Evgenii, 56, 87, 88,
 99, 396
Kropivnitsky, Lev [1922–1985], 4,
 26, 56, 86, 138, 155, 396
Kruger, Barbara [b. 1945], 390
Kudriashev, Ivan, 86, 87
Kultunov, Volodia, 125
Kulukhin, Sergei, 398
Kuprin, Aleksandr
 [1880–1960], 84, 310
Kuspit, Donald, 8, 8n, 9n, 19,
 20, 20n
Kustodiev, Kiril, 251
Kustodiev, Boris, 251
Kuzminsky, Konstantin, 3n,
 21n, 32
Kuznetsky Bridge, 72, 227, 245,
 310, 326, 333, 346
Kuznetsov, Pavel [1878–1968] 54
Kuznetsova, Liudmila, 139, 240

★ L ★

Lamm, Leonid [b. 1928], 7, 19–21,
 19n, 20n, 21n, 106–113, 314
Larionov, Mikhail
 [1881–1964], 134
Léger, Fernand [1887–1975], 169
Lekova-Lamm, Innesa, 6n, 111
Leonov, Aleksandr, 278, 279
Levin, Alexander, 32, 166
Levitas, Eliazar, 45
Liagachev, Oleg, 252, 297, 396
Liagachev, Vladimir, 252, 297, 396
Lichtenstein, Roy, 255, 275

Lifton, Robert Jay, 9, 9n
Lion, Dmitrii [1925–1994], 44–52
Lissitzky, El [1890–1941], 125, 300
Ludwig, Peter, 229, 327, 330
Lukka, Valerii [b. 1945], 17

★ M ★

Magritte, René [1898–1967], 259
Maillol, Aristide [1861–1944], 114
Main, Galina, 33
Maiorova, Elena, 364
Makarenko, Mikhail, 300
Makarenko, Vladimir, 297
Makarevich, Igor [b. 1943], 9, 11,
 218n, 285–292, 347, 356
Malevich, Kazimir [1878–
 1935], 17–20, 38, 39, 42, 46, 49,
 53, 54, 58, 80, 86, 106, 109, 123,
 125, 134, 167, 168, 187, 196, 204,
 219, 236, 262, 278, 341, 348
Manezh exhibition, 4, 7, 36–37,
 38, 47–48, 56, 64, 69, 78, 82, 87,
 93, 95, 96, 108, 116, 126, 131, 145,
 167, 193, 194, 206, 211, 212, 214,
 216, 232, 248, 396
Manizer, Matvei [1891–1966], 69
Marinetti, Filippo
 [1876–1944], 125
Masterkova, Lydia [b. 1927], 12,
 34n, 56, 84–89, 94, 95, 154, 268n,
 396
Matisse, Henri [1869–1954], 3, 16,
 17, 122, 133, 191, 193, 253, 272,
 311, 378
Matiushin, Mikhail
 [1861–1934], 123
Mayakovsky, Vladimir
 [1893–1930], 125, 323
Melamid, Alexander [b. 1945], 6,
 15, 41, 97, 141, 144, 175, 189, 209,
 220, 258, 264–276, 268n, 314, 348,
 365, 387, 395, 397

Melkanian, Jack, 197, 198, 201

Melnikov, Konstantin [1890–1974], 249

Mies van der Rohe, Ludwig, 117

Mikhnov-Voitenko, Evgenii, 34n, 280

Miró, Joan [1893–1983], 17, 341

MITKI, 5

Miturich, Petr [1887–1956], 123, 124, 127

Monastyrsky, Andrei, 347, 367, 368, 395

Monet, Claude [1840–1926], 157

Moore, Henry [1898–1986], 80, 187

Morozov, Alexander, 326, 328

Morozov, Ivan, 272

Motherwell, Robert [1915–1991], 20, 21n, 240, 241

Mukhomor (Toadstool) Group, 5

★ N ★

Nabokov, Vladimir [1899–1977], 263

Nakhamkin, Eduard, 32, 34

Nakhova, Irina [b. 1955], 14, 366–372

Nazarenko, Tatiana [b. 1944], 326

Neizvestny, Ernst [b. 1926], 4, 36, 40, 43, 69, 75–83, 95, 108, 114, 116, 155, 212

Nekrasov, Vsevolod, 56, 154, 240

Nemukhin, Vladimir [b. 1925], 17, 26, 53–59, 85, 86, 87, 88, 95, 154, 278, 395, 396

Nesterova, Natalia [b. 1944], 305–312

Newman, Barnett [1905–1970], 20, 20n

New Ones, The, 5

Novikov, Timur [b. 1958], 389

Novikov, Yurii, 237

Nusberg, Lev [b. 1937], 5, 21, 129, 324, 396

Nutovich, Evgenii, 86

★ O ★

Oldenburg, Claes [b. 1929], 149, 150

Olster, Iulos, 302

Oreshnikov, Viktor [1904–1987], 74

Orlov, Boris [b. 1941], 220, 221

Ovchinnikov, Vladimir [b. 1941], 251–256

★ P ★

Petrov, Alexander [b. 1947], 323–331

Petrov, Arkadii [b. 1940], 227–234

Petrutsky, Mikhail, 84, 85

Picasso, Pablo [1881–1973], 3, 16, 17, 39, 49, 141, 157, 168, 187, 193, 205, 214, 215, 253, 272, 273, 290, 294, 301, 341, 355, 356

Pivovarov, Viktor [b. 1937], 366, 367, 397

Plavinsky, Dmitri [b. 1937], 26, 86, 95, 185–189, 212

Polikarpov, Dmitrii, 4

Pollock, Jackson [1921–1956], 39, 134, 157, 169, 187, 188, 195, 206, 208, 240, 341, 342

Pol'sha [Poland], 134, 273

Poor Sybarites, The, 106, 346

Popkov, Viktor, 362

Prigov, Dmitrii [b. 1940], 130, 131, 218–226, 287, 330

Prince, Richard, 390, 392

Prokofiev, Oleg [b. 1928], 193, 201

★ R ★

Rabin, Oskar [b. 1928], 4, 5, 28, 40, 56, 62, 70, 82, 86, 87, 88, 94–105, 129, 138, 139, 155, 166, 169, 194, 195, 267, 268, 268n, 269–270, 271, 296, 396

Rabinovich, Liuba, 191, 317

Rakhman, Vitalii, 34n,

Raphael [1483–1520], 146

Rauschenberg, Robert [b. 1925], 3, 79, 255, 393

Ray, Man [1890–1976], 259

Rembrandt van Rijn [1601–1669], 133, 168, 208, 256

Renoir, Auguste [1841–1919], 157

Repin, Ilya [1844–1930], 121

Riabov, George, 35

Roach, Dennis, 34

Rodchenko, Aleksandr [1891–1956], 6, 107, 324

Rodin, Auguste [1840–1917], 114

Ronberg, Oswald, 41, 114

Rothko, Mark [1903–1970], 206, 277, 291

Rousseau, Henri [1844–1910], 168

Rubens, Peter Paul [1577–1640], 133, 168, 169

Rukhin, Evgenii [1943–1976], 26, 29, 88, 96, 103, 268n, 395

★ S ★

Sarabianov, Dmitrii, 358

Savadov, Arsen [b. 1966], 379–388

Senchenko, Georgii [b. 1962], 379–388

Serov, Vladimir [1910–1968], 4, 57, 64, 69

Shakovski, Prince, 300

Shchukin, Sergei, 84

Shelkovsky, Igor [b. 1937], 117, 145, 156, 172, 173, 175, 190–203, 395

Sherstiuk, Sergei [b. 1951], 35, 35n, 326, 355–365, 382, 396

Shestakov, Victor, 187, 191

Shklovsky, Viktor [1893–1984], 125

Shnurov, Aleksandr [b. 1955], 34n, 35n

Shteinberg, Eduard [b. 1937], 18–19, 46, 204–210, 212, 213, 286, 366, 397

Shvarts, Sholom, 10, 135

Shvartsman, Mikhail [b. 1926], 155, 302

Sidorov, Aleksandr, 172, 197

Siniavsky, Andrei, 57, 57n

Sitnikov, Aleksandr [b. 1945], 286n, 326, 332–343

Skulme, Džemma [b. 1925], 65–74

Skulme, Marta [1890–1962], 65–66

Skulme, Oto [1889–1967], 65–66

Slepian, Volodia, 193

Smith, Hedrik, 15n, 111, 268

Sobolev, Yurii, 107, 108, 154, 265

Sokolov, Petr, 53, 54, 56, 58, 86

Sokov, Leonid [b. 1931], 6, 114–119, 128, 172, 175, 197, 221, 278, 287, 397

Sooster, Ullo [1924–1970], 107, 108

Sotheby auction, 23, 41, 57–58, 102, 130, 148, 216, 321, 370, 371, 384–385

Sretensky Boulevard Group, 4, 142, 152, 177, 204, 397

Stepanova, Varvara [1894–1958], 6, 312

Sterligov Group, 3n, 34n

Sterligov, Vladimir [1904–1979], 235, 236, 237, 239, 240, 242, 278

Sveshnikov, Boris [b. 1927], 7, 13, 21, 56, 90–93

★ T ★

Tanguy, Yves [1900–1955], 206

Tatlin, Vladimir [1885–1953], 6, 41, 80, 122, 123, 128, 249, 323

Tertz, Abram *see* Siniavsky, Andrei

Tolstoy, Lev [1828–1910], 77

Tomsky, Nikolai [1900–1984], 69

Trotsky, Leon [1879–1940], 121

Tselkov, Oleg [b. 1934], 20, 138, 155, 162–170, 193, 195

Tserlin, Ilya, 185

Tsvetaeva, Marina [1892–1941], 312

Tupitsyn, Margarita, 3n, 13n, 33n, 268

Tupitsyn, Rita, 32, 34

Tupitsyn, Victor, 9n, 13n, 32, 33n

★ U ★

Uccello, Paolo [1397–1475], 214

Udaltsova, Nadezhda [1885–1961], 312

Ufliand, Vladimir, 252

Ulanova, Galina, 121

★ V ★

Van Gogh, Vincent [1853–1890], 49, 187, 193, 234, 272, 358

Vasiliev, Anatolii, 297, 396

Vasmi, Rikhard, 135

Vassiliev, Oleg [b. 1931], 11, 12, 12n, 13n, 115, 144, 146, 152–161, 211, 220, 221, 357, 397

Vechtomov, Nikolai [b. 1923], 5, 56

Vierny, Dina, 201, 299, 302, 303

Vinitsky, Gregory, 32

Volkov, Andrei [b. 1948], 324, 326

Vrubel, Mikhail [1856–1910], 157, 382

★ W ★

Warhol, Andy [1928–1987], 116, 260, 261, 274, 275, 327, 393

★ Y ★

Yakhnin, Andrei [b.1966], 15, 16

Yakolev, Vladimir [1934], 26

Yakovlev, Oleg, 213

Yankilevsky, Vladimir [b. 1938], 13, 21, 22, 31, 40, 46, 82, 108, 138, 155, 211–217, 302, 319, 366, 393, 397

Yesaulenko, Evgenii, 297, 396

Yevtushenko, Evgenii [b. 1933], 25, 166

Yulikov, Aleksandr [b. 1943], 14, 14n, 117, 175

Yurlov, Valery [b. 1932], 12, 120–131

★ Z ★

Zakharov, Petr, 122, 123, 124

Zakharov, Vadim [b. 1959], 33

Zharkikh, Yuri [b. 1938], 97, 103, 241, 268n

Zhilinsky, Dmitrii, 265, 266, 305

Zhurkov, Igor, 389

Zinnik, Zinovii, 267

Znanie Sila [*Knowledge is Power*], 265

Zubkov, Genadii [b. 1940], 3n, 34n, 235–242

Zuikova, Assia, 73

Zverev, Anatolii [1931–1986], 26, 155, 286

Zvezda [*Star*], 300

Zvezdochetov, Konstantin [b. 1958], 8